HISTORIC PHOTOS OF
SYRACUSE

TEXT AND CAPTIONS BY DENNIS J. CONNORS
OF THE ONONDAGA HISTORICAL ASSOCIATION

TURNER
PUBLISHING COMPANY

The Erie Canal is visible in the late 1880s as it continues west from Clinton Square through the industrial district on the city's Near West Side. Two breweries are visible and the city's coal gas manufacturing complex. The latter is located near the two canal barges and extends north to the round gasholder structure on the right.

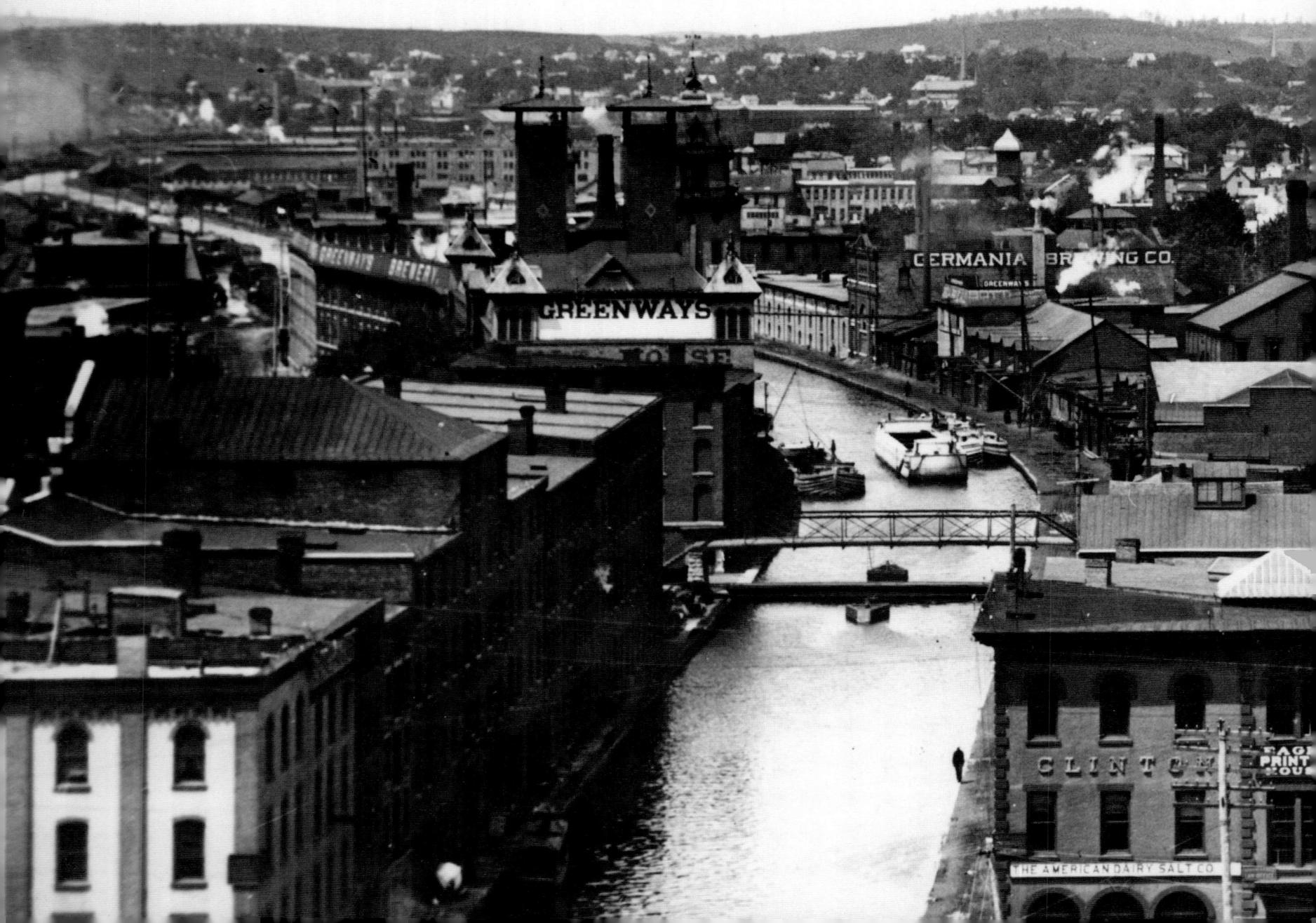

HISTORIC PHOTOS OF
SYRACUSE

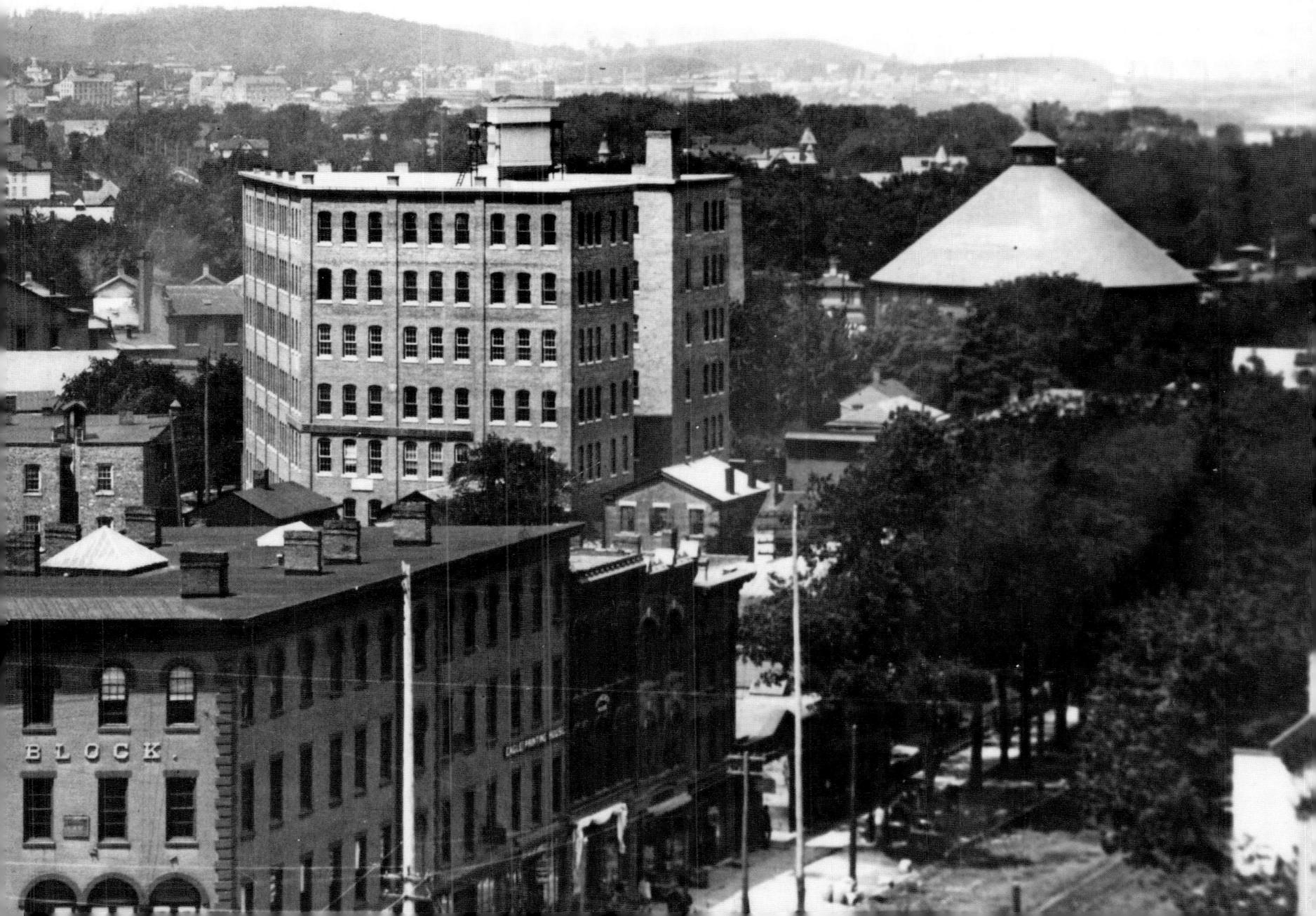

Turner Publishing Company
200 4th Avenue North • Suite 950
Nashville, Tennessee 37219
(615) 255-2665

Historic Photos of Syracuse

www.turnerpublishing.com

Library of Congress Control Number: 2008901901

ISBN-13: 978-1-59652-432-3

Printed in the United States of America

08 09 10 11 12 13 14 15—0 9 8 7 6 5 4 3 2 1

CONTENTS

ACKNOWLEDGMENTS...VII

PREFACE ...VIII

A CITY BORN OF SALT
 (1854–1900) ..1

SYRACUSE MATURES
 (1901–1920) ...51

OLD CHALLENGES AND NEW OPPORTUNITIES
 (1921–1945) ...103

CHANGING TIMES
 (1946–1980)..173

NOTES ON THE PHOTOGRAPHS203

Perry & Robinson was a grocery and provisions store that occupied the corner of a building at Fayette and Warren streets in this 1880s view. Only one of these buildings stands today, the Granger Building, now known as City Hall Commons, second from far-left.

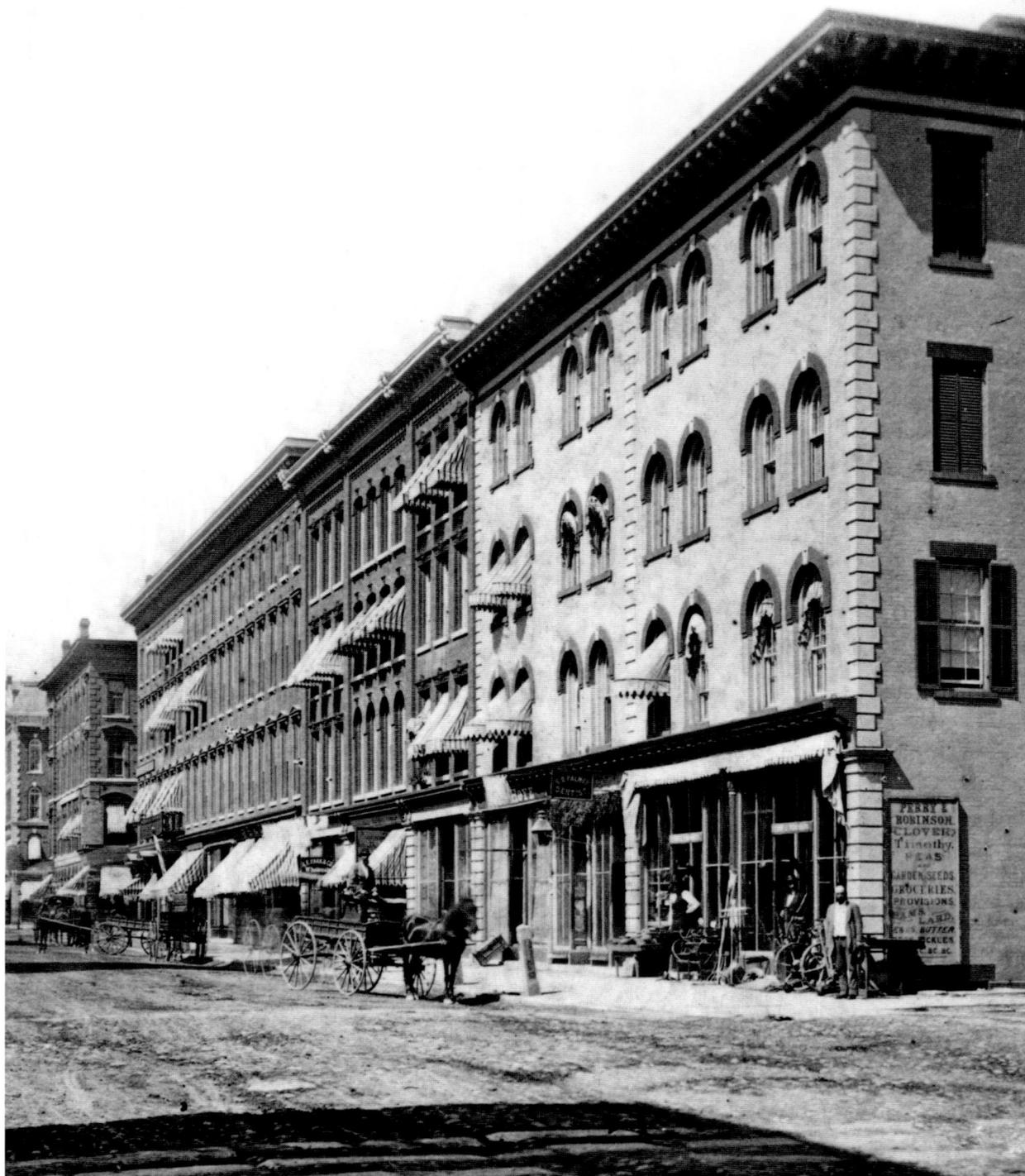

Acknowledgments

This volume, *Historic Photos of Syracuse,* would not have been possible without the diligent efforts, over many years, of the dedicated staff and volunteers at the Onondaga Historical Association. Past OHA director Richard N. Wright's work with the photography collection should be especially noted and the current assistance of archivist Michael Flanagan is greatly appreciated.

The Association's holdings include thousands of original photographic images, covering a span of more than 160 years. These have been collected and arranged in order that the community history contained in them is preserved for future generations. Production of this book is just one of several ways that these images are made accessible and relevant.

Equally important and to be thanked are the many individuals and institutions that have generously donated historical photographs to the Association during its nearly 150 years of existence. Although it is impossible to list them all, a few key donors should be singled out since the scale of their photographic gift was significant and because several of the photos in this publication were drawn from those collections:

Robert Arnold

James Barstow

The *Post-Standard*

The continuing authorizations of Onondaga County and the City of Syracuse form a critical measure of fiscal support for the Association and are most valued. And a special thanks is extended to the several hundred other supporters of the OHA. Through their memberships and gifts, they provide the vital private financial assistance that allows the organization to continue much of its daily work, including the preparation of this book.

PREFACE

The images that appear in this book have all been drawn from the extensive photographic holdings of the Onondaga Historical Association Museum & Research Center. The Association, regularly known as the OHA, is the primary historical agency serving Syracuse and Onondaga County. Organized in 1862, it is one of the oldest cultural institutions in Central New York. The archival holdings in its downtown Research Center include thousands of historic images, which constitute much of the visual history of Syracuse. The grouping of photographs reproduced in this book provides an introductory selection that can be used to begin an intriguing exploration of the city's past.

As a community, the experiences of those who have lived here before us, and the physical legacy they passed on to us, form a large measure of what defines Syracuse as a unique place. Our history is part of the glue that holds us together as a distinct community. And it can add an almost spiritual value to our lives as we experience buildings, landscapes, or just street corners that connect us to those who walked these streets, 50, 100, or 150 years ago.

Photography was in its infancy as Syracuse grew from a small village to a young city. The earliest photos taken here were undoubtedly daguerreotype images during the 1840s of individuals stiffly posed inside a studio. But eventually, these early daguerrean artists turned their cameras to street scenes, documenting the daily life of their community. They, and the photographers who followed them, captured a city centered on two canals. Later, railroads joined those arteries as vital economic connections to the rest of the nation. With cameras large and small, photographers went on to record the city's architecture, commerce, people, dress, transportation modes, schools, products, and personality—all intriguing themes that can be explored within this publication.

Obvious to us today, they also documented the sweeping physical changes Syracuse underwent during these many decades. Such images make us think about the decisions we make, and how they will alter the nature of our city in

the future. Perhaps even more striking, they show us how much of the city's physical history has been lost over time. Although change is inevitable, if we continue to sacrifice too much of Syracuse's physical heritage, we erase the distinct personality of a place. And it is that personality that imparts character and a certain dynamic quality of life to a city.

It is hoped that this book educates and amuses, but also gives cause to reflect on what is best for the future of our city.

—Dennis J. Connors

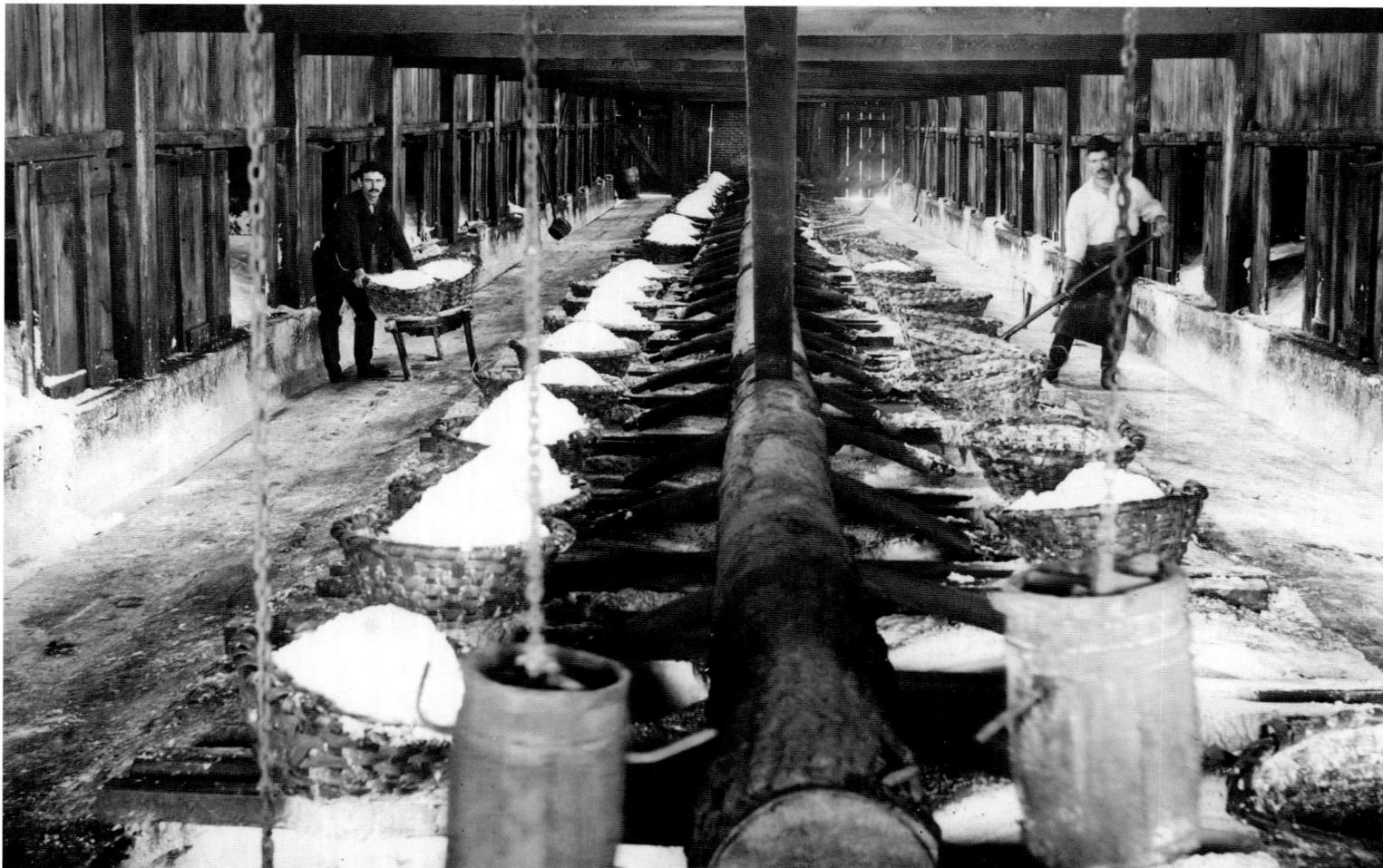

Syracuse's most famous industry in the nineteenth century was salt manufacturing. The method involved evaporating brine found in underground springs. In this 1880s view, the boiling process is seen, involving two rows of large iron kettles fed by a log pipe system. The salt crystals are scooped from the surface of the boiling brine and deposited in large baskets above the kettles to drain.

A City Born of Salt

(1854–1900)

It was a cold time to hold a public referendum, January 3, 1848. But snow and frigid weather have rarely stopped Central New Yorkers. That was the day the residents of two growing villages in the region went to the polls to vote on a charter that would merge their communities into one new city. The village of Salina dated to 1824 and its life and economy centered on making salt from the underground brine springs located near Onondaga Lake. A mile or so to the south was the village of Syracuse, organized in 1825, the same year that the Erie Canal was completed. "Clinton's Ditch," that engineering marvel of its age, had already changed all the rules for where commerce flowed and people traveled in America. Pioneers and immigrants heading west used it while goods flowing from as far away as Chicago poured east along its path. And sitting astride this wonder was the village of Syracuse.

The next day, newspaper headlines announced, "THE PEOPLES' CHARTER TRIUMPHANT!" and the new city of Syracuse was off and running. The combination of a burgeoning salt industry and good canal transportation fueled the municipality's economy and drew waves of arrivals from Germany and Ireland. Salt manufacturing spawned supportive enterprises like iron foundries, to cast the massive kettles for boiling brine, and dozens of cooperages to produce the thousands of barrels needed annually to ship the salt. Railroads soon joined the mix, expanding the city's good transportation links. And the capital derived from salt helped seed other industries.

Clinton Square became the commercial and social heart of the city. Hanover Square and then Salina Street emerged as retail districts with an increasing variety of stores, services, and entertainments. Hotels rose. Dirt roads became paved streets. Various residential neighborhoods grew to the north, south, east, and west. Streetcars evolved from simple horse-drawn affairs into a massive, electrically powered transit system that linked all of these districts. And all this while, fortunes were being made, so some of those neighborhoods boasted impressive Victorian mansions. Beginning in the 1850s, local photographers began to document all of this development.

Syracuse became the largest city in Central New York, with a population that exceeded 100,000 by the end of the century. As it looked forward to the twentieth century, it could boast tremendous growth in its first 50 years.

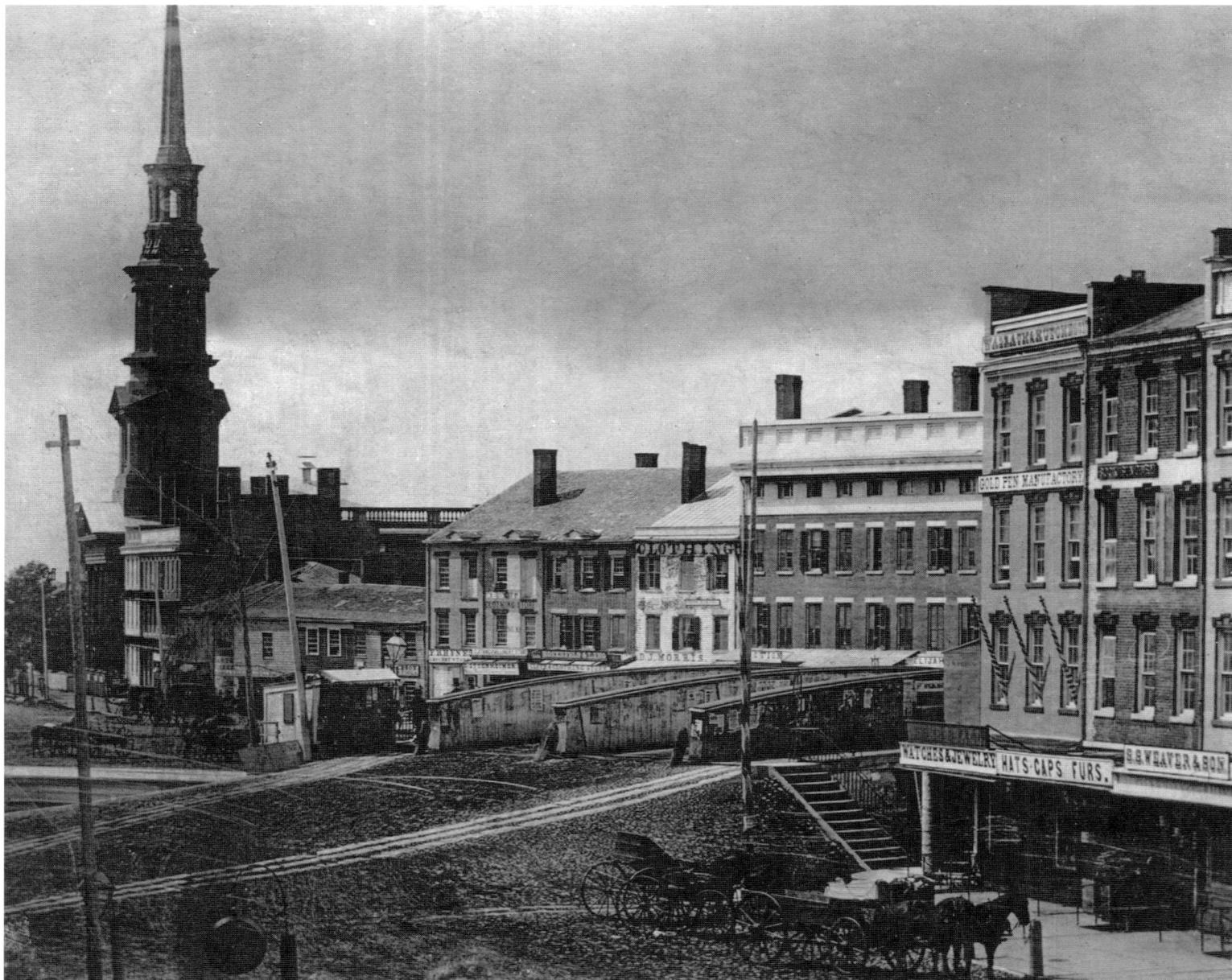

This is believed to be one of the earliest photographs of Syracuse, taken in 1854 from Hanover Square facing northwest into Clinton Square. Salina Street, the city's "main" street, is ramped up to meet a stationary bridge over the Erie Canal. The steeple of the First Baptist Church is visible in the distance.

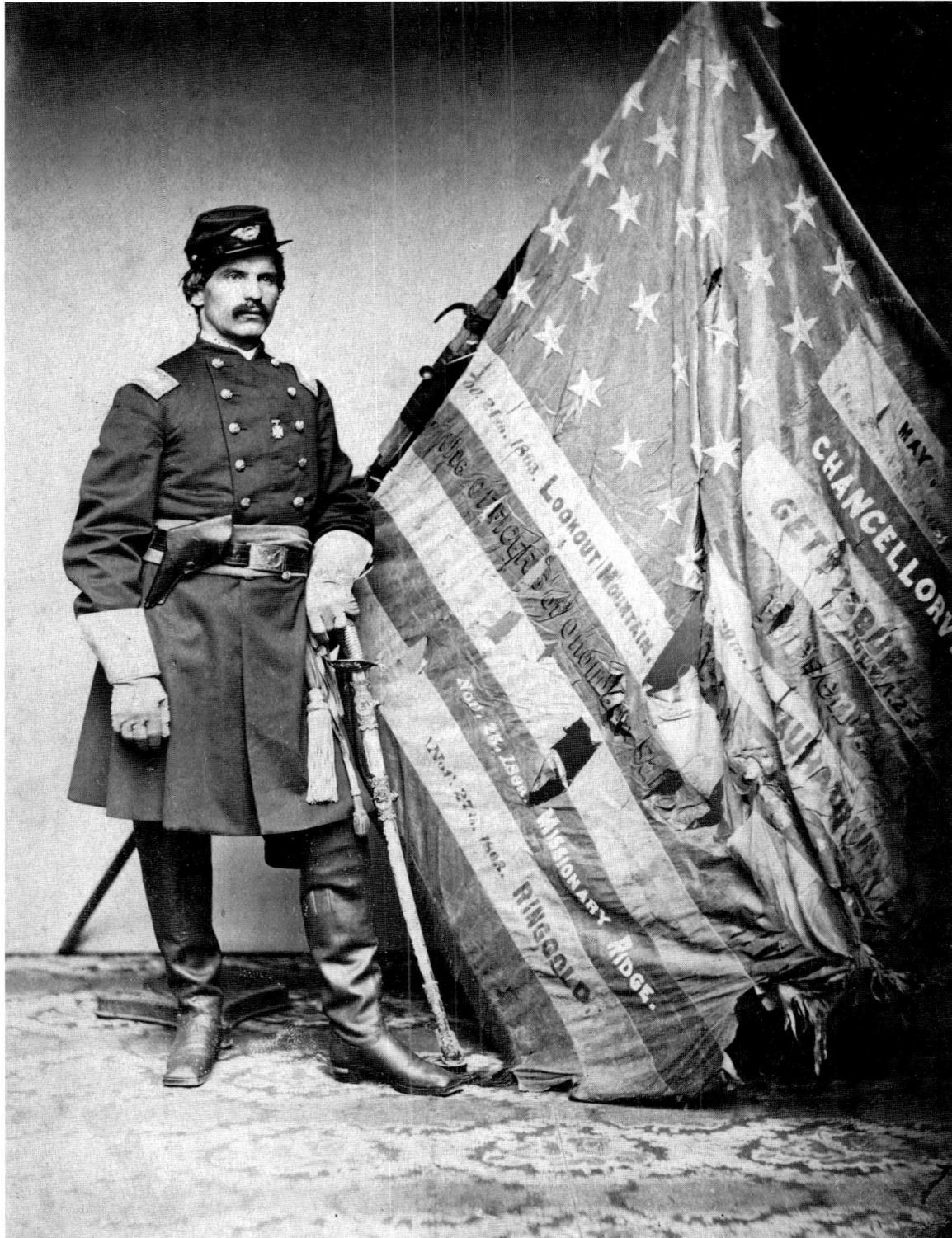

Colonel Henry A. Barnum of Syracuse commanded the 149th New York Volunteers, a Civil War regiment raised primarily in his city and the surrounding area. He poses here with his unit's national colors in 1864. The 149th fought with distinction at numerous battles including Gettysburg, Lookout Mountain, and Missionary Ridge.

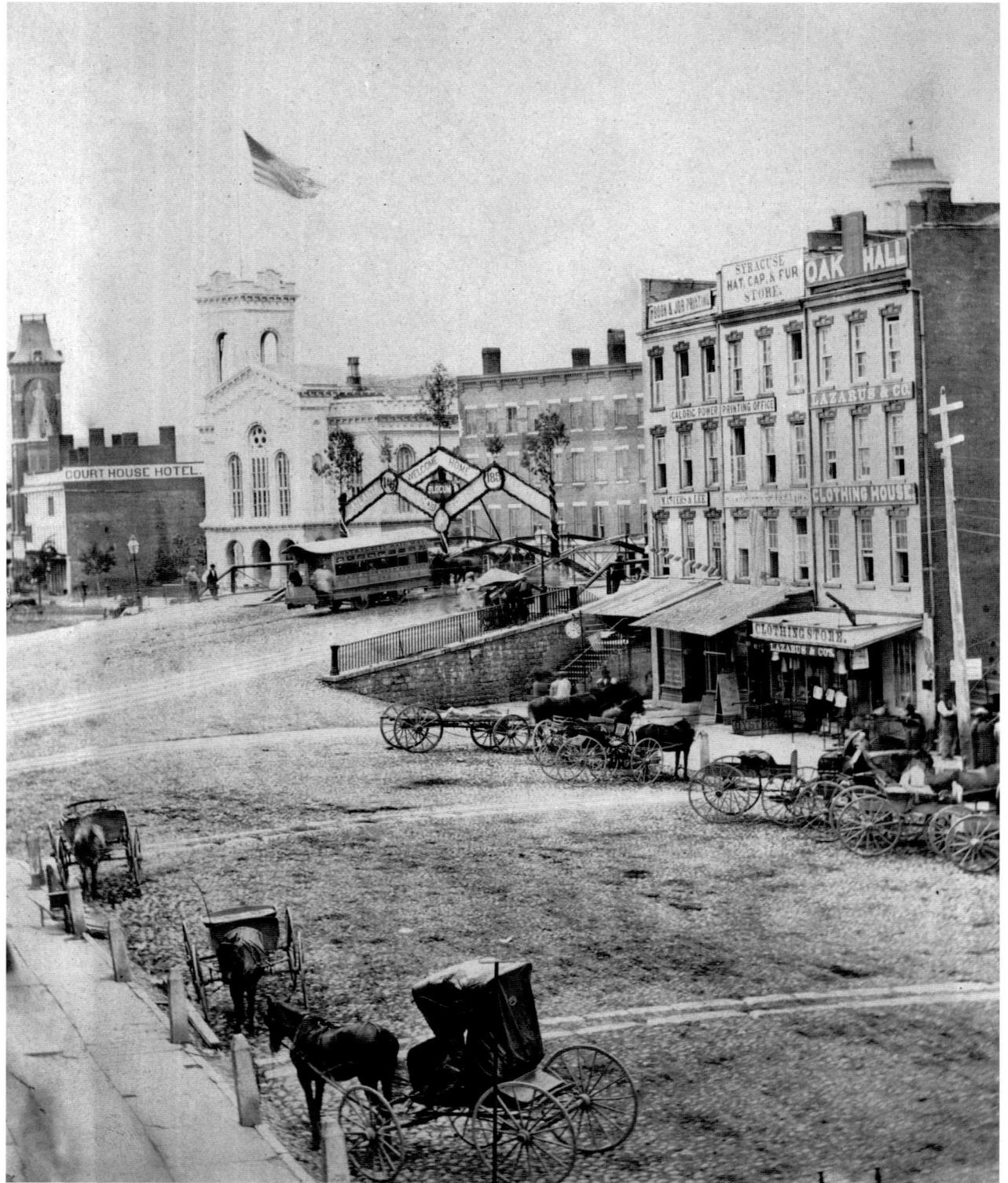

This 1865 view along Genesee Street includes the Third Onondaga County Courthouse in the distance, on the north side of Clinton Square. A horse-drawn streetcar passes beneath an arch, erected to welcome returning Civil War veterans, as it approaches the Salina Street bridge over the Erie Canal.

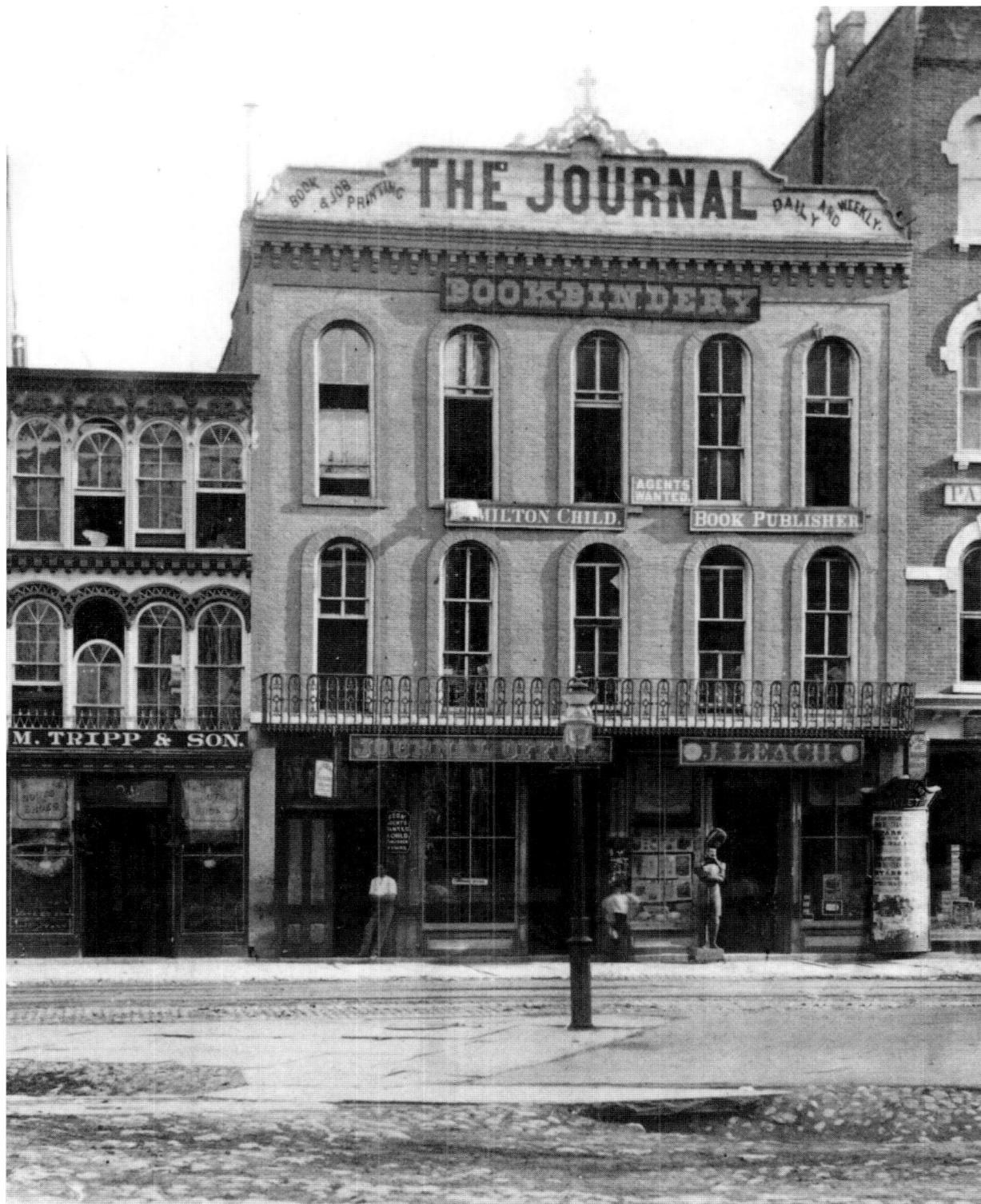

This image shows the offices of the *Syracuse Journal,* a local newspaper, as they appeared about 1876. The building stood along East Washington Street, just west of Montgomery Street.

Vanderbilt Square appears empty from the second-floor balcony of the St. Charles Hotel in this view from around 1875. Another hotel, the Vanderbilt House, stands farther down the street at the northeast corner of Warren and Washington. To the left, the 4-story Granger Block has yet to have the three floors added that would result in its name change to the SA&K Building, now City Hall Commons. Visible in the distance is the Courier Building, which also survives.

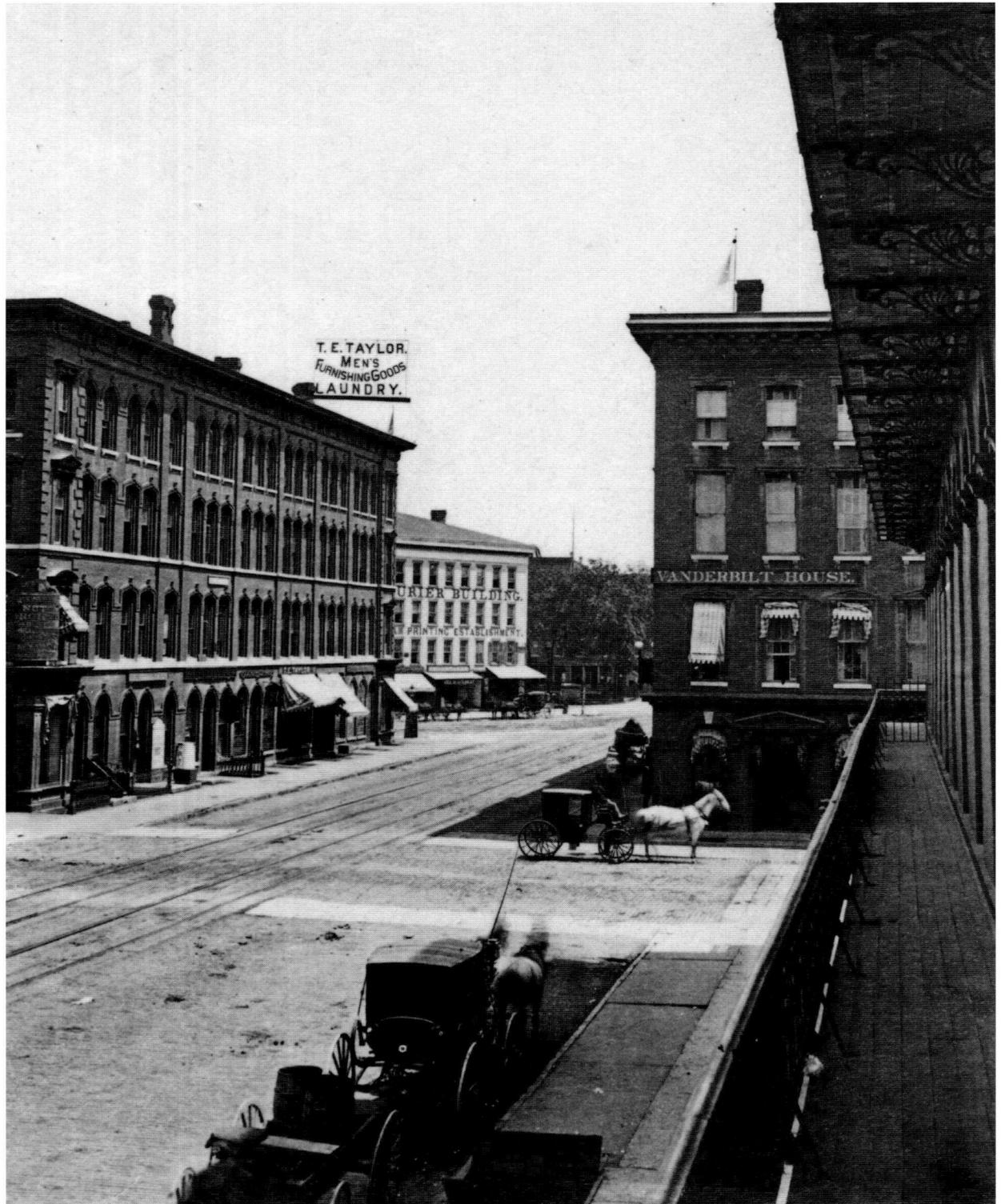

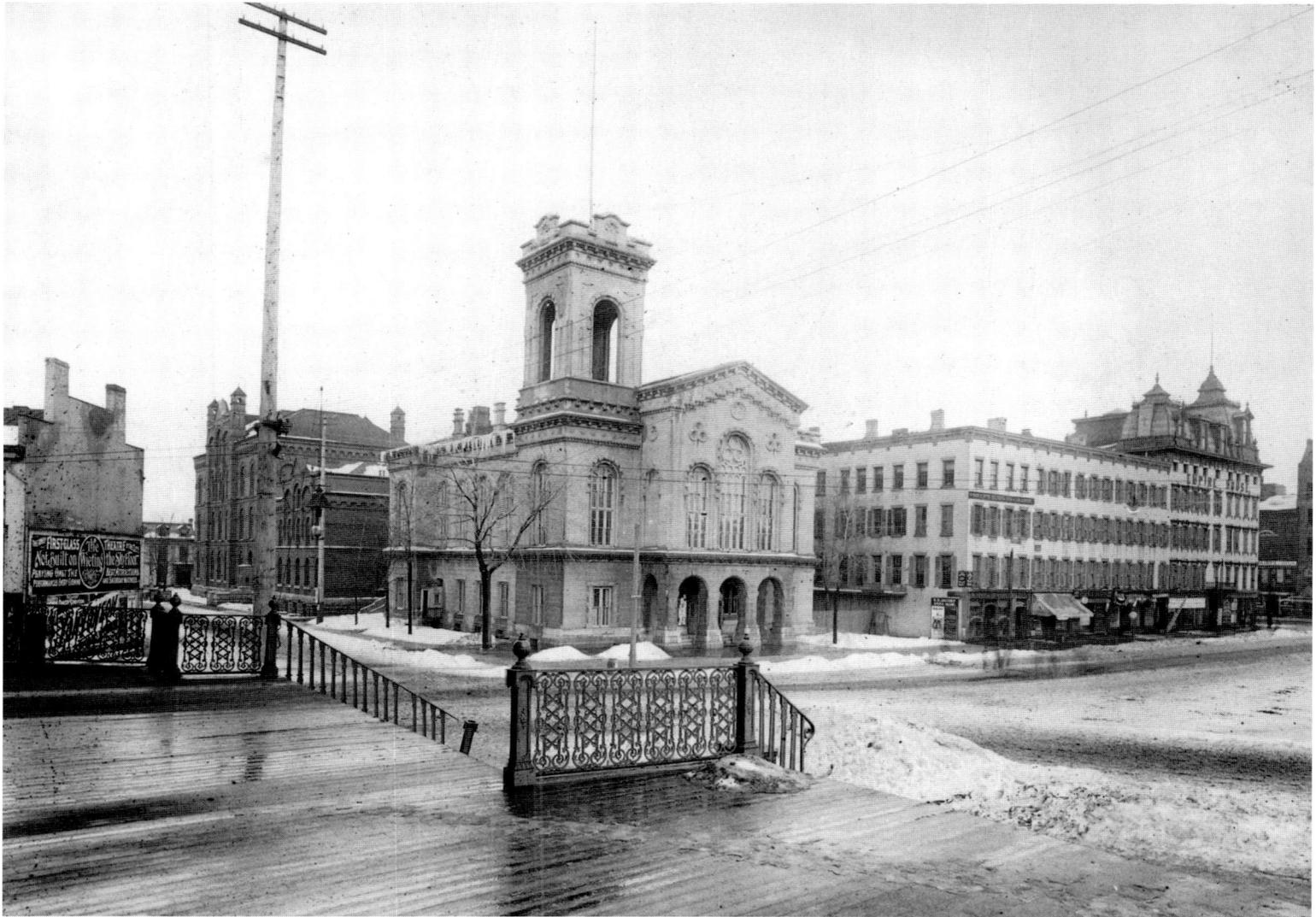

The Third Onondaga County Courthouse opened in 1857, designed by Horatio Nelson White. The limestone structure was demolished in 1967, but smaller, brick versions designed by White still serve their communities in Watertown and Elmira, New York.

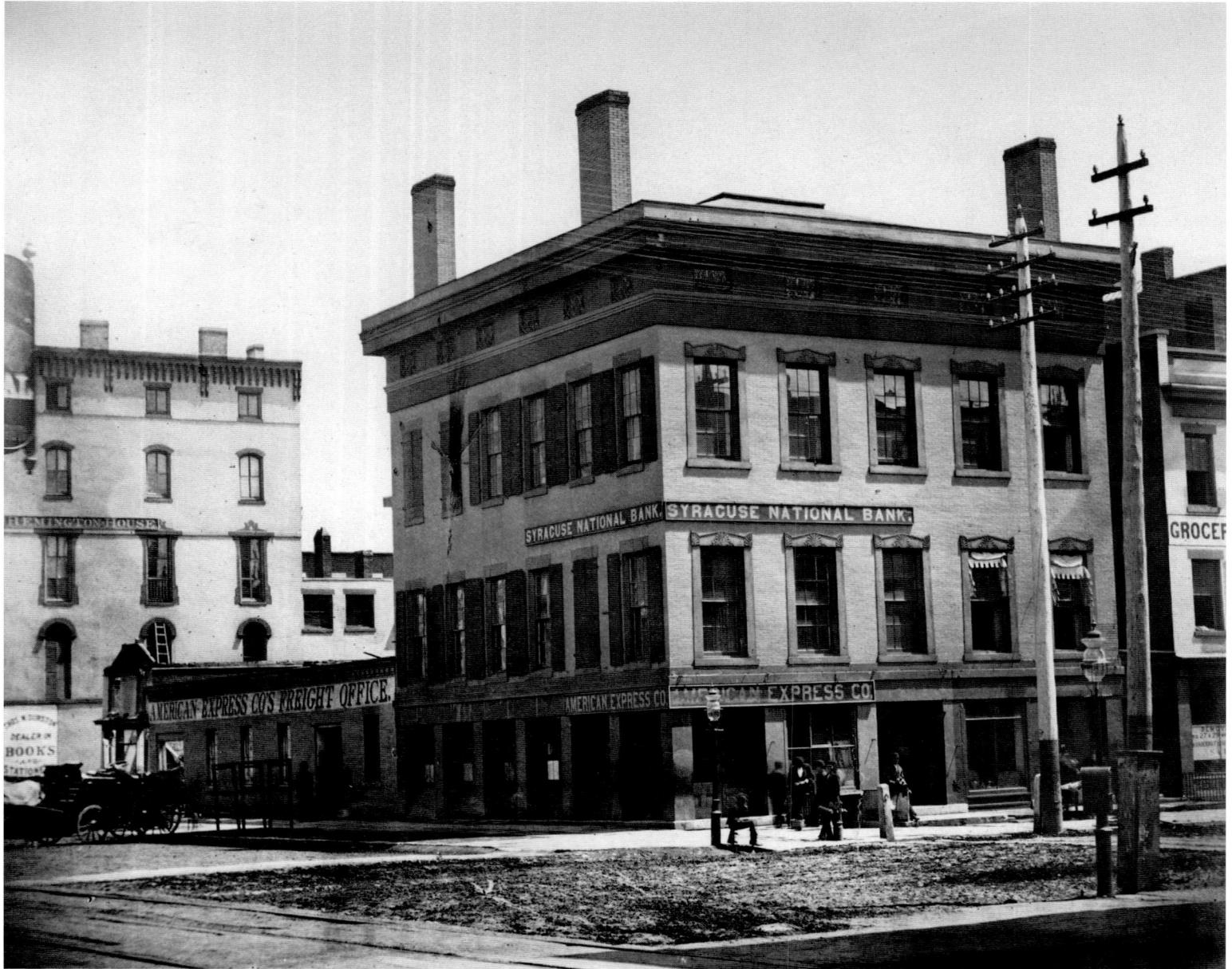

This 1876 photograph shows a structure about to be demolished for construction of the more flamboyant White Memorial Building at the corner of Washington and Salina streets. This early bank building was a classic commercial example of the Greek Revival style, popular in Syracuse during its period of rapid growth following the 1825 completion of the Erie Canal.

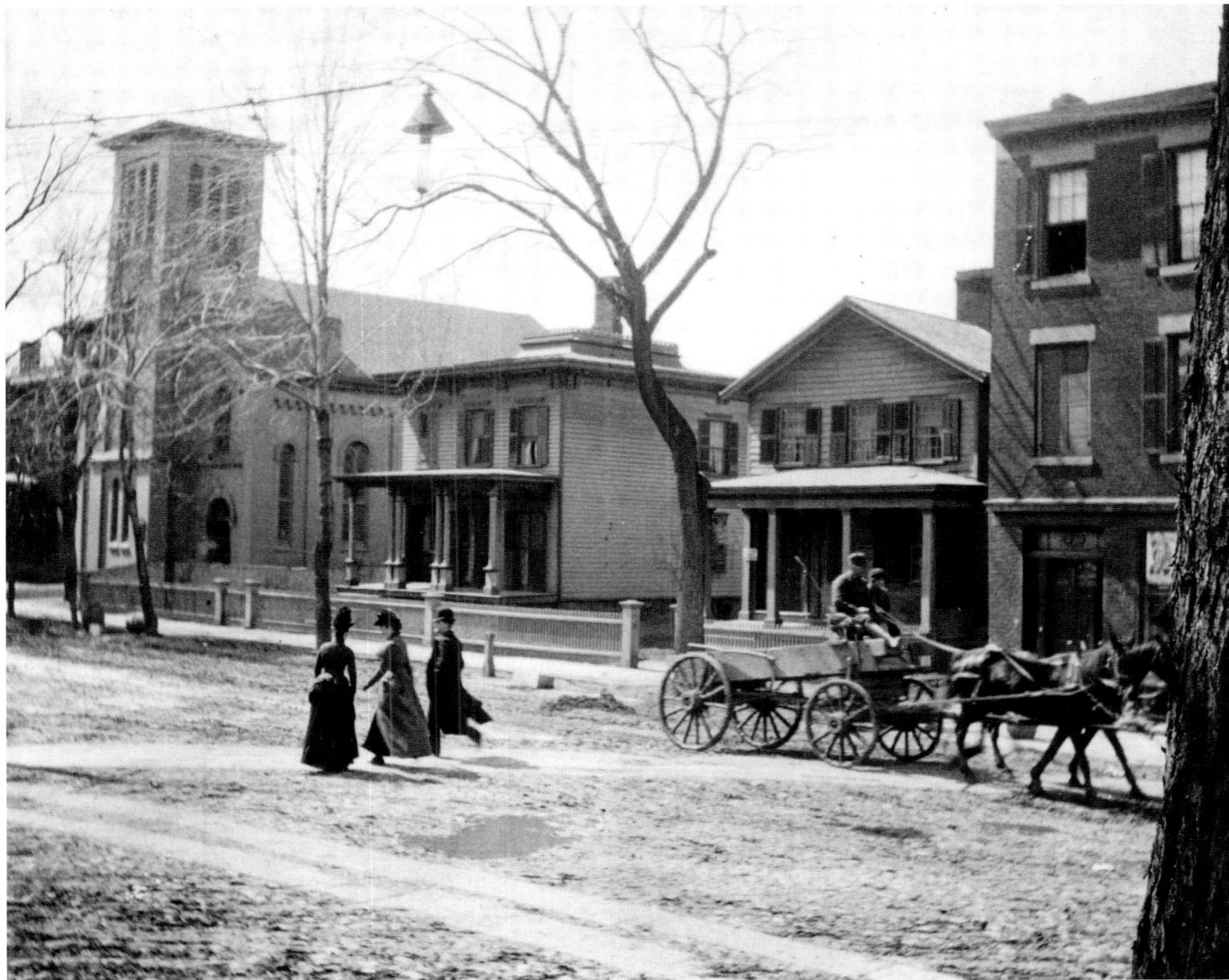

Two women and a man appear to hurry across East Onondaga Street around 1880, just to the west of Fayette Park. This part of downtown was primarily residential until the early twentieth century, except for several churches. In the background is the Church of Christ building, erected in 1864. It was remodeled into a hotel in 1918, then demolished in 1969.

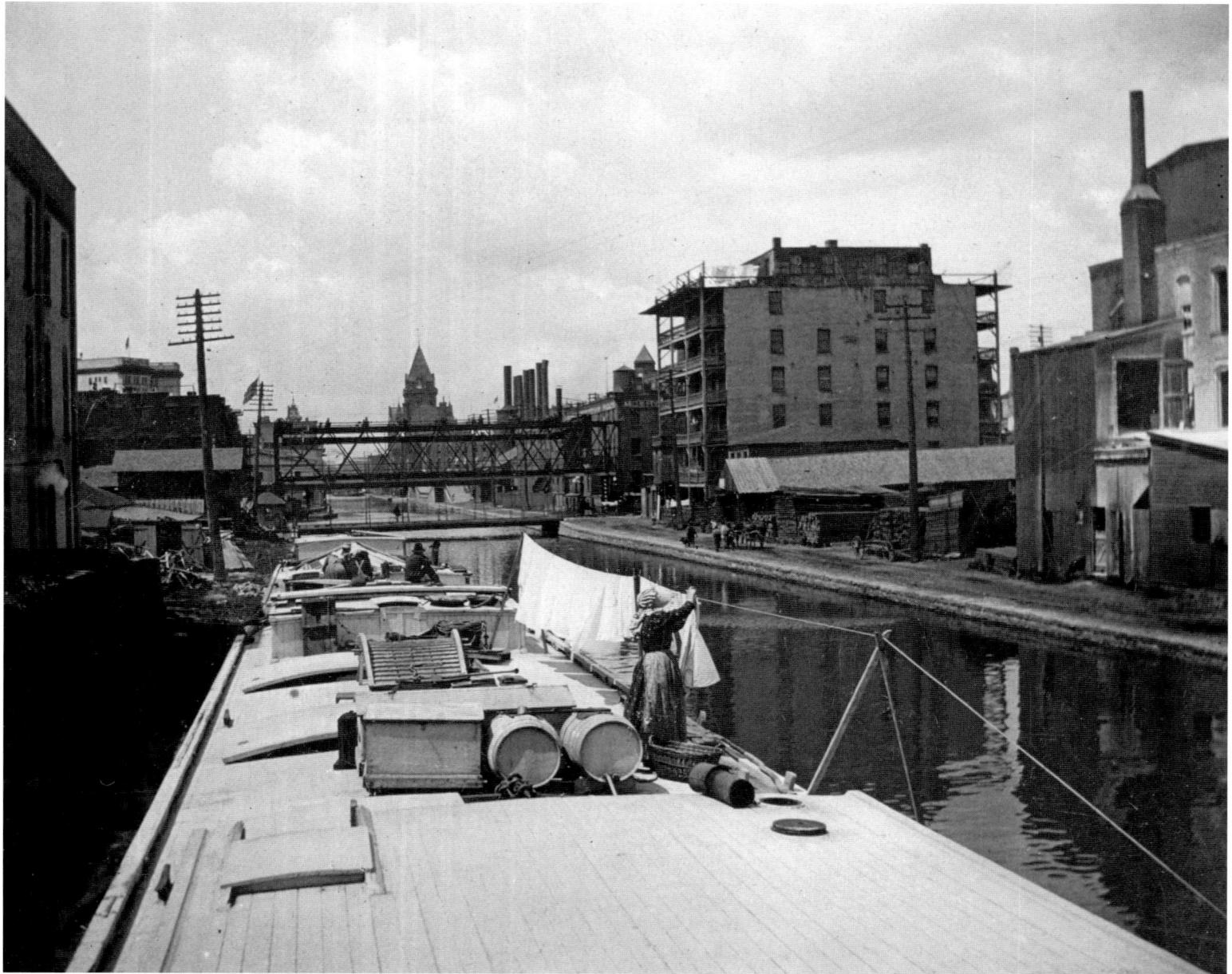

Just a few blocks east of Salina Street and Clinton Square, a woman hangs her laundry on a canal barge docked on the Erie near Townsend Street. Canal boat owners and their families often lived aboard their vessels.

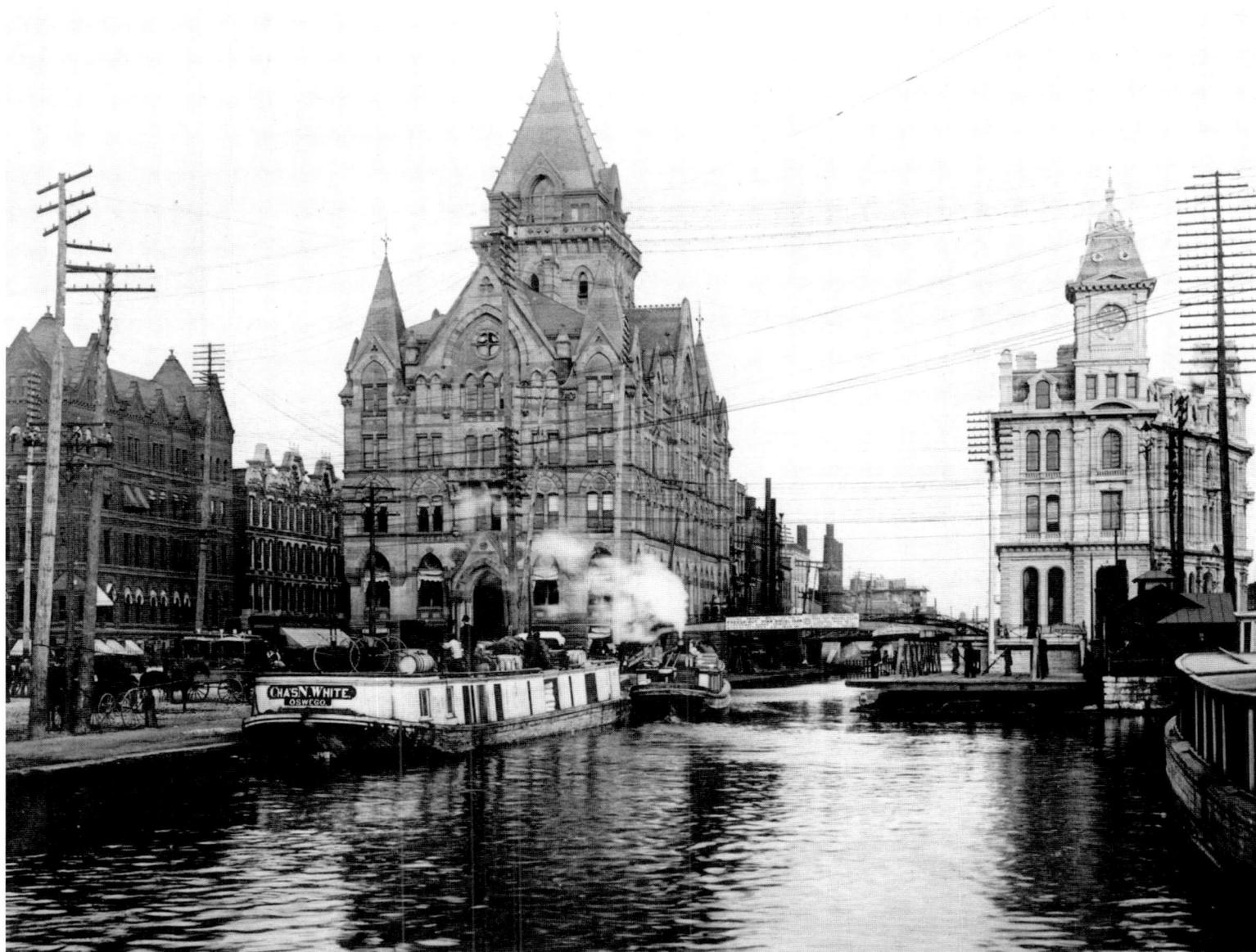

A steam launch pulling the *Charles N. White* canal barge past the Salina Street swing bridge in Clinton Square creates a scene that defines the nineteenth-century image of Syracuse. The three main structures visible left to right in this 1894 view of the Erie Canal are the Third National Bank, Syracuse Savings Bank, and the Gridley Building. All remain standing as treasured landmarks today.

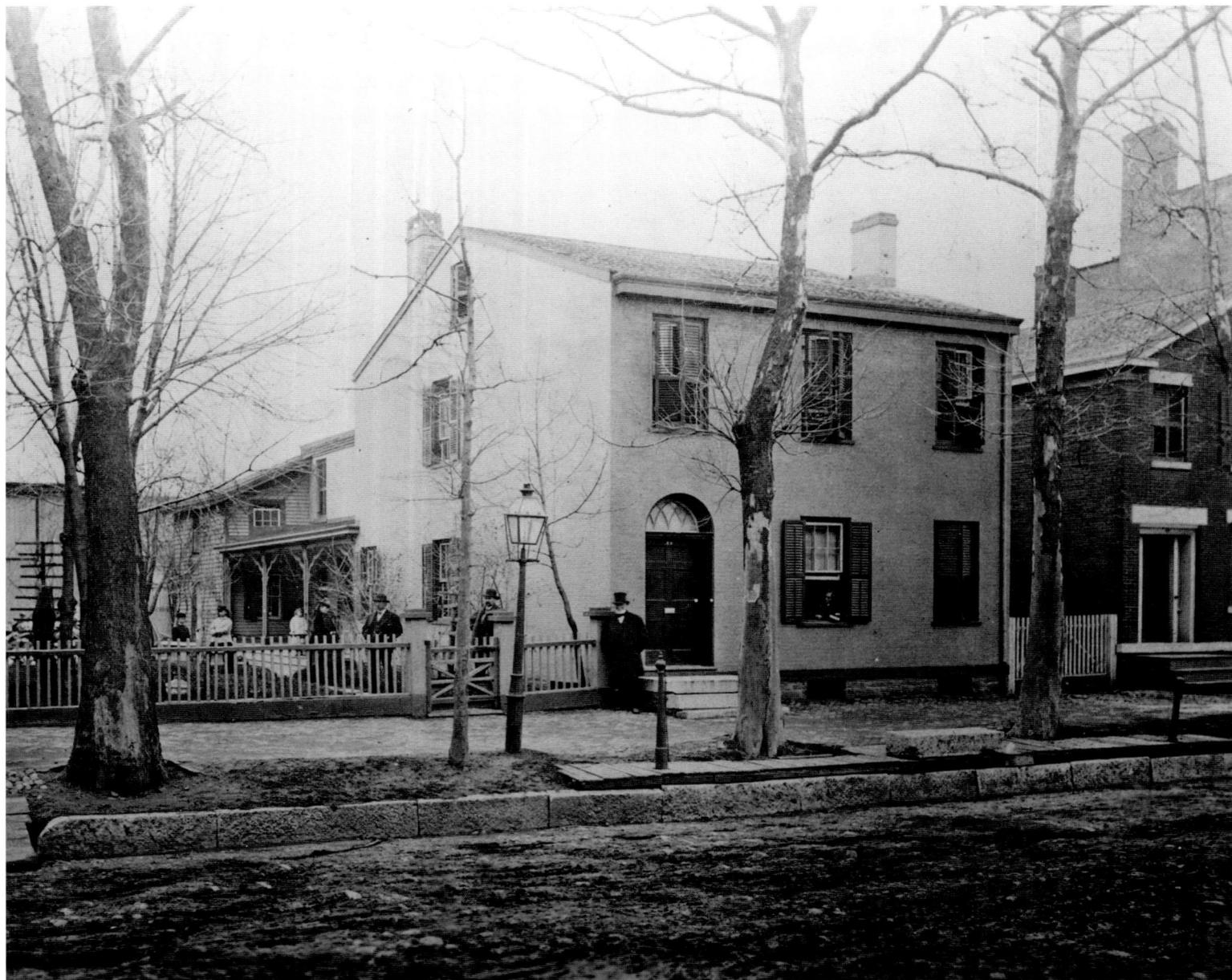

Christopher Columbus Bradley and his family pose in front of his home on West Water Street, the site of the present-day Federal Building. Bradley started an iron foundry to cast salt kettles and parts for machinery. As downtown expanded in the decades after the Civil War, Bradley's residential neighborhood would quickly give way to numerous commercial buildings.

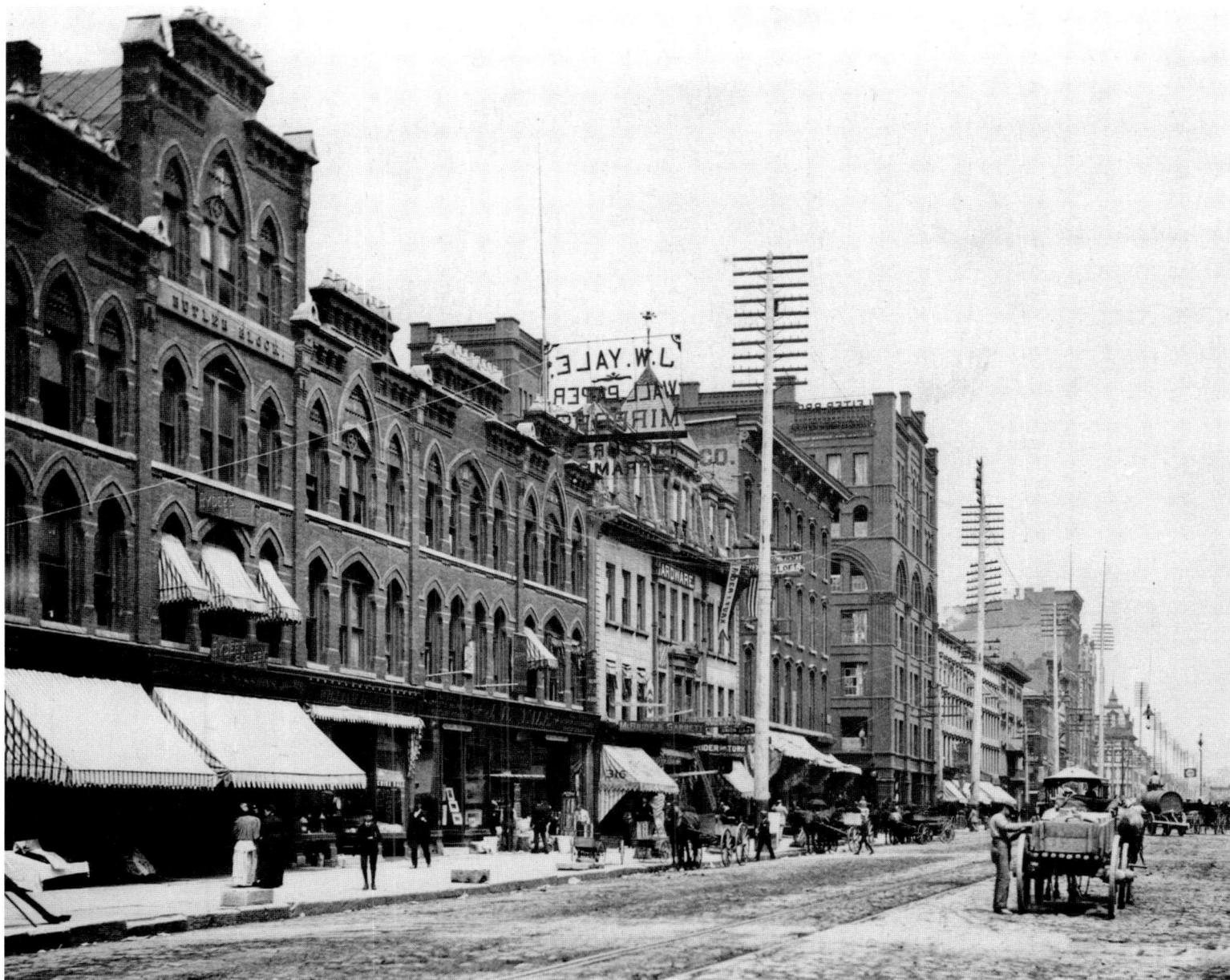

Facing north on downtown's Salina Street, this 1890 view offers the flavor of daily life in the decade prior to the arrival of the automobile.

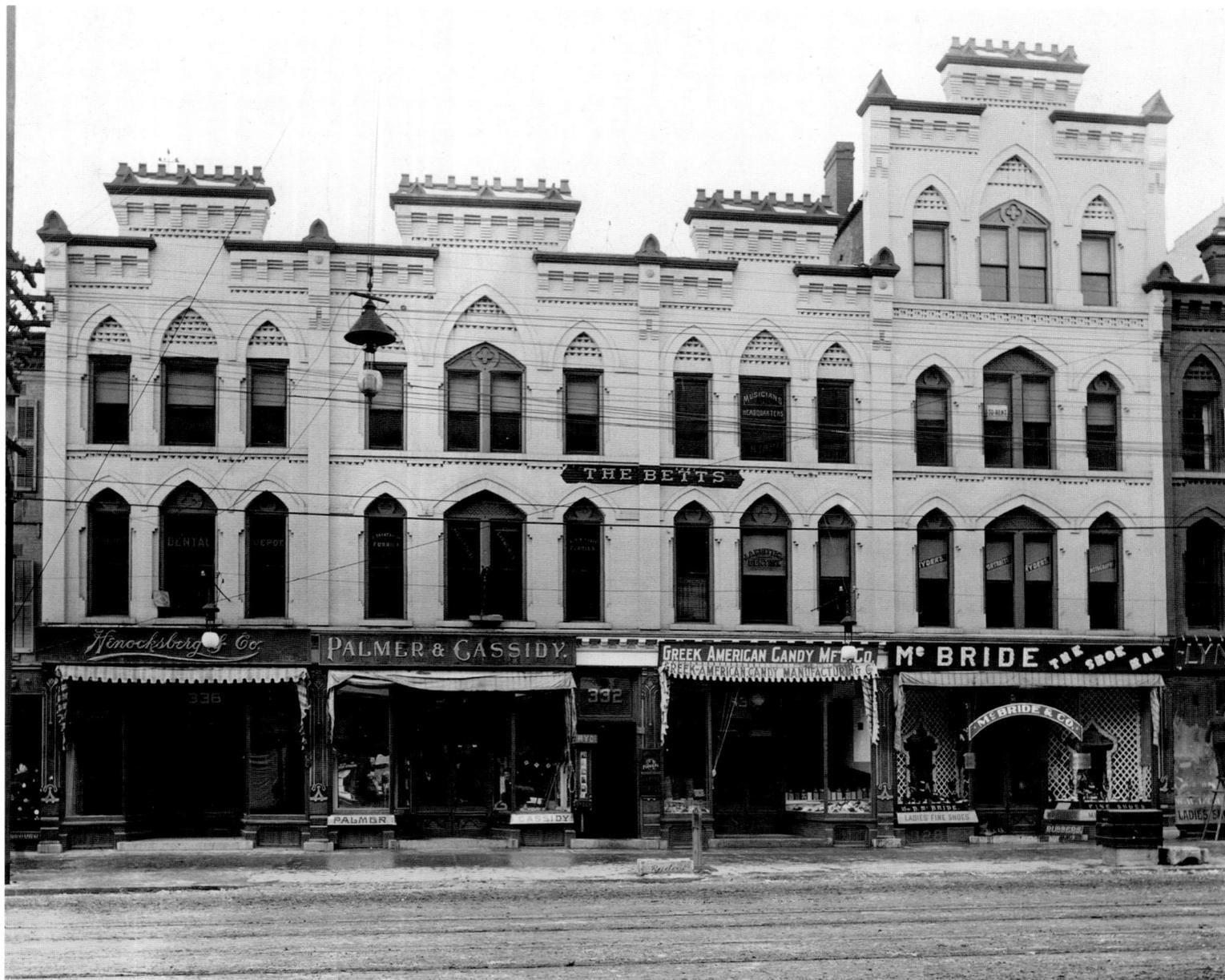

One of the more distinctive of downtown's several Victorian edifices was the Betts Building, which stood on the west side of South Salina Street's 300 block. Its style was Gothic Revival, complete with cornice details that resemble a castle's battlements. The building's storefronts advertise businesses ranging from shoe store to candy manufacturer.

The presence of the Erie and Oswego canals through Syracuse for most of the nineteenth century required the construction of several bridges throughout downtown. Here, in this scene from around 1890, is a railroad lift bridge over the Oswego Canal, just north of James Street. The all-iron structure could reportedly be raised 10 feet in 30 seconds, by way of counterweights, to permit boats passage.

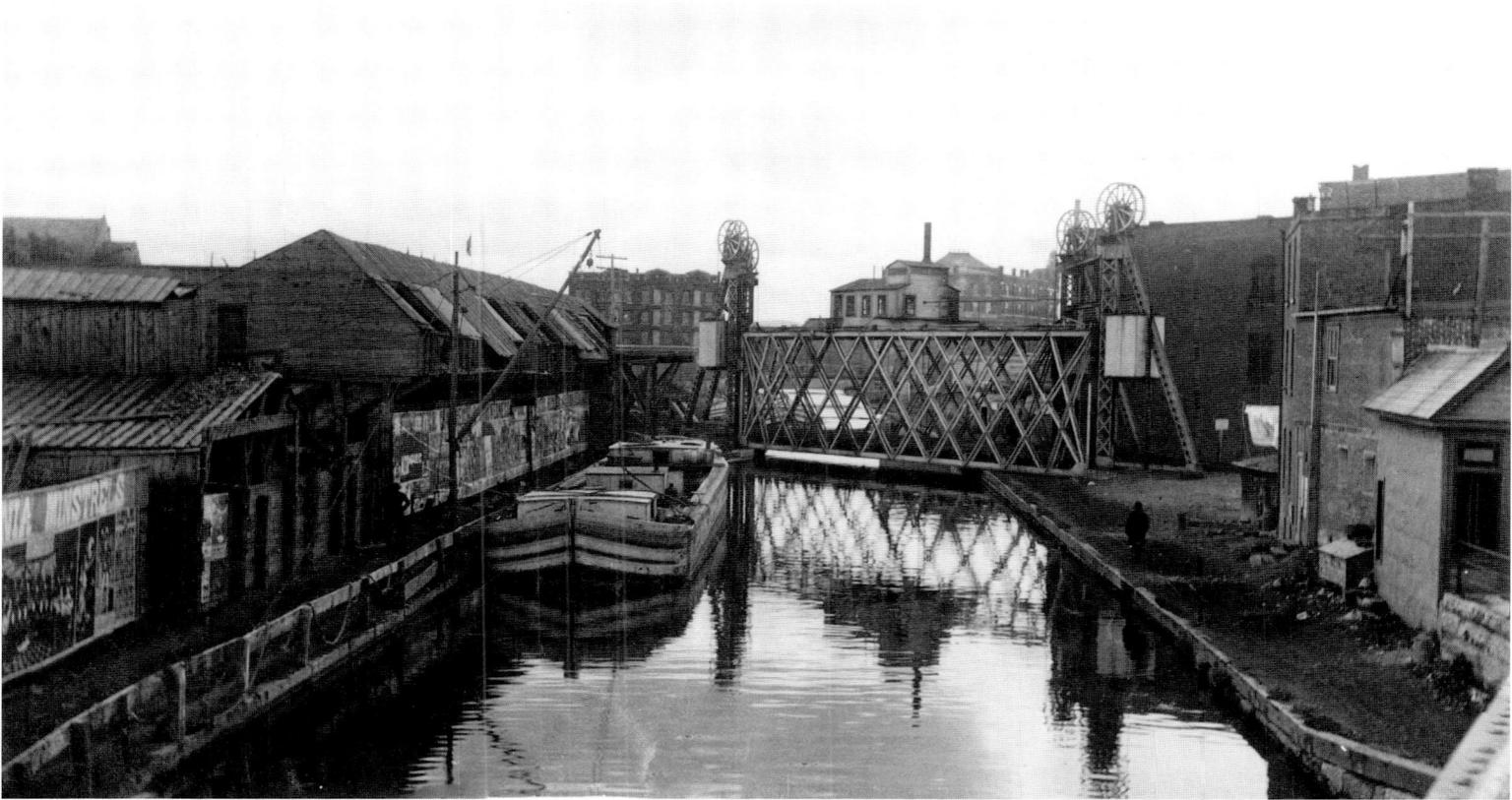

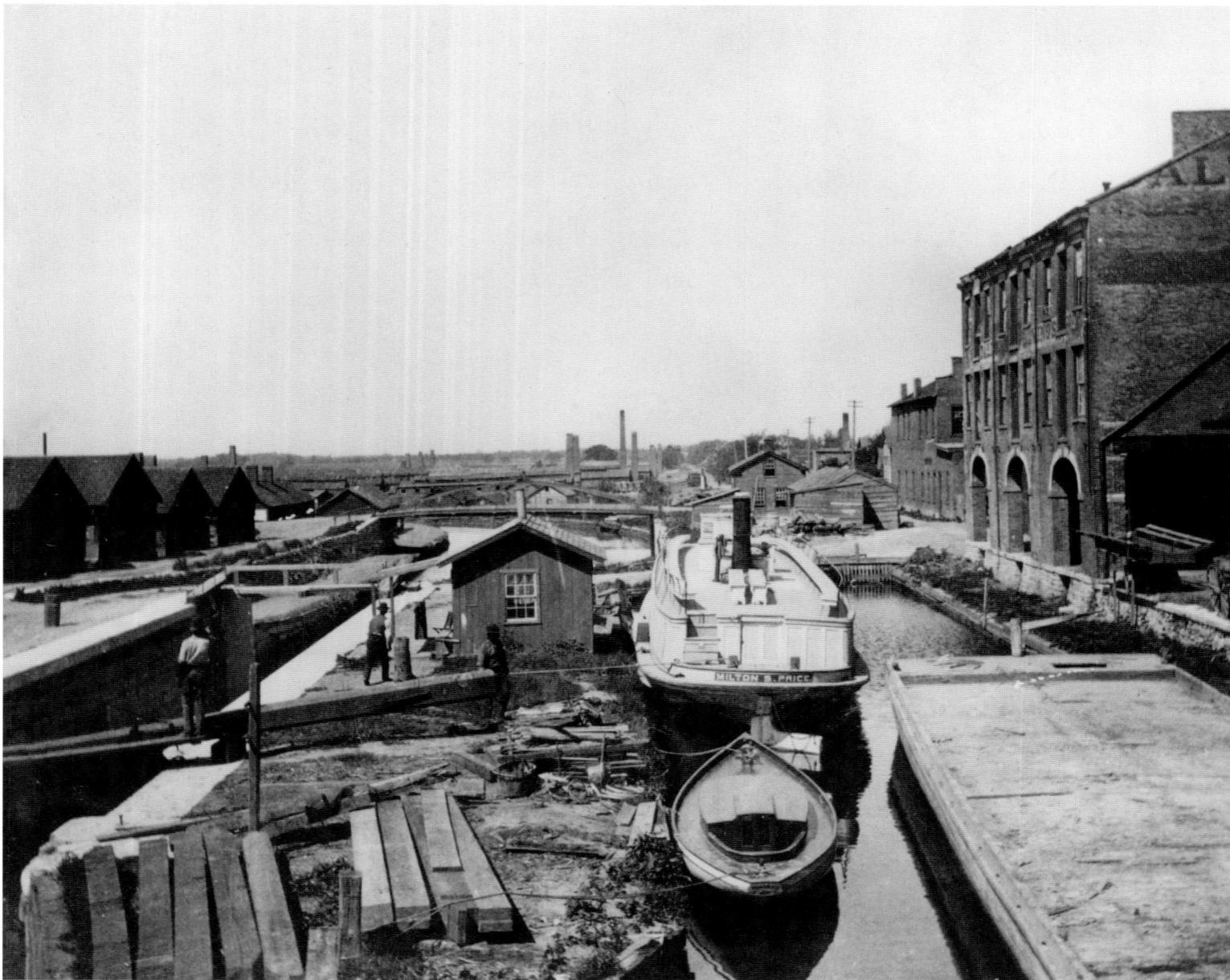

The Oswego Canal, completed in 1828, connected downtown Syracuse with the Lake Ontario port of Oswego. It passed through a series of locks along the way. This lock, visible on the left, was located just east of today's intersection of Hiawatha Boulevard and North Salina Street. The steam packet boat *Milton S. Price* is docked in a small nearby slip.

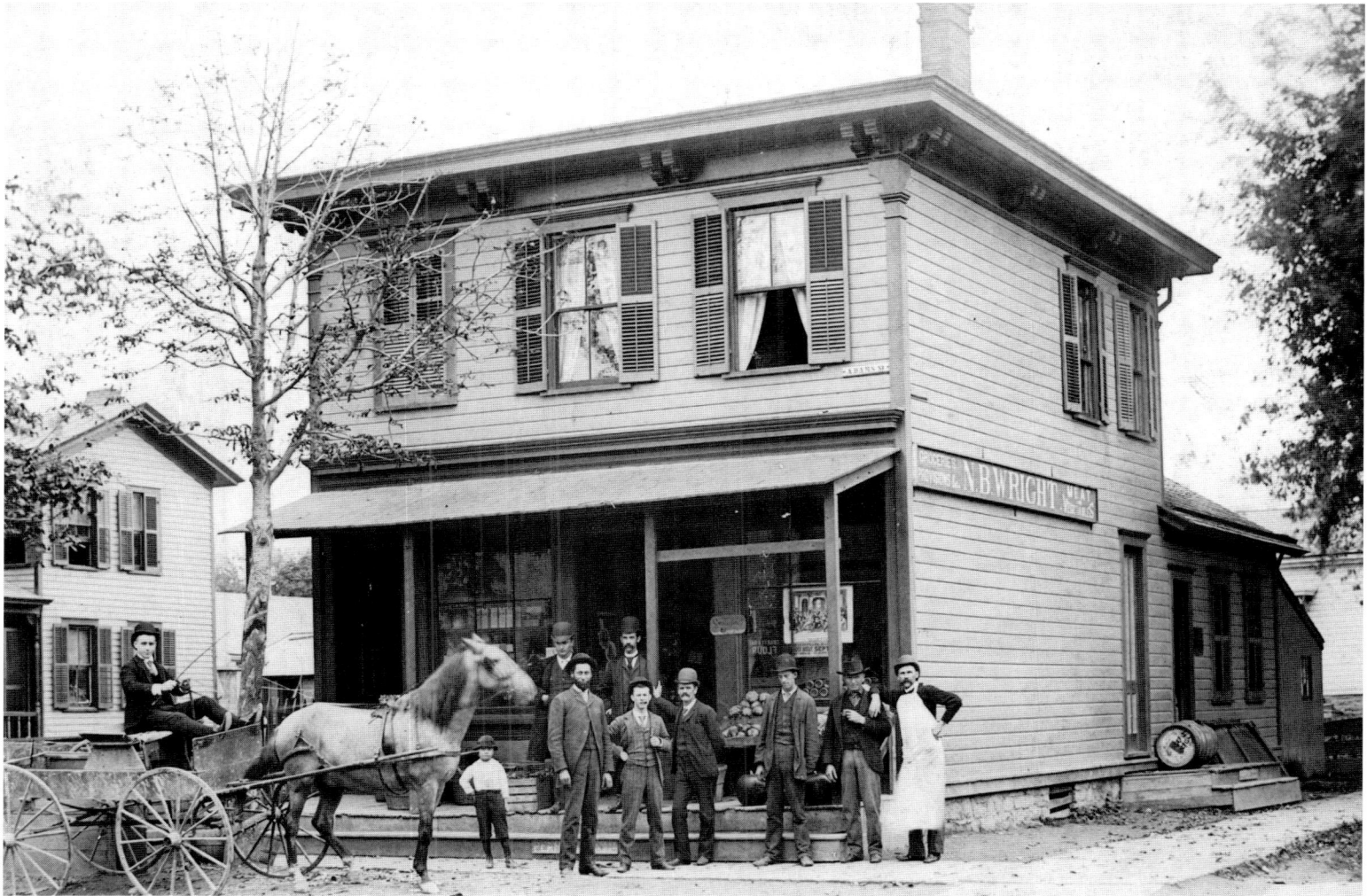

Napoleon Wright's grocery was located on the southeast corner of Adams and McBride streets in the heart of the city's old Jewish quarter. The building is long ago demolished and the site today falls within the 1930s Pioneer Homes complex.

Following Spread: Syracuse's underground brine was reached by drilling wells. The brine was raised into large reservoirs by water-powered pumps housed in stone structures like this one. The brine then flowed by gravity to either salt boiling "manufactories" or to solar evaporation sheds. Some sheds are visible to the left in this 1878 view.

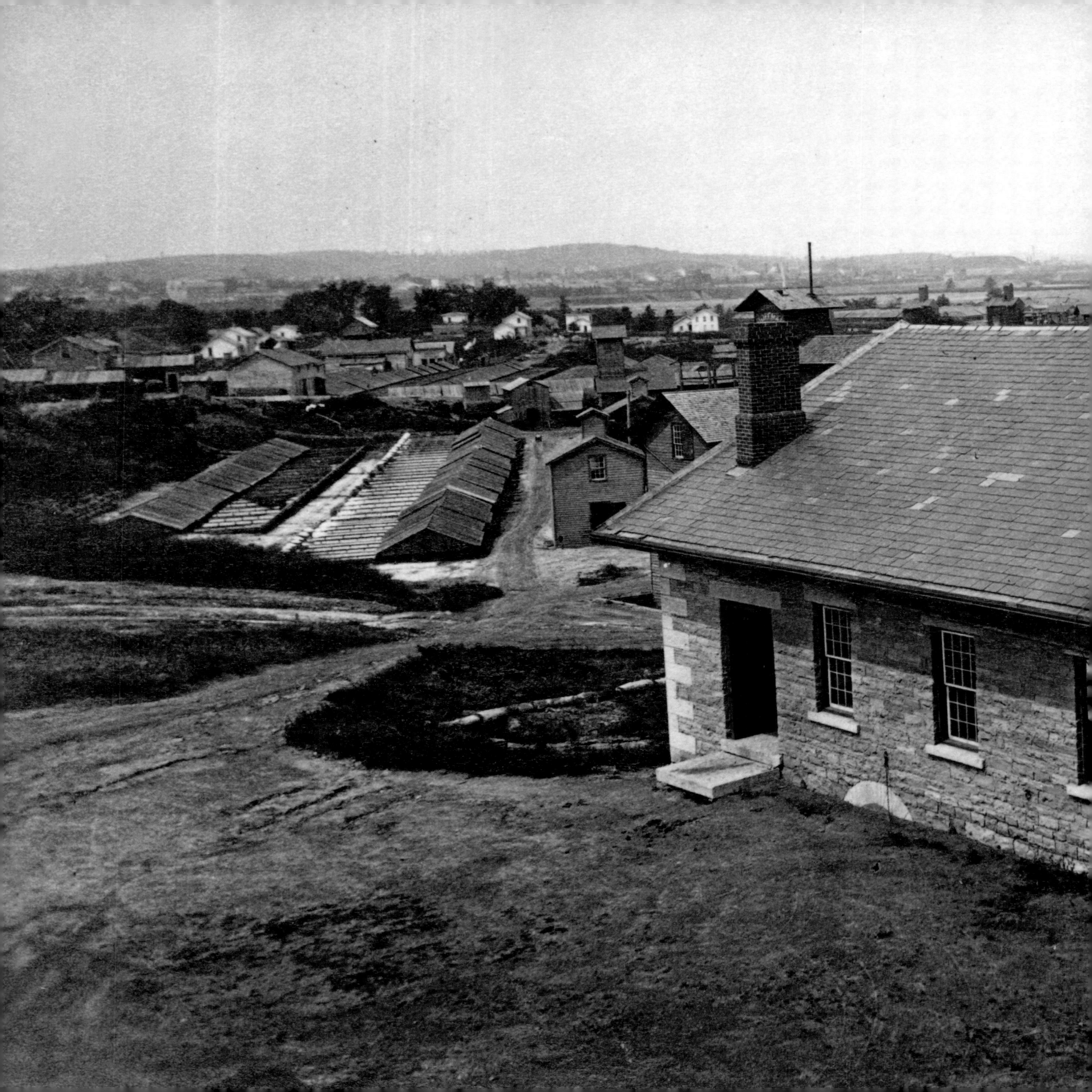

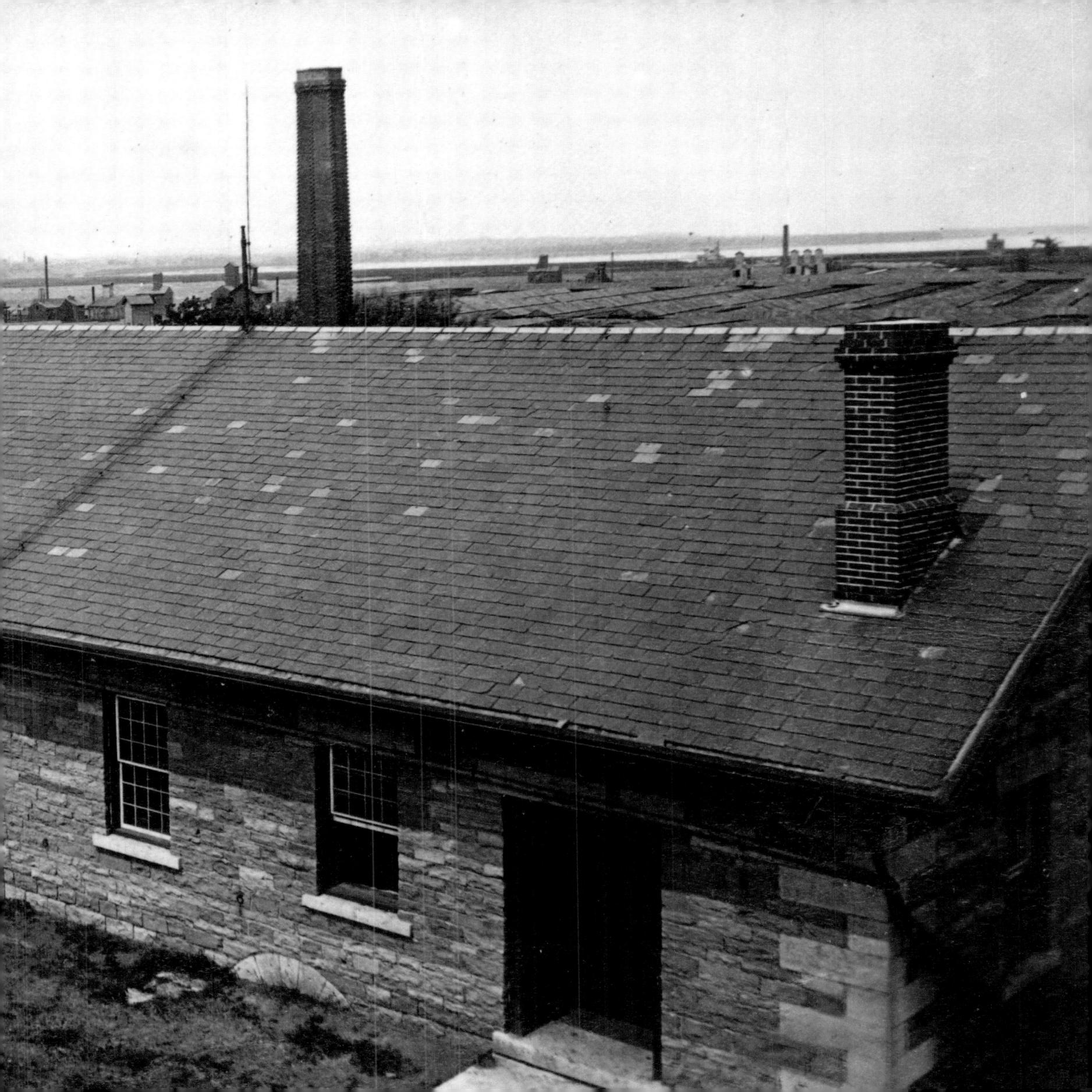

The Sanderson Steel Company, which evolved into today's Crucible Steel, originally had its plant along the Erie Canal in the 1880s, just west of Geddes Street.

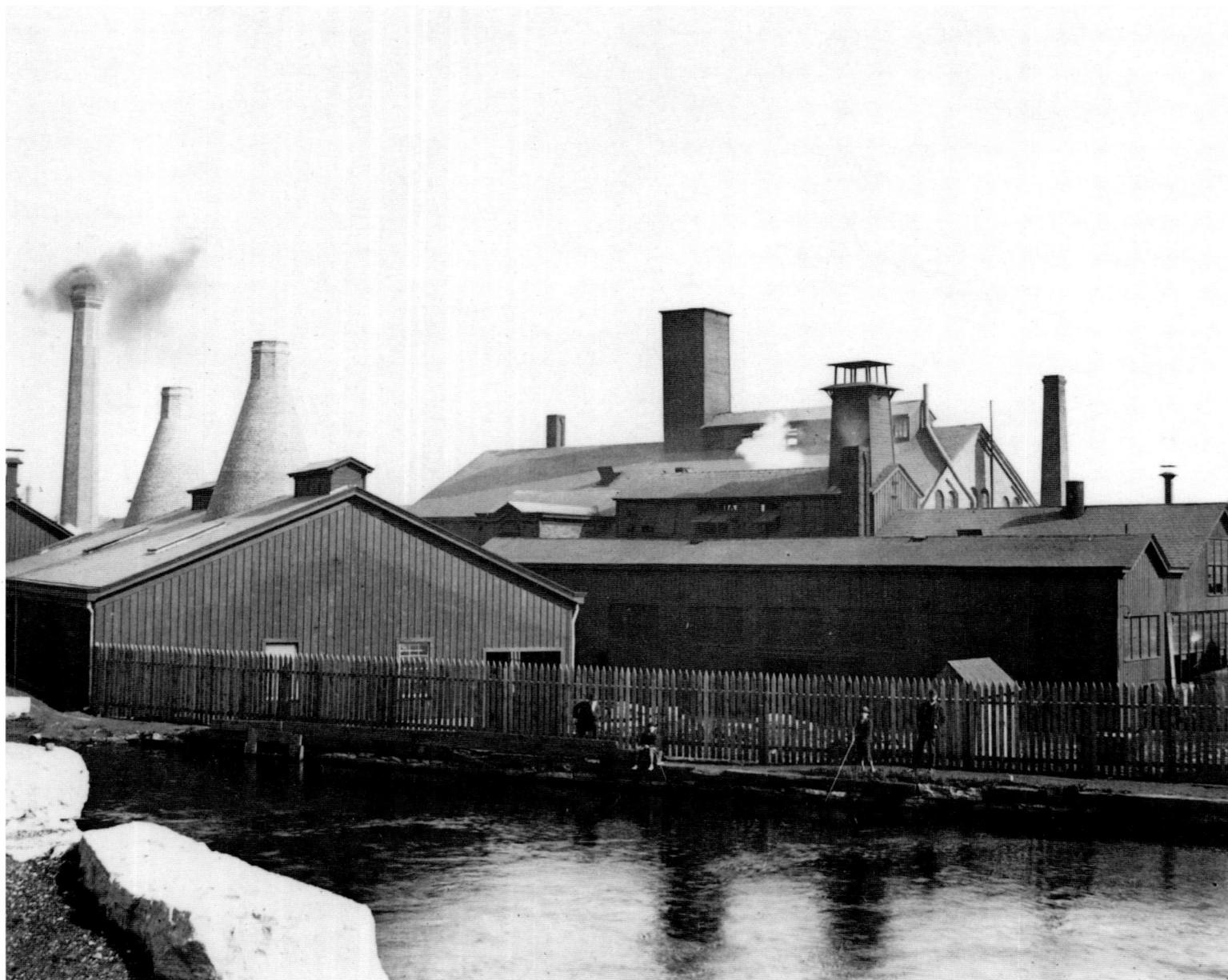

Two of Syracuse's more colorful nineteenth-century residents stand downtown in this 1887 photograph. Dan O'Keefe, on the left, was born in Ireland. He worked his way up in the local hotel business from porter to owner of a small establishment at Fayette and Franklin streets. He loved racing his horse, and was a master at pool and euchre. Always nattily attired, his signature piece was the silk top hat. An 1890 newspaper story referred to his associate here, Edward DeGan, as "a well known character about town and an actor-barber."

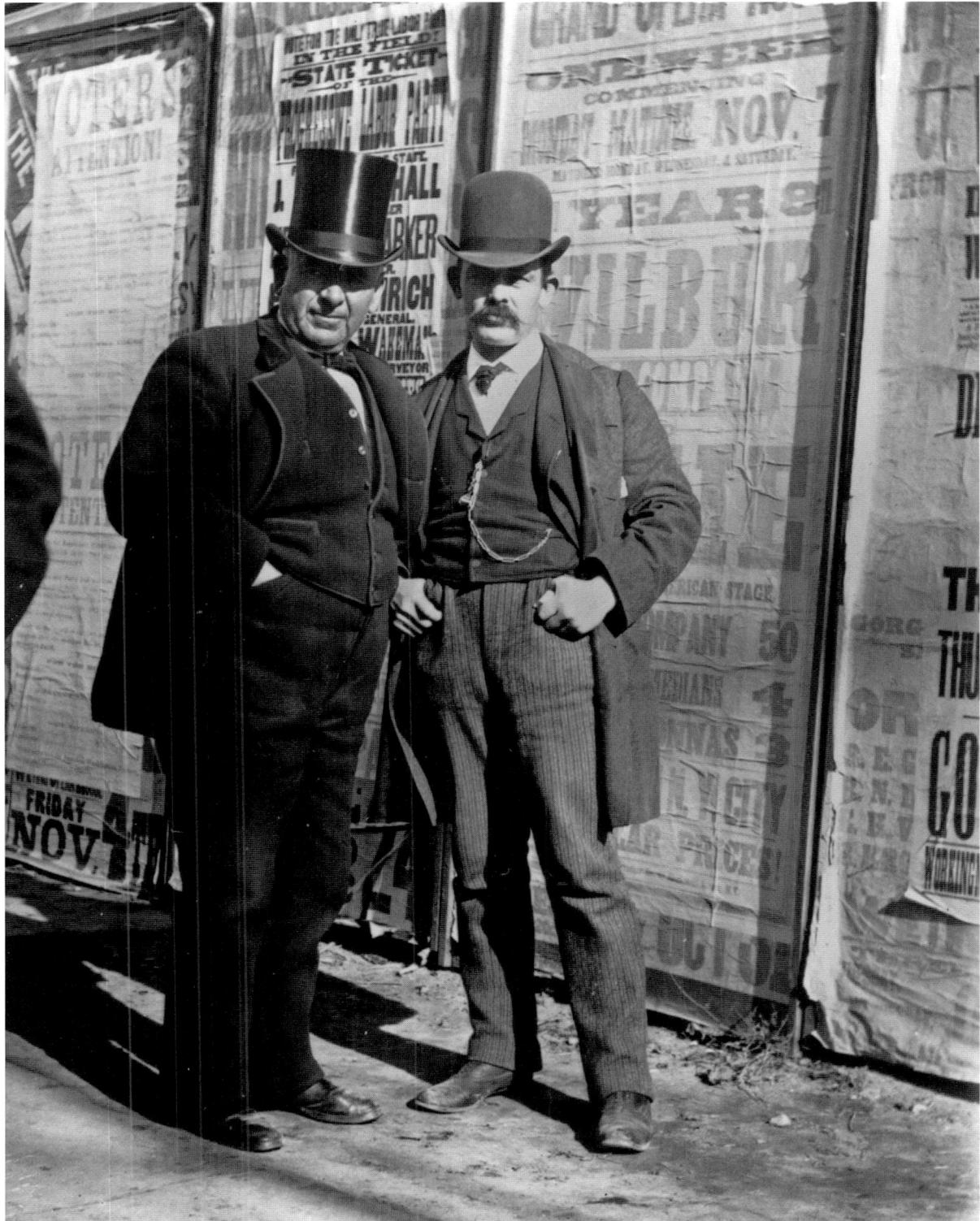

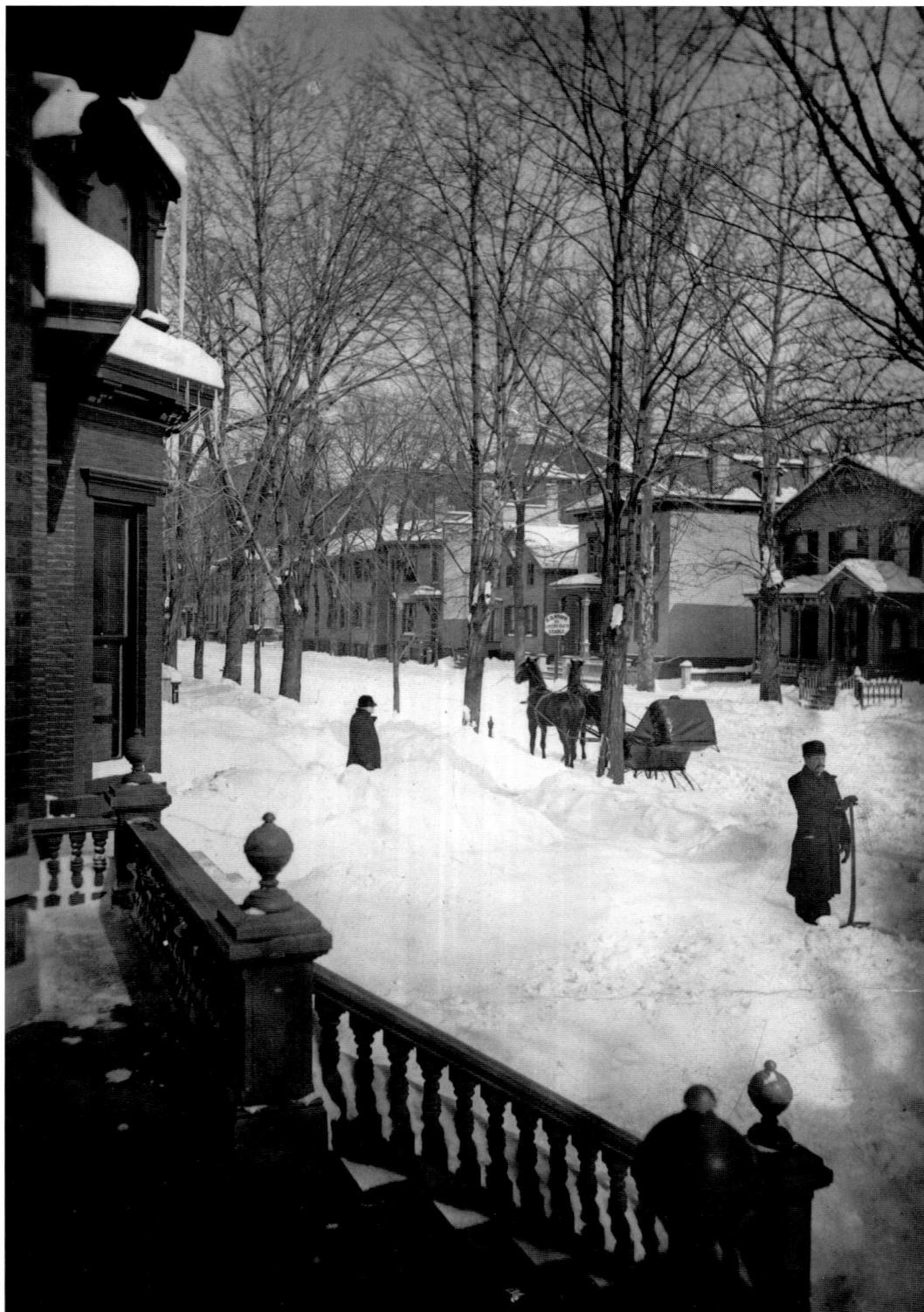

Snow is a Syracuse constant. Here, about 1890, a resident shovels the walk in the 300 block of Montgomery Street, then a middle-class neighborhood.

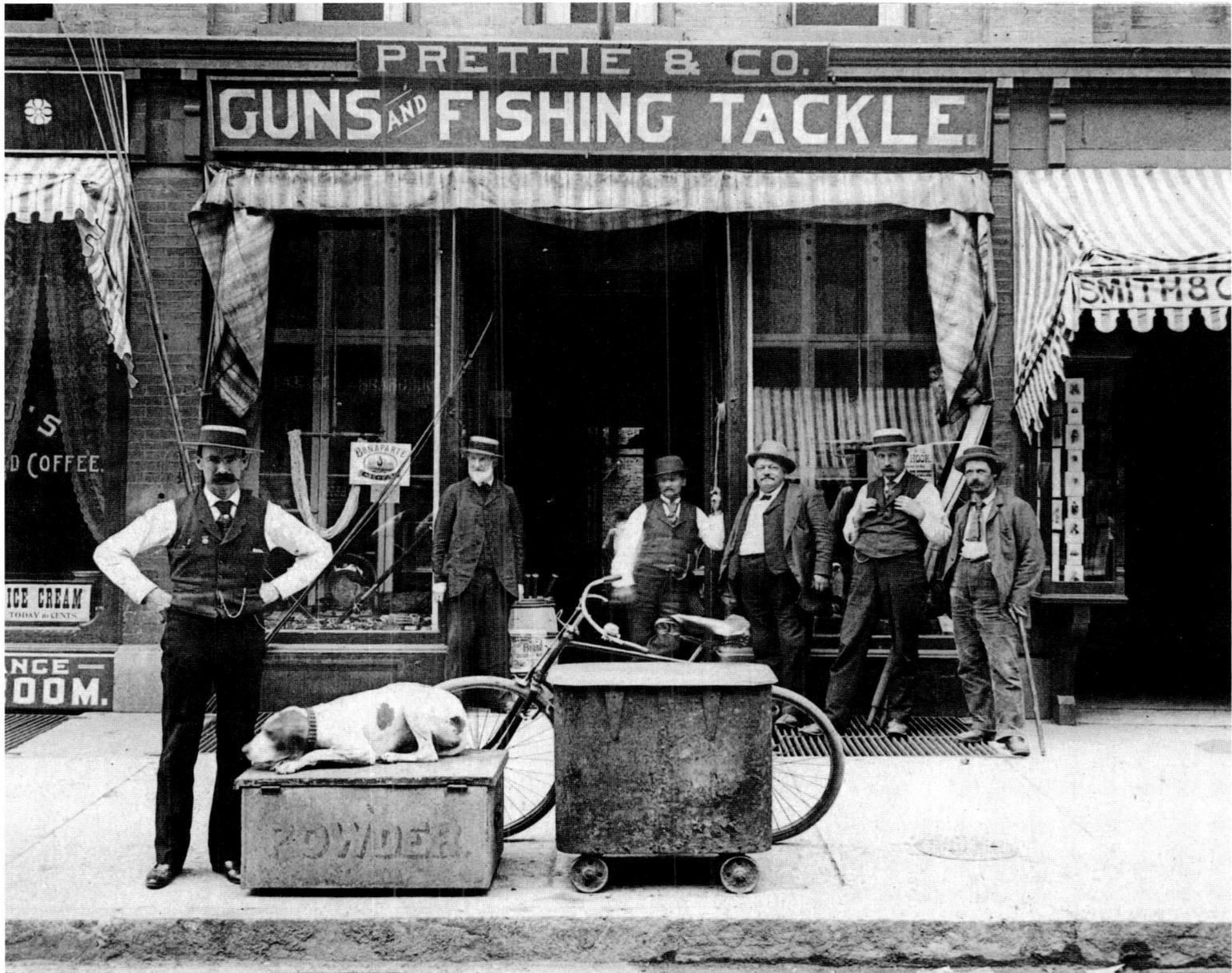

Prettie's sports shop was located on West Washington Street in the 1890s, between Salina and Clinton streets. Next door was George Ford's restaurant, serving "unsurpassed coffee." The high-wheeled penny-farthing was giving way to bicycles like this model, which became extremely popular in the 1890s. Syracuse had more than one bicycle manufacturer during the era.

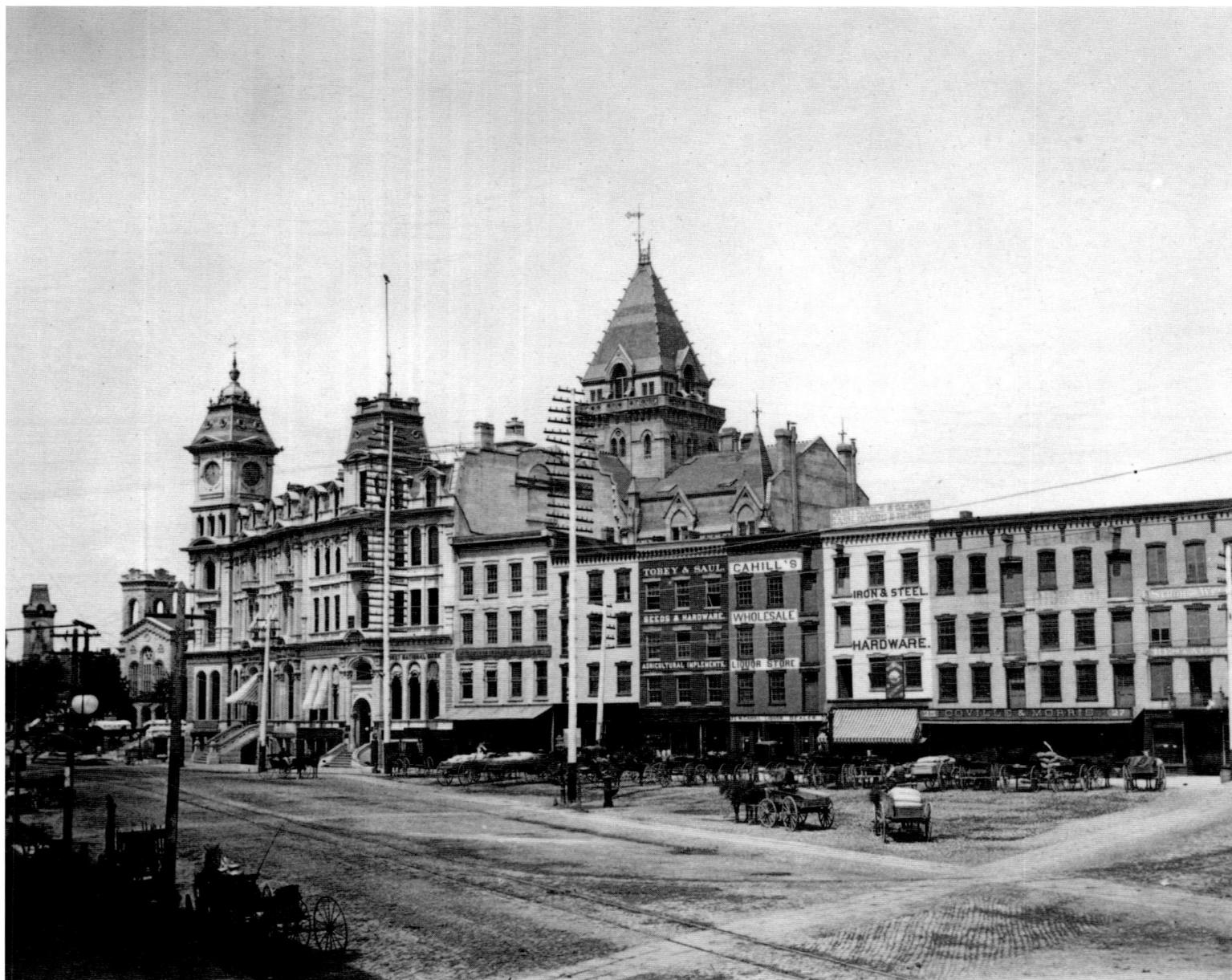

Until about 1890, Hanover Square was a large open space, regularly used as an assembly area for teamsters, who rented their rigs for short-term hauling jobs. Periodically, it was also used for public gatherings, such as the memorial services for President Lincoln when his funeral train passed through the city in April 1865.

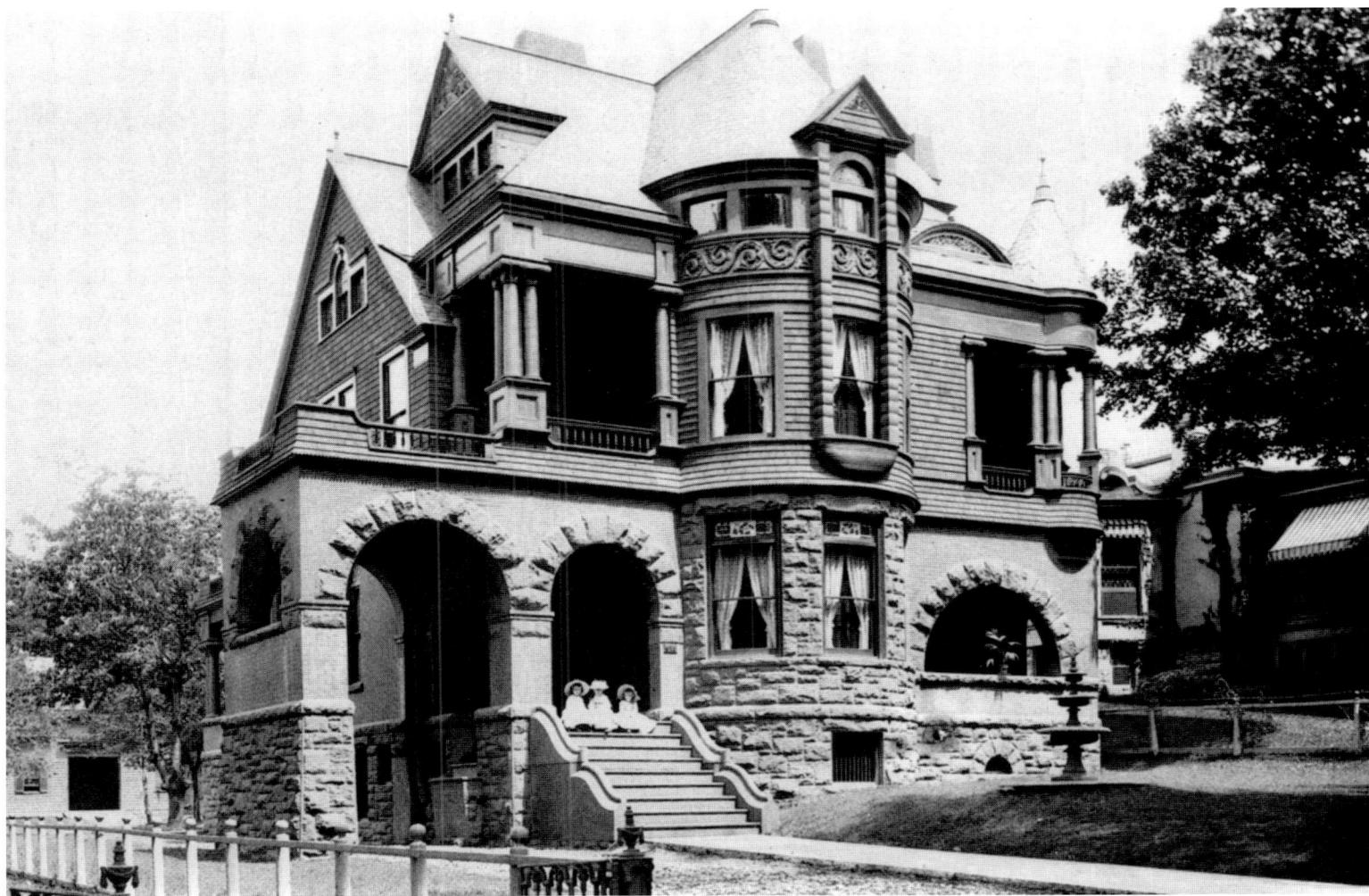

The residence of the Charles F. Saul family stood on James Street in this image from 1890. James, West Genesee, and West Onondaga streets were Syracuse's most elegant thoroughfares in the late nineteenth century, boasting impressive homes of the city's elite. Saul was in the hardware business.

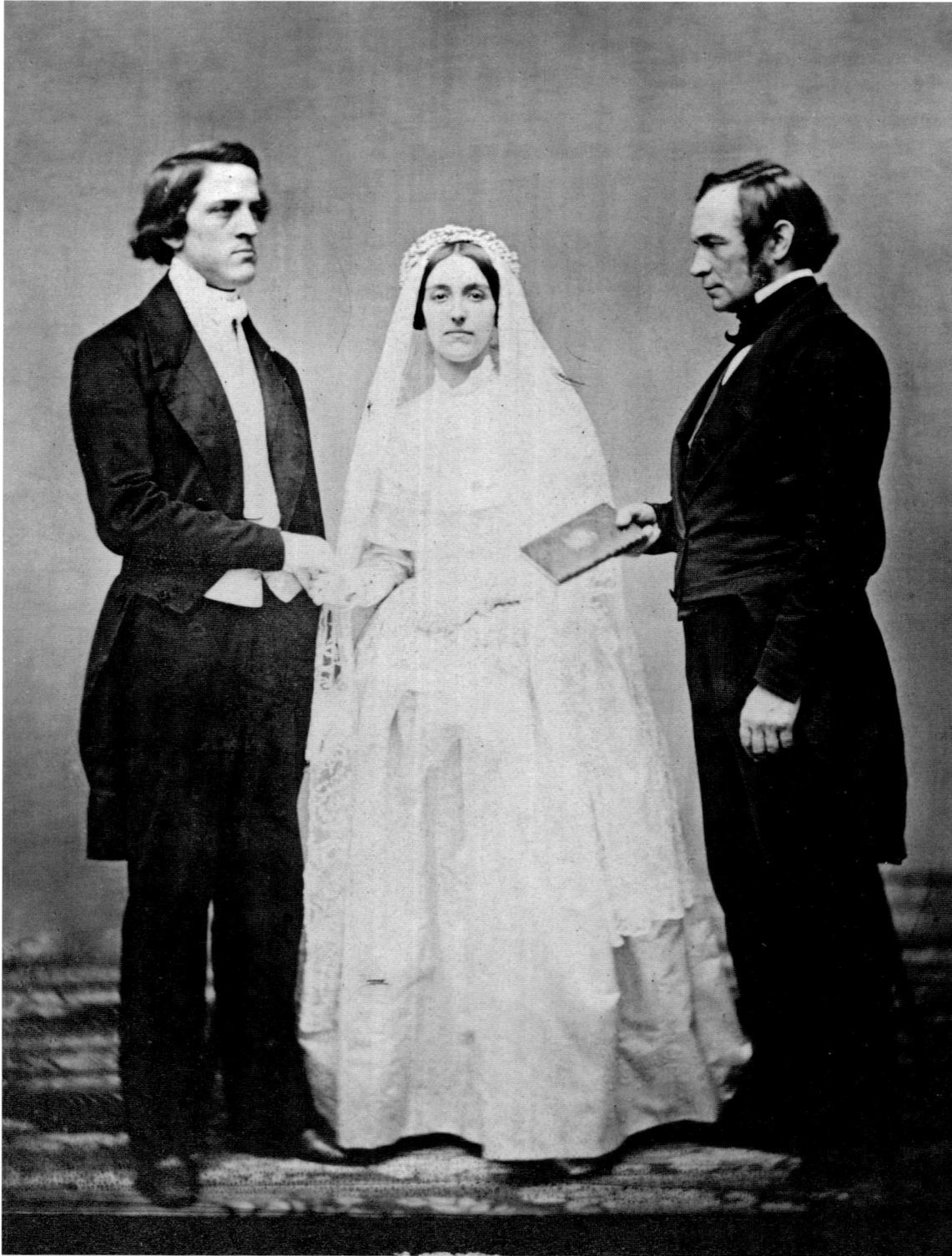

Samuel May, the famous abolitionist, reformer, and woman's rights advocate, presided at the 1849 marriage of George Barnes and Rebecca Heermans. Barnes, a native of England, immigrated to America in 1844 at age 17 and became a wealthy man in Syracuse through early involvement in railroads, steel manufacturing, and banking.

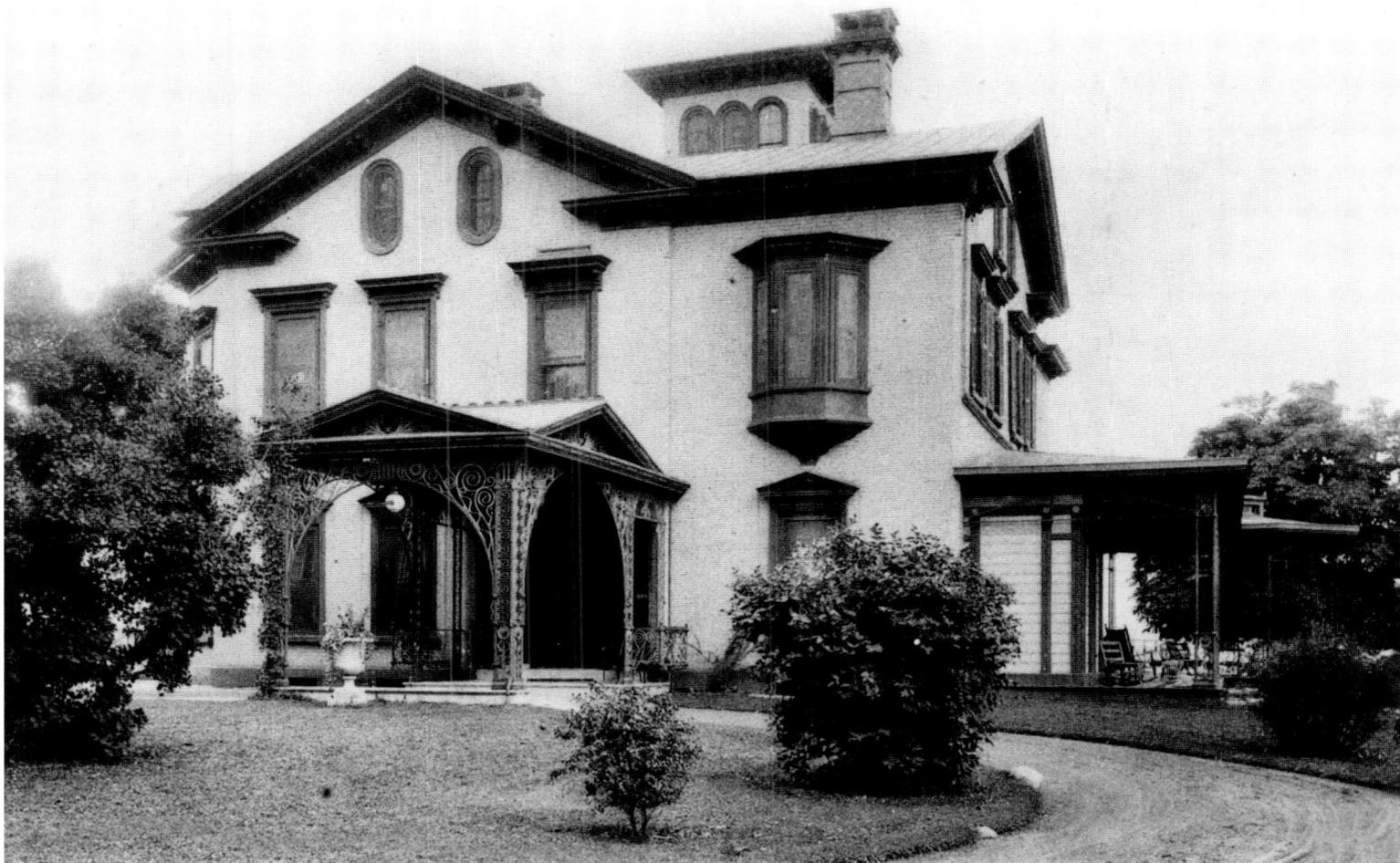

Barnes built this home on James Street Hill in 1853. It was later remodeled by his daughter and son-in-law into a Georgian revival mansion, which still stands as the Corinthian Club.

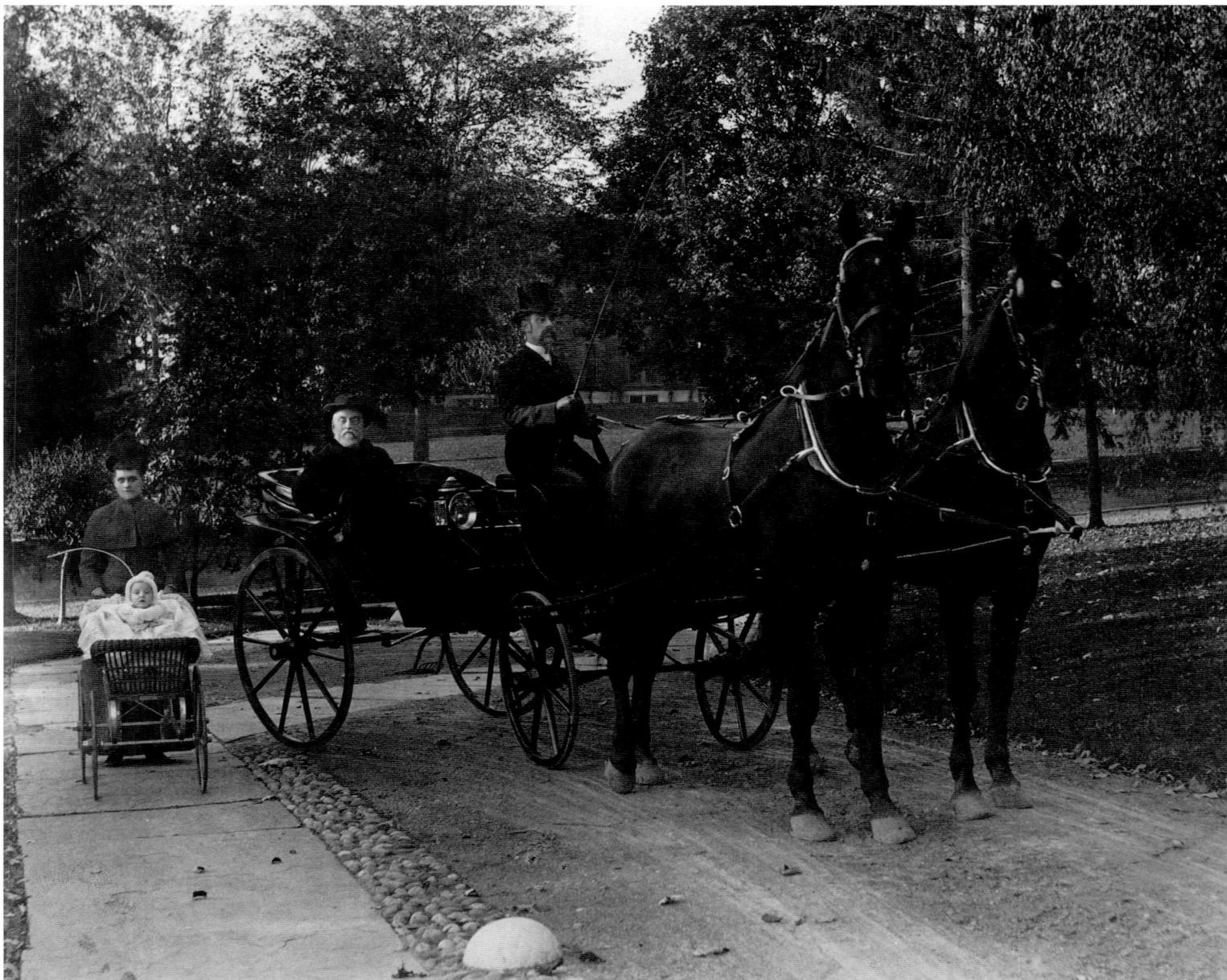

George Barnes, around 1889, poses in his carriage near his James Street house. His daughter pushes her son, George, in the baby stroller. James Street was the height of upper-class fashion in this era.

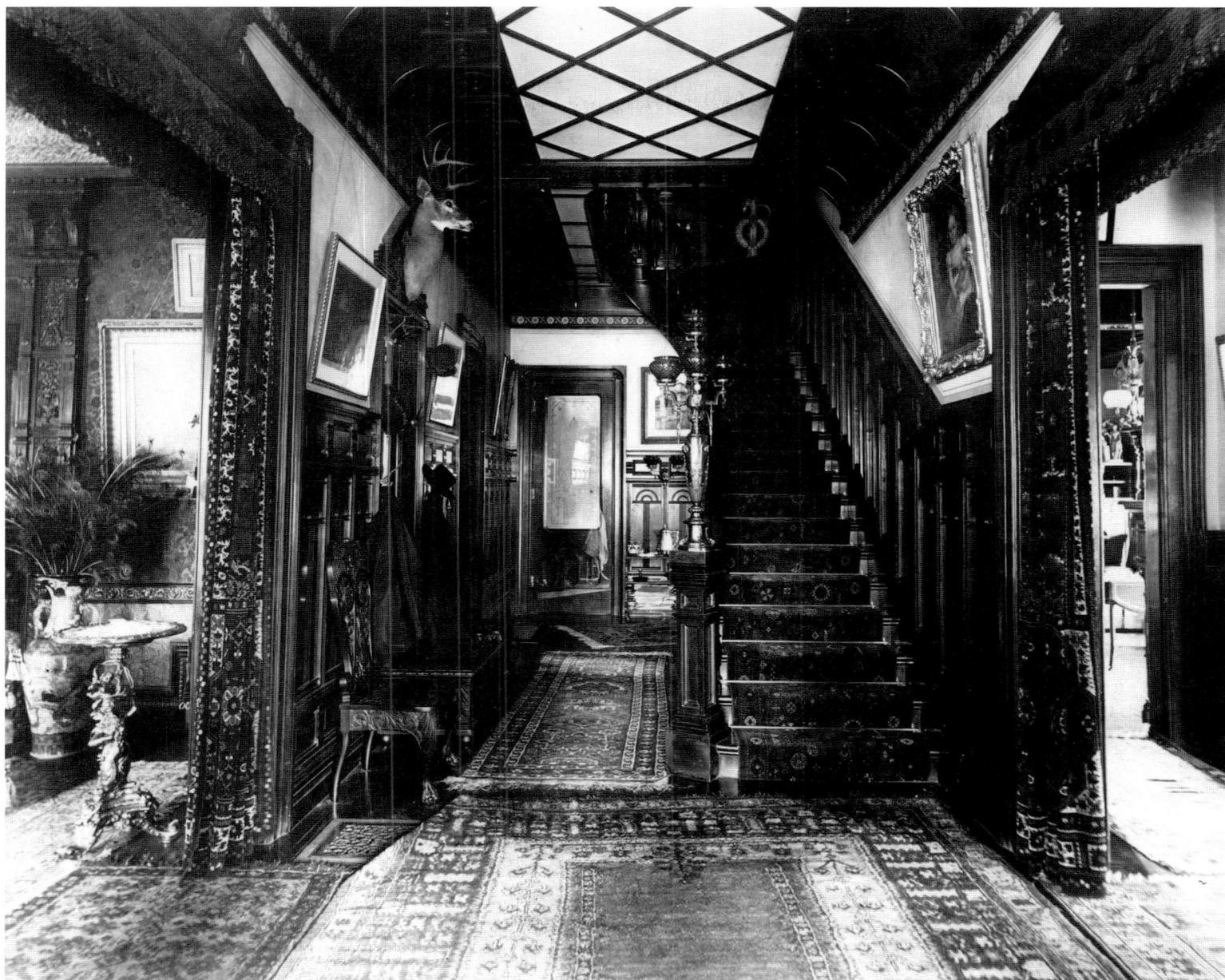

The interior of the Barnes-Hiscock mansion is documented here before it was remodeled. A large gaslight fixture adorns the newel post of the main staircase. The large urn to the far left holds a swash of peacock feathers.

The south side of Hanover Square was one of Syracuse's earliest retail addresses in the 1830s and 1840s. A few of the smaller buildings of this era remain standing today, along with some post–Civil War additions like the central structure in this image from around 1877. At that time, it housed Charles Wesley Snow's drug store establishment.

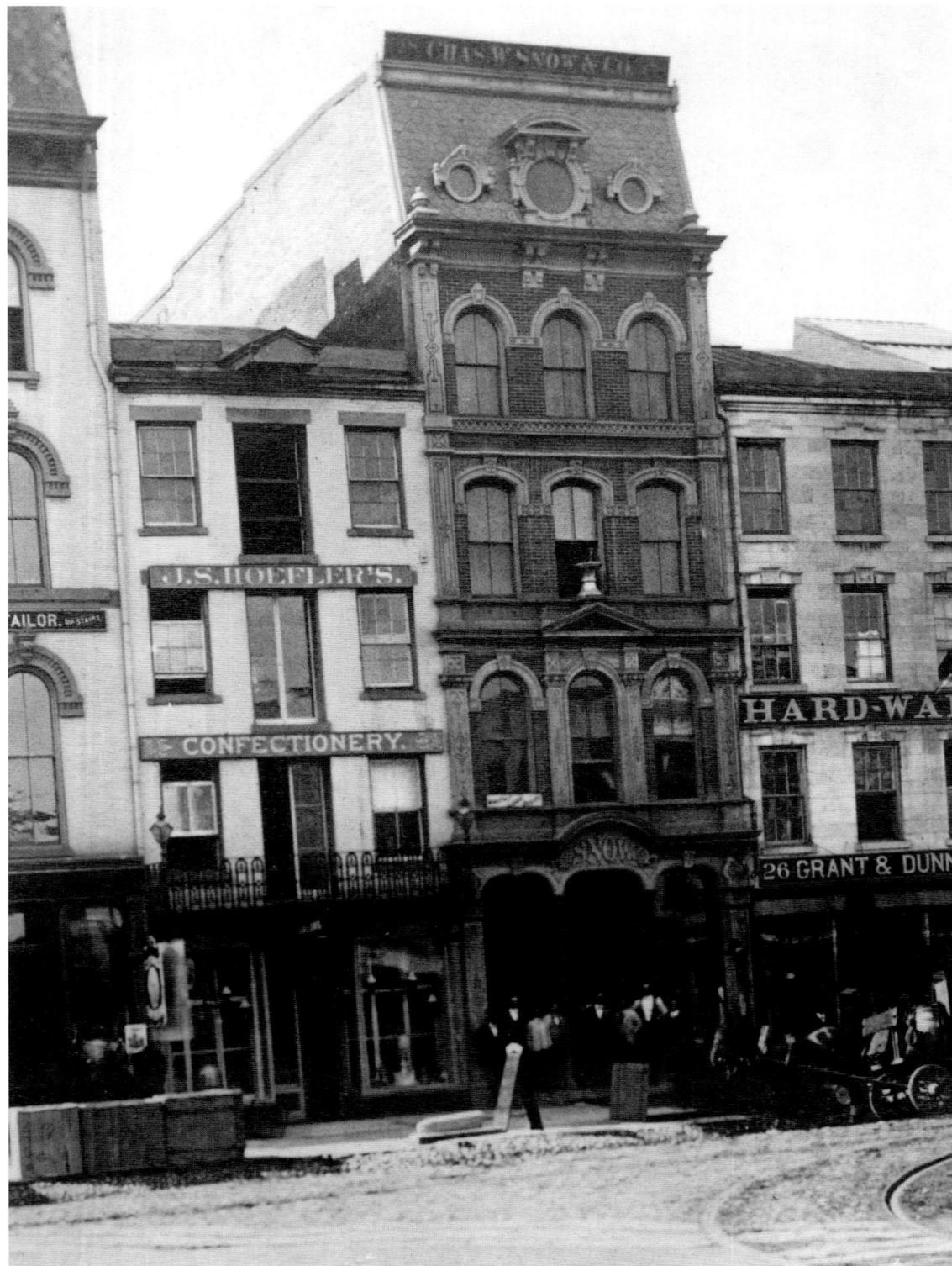

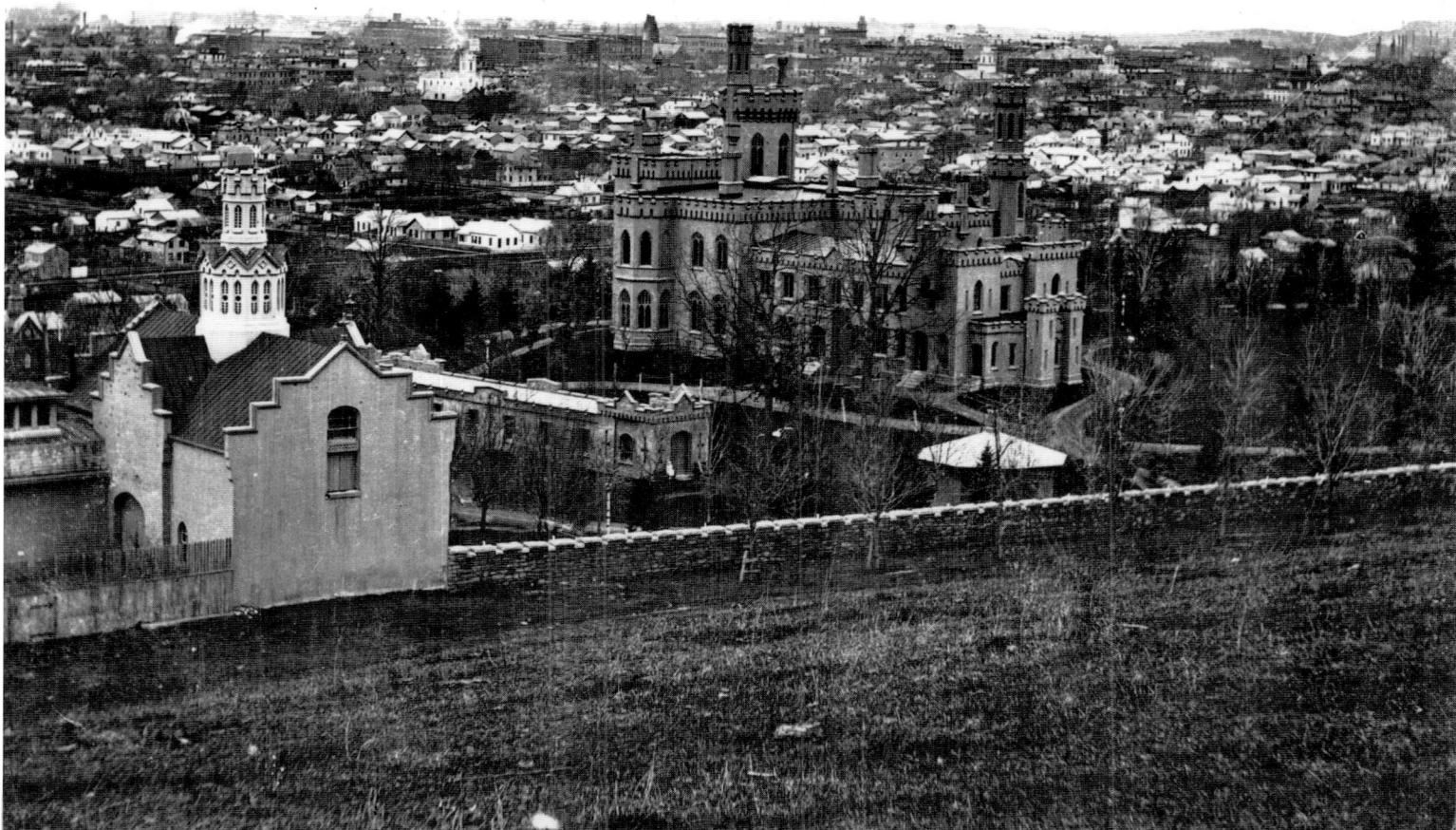

Yates Castle was the work of noted American architect James Renwick, who also designed the famous Smithsonian Castle in Washington, D.C. The residence was originally built in 1852 for C. T. Longstreet, but he traded this home with Alonzo Yates a few years later, believing it too remote from the city. This Gothic Revival landmark, once adjacent Syracuse University, would be demolished in the 1950s.

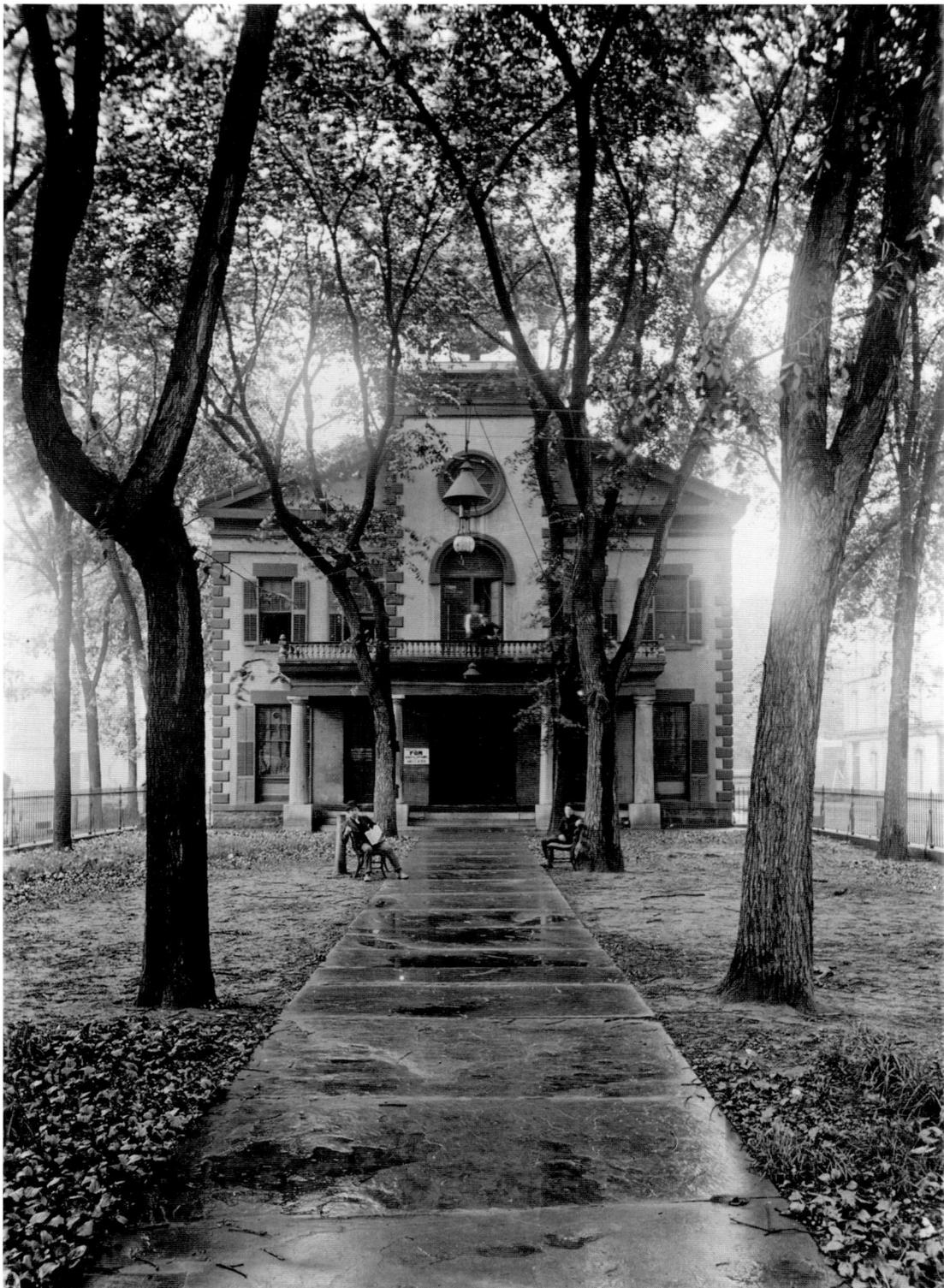

Before the city's 1889 City Hall was built, the site was occupied by the City Hall shown here. It had been built in 1845 primarily as a market place, but village offices occupied part of the upper floor. Eventually, city government took over the whole structure. It was the site of many emotional anti-slavery gatherings in the years before the Civil War and hosted speeches by abolitionist leaders, such as Frederick Douglass. In the foreground, an electric arc lamp hangs suspended from the trees.

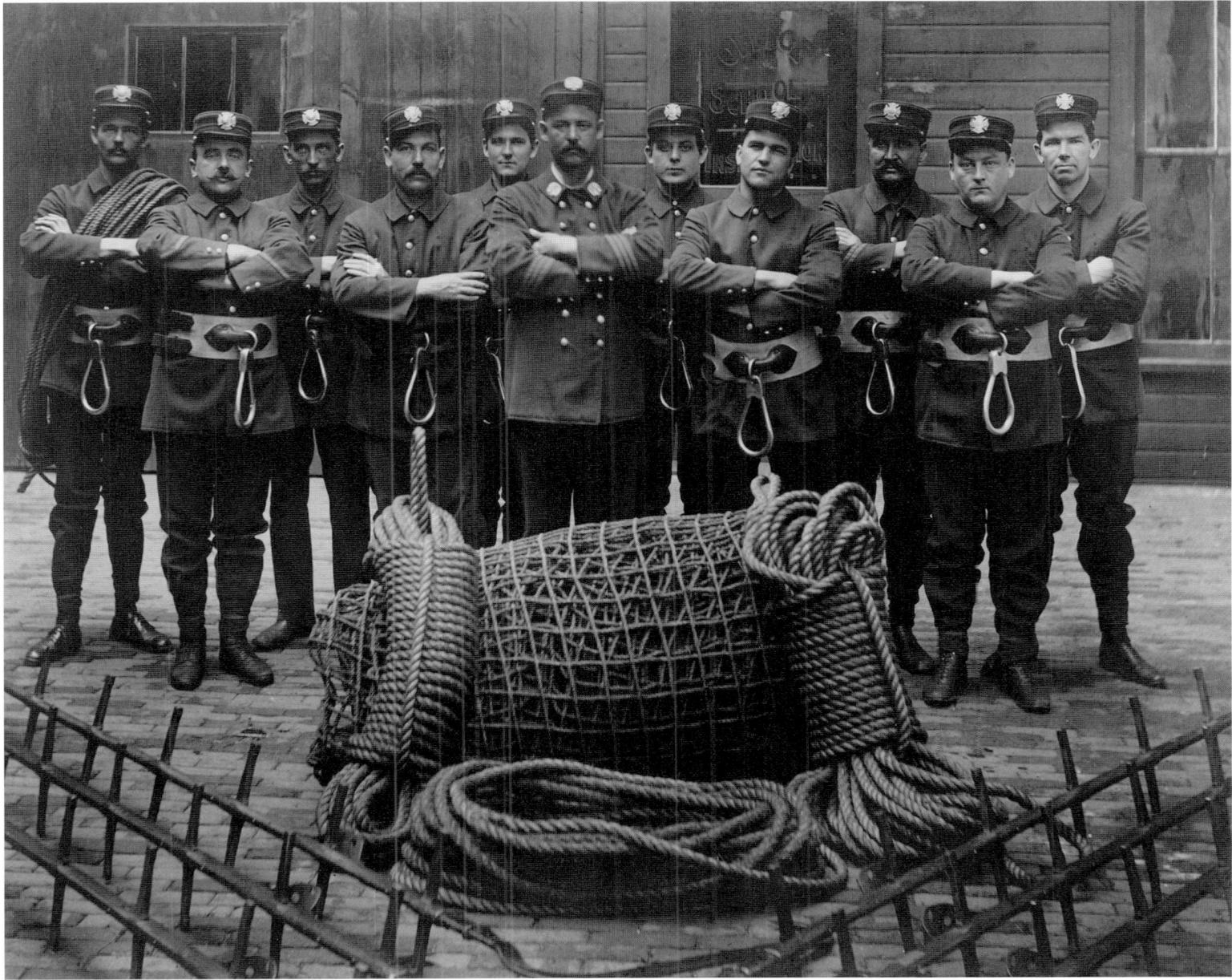

The Syracuse Fire Department included a "Life Saving Corps" around 1900.

Like many cities, Syracuse suffered damaging fires in the nineteenth century. This one struck the Wieting Block at the corner of Water and Salina streets in 1881. Lack of adequate water pressure for fighting fires was one of the reasons for building a new municipal water system from Skaneateles Lake in 1894.

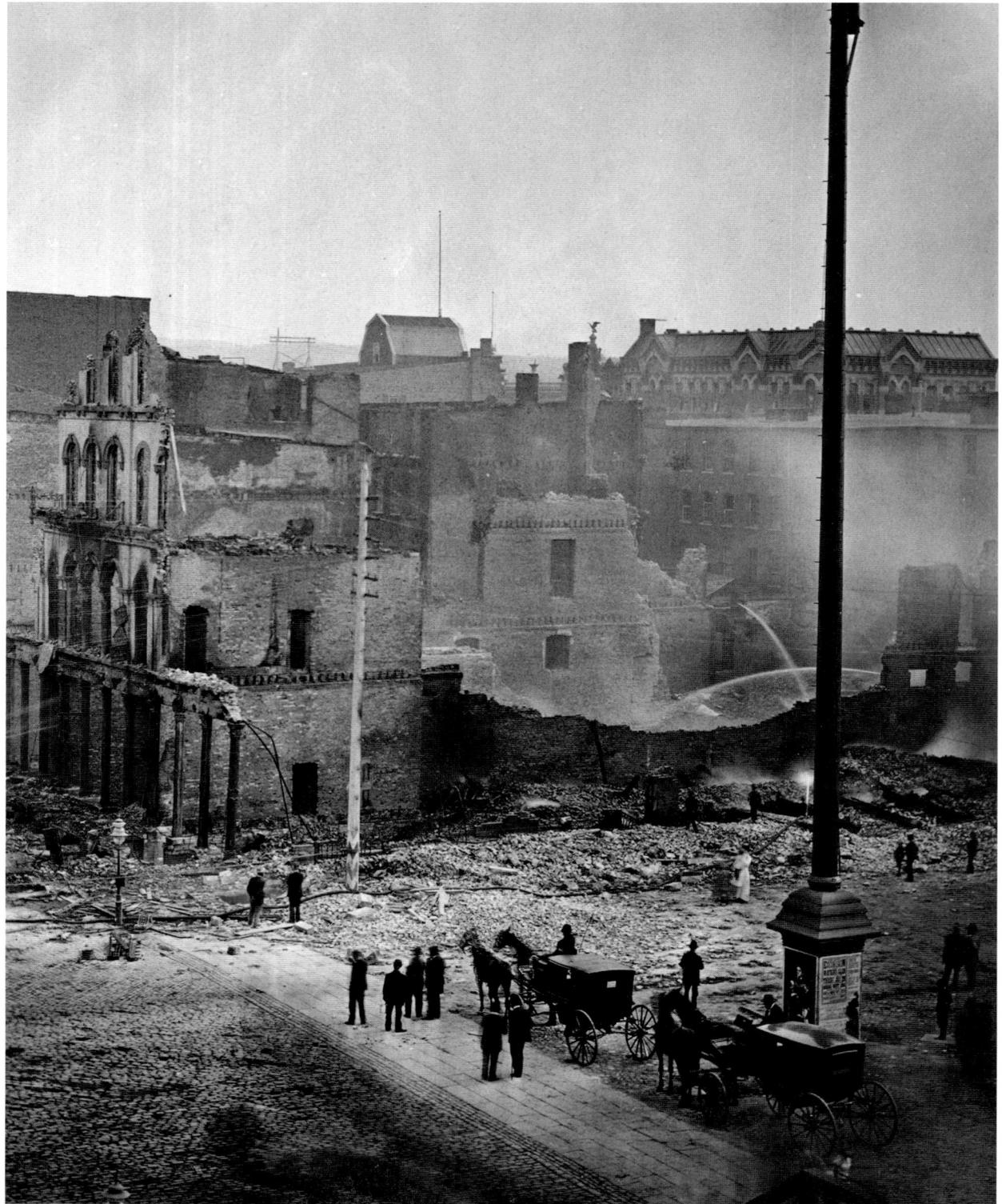

Peter J. Brummelkamp poses in 1886 with his daughter Jessie, left, and other neighborhood children, probably in the rear of his West Genesee Street home. Although his previous business was in retail men's clothing, his active role in local politics brought him an appointment as Superintendent of the New York State Salt Springs Reservation by Governor Grover Cleveland in 1883.

Estella Elizabeth Padgham was born in 1874 and grew up at 120 Shonnard Street. After graduating from Smith College, she joined the Unitarian ministry and was ordained in 1901. She served for 26 years and then retired to her girlhood home where she died in 1952.

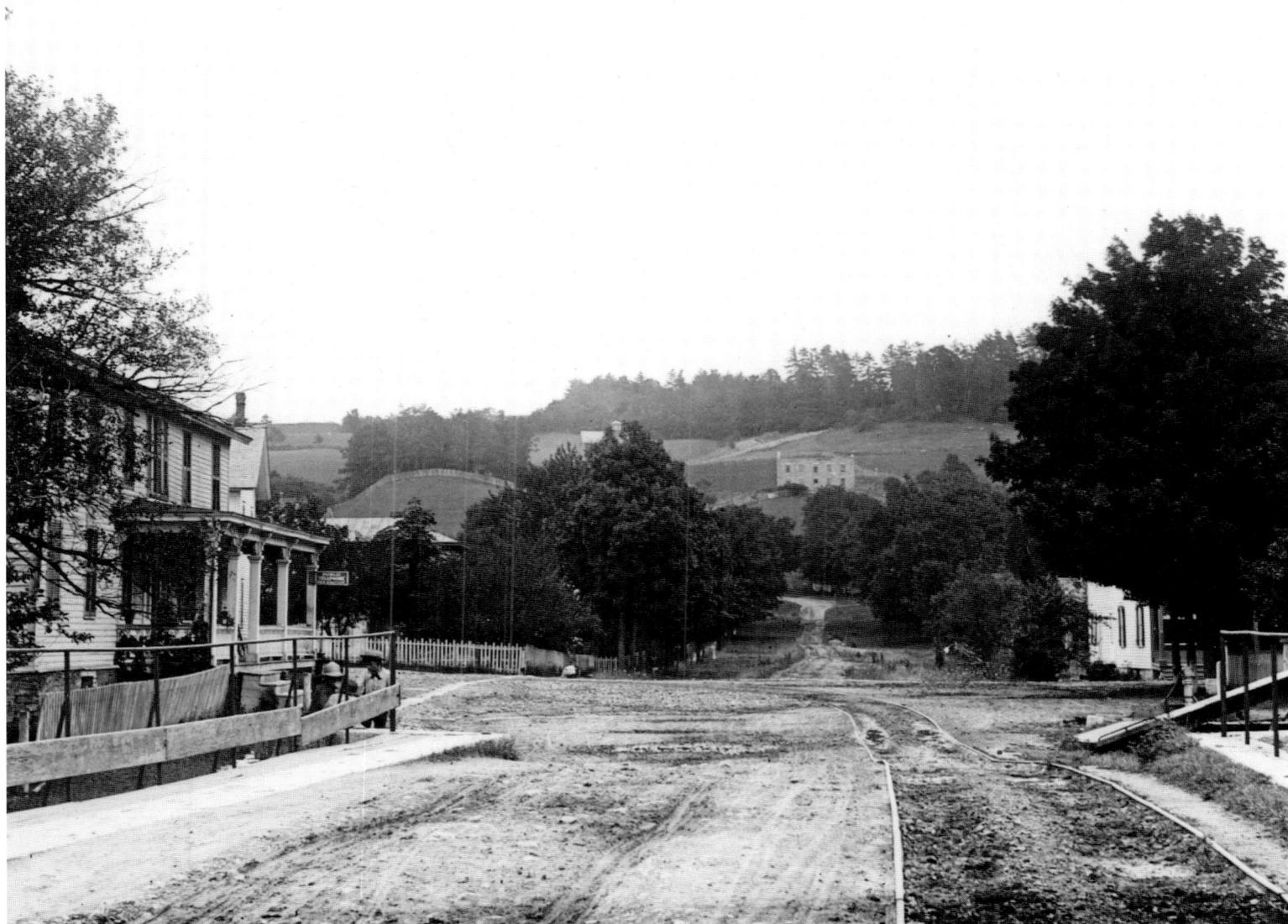

A quiet day in 1889 facing east along the Seneca Turnpike in what would become the Valley section of Syracuse. The intersection is with Salina Street. Visible in the distance on the side of the hill are the ruins of the old War of 1812 arsenal. The sign on the building at left says "Public Telephone Pay Station"—the invention was 13 years old.

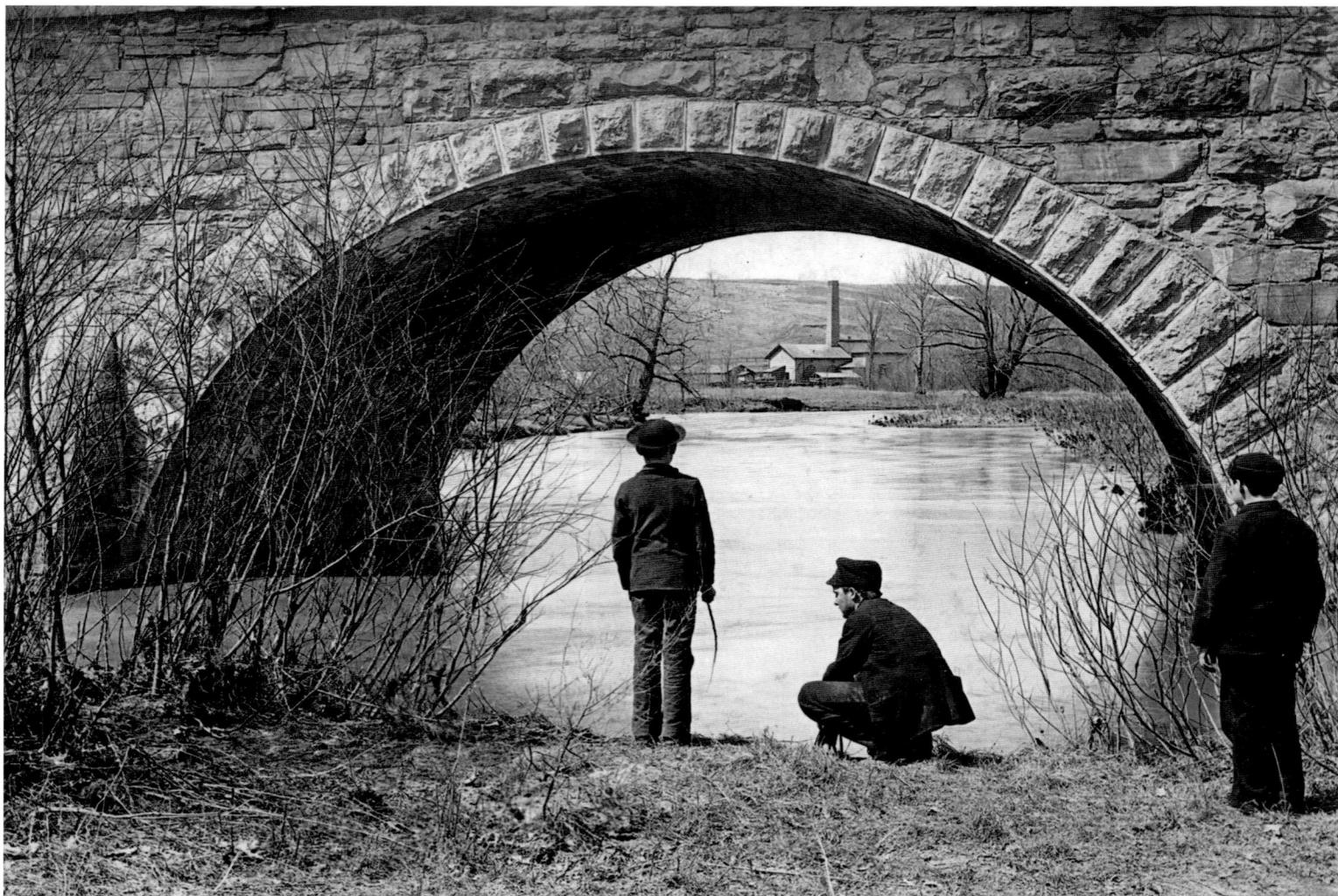

The stone arch of the Cortland Avenue (now South Avenue) bridge over Onondaga Creek frames a view through to the pump house of the Syracuse City Water Works Company. In the 1870s and 1880s, this private company supplied water to residents by pumping it from the creek, not a particularly wholesome source at the time. The hill in the background would later become Upper Onondaga Park.

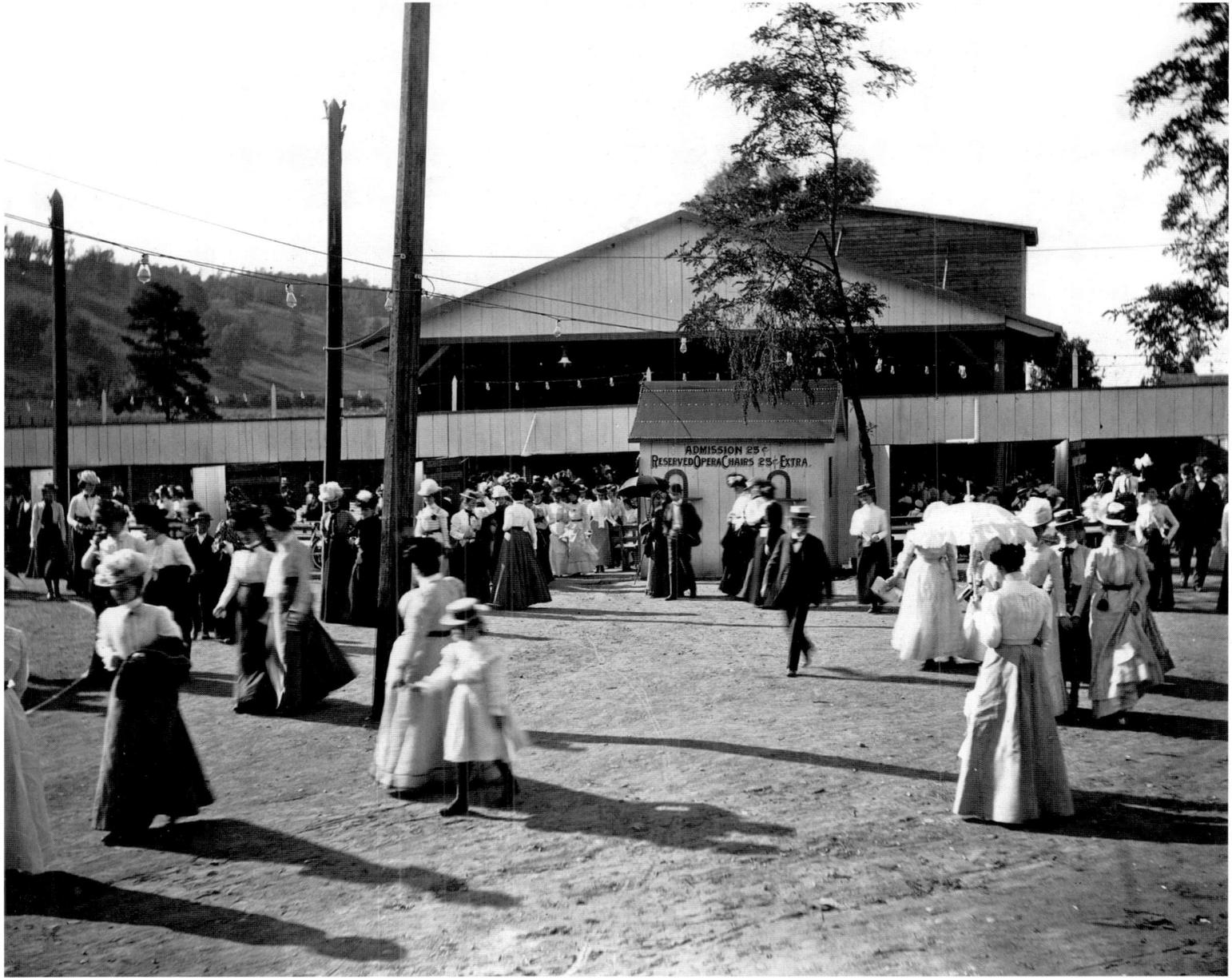

The Valley Theater was a semi-outdoor venue at the northwest corner of Valley Drive and Seneca Turnpike. It was built in 1900 by the Syracuse Rapid Transit Company as a destination on their streetcar line. During the summer, it presented light comedies and operettas, such as *H.M.S. Pinafore* by Gilbert and Sullivan.

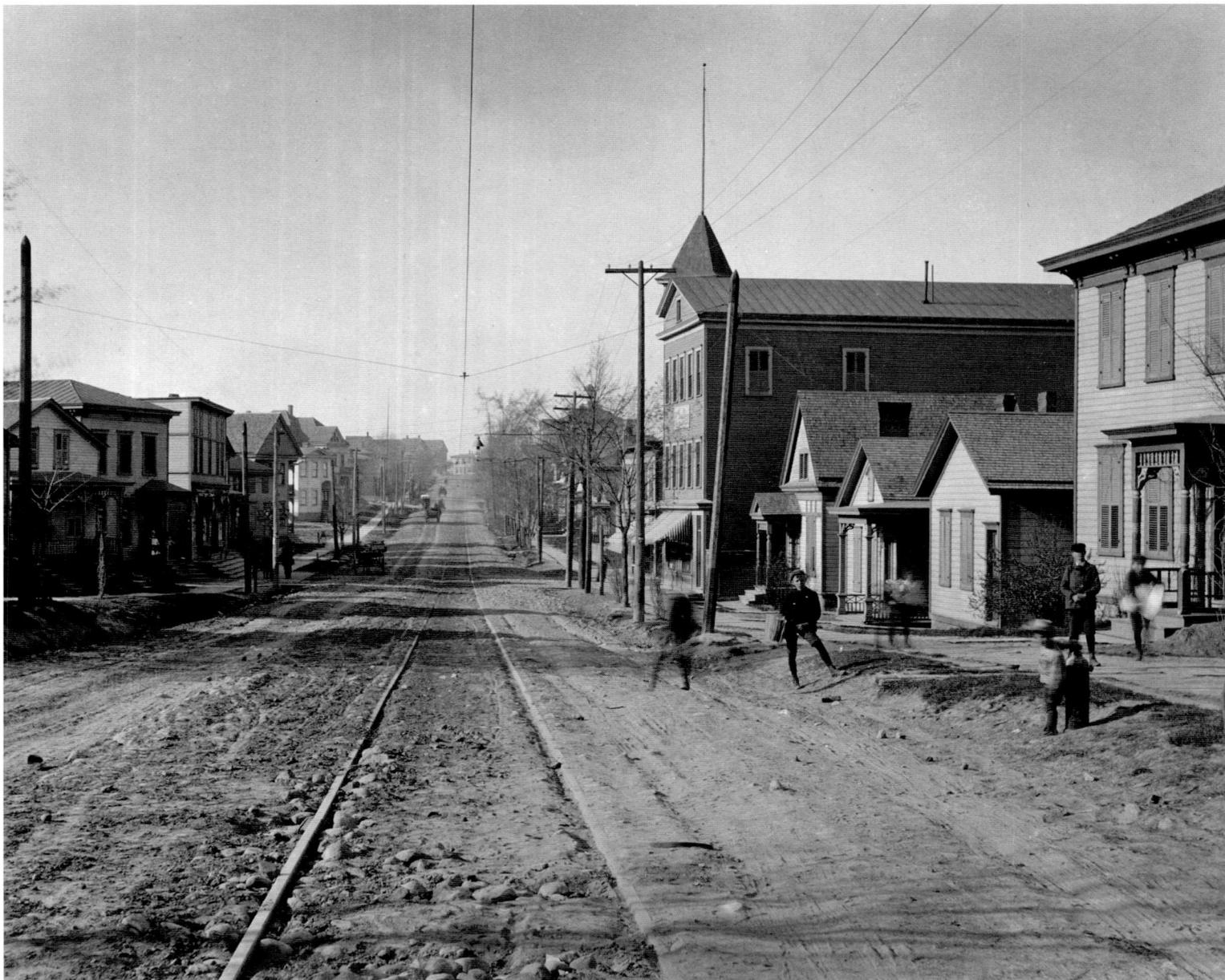

This 1899 view shows the streetcar tracks running up Butternut Street on the city's North Side, near Knaul Street. This was a German-American neighborhood for much of the nineteenth century.

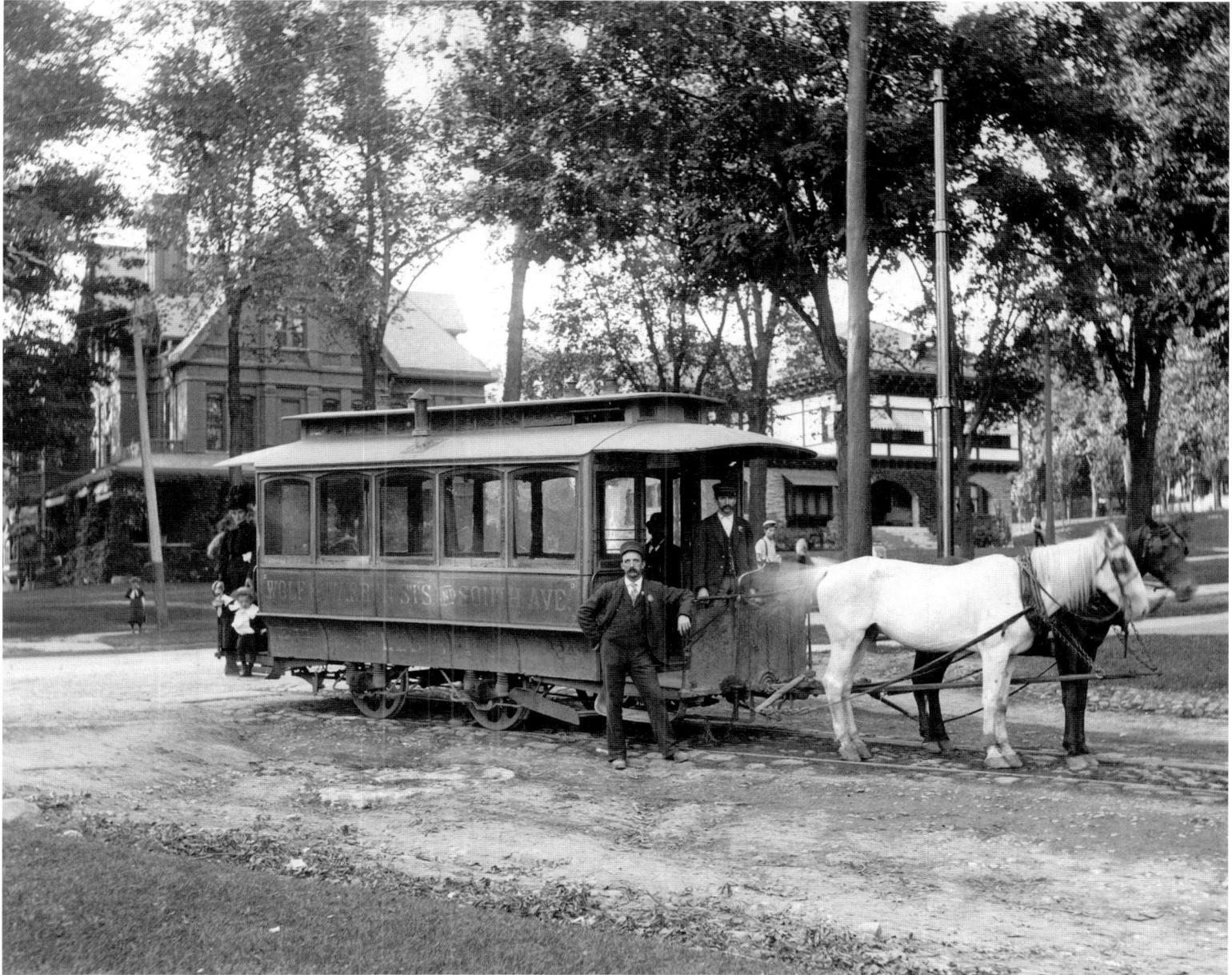

The last horse-powered city streetcar is seen here about 1900 at the intersection of Lodi and James streets. The 1890s witnessed the conversion of all the lines to electric power. This mass transit system enabled the development of many new residential areas in the city.

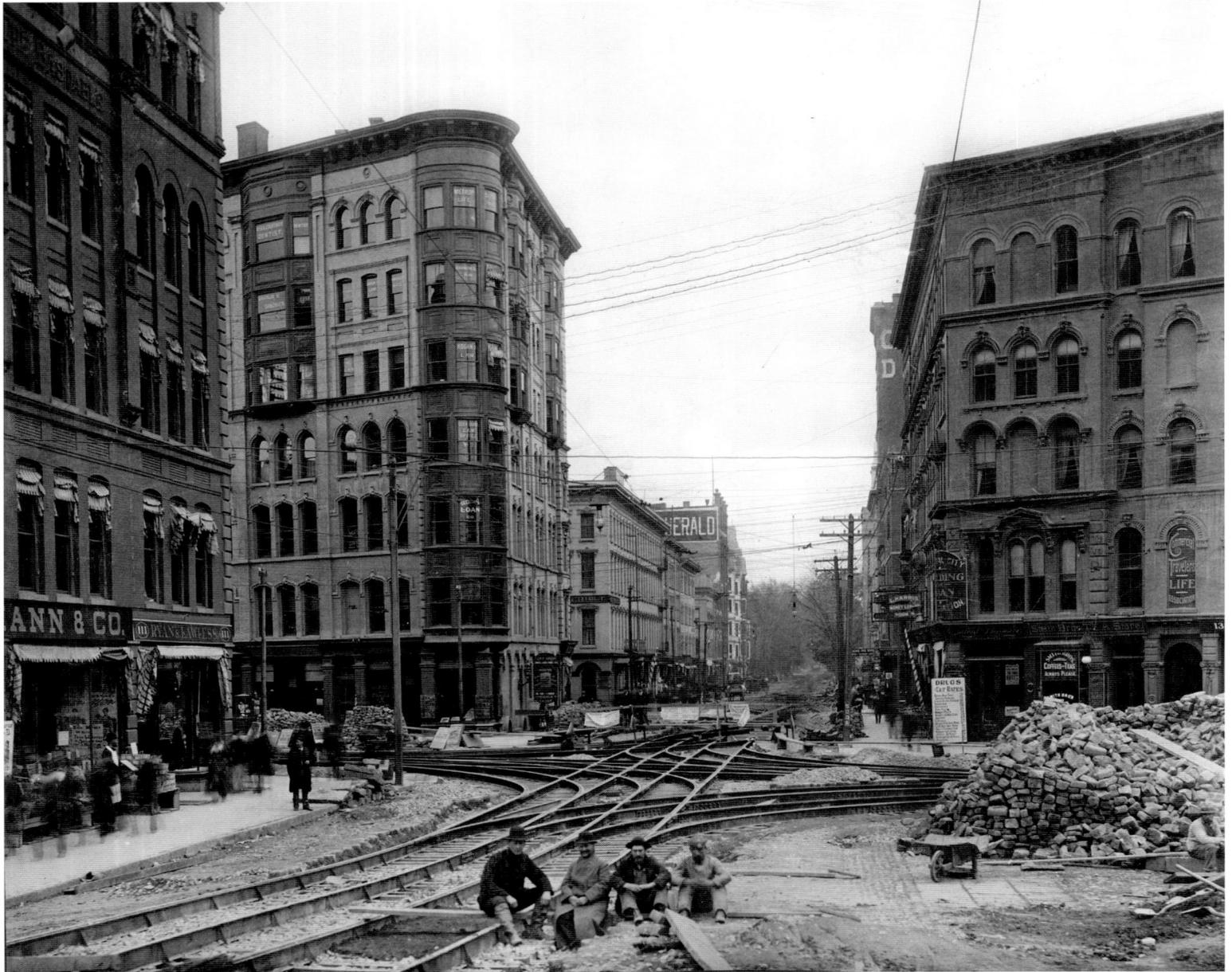

The electric streetcar system required serious infrastructure—in the late 1890s, workers installed upgraded tracks in Hanover Square. In this view facing south on Warren Street, the SA&K Building is on the left and the Larned Building on the right.

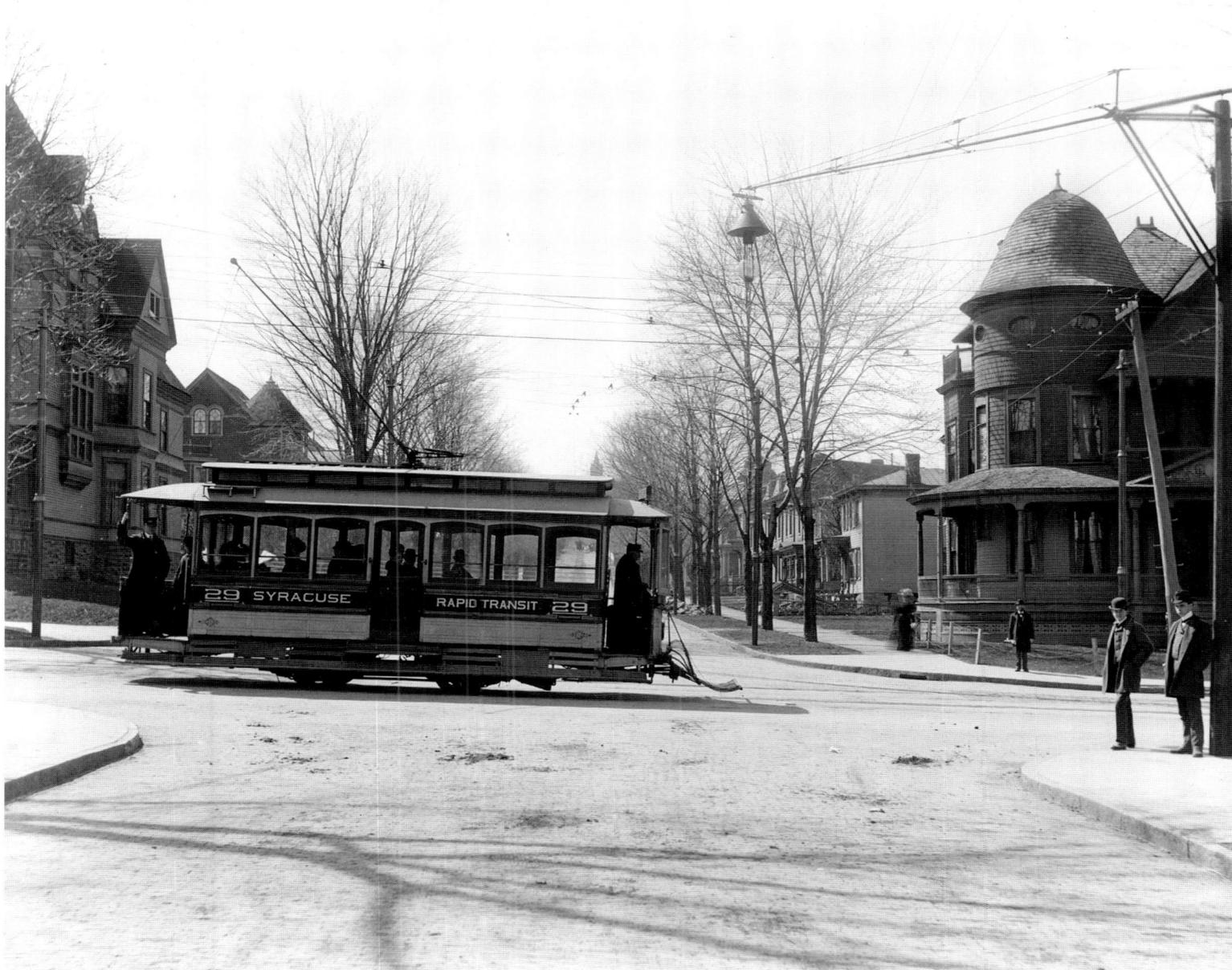

A city streetcar passes South Crouse as it heads west toward downtown on East Genesee Street, probably around 1899 cr 1900. The overhead wires provided electric power to the system.

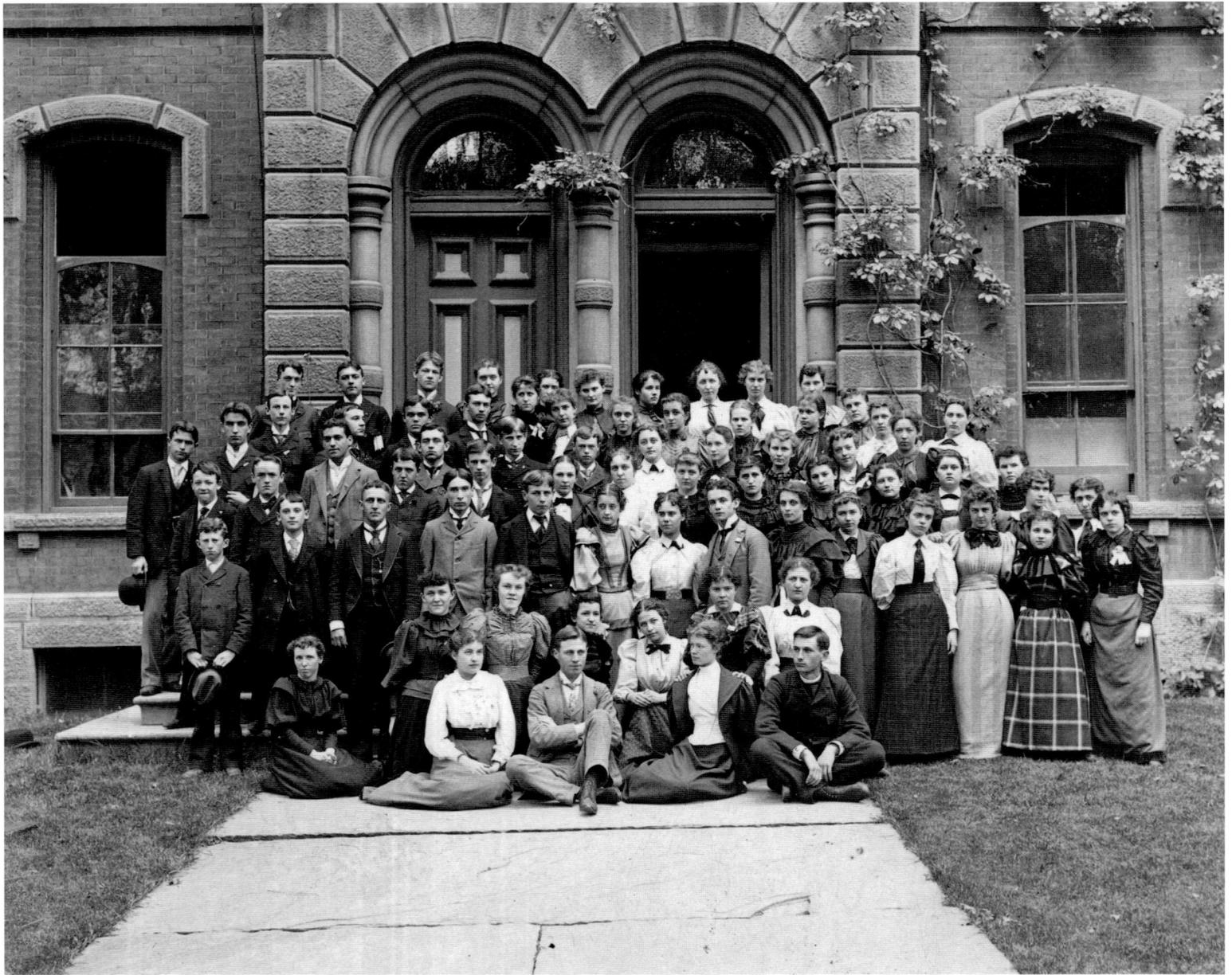

The Syracuse Senior Class of 1894 poses in front of the old high school on West Genesee.

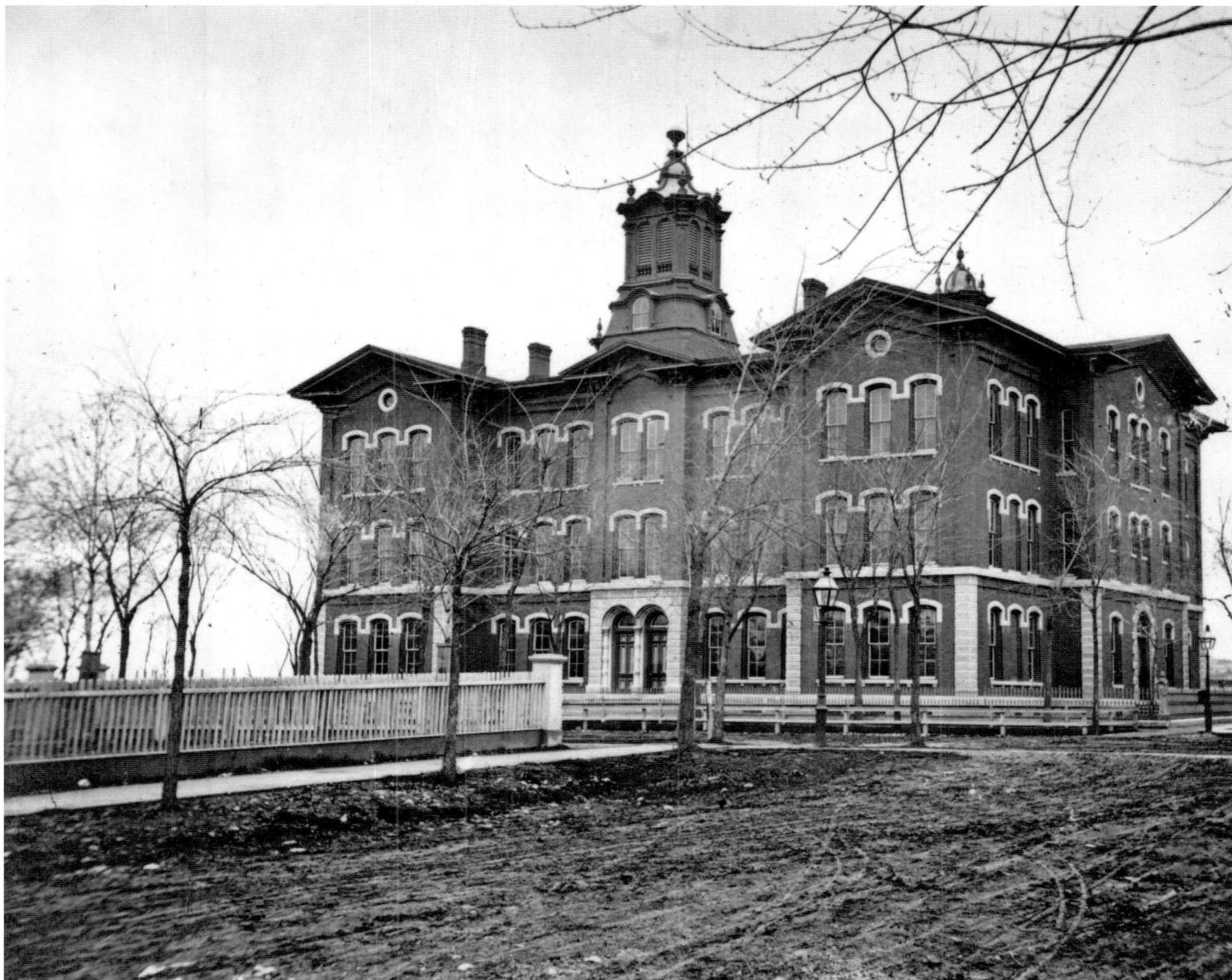

Syracuse built this high school in 1868 on West Genesee Street, along the east bank of Onondaga Creek. It also housed, for a time, the city's main library. It was replaced in 1902 by Central High, and this site later became home to a fire station.

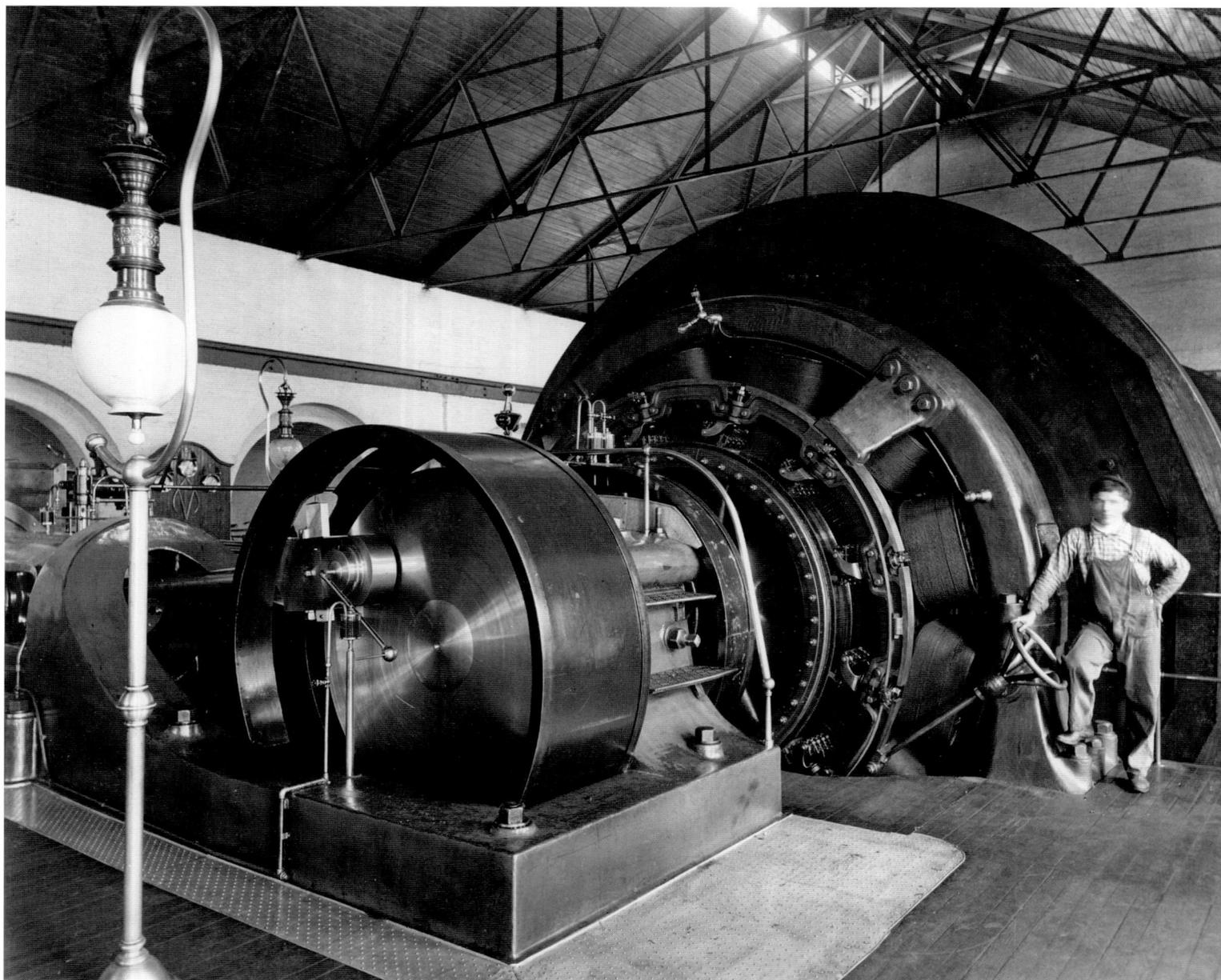

The transit company generated its own electricity for its streetcar system. A major power plant was located at Tracy Street on the city's West Side, adjacent the Erie Canal for easy delivery of coal by barge. This 1890s view shows a generator. The building still stands today but is used for other purposes.

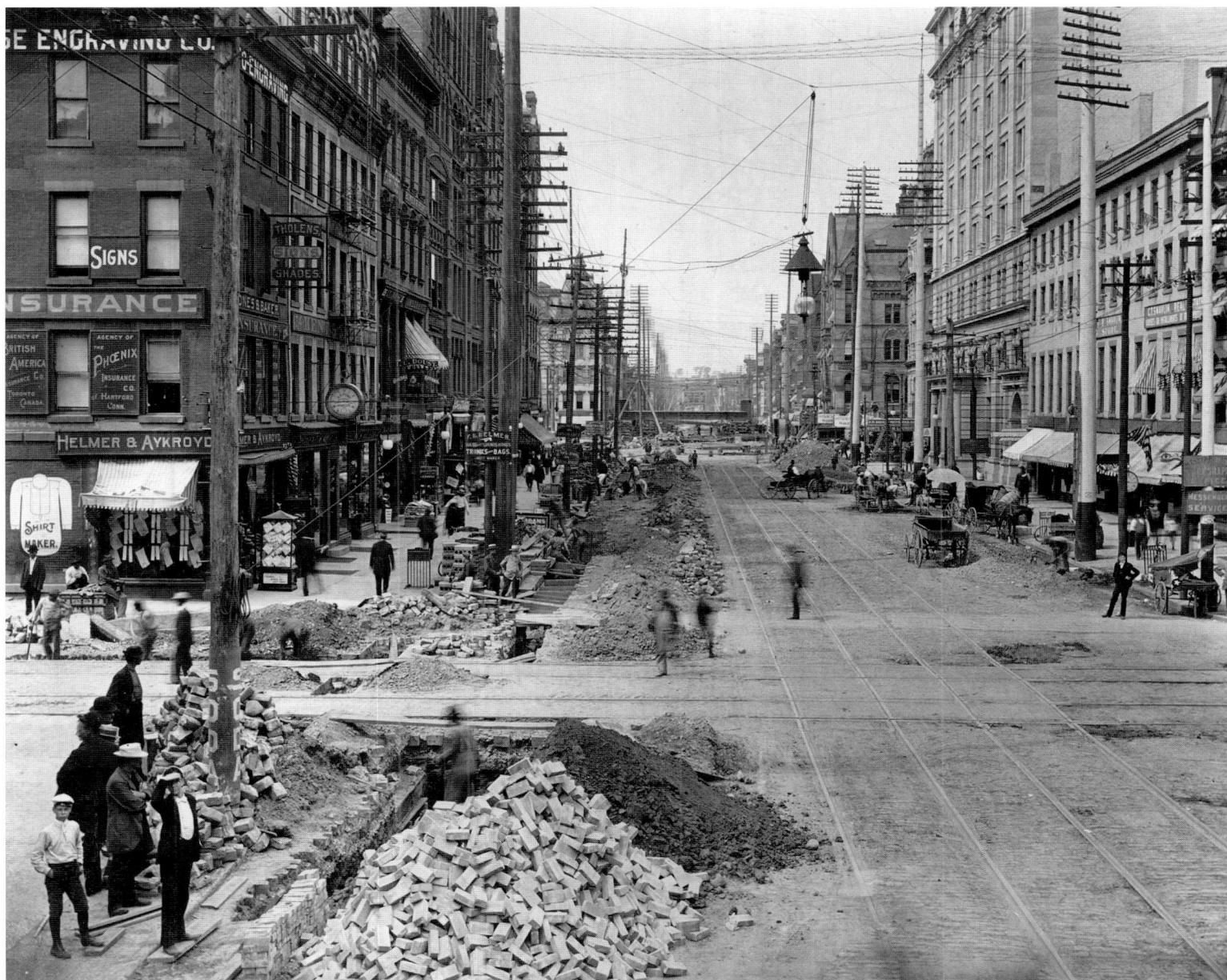

A view north on Salina Street where it intersects Washington Street reveals some heavy utility work under way in 1898. In the distance, a new lift bridge over the Erie Canal is being installed.

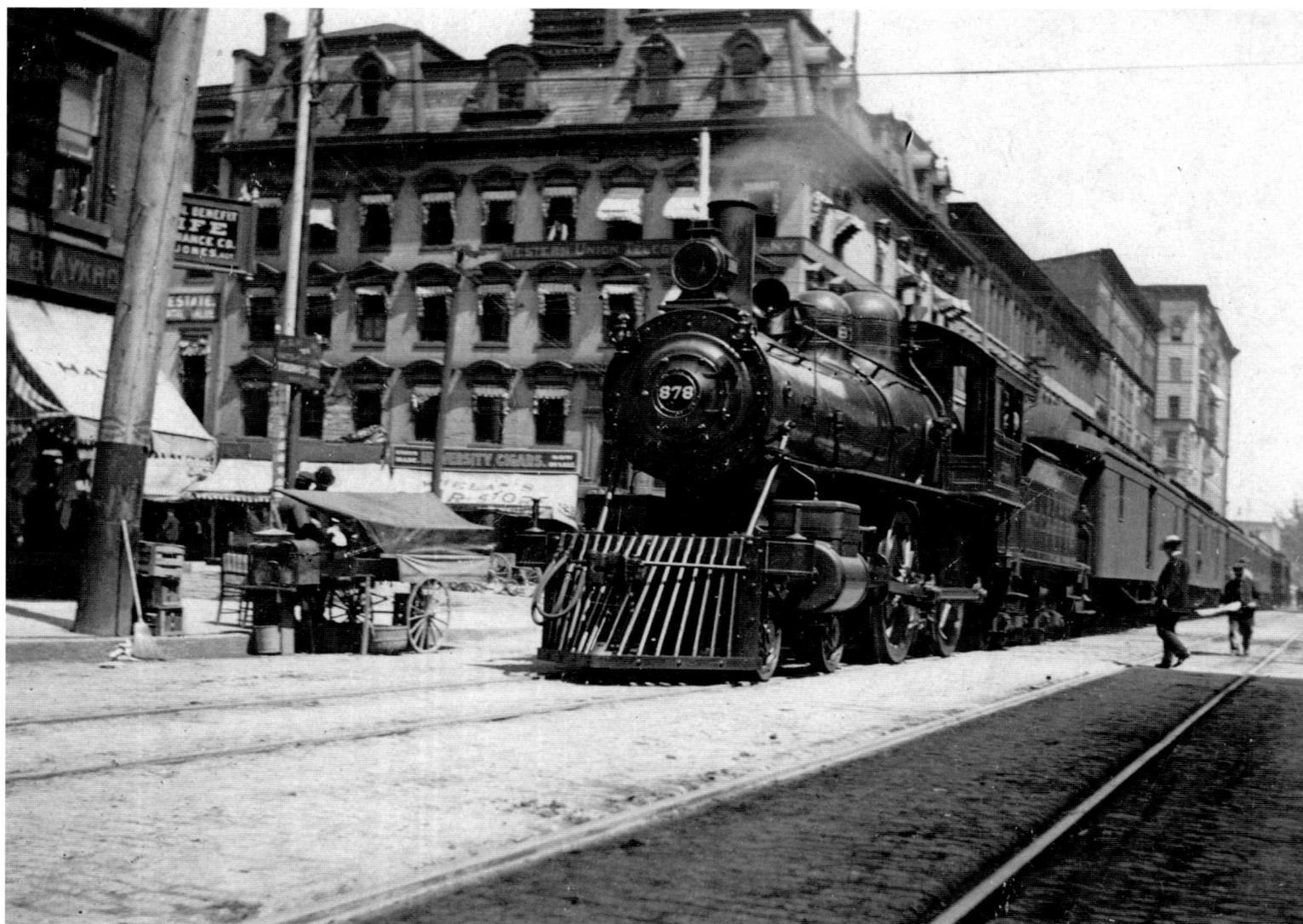

One of the city's distinctive, but increasingly problematic features in the nineteenth century was the main line of the New York Central Railroad running down the middle of Washington Street. Here, probably in the 1890s, a westbound passenger train rumbles toward the Franklin Street station as it crosses Salina Street. The arrival of automobiles in the next decade would escalate the conflict with street traffic.

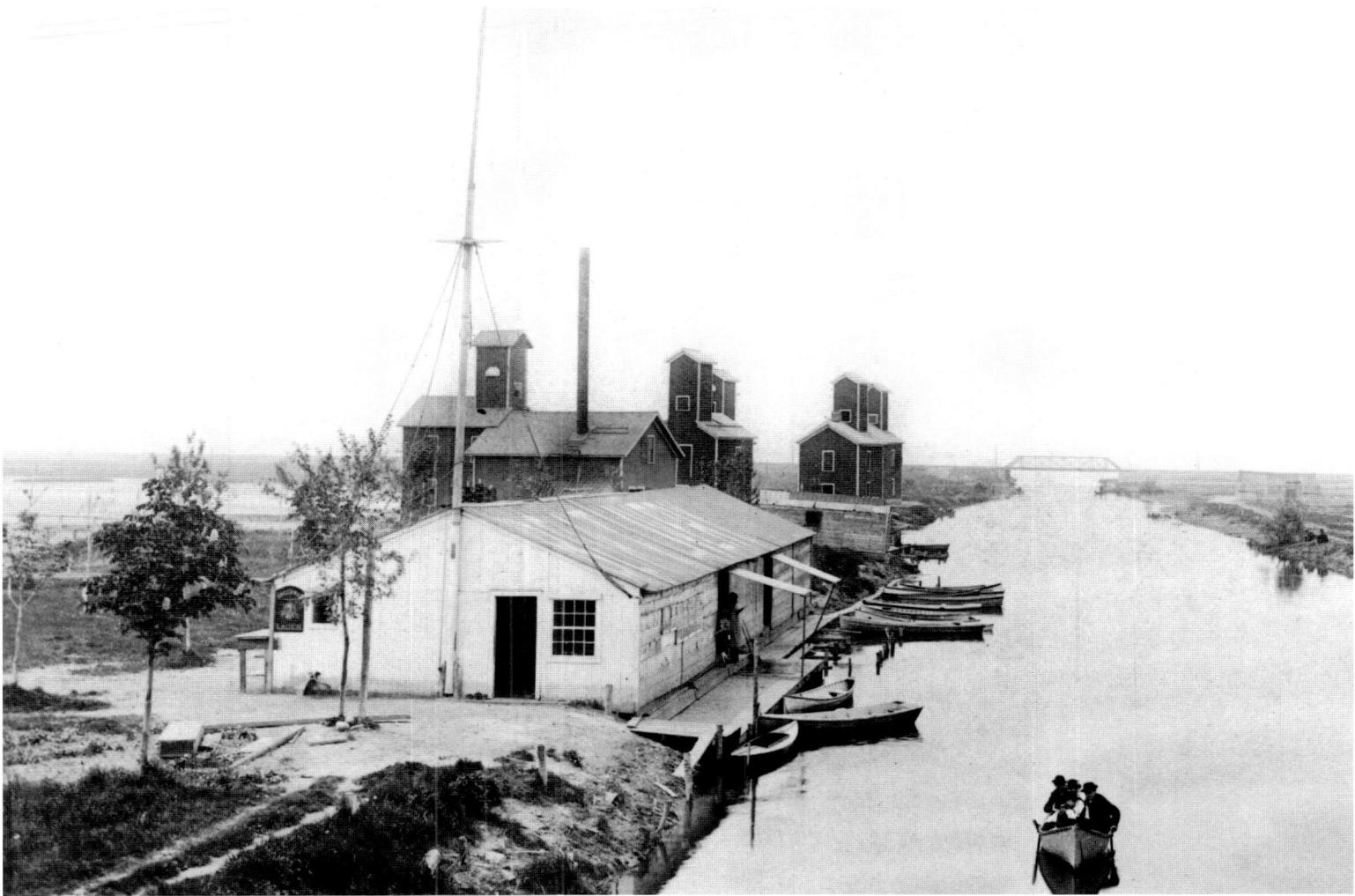

For much of the nineteenth century, the salt industry's dominance over Onondaga Lake's southern shore would hinder the reality that Syracuse had a waterfront. But points of access were created, such as this late-nineteenth-century boathouse along Onondaga Creek's outlet to the lake. Beyond it stand several well houses used to draw brine from the area's salt springs.

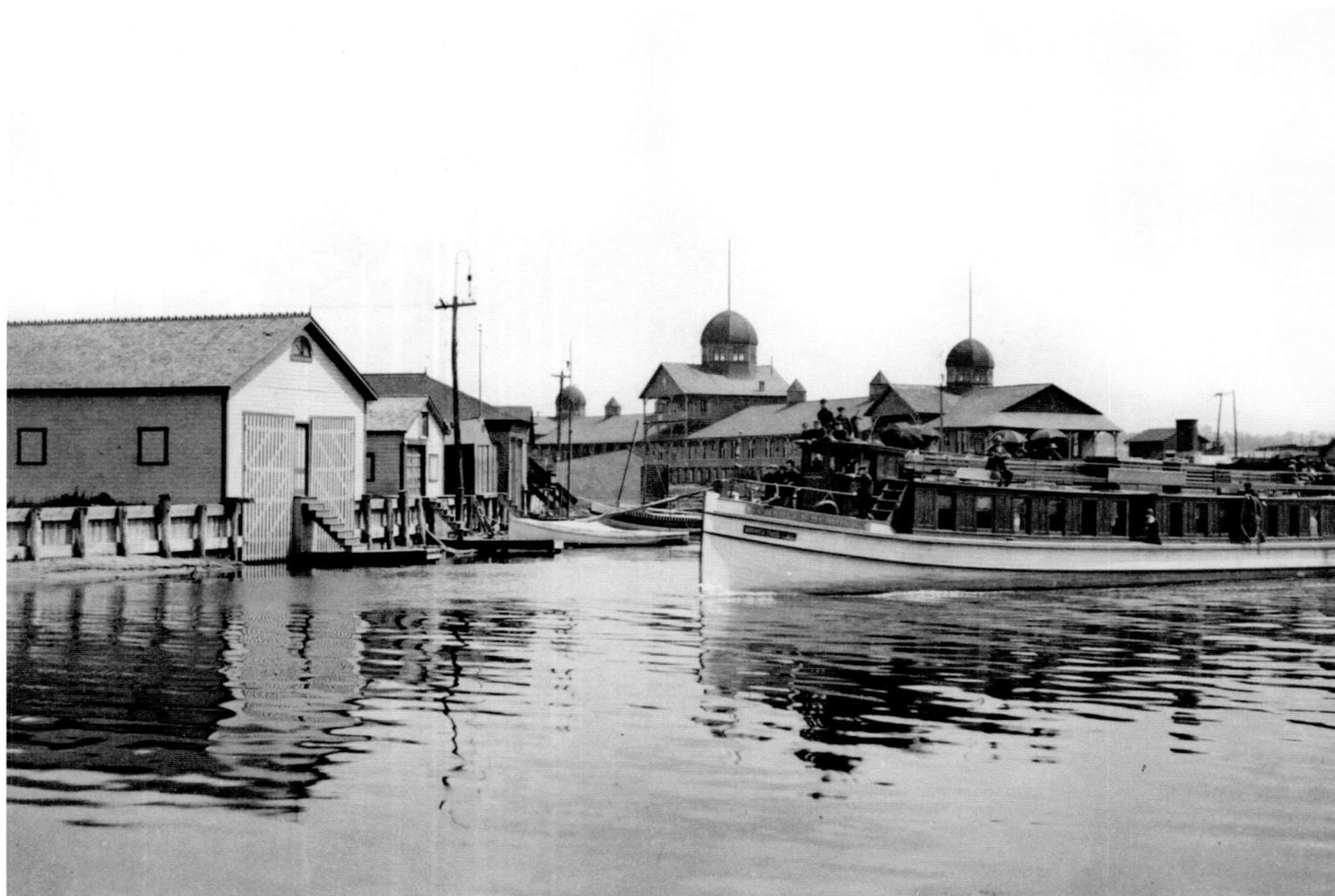

In the late nineteenth century, several resorts were developed on the northwest shore of Onondaga Lake, technically in the town of Geddes. But the Iron Pier, seen here in 1899, was opened on a narrow length of waterfront along the city's side of the lake. It featured dancing, dining, and other amusements, as well as the chance to board steamers for the resorts across the lake.

Syracuse Matures

(1901–1920)

"The more I look into the automobile situation, the more convinced I am that we want to go into the business. The industry is going to develop enormously during the next few years."

So wrote H. H. Franklin in 1901 to fellow Syracuse industrialist, Alexander T. Brown. Each had recently rode in a "horseless carriage" built by a local bicycle engineer, John Wilkinson, and were considering investing in a company devoted to mass production. The Franklin Manufacturing Company would sell its first automobile in 1902 and go on to become one of the city's largest employers by 1920. It was an era of great optimism for Syracuse. Although the local salt industry had long since begun to fade, it had been replaced with a broad diversity of industrial firms that kept the local economy thriving. Brown, himself, was heavily invested in typewriter manufacturing and gear production.

The community was now exploring opportunities to enhance the city with grand municipal buildings and an expanding parks system. By 1907, a handsome new library and a gloriously domed new county courthouse graced what was known as Library (later Columbus) Circle. Onondaga, Thornden, and Kirk parks offered pleasing vistas for the growing neighborhoods to the west, east, and south of downtown, respectively. Medical facilities were advancing, as was Syracuse University. Founded in 1870, the SU campus on University Hill was not only growing physically, but also emerging to play a greater role in the life of the city.

The Erie Canal and intersecting Oswego Canal remained and were regularly used. But they had been replaced by railroads as the chief haulers of raw materials to Syracuse factories and the transporters of its finished goods to worldwide markets. Residents still had to deal with the numerous canal bridges and grade-level railroad crossings that wove across downtown—impediments that were becoming increasing nuisances to the new mode of transportation—the automobile.

The auto's popularity provided job opportunities at the Franklin Company, but the expanding number of local owners driving cars created traffic conflicts with raised canal bridges and the passing trains of the New York Central and DL&W railroads. These growing urban challenges would need to be faced, but America's 1917 entry into World War I would require the attention of Syracusans until the arrival of the Roaring Twenties.

Clinton Square and the Onondaga Savings Bank building are decorated around 1912 for the annual "Ka-Noo-No Karnival of the Mystic Krewe." Syracuse's Mardi Gras–like celebration was timed as a promotional activity for the State Fair. The stairway on the left was used by pedestrians to reach and cross the Salina Street lift bridge when it was raised for canal boat traffic. The stand underneath sold popcorn, lemonade, and peanuts.

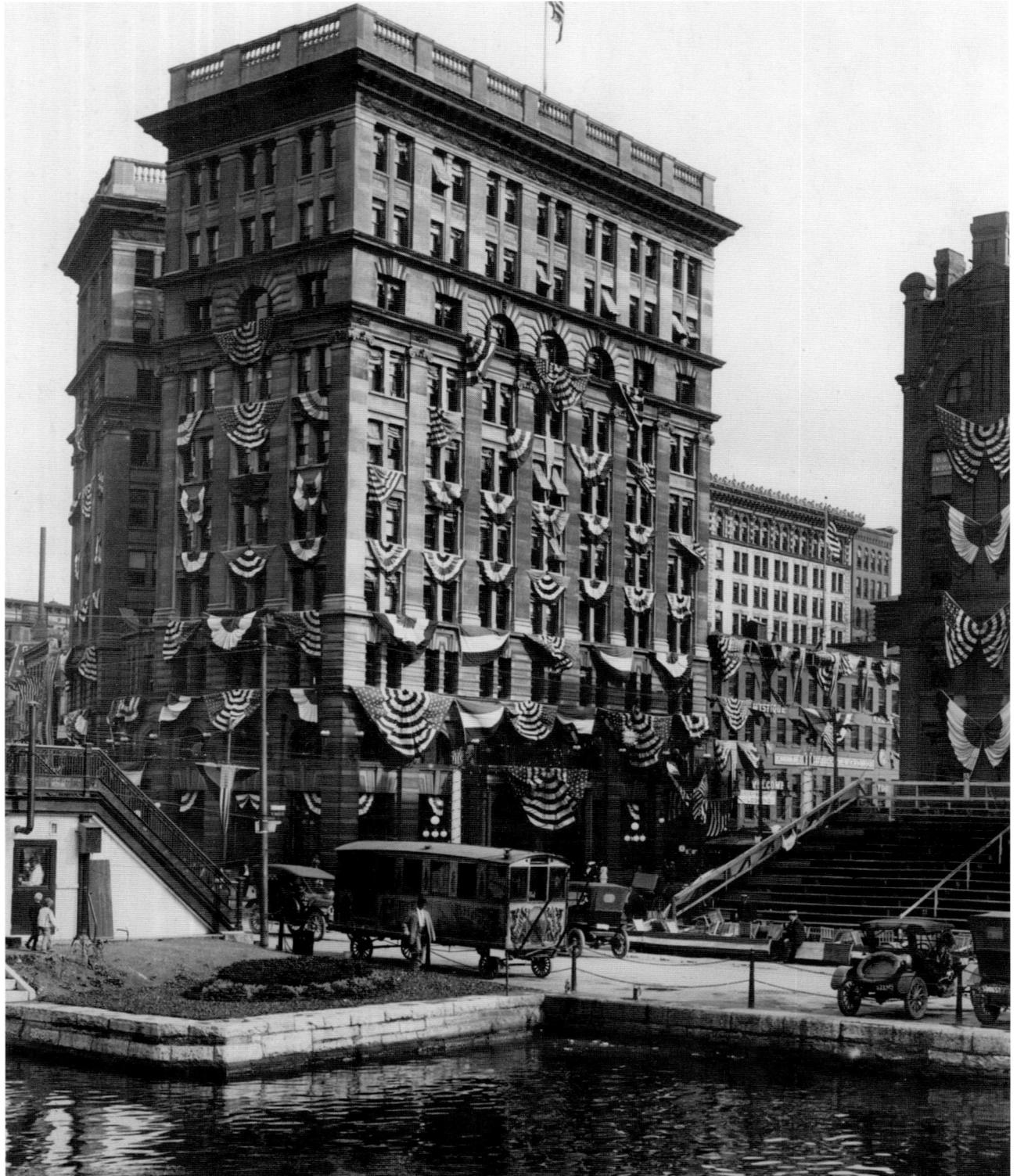

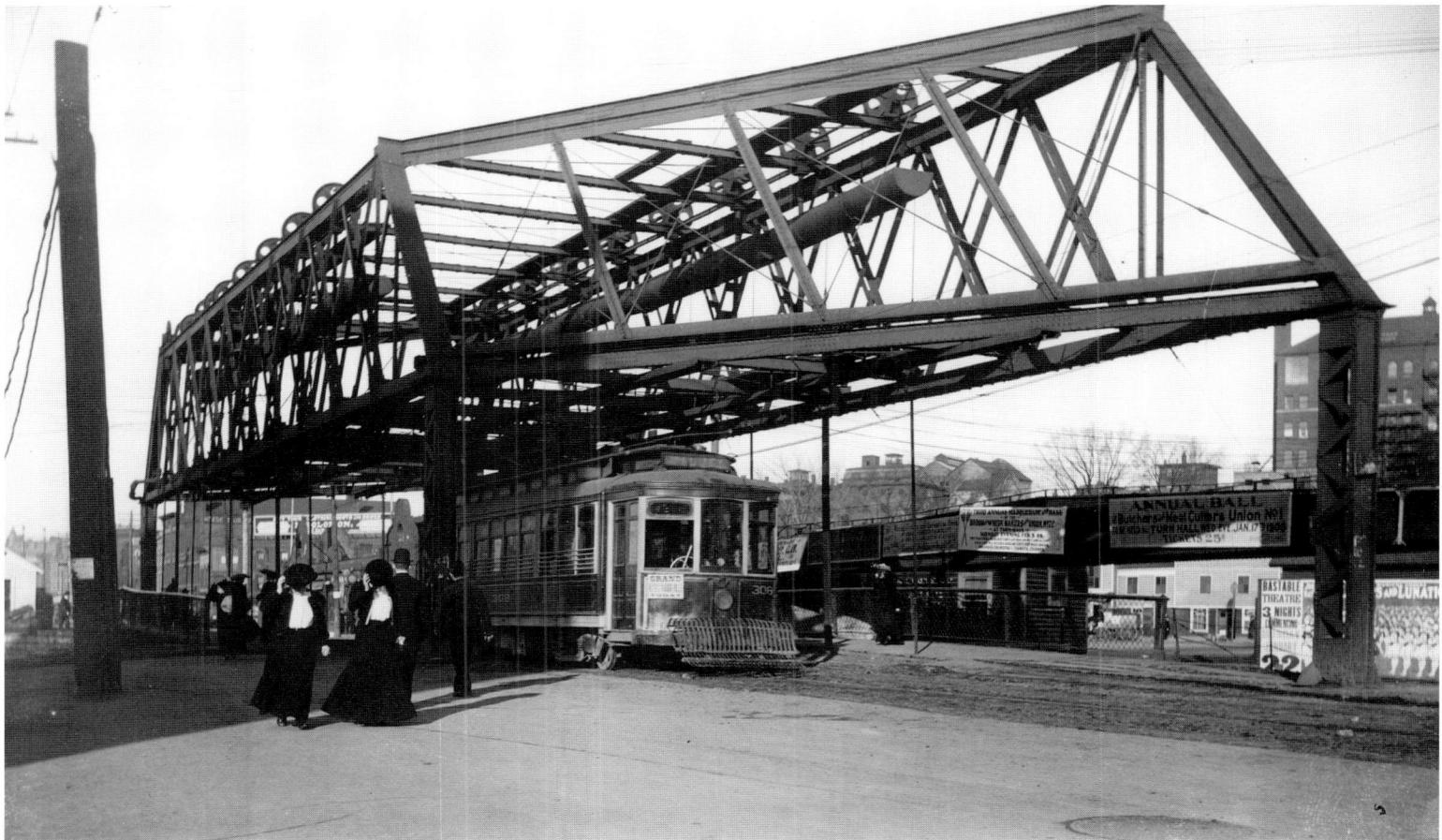

On a windy day in 1906, a streetcar heading south on Salina Street crosses over the Oswego Canal, a few blocks north of Clinton Square. Signs advertise the "Annual Ball of the Butchers and Meat Cutters Union" at the Turn Hall, a musical at the Bastable Theater, and a lecture with "moving pictures" on the "History of the Indian."

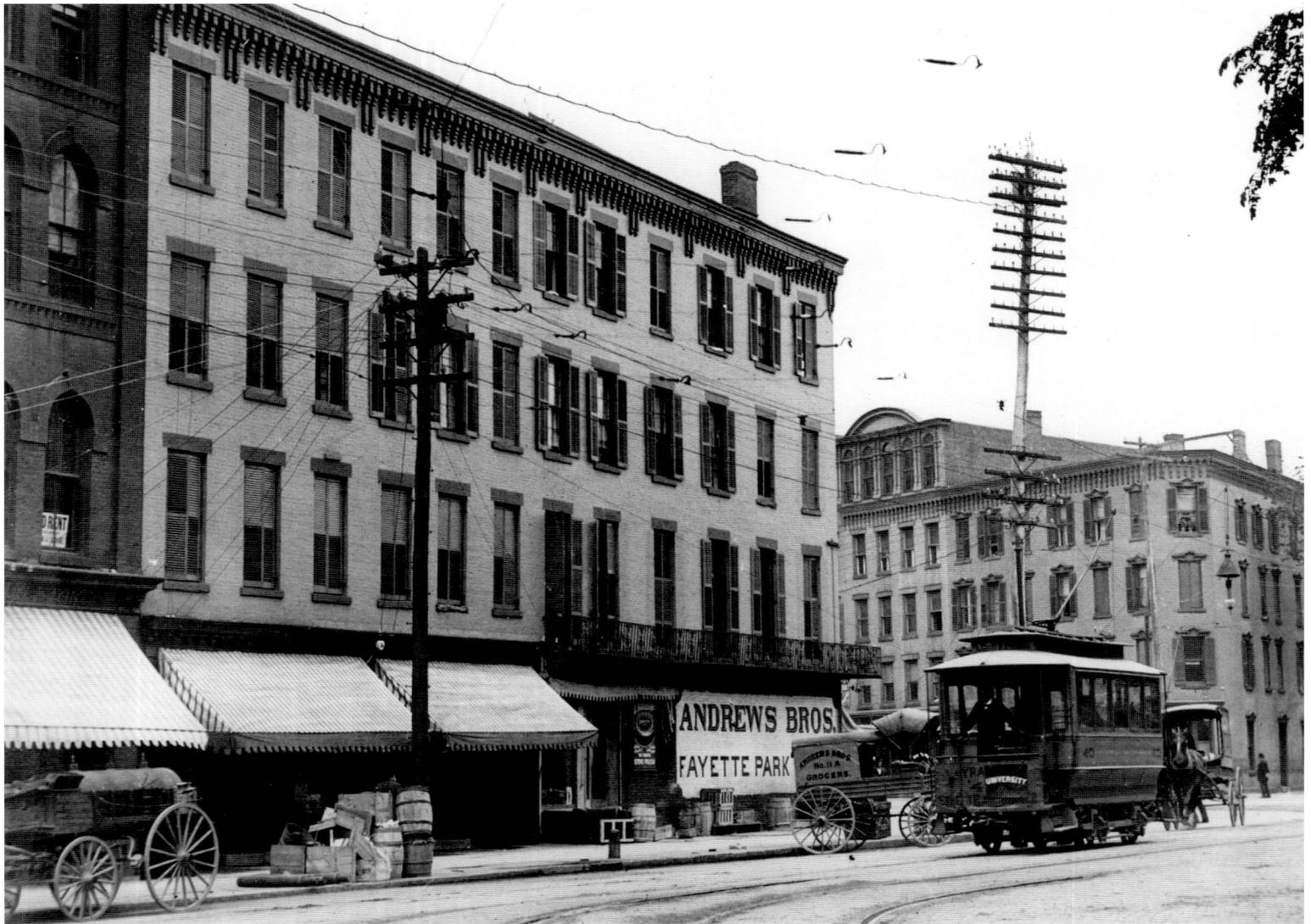

This streetcar, bound for Syracuse University in 1903, passes by the Jervis House on State Street, across from Fayette Park. This is the site today of the One Park Place office building.

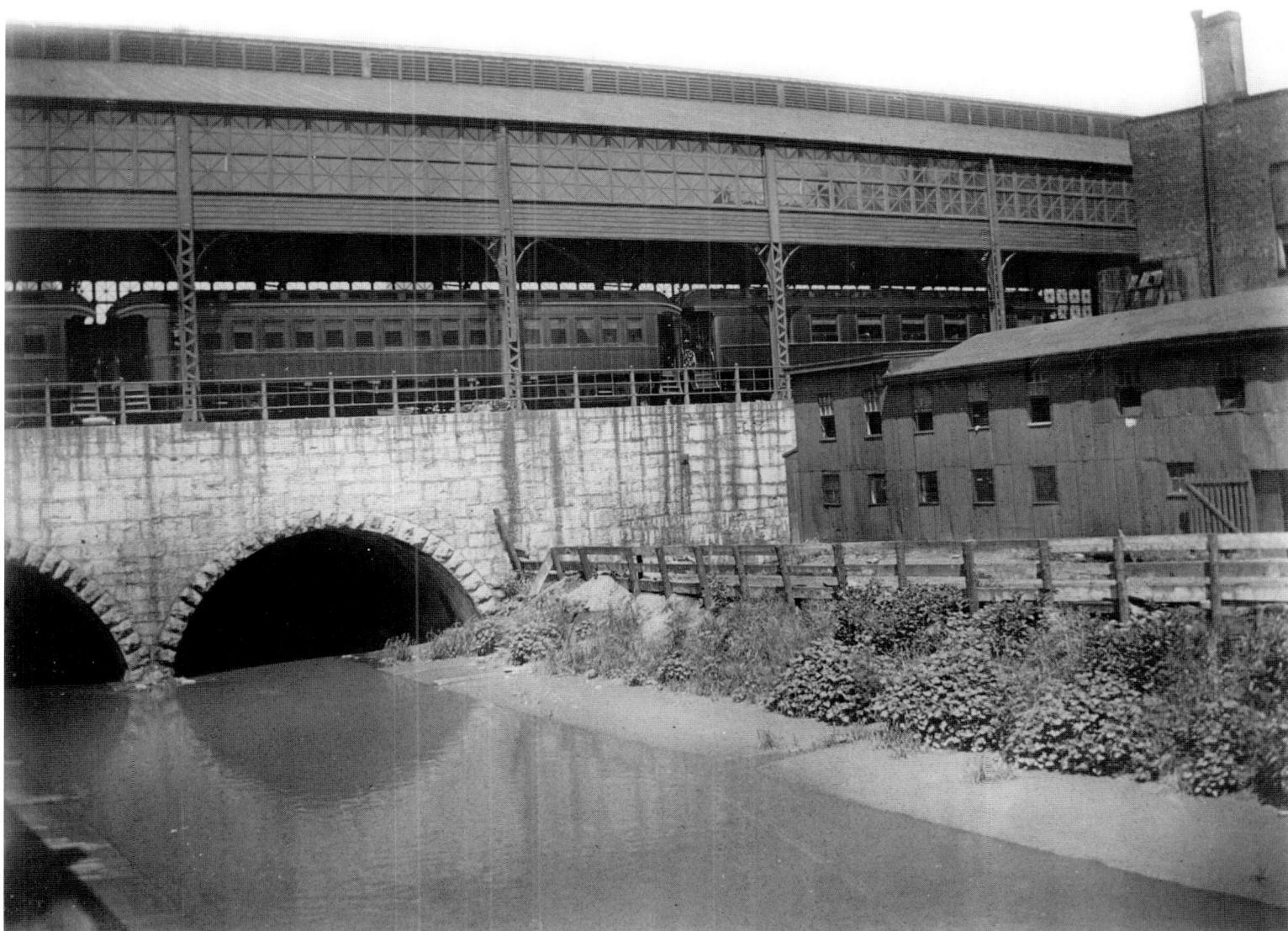

The 1895 New York Central Railroad passenger station included a huge metal-roofed train shed. It extended west from the station completely across Onondaga Creek, supported by a much older limestone bridge. The train shed was demolished in the 1930s, when the station was relocated, but the stone bridge and a portion of the 1895 railing still stand in 2008.

Following Spread: The 1895 station itself was a marvelous Richardsonian Romanesque–style structure built of sandstone. It occupied the northwest corner of Franklin and Fayette streets, in what today would be the Armory Square Historic District. To the dismay of many today, it was demolished in 1939.

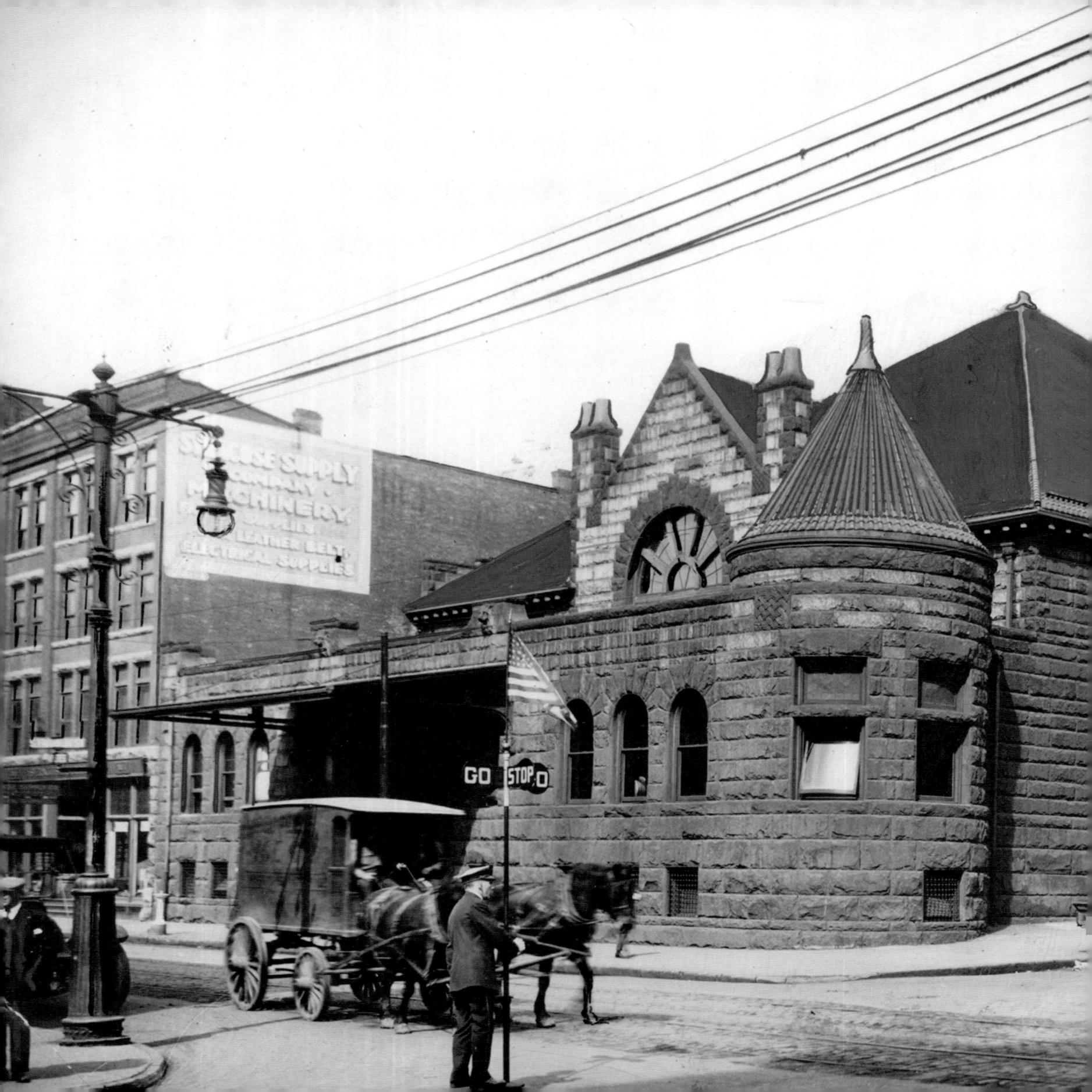

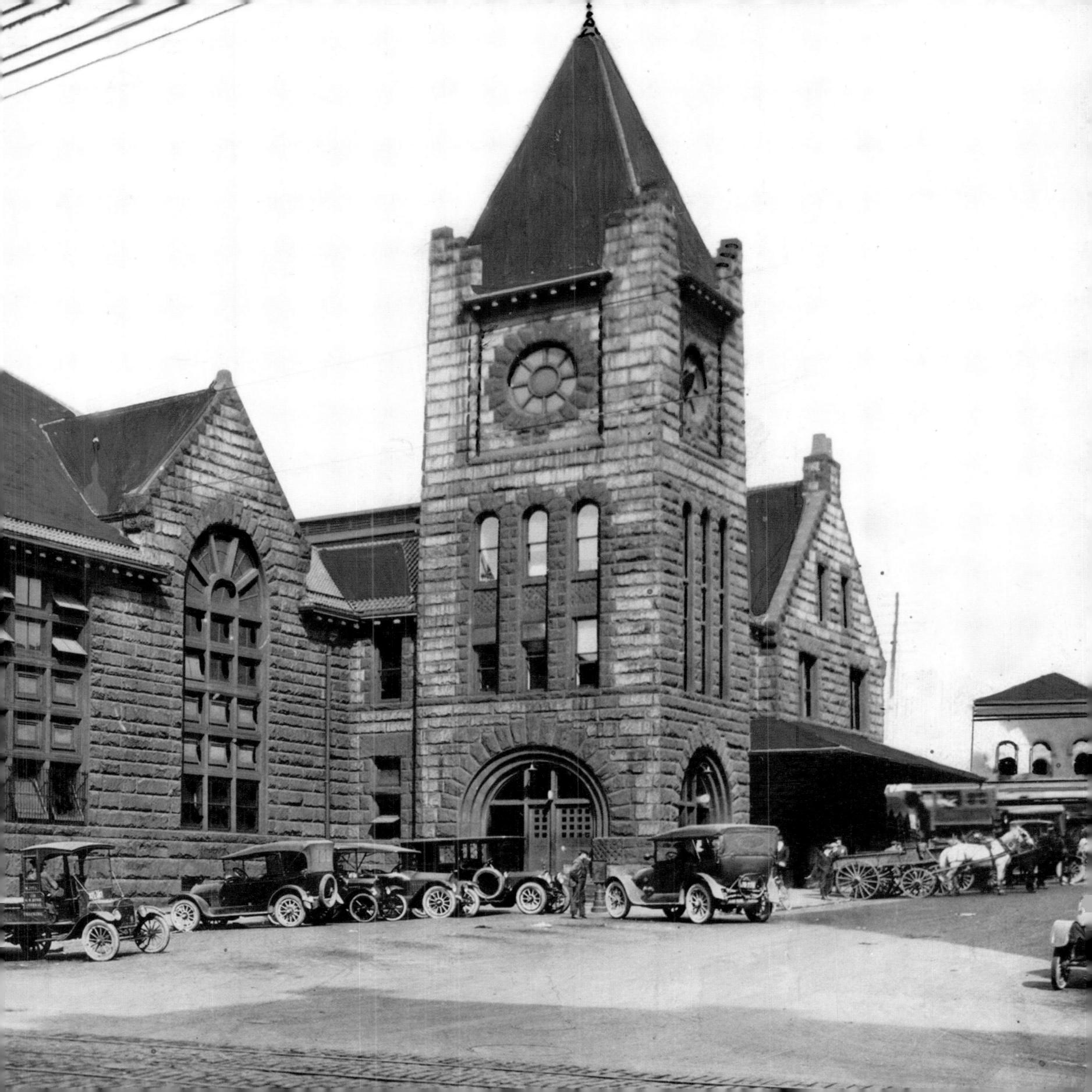

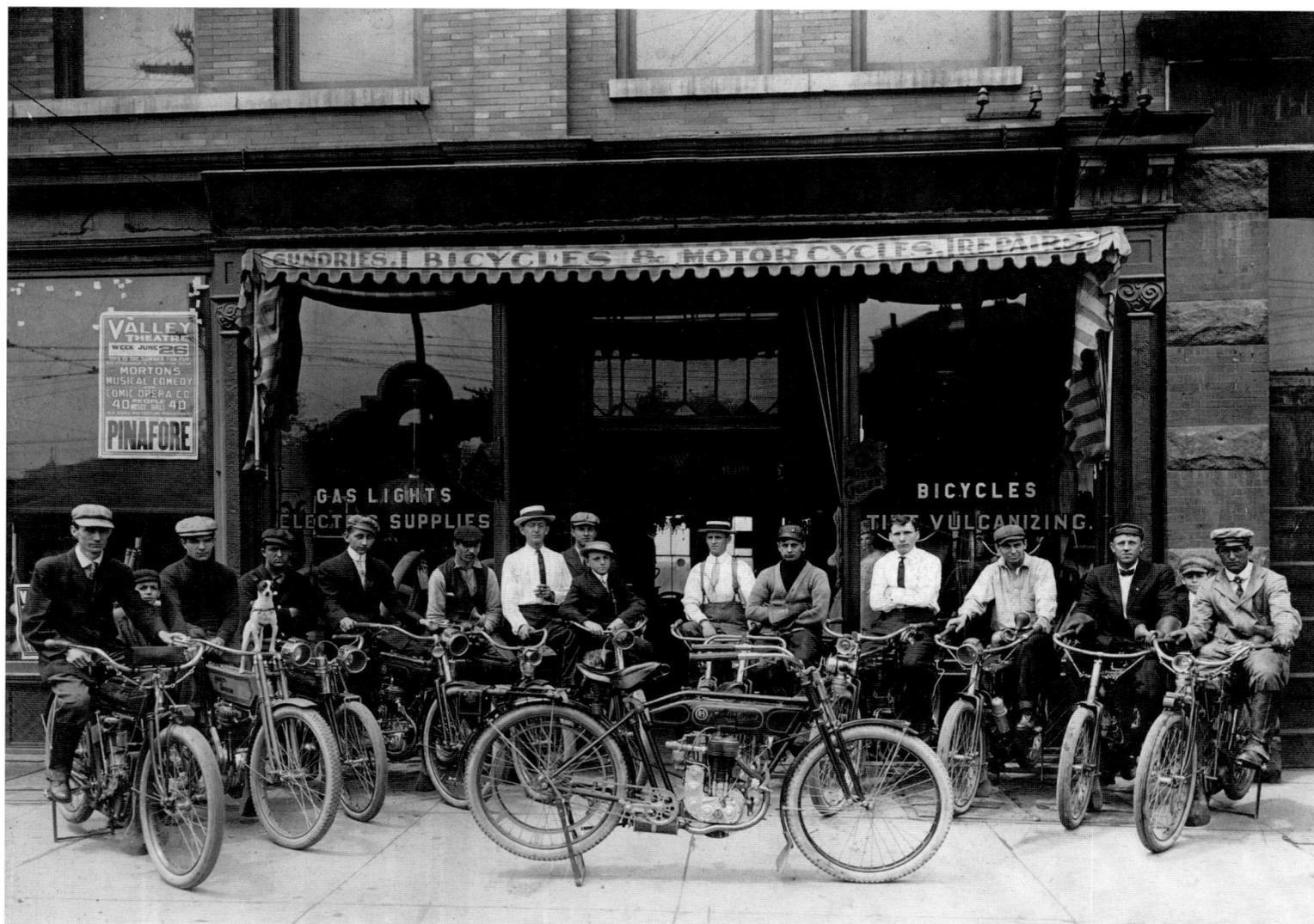

A group of motorcycle enthusiasts pose in front of a North Salina Street business around 1910. The store was a retail outlet for Reading Standard motorcycles, but the bike second from left is a Harley Davidson, complete with an optional fox terrier.

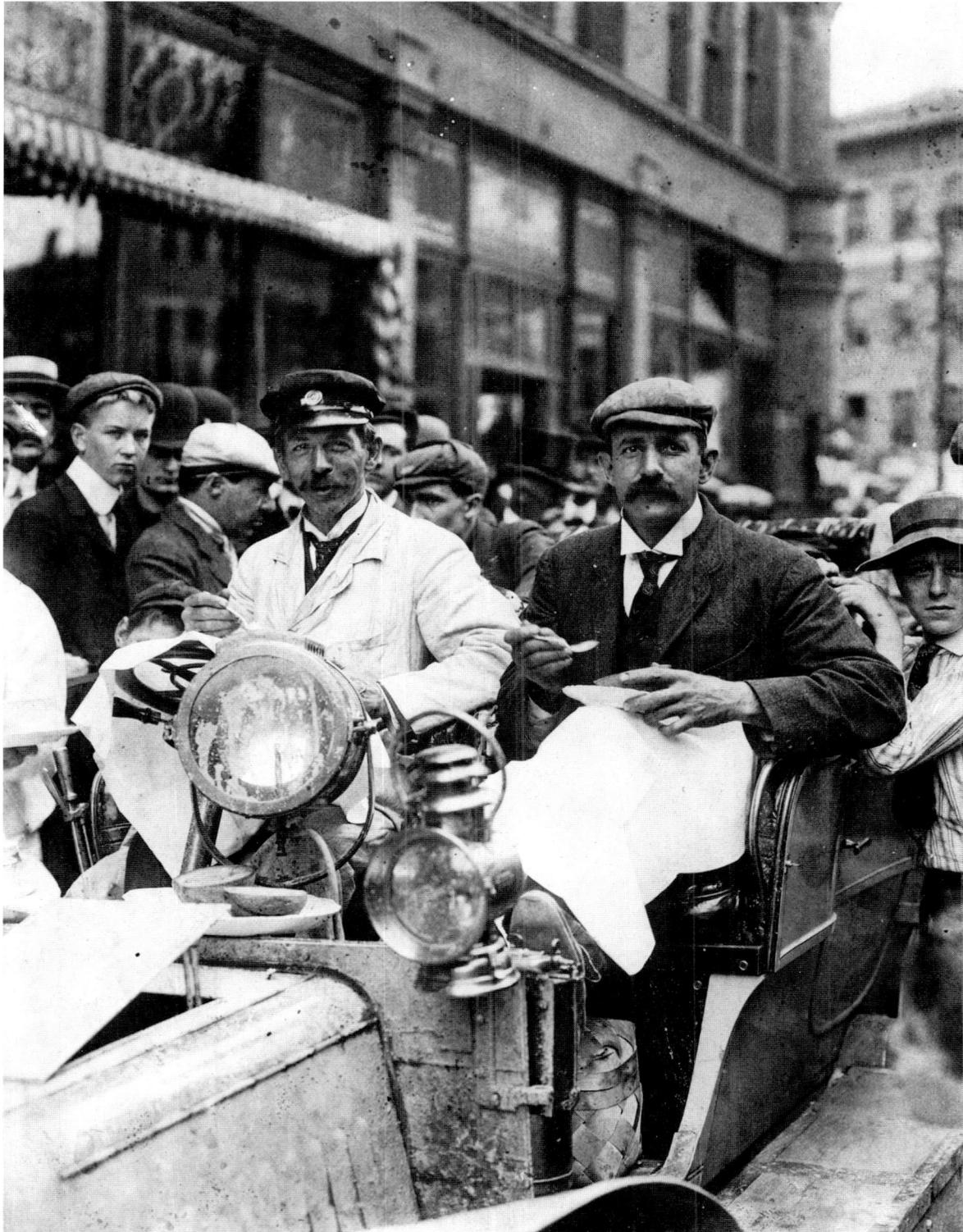

The first decade of the twentieth century brought with it the automobile and a widespread fascination with the invention. There were numerous, promotional cross-country races at the time—coast-to-coast and even around-the-world competitions. Often, they started in New York City and would pass through Syracuse heading west. Here, two drivers in 1904 grab a quick bite in front of the Yates Hotel downtown.

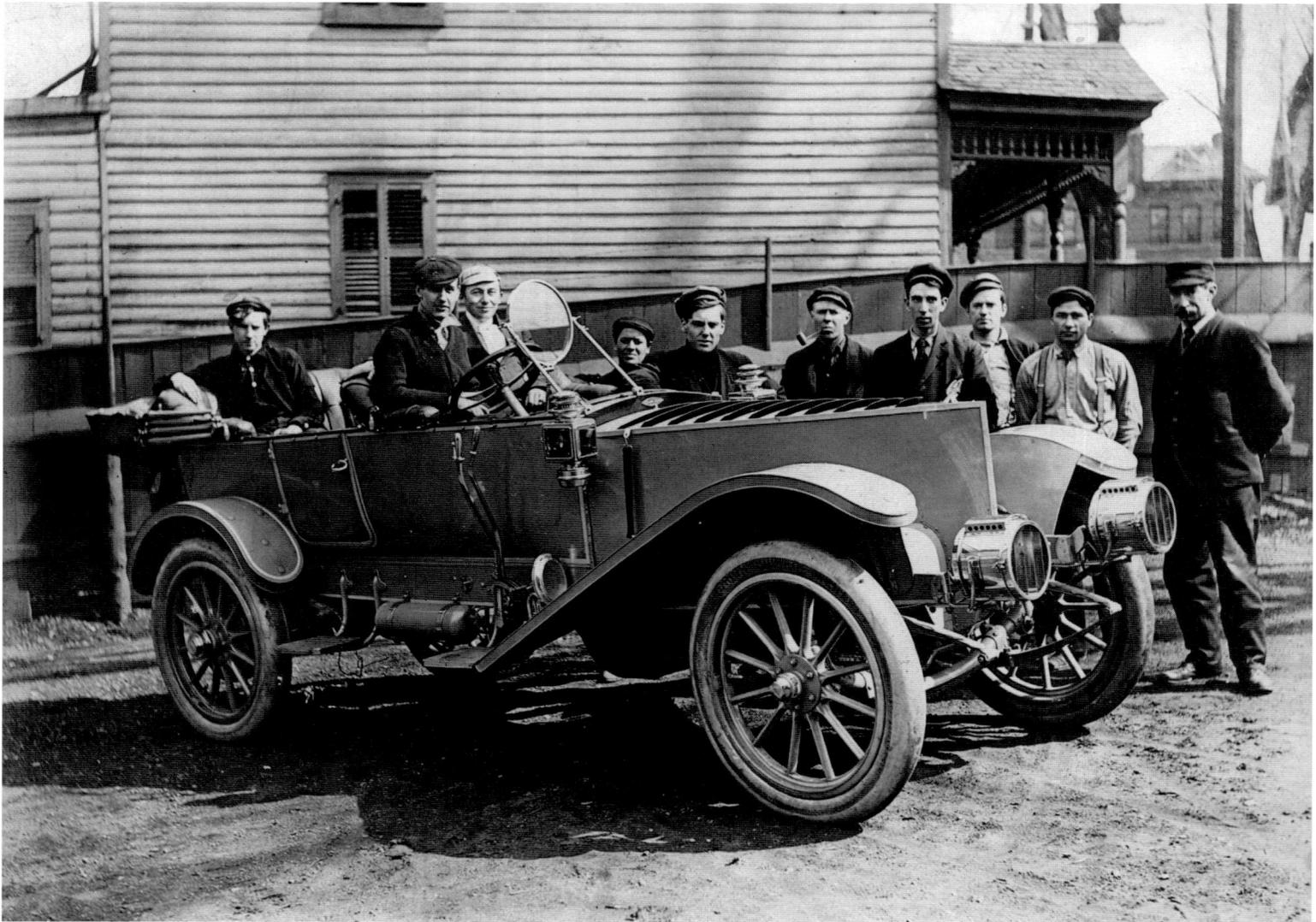

Syracuse was home to some early automobile manufacturers, the largest and longest lasting being the Franklin. In 1909, executive H. H. Franklin had this special model built for himself, nicknamed the "Torpedo." It had no radiator, but rather air vents on top of the hood. Franklin engines were always air-cooled and never required radiators.

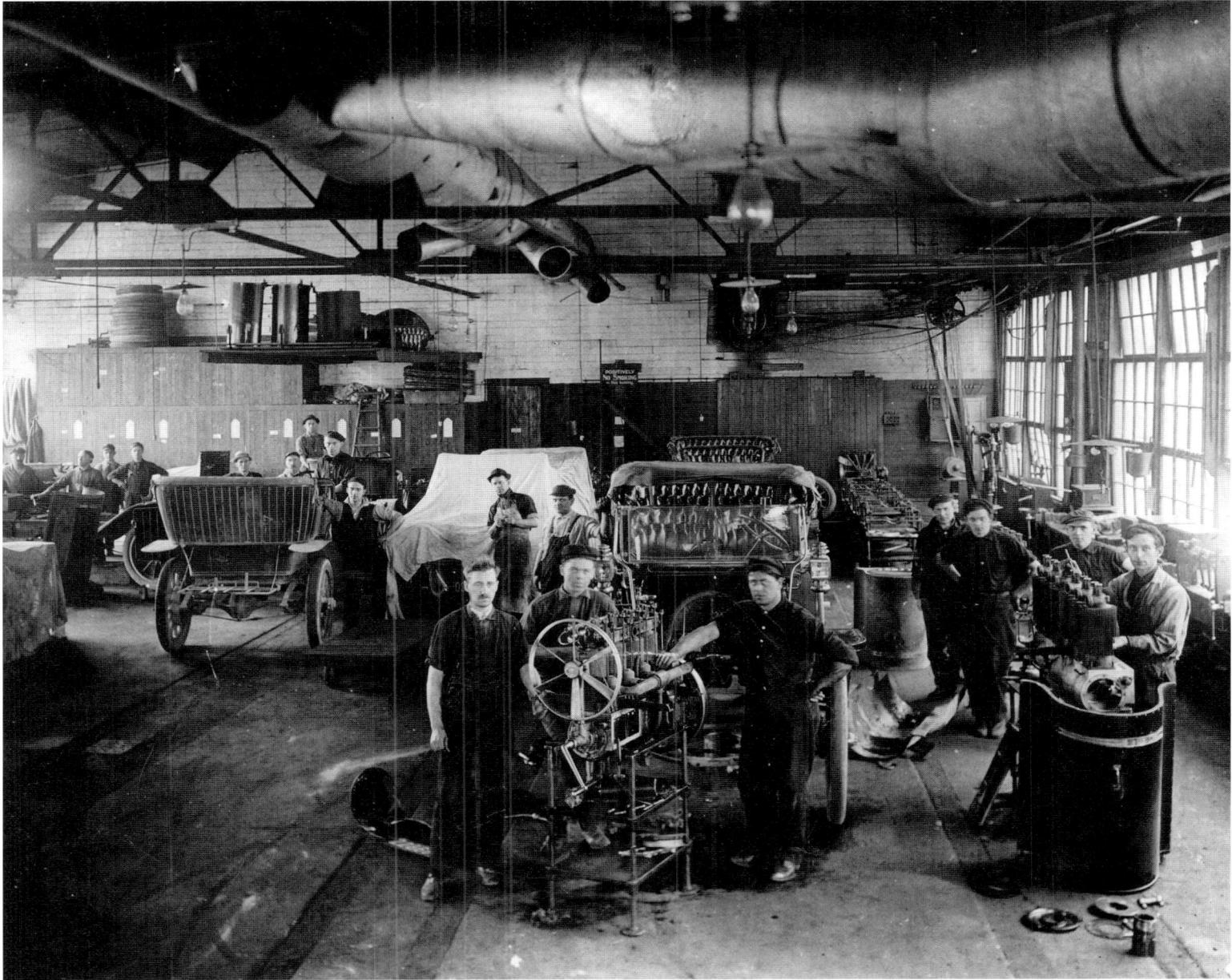

Beginning in 1904 and lasting into the early 1930s, the Franklin Manufacturing Company built a sprawling factory complex on Geddes Street. In this 1909 view, workers in the company's repair shop pose for the photographer.

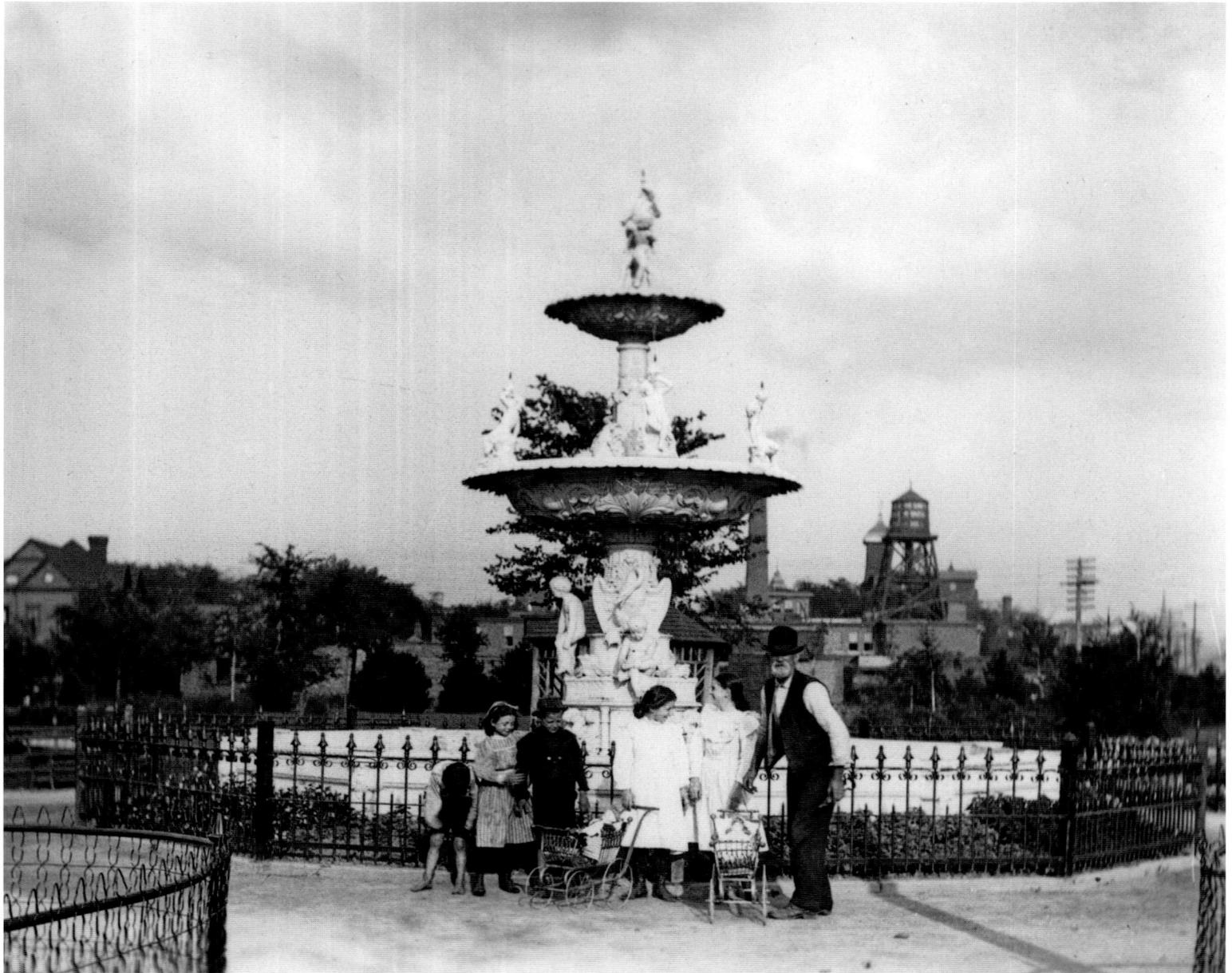

By the beginning of the twentieth century, Syracuse had a growing parks system. Many of the older parks were smaller, rectangular green spaces laid out in various neighborhoods, sometimes with elaborate cast-iron fountains. This is Leavenworth Park on the city's West Side about 1900.

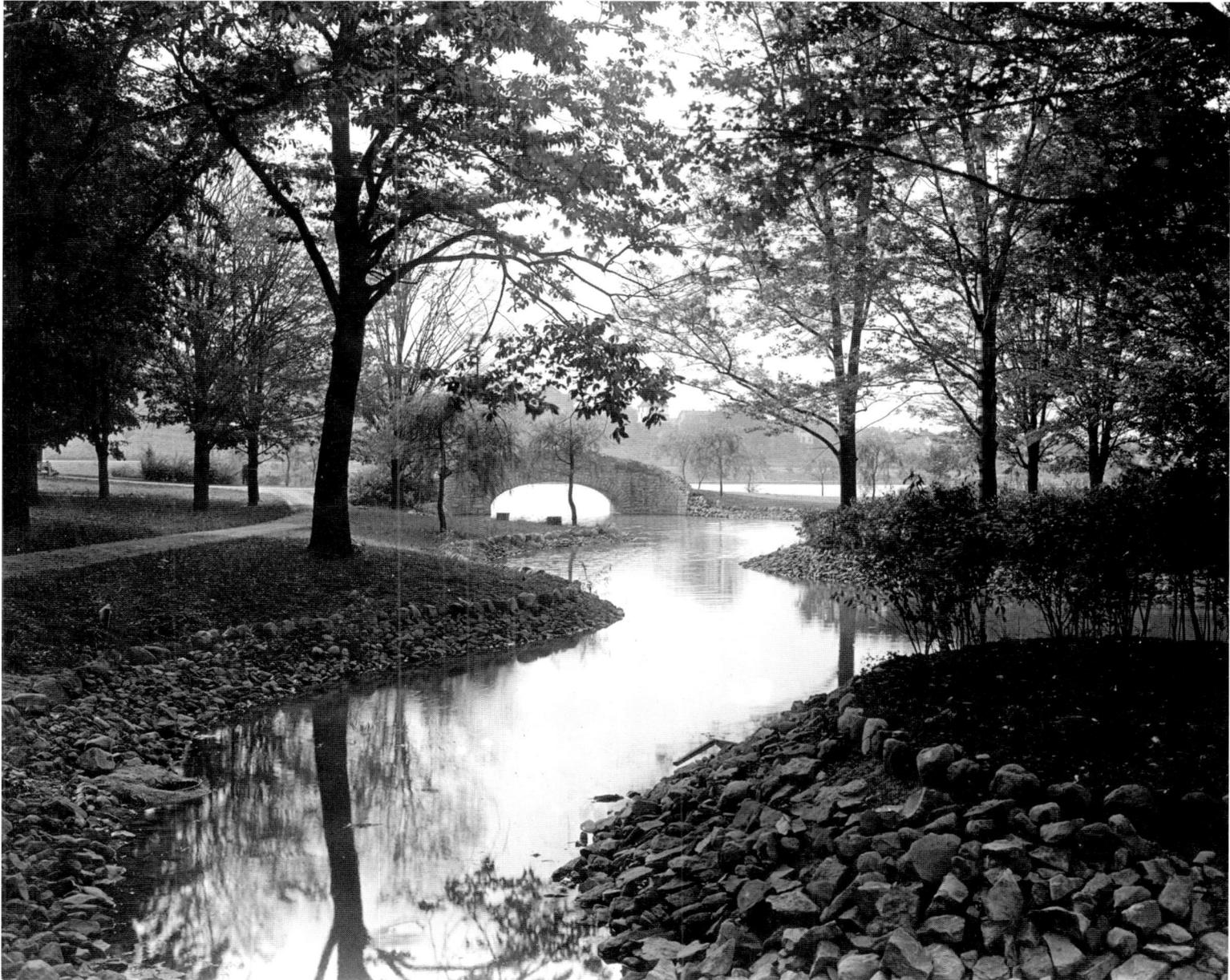

Larger city parks such as Burnet, Thornden, and Onondaga were eventually added to the system, providing the opportunity for more creative landscaping in the early twentieth century. This stone bridge and lagoon area were photographed in Upper Ononcaga Park, reportedly in 1913.

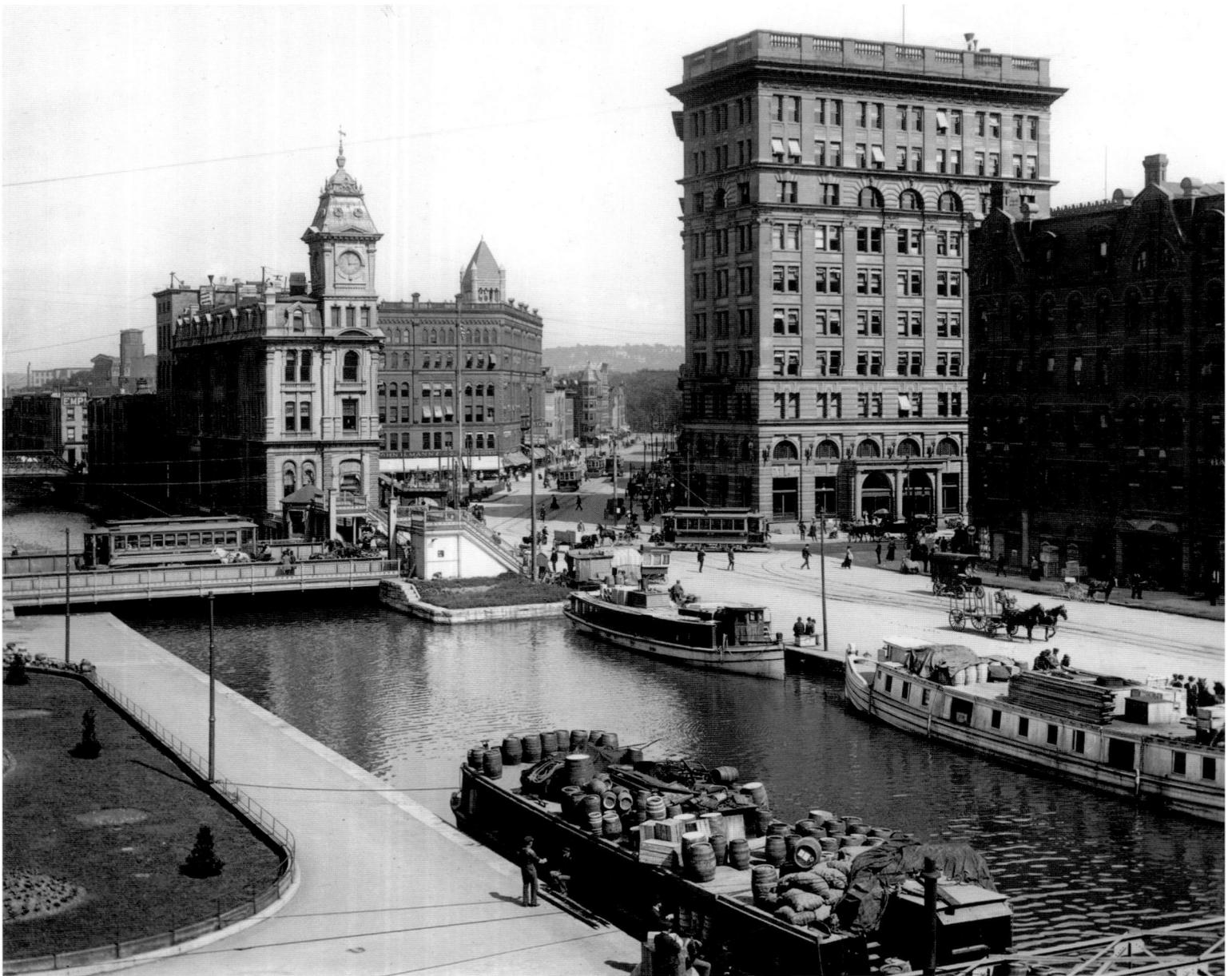

Although the Erie Canal was more than 75 years old by the time this photograph was taken around 1905, it was still being used to haul cargo. And boats could still unload in the middle of downtown at the Clinton Square landing.

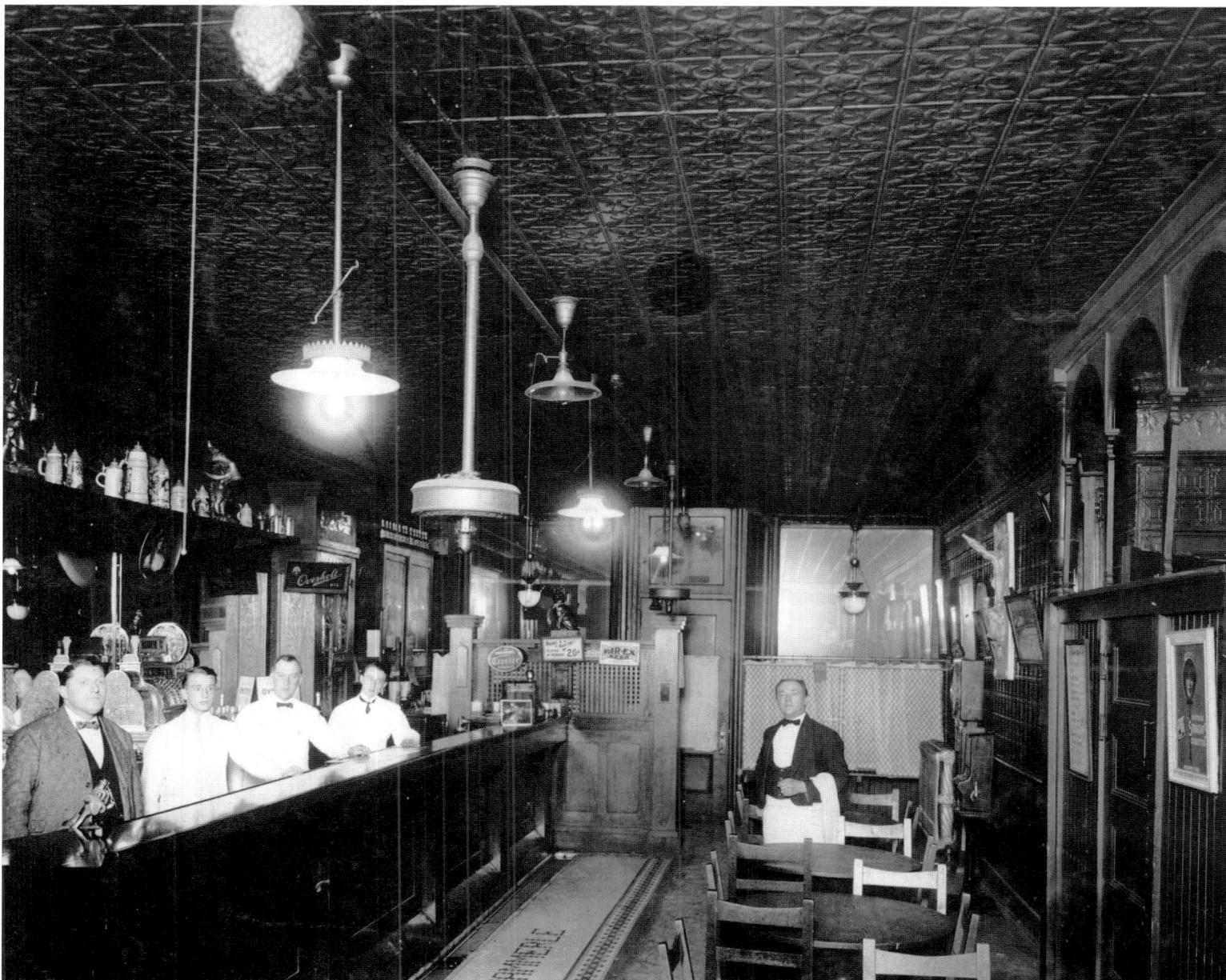

The numerous factories in early twentieth century Syracuse made the city a true working-class town. Not surprisingly, there were a variety of neighborhood taverns offering locally brewed beer and, often, great ethnic food. The North Side German district had several. August Hammerle ran this establishment in the 500 block of North Salina Street when photographed around 1912.

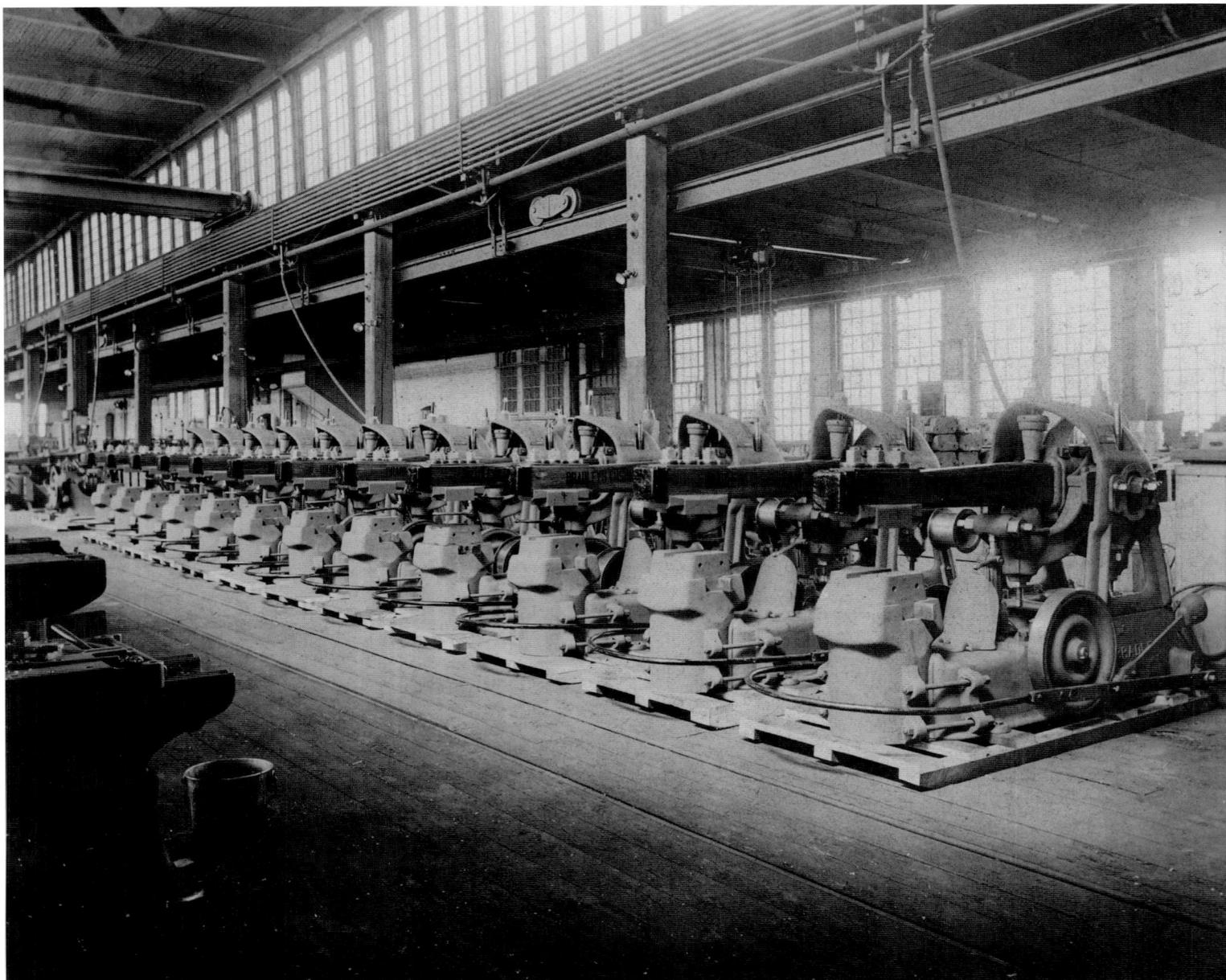

The interior of the Bradley Manufacturing Company on North Franklin Street around the time of World War I. Forging hammers like these were shipped from Syracuse to places as diverse as Vladivostok to help build the Trans-Siberian Railroad, and Colon, Panama, for use in repairing equipment building the Panama Canal. This building still stands in Franklin Square, now converted to first-class office space, but still featuring the rolling ceiling crane.

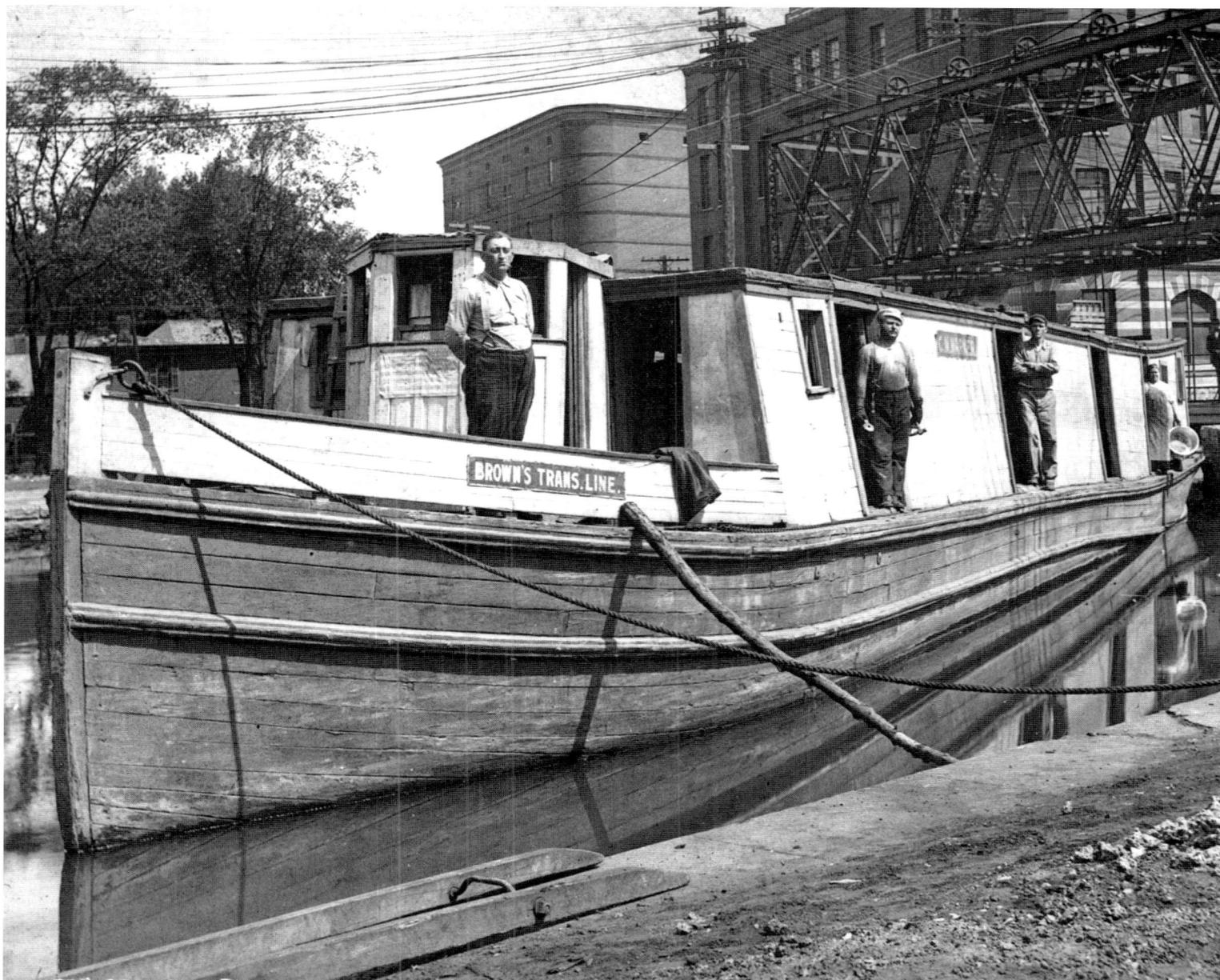

Until the old Erie and Oswego canals were filled in during the early 1920s, one could find boats of various kinds tied up here and there along those waterways as they crisscrossed the city. The *C. M. Warner* was a steam-powered packet, seen here docked near the West Street lift bridge about 1918.

In 1911, the offices of the *Syracuse Journal* were on Warren Street, just a few doors south of Fayette. The crowd is gathered on October 25 to watch the box scores being posted in the window for Game 5 of the World Series between the New York Giants and the Philadelphia Athletics at the Polo Grounds. The Giants won 4-3 but would lose the series in Game 6.

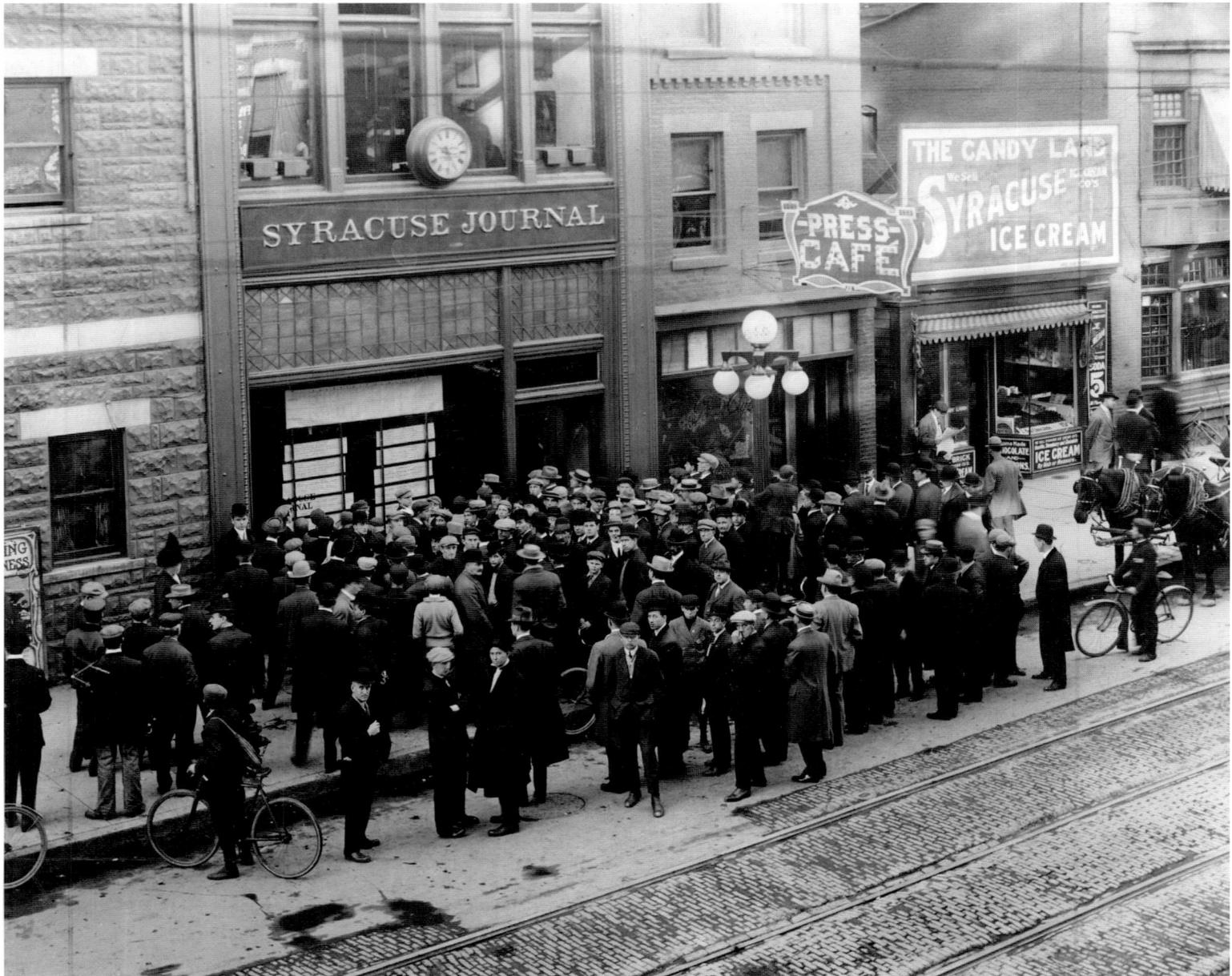

One of the biggest and grandest construction projects in Syracuse during this era was a new courthouse for Onondaga County. With its classical dome, it dominates this view of the city skyline around 1920. It still serves as the courthouse today. In the foreground is Plymouth Congregational Church.

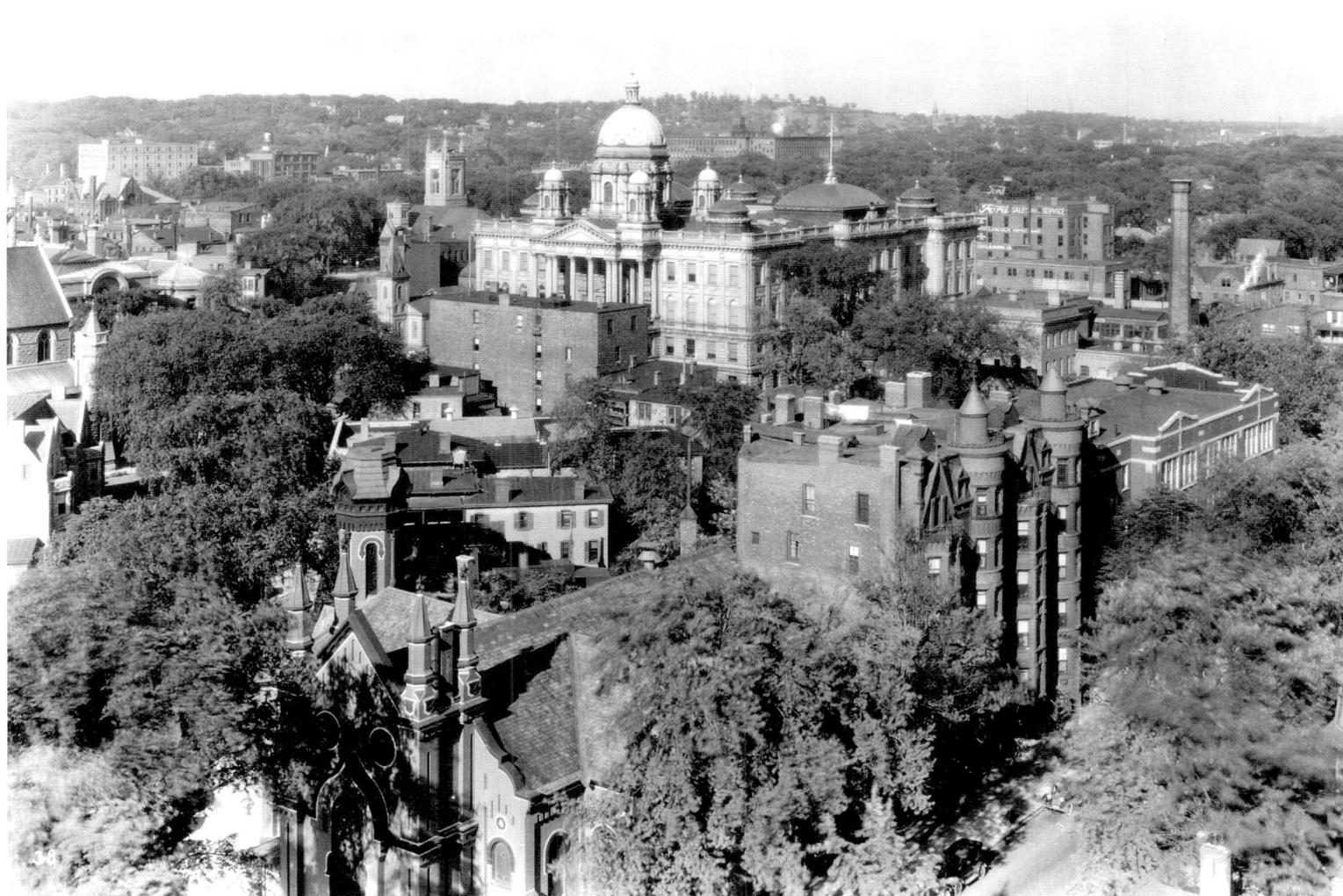

Following Spread: This 1904 panorama shows the growing campus of Syracuse University. At far-right is Crouse College. In the center is the Hall of Languages, the university's first building in 1873. Toward the left is Smith Hall, a 1901 addition.

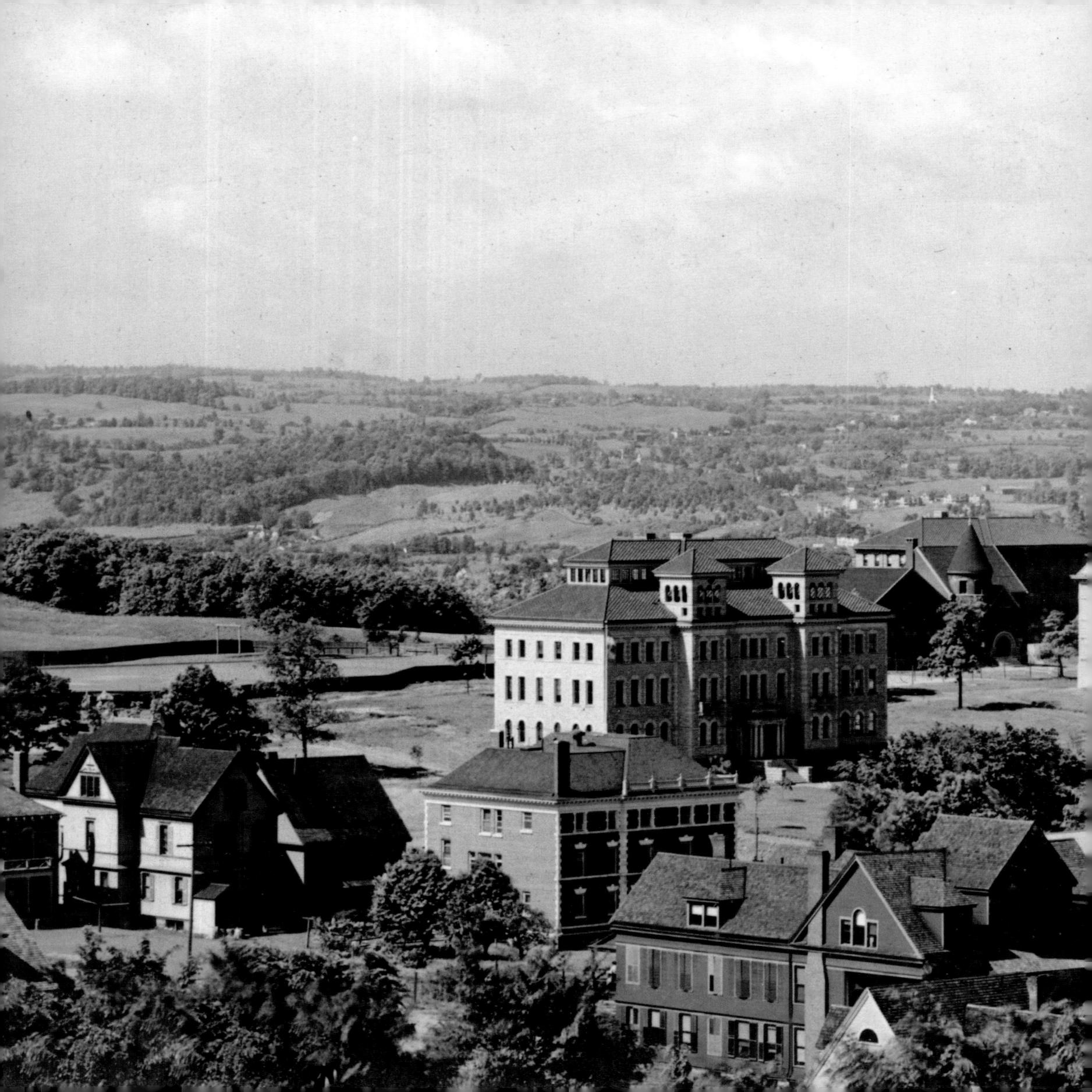

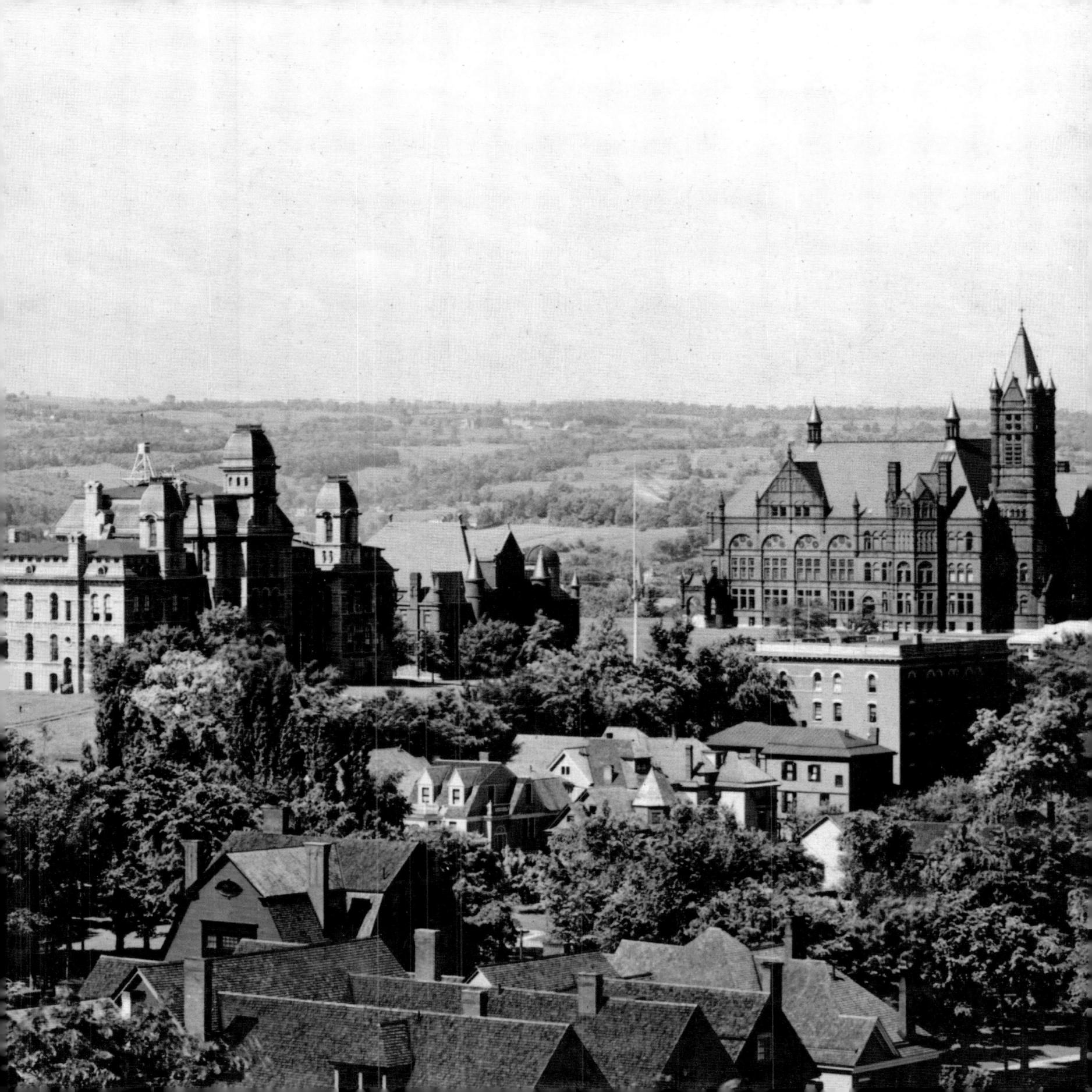

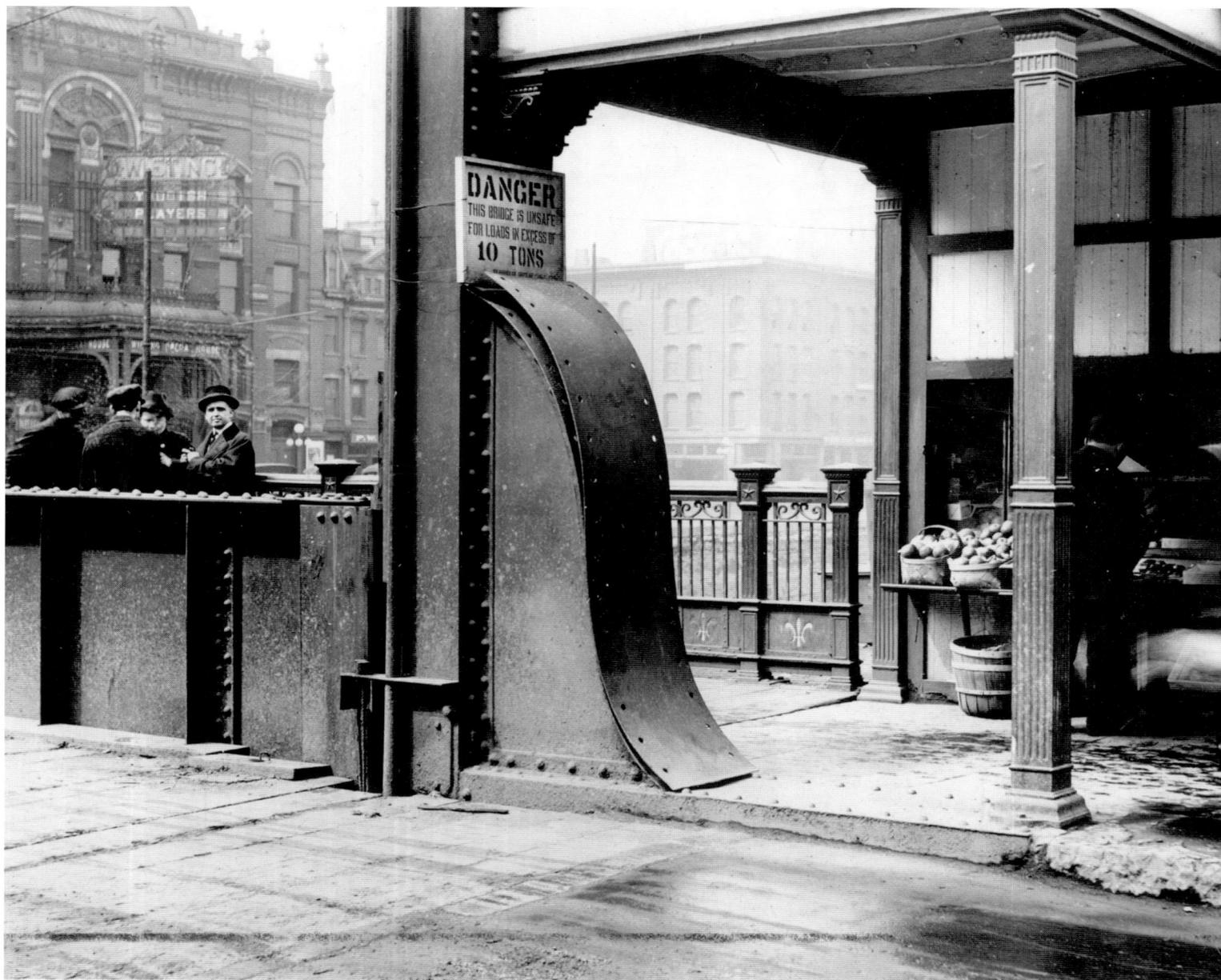

Despite the presence of streetcars and an occasional automobile, the city was very much a pedestrian world one hundred years ago. Buildings and structures presented details that could only be appreciated at a walking pace. In this view of the Salina Street lift bridge in Clinton Square, perhaps around 1910, decorative railings and columns are clearly visible. A small fruit-and-vegetable stand rents space under the bridge's stairway.

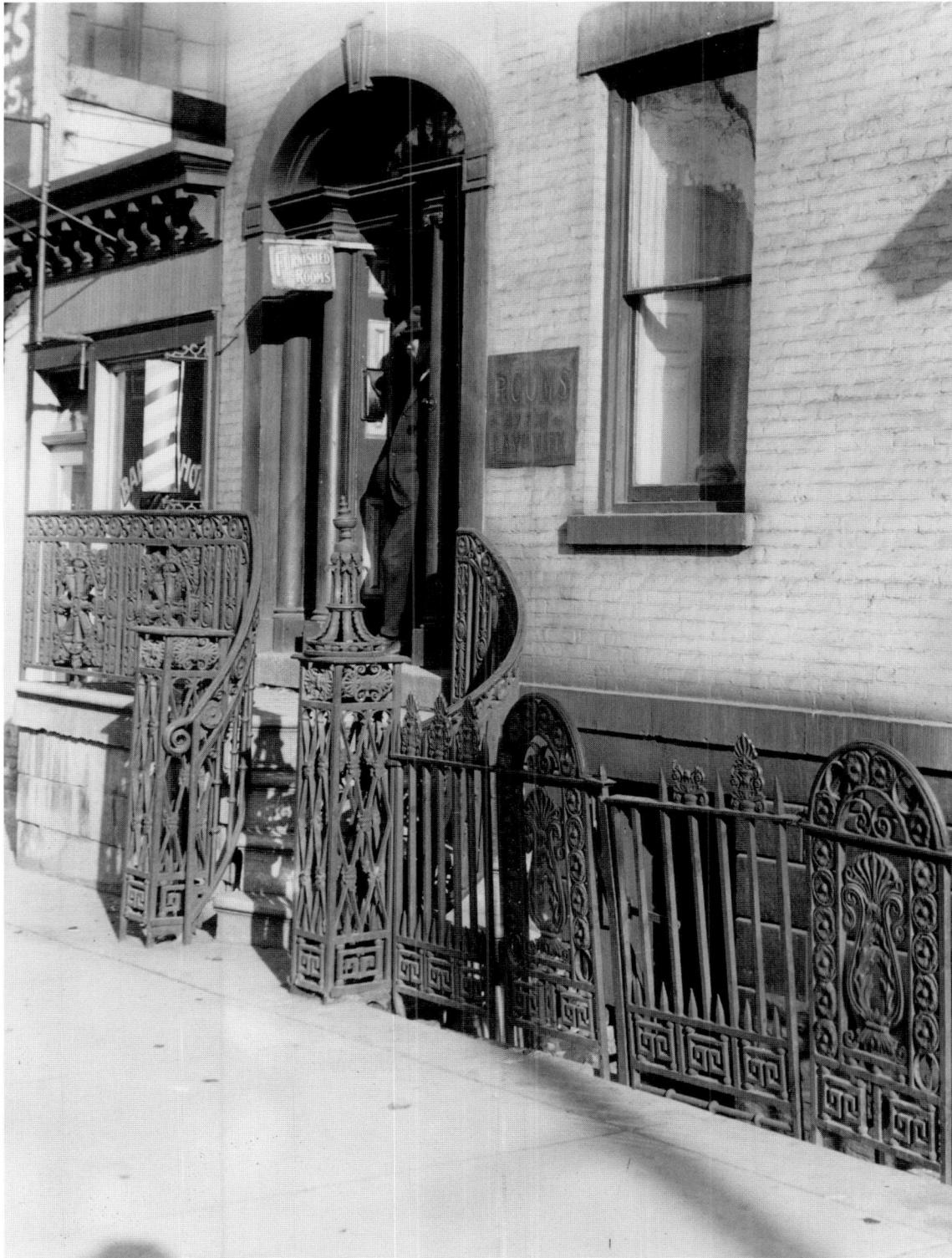

In 1914, Syracuse was a rapidly growing city. Building activity was booming and structures from its early village days were rapidly disappearing. But traces were still visible, such as this ornate cast-iron railing that graced what once was the private Dana Home, at the northwest corner of Clinton Square. By the time this photograph was made, the building was a rooming house. It would soon be demolished for a larger commercial structure.

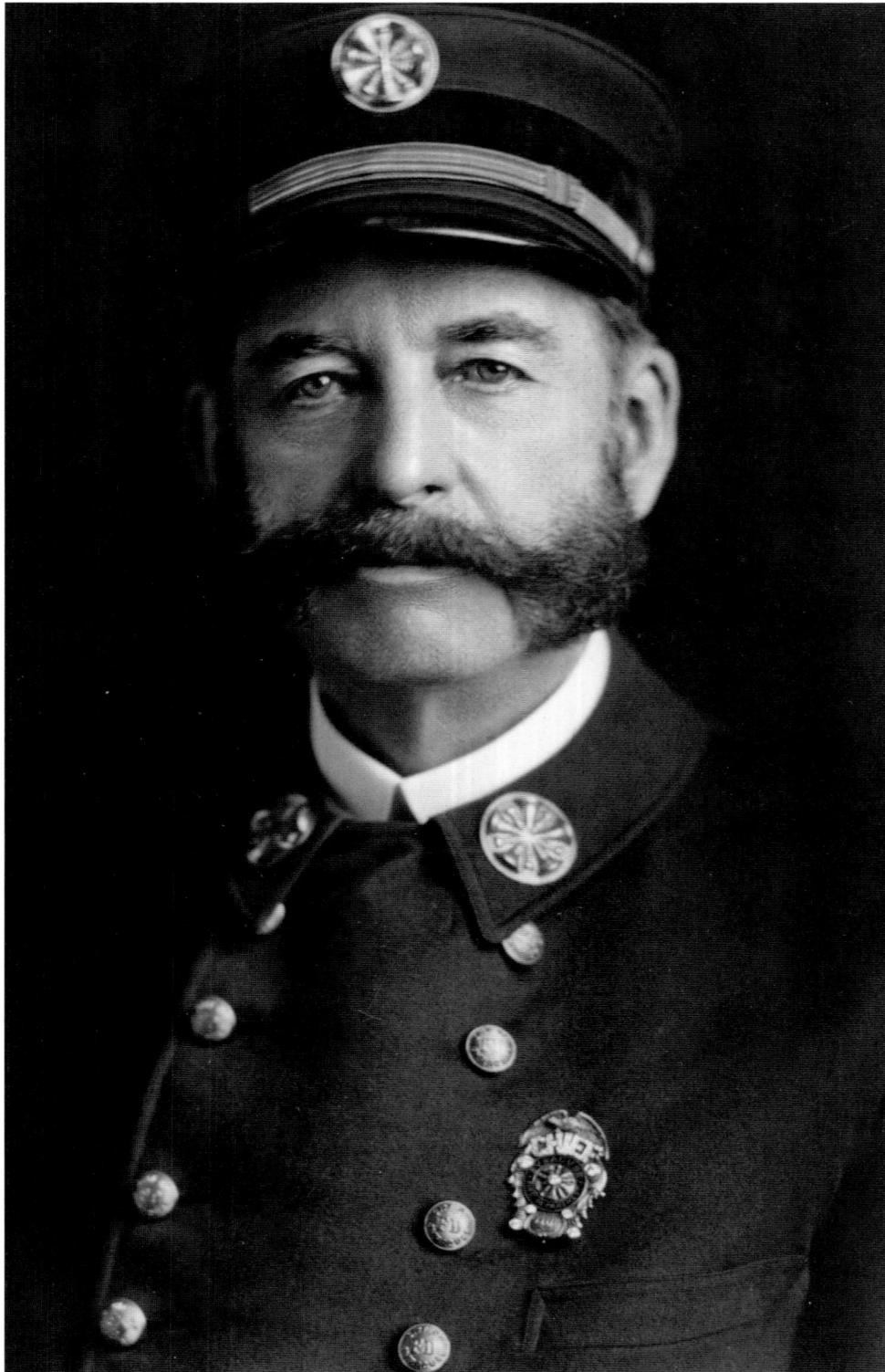

Fire Chief Thomas F. Ryan joined the department as a young man in 1883 and rose through the ranks to become chief in 1914. He was very popular and easily recognizable with his distinctive mutton-chop whiskers. He led the department in converting from horse-drawn to motorized equipment. Symbolically, upon his retirement in 1921, he was presented with a Franklin touring car.

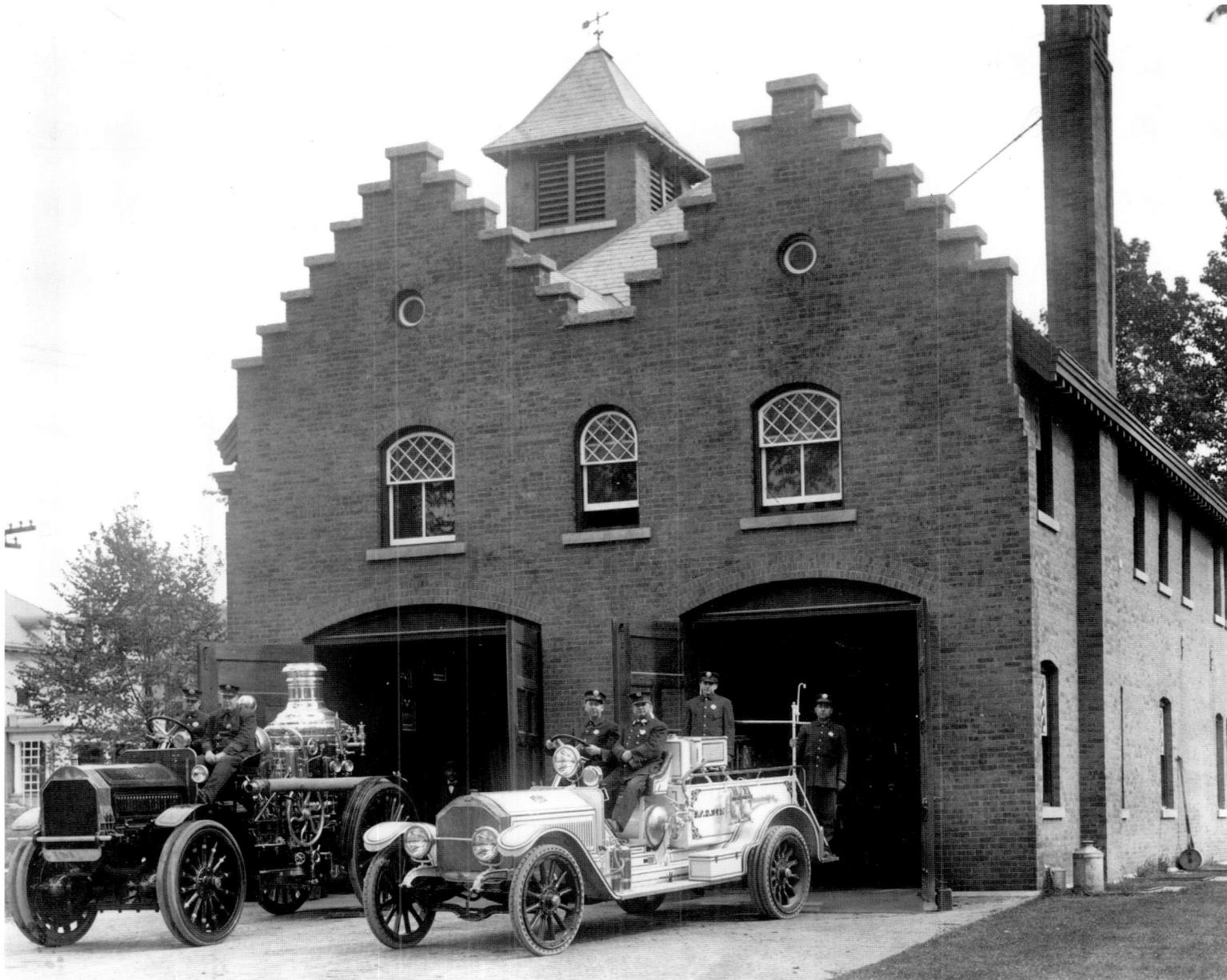

Syracuse fire fighters proudly pose with some of their new motorized equipment around 1920 at Firehouse 10 on Euclid at Westcott Street. The building is now a community center.

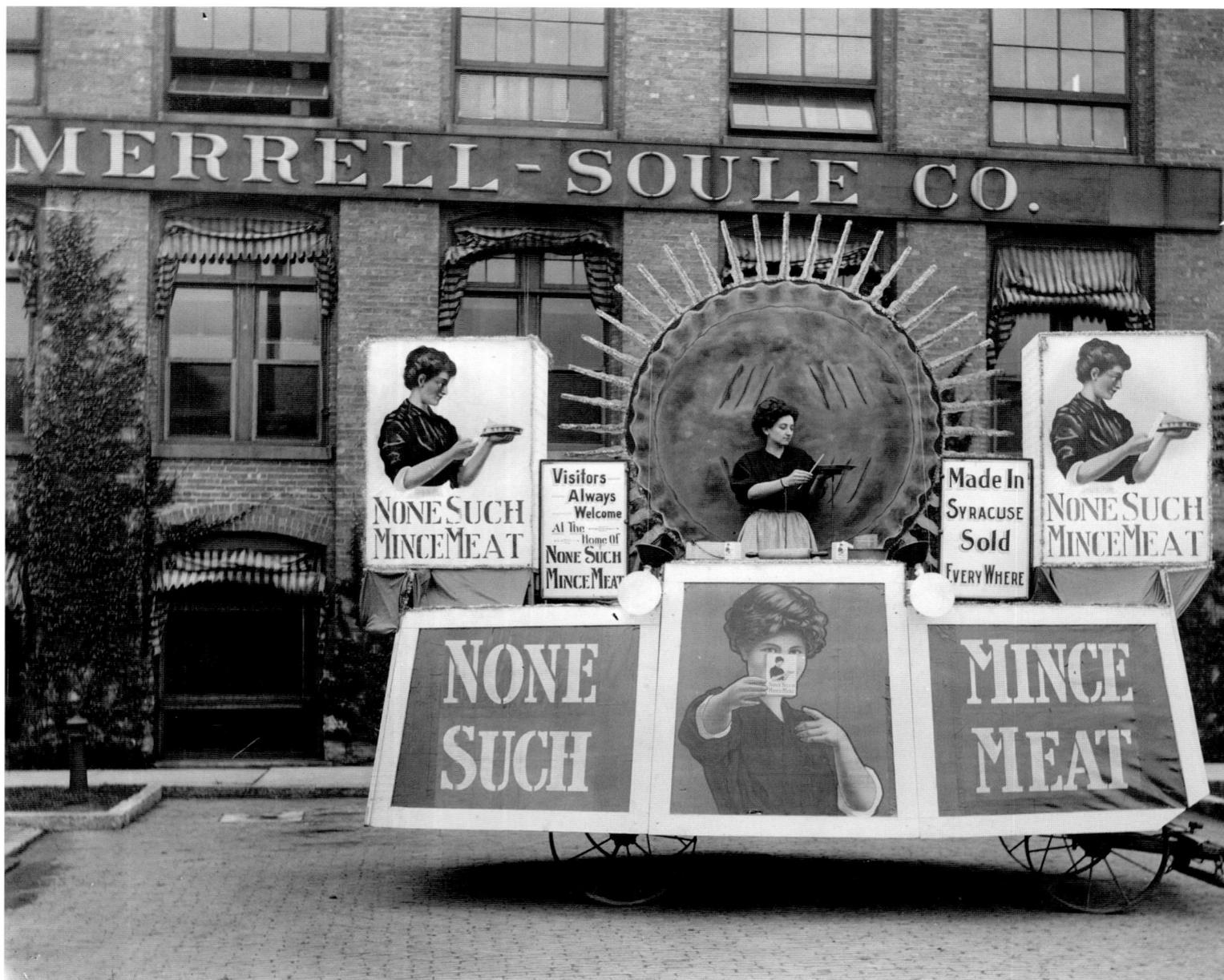

The Merrell-Soule Company's most famous products were powdered milk and None Such mincemeat. Their former factory, in today's Franklin Square district, has been converted into office space.

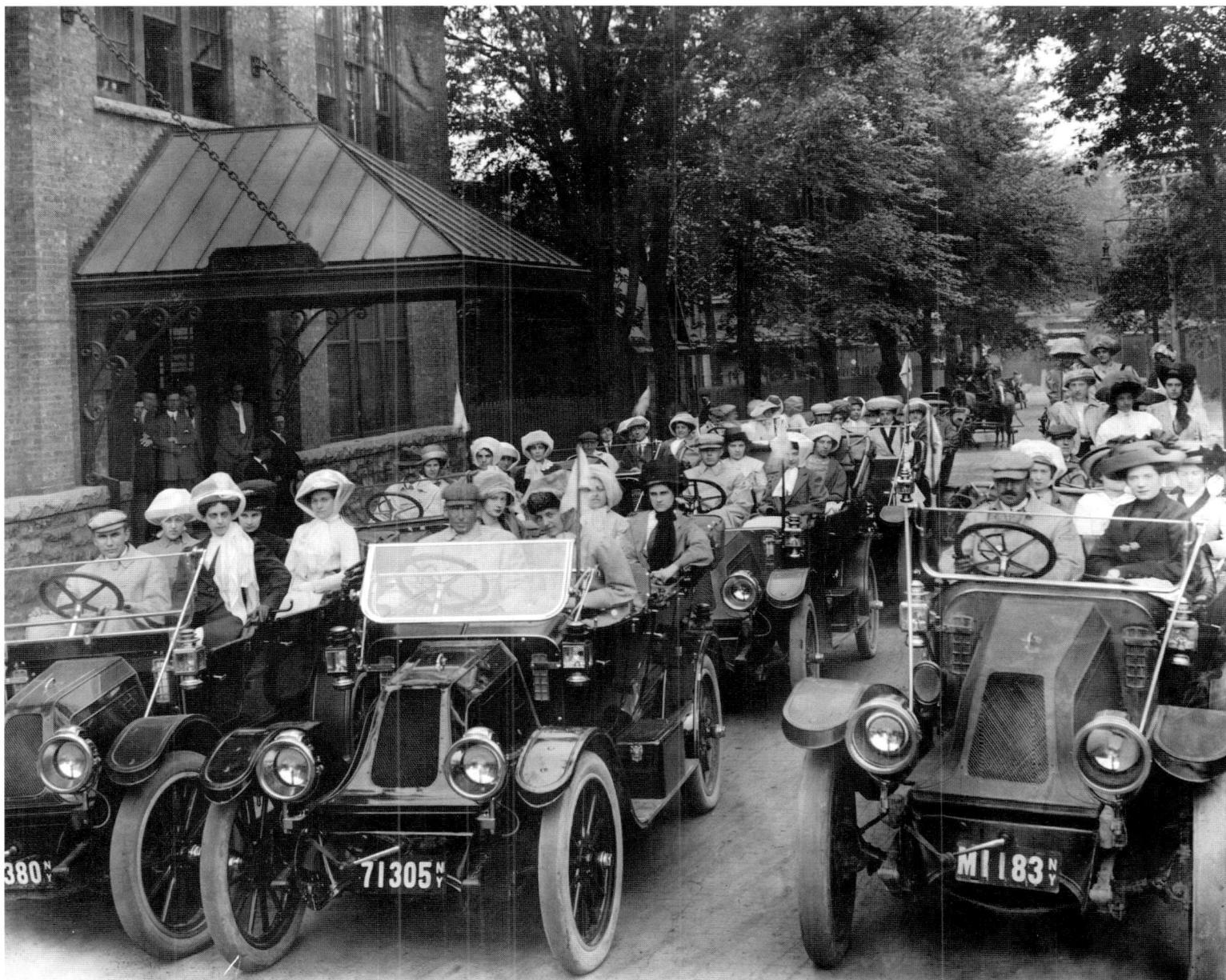

In 1911, many of the women clerical workers at the Franklin factory were treated to a picnic outing, with transportation by way of a fleet of Franklin autos. This image was captured near the entrance to the company offices on Marcellus Street.

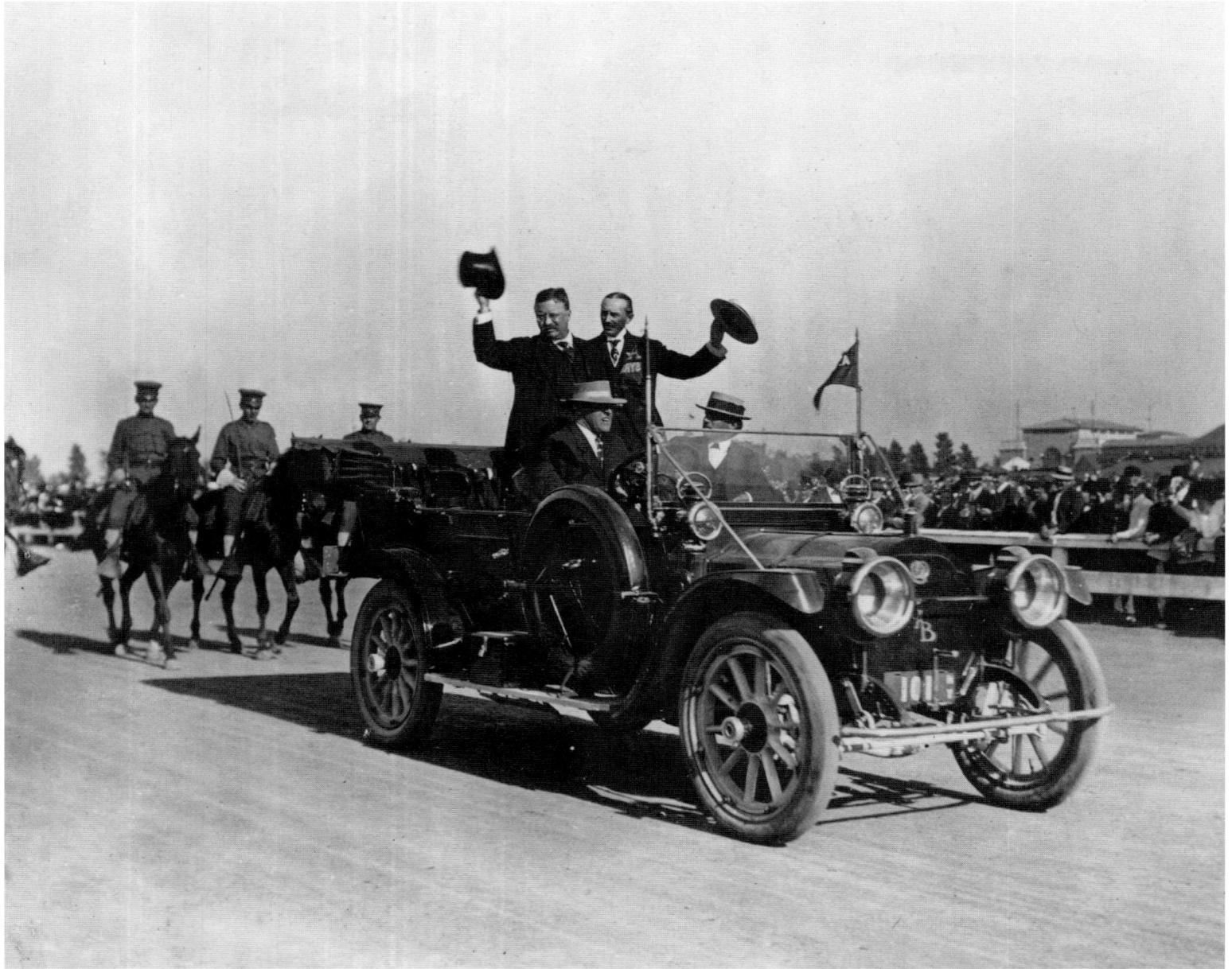

One of the dominant personalities of the era was Teddy Roosevelt. He was familiar to Syracusans for his keen interest in the locally based New York State Fair while he was governor. Here he revisits the fair grounds in 1910, as the former President, sharing the ride with native Syracusan Horace White who was lieutenant governor at the time.

Theodore Roosevelt would return once more to Syracuse in 1915. He was defending himself against a libel suit brought by William Barnes. Roosevelt had accused the state party boss of corruption. Syracuse was considered a neutral site for the politically charged trial. Eagerly followed by the public and the national press, the Syracuse courtroom became another "bully pulpit" for Roosevelt. Teddy not only stole the show, he effectively proved his charges to be true and was acquitted.

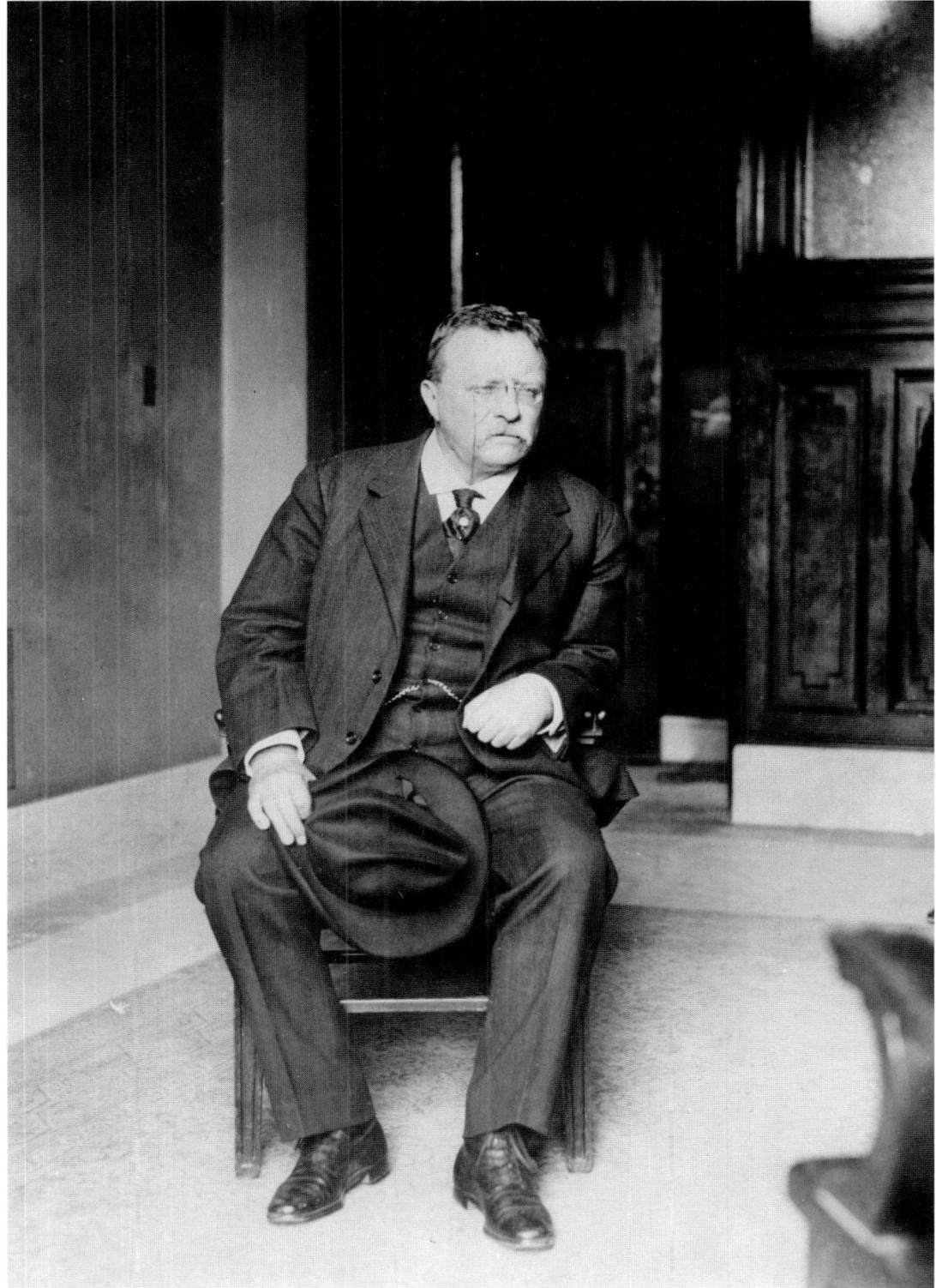

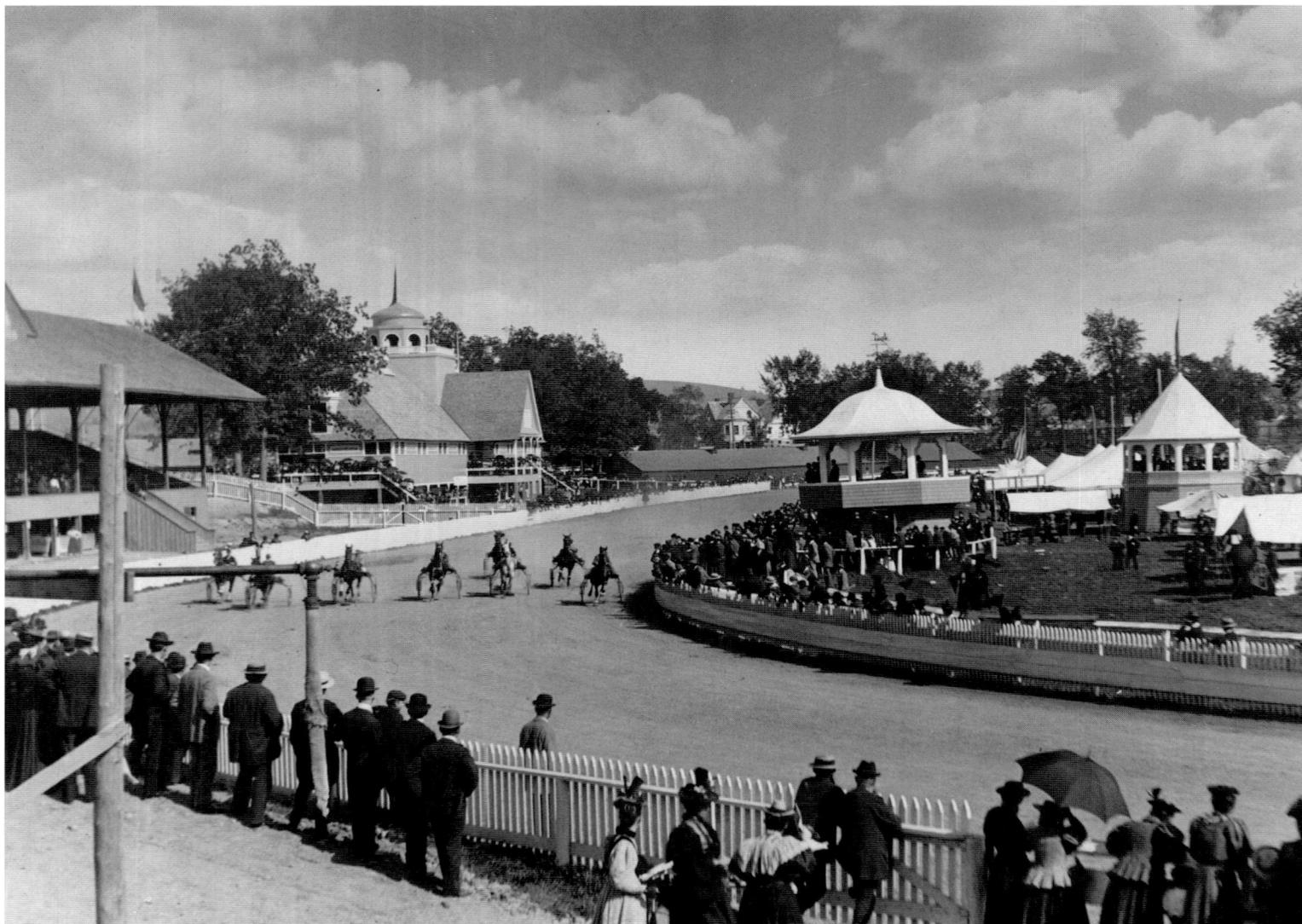

The privately owned grounds of Kirkwood Park, on the city's South Side, included a racetrack in the late nineteenth and early twentieth centuries. It was used for both horse and bicycle racing. The city bought the land in 1909 and it became the municipal Kirk Park. Under way here is a harness race, a form of horse racing still popular today in some parts of the nation.

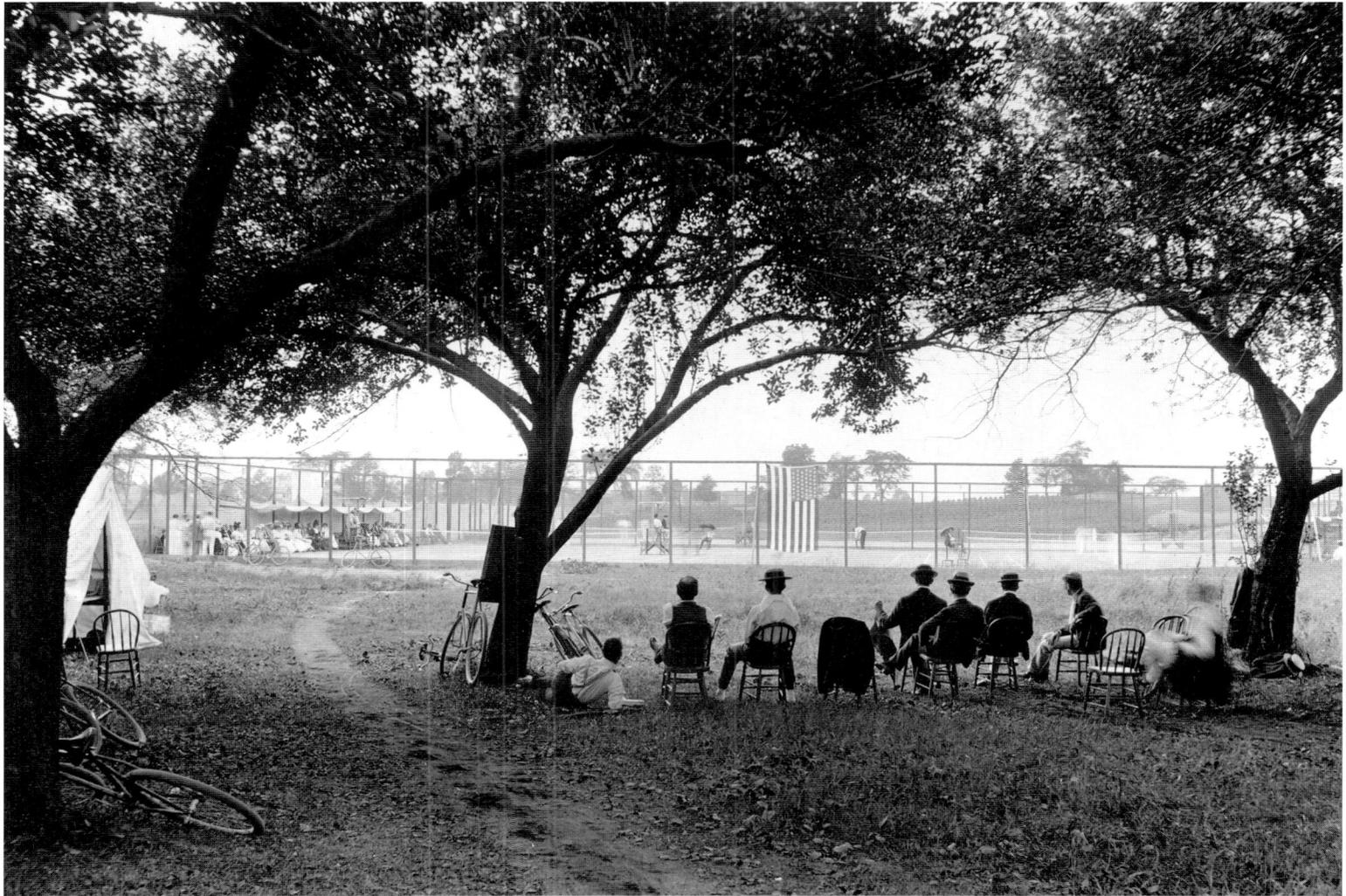

One of the oldest sports institutions in Syracuse is the Sedgwick Farms Tennis Club. Probably in the early 1900s (the American flag bore 45 stars from 1896 to 1908), a match is under way at the club on what must have been a warm day. Several gentlemen have positioned themselves in the shade, and the courtside spectators have fashioned a makeshift awning over their seats.

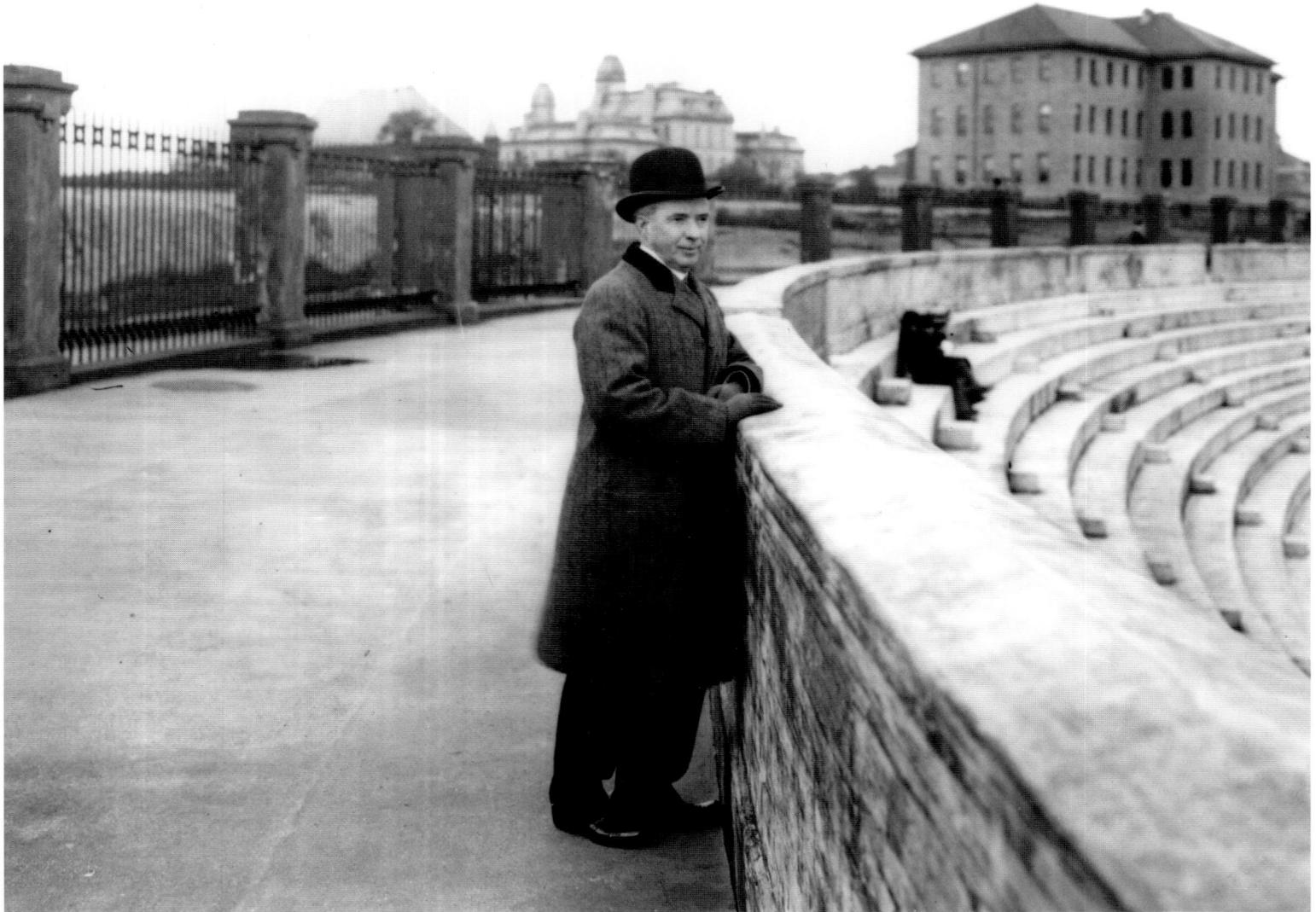

John D. Archbold was a capitalist, philanthropist, and president of the board at Syracuse University. He was also known as John D. Rockefeller's right-hand man at the Standard Oil Company. He gave almost $4,000,000 to the university over his lifetime. His donations financed, most famously, Archbold Stadium where he stands in this image. Archbold was used from 1907 until it was demolished in 1978.

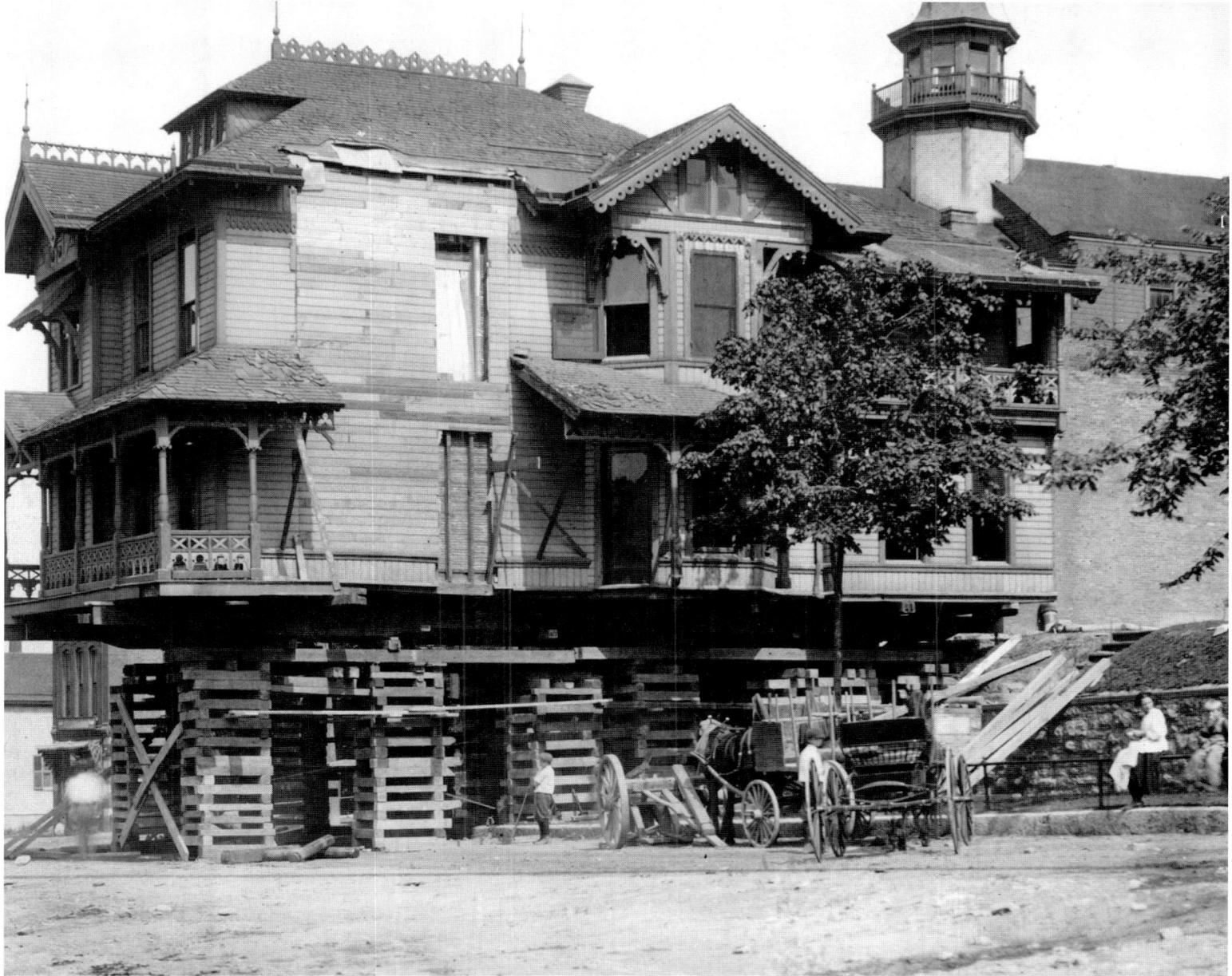

In 1879, local architect Charles Colton designed this house for brewer Xavier Zett at the corner of Lodi and Court streets. By 1912, the site was needed for expansion of the brewery and the house was moved to 410-412 Danforth Street where it stands today, though greatly altered.

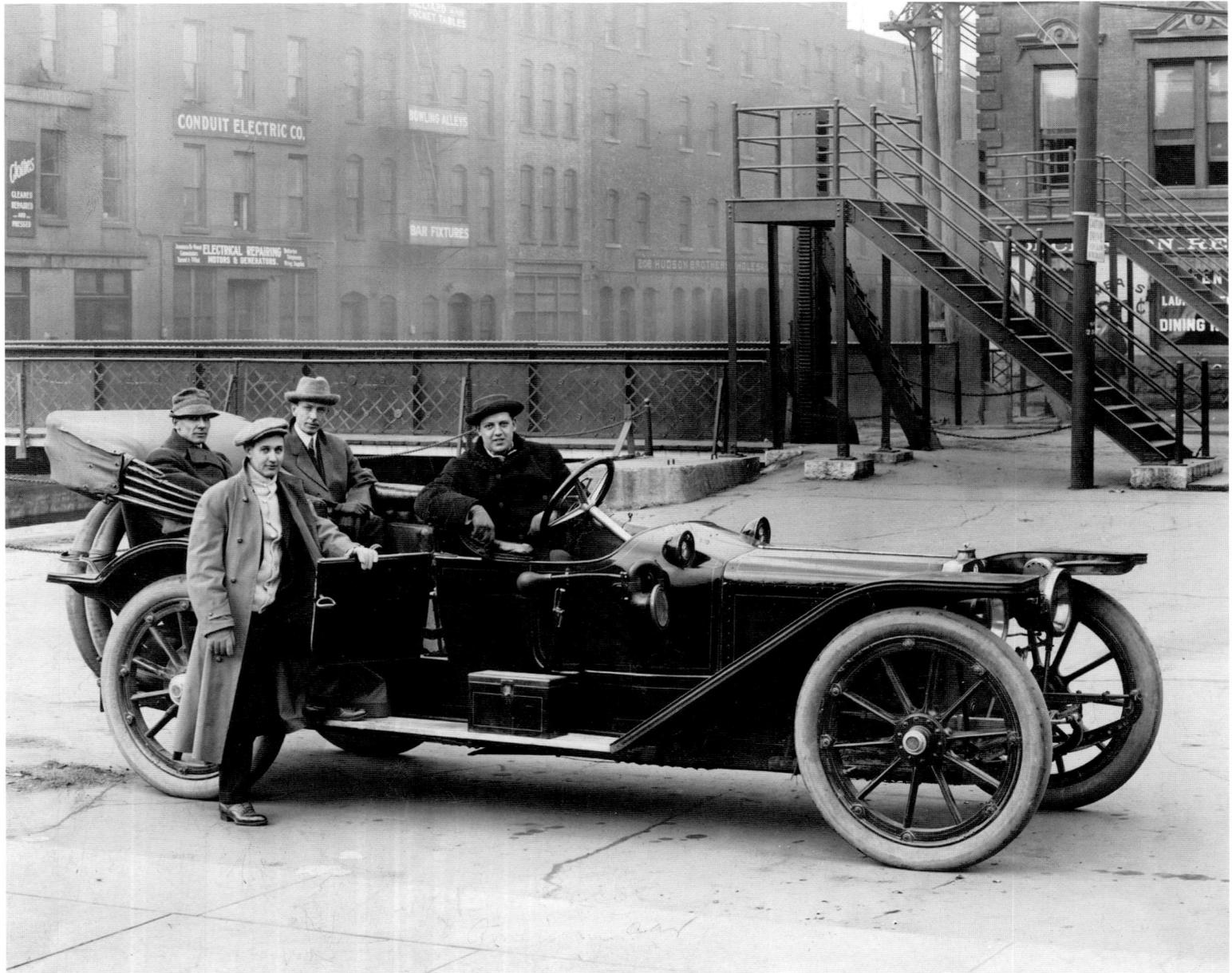

Four gentlemen pause to have their picture taken in 1912. They are parked in Clinton Square, with the Clinton Street lift bridge over the Erie Canal in the background. In the distance is a row of buildings that backed on the canal and fronted on Water Street. Only one survives, the Amos Building, now upscale apartments.

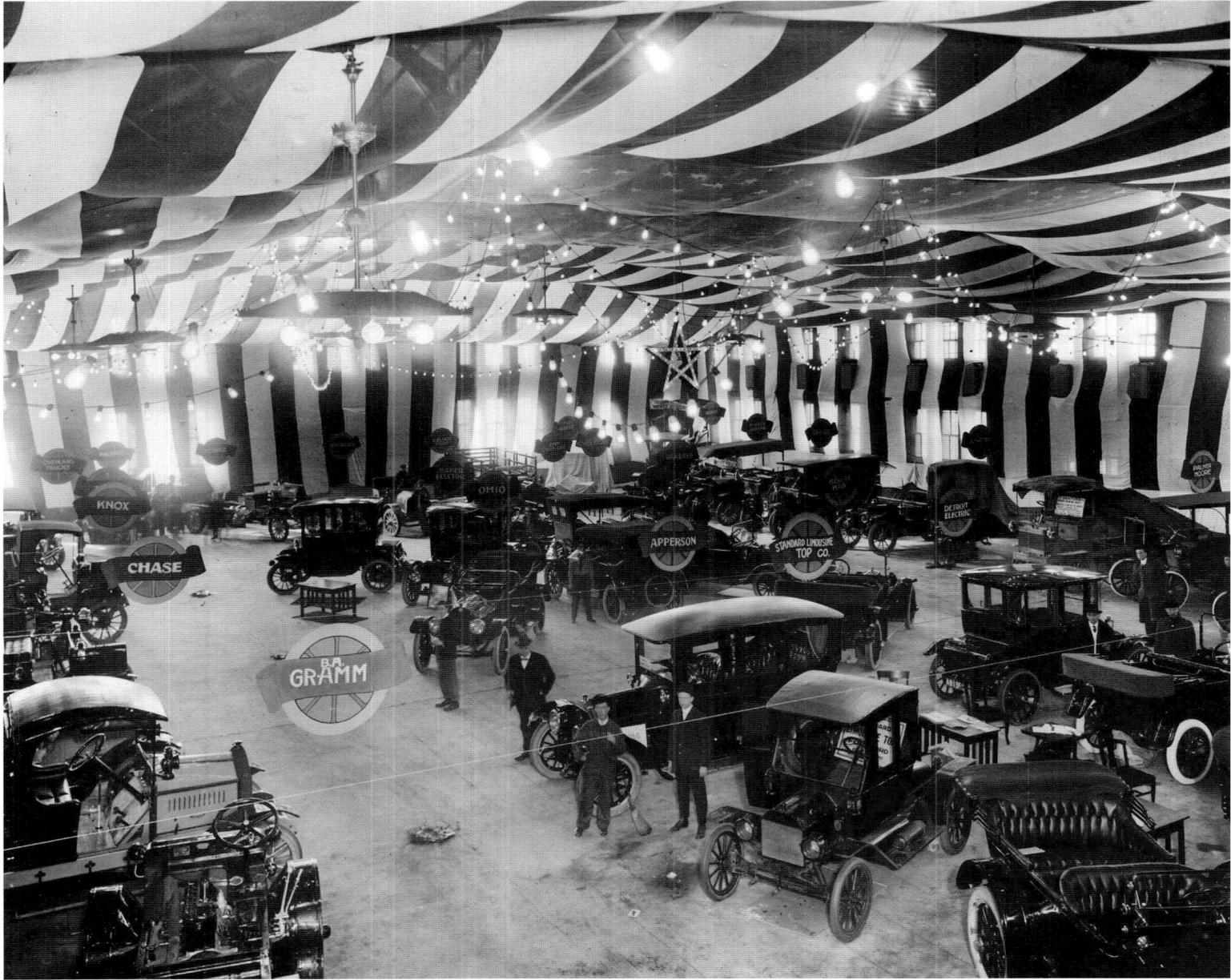

The annual Syracuse Auto Show has been running for more than 100 years. In its early incarnations, like this one in 1913, it was staged at the downtown Jefferson Street Armory, now the Museum of Science & Technology.

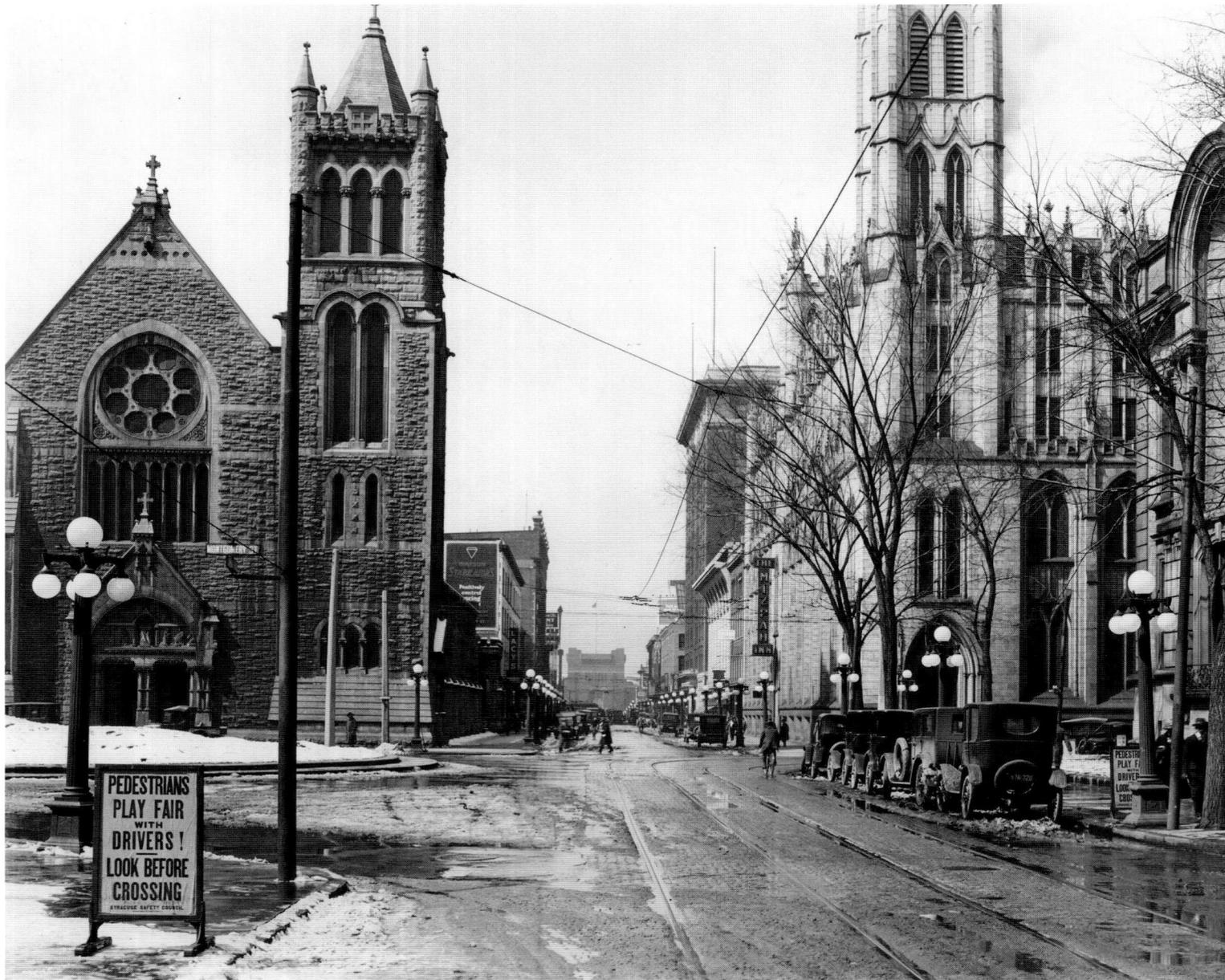

As more and more automobiles arrived on Syracuse streets, pedestrians had to adjust their habits, as this sign in Columbus Circle announces. This view from around 1920 faces west on Jefferson Street with the Armory in the distance. The Cathedral of the Immaculate Conception is on the left and the First Baptist Church is on the right.

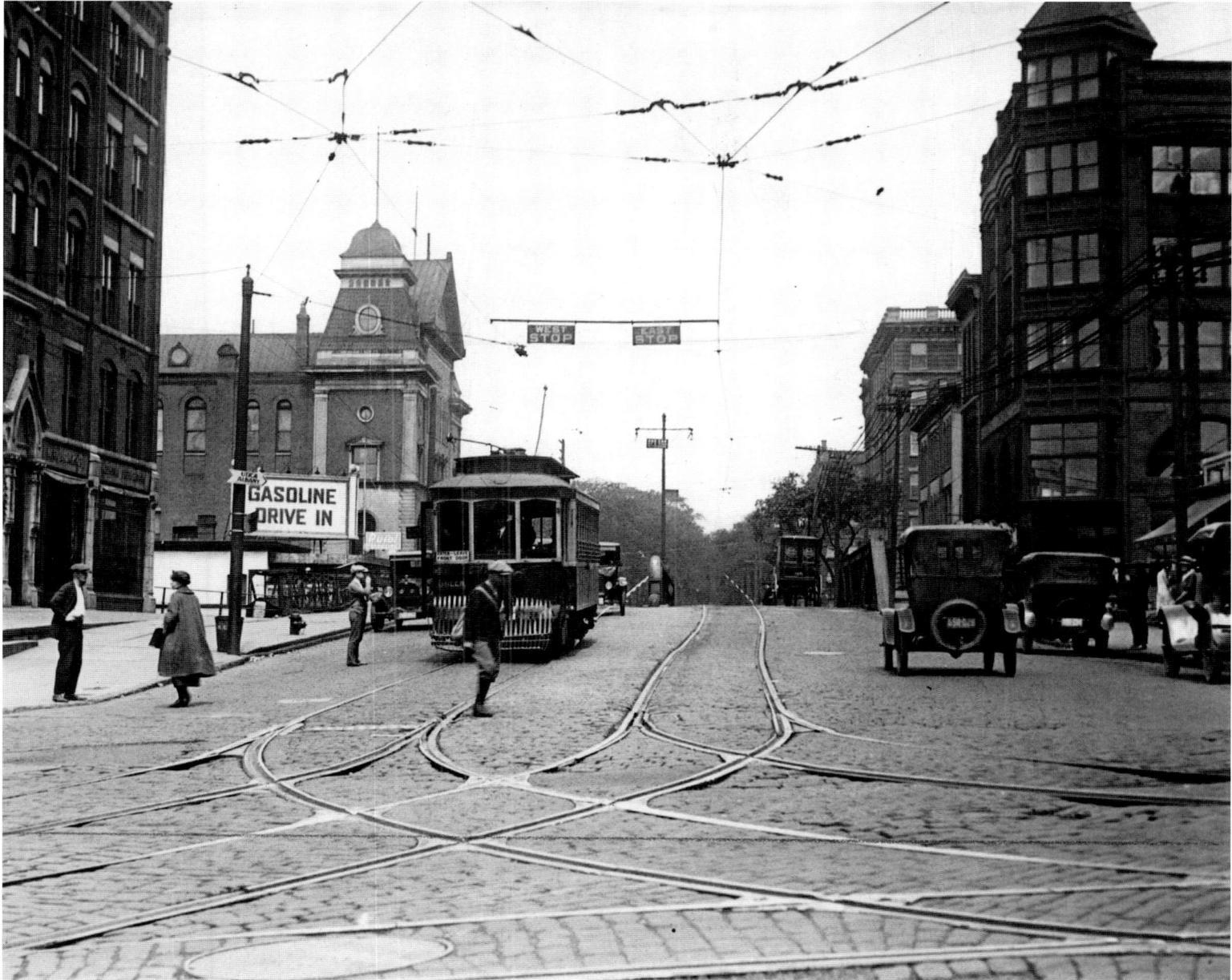

James Street rises up to provide clearance at the bridge for boats passing along the Oswego Canal. The building at left with the tower is the Alhambra, a large assembly hall used for concerts, conventions, and even roller-skating. It would burn in a dramatic fire in 1955.

This view from 1915 overlooks the developing Strathmore neighborhood. Crossett Street is on the left and the new Hiawatha Lake in Upper Onondaga Park is on the right. Still visible at this time is the former gatehouse for the Wilkinson Reservoir, the water feature that was reconfigured into Hiawatha Lake and had served as part of the city's old water system.

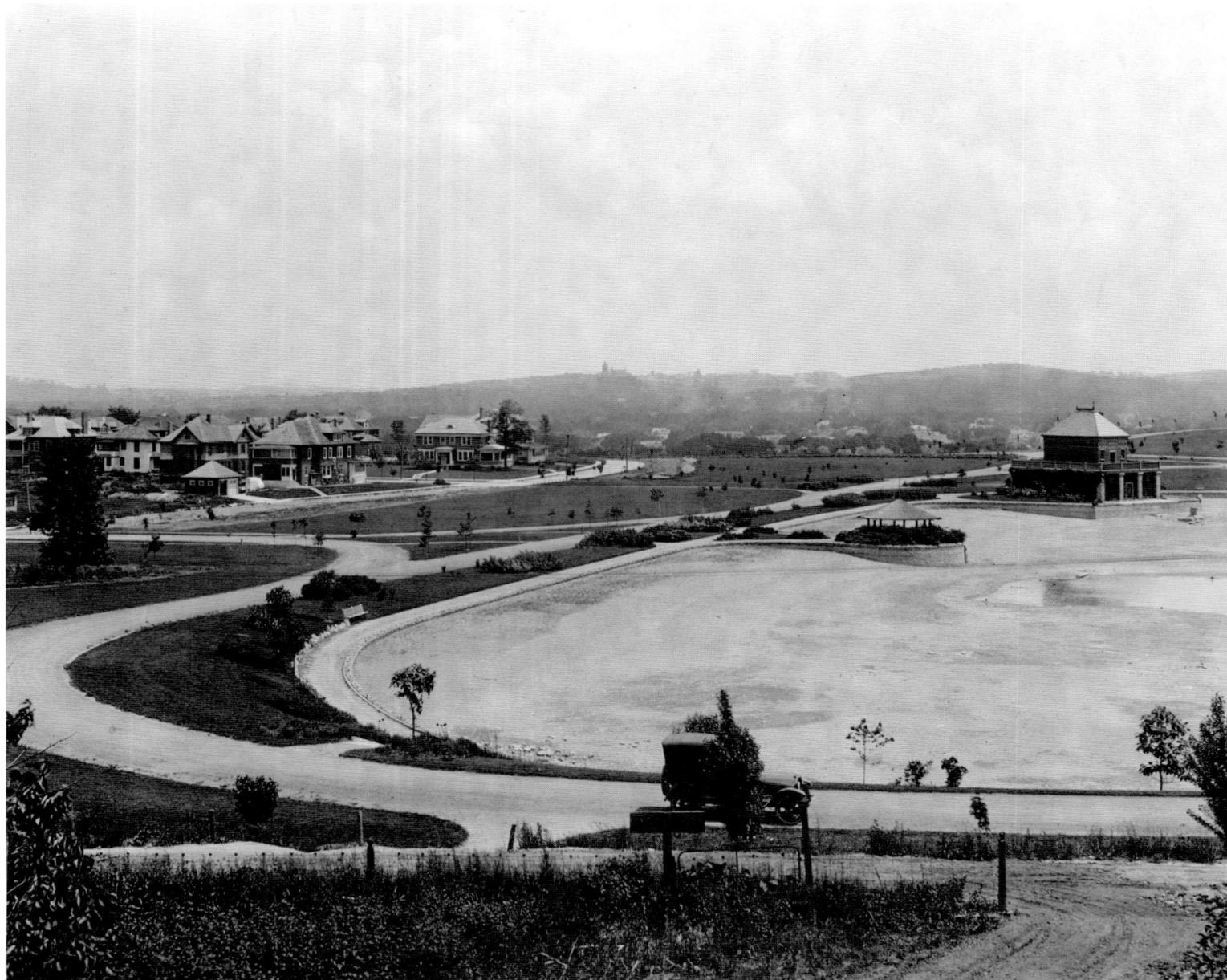

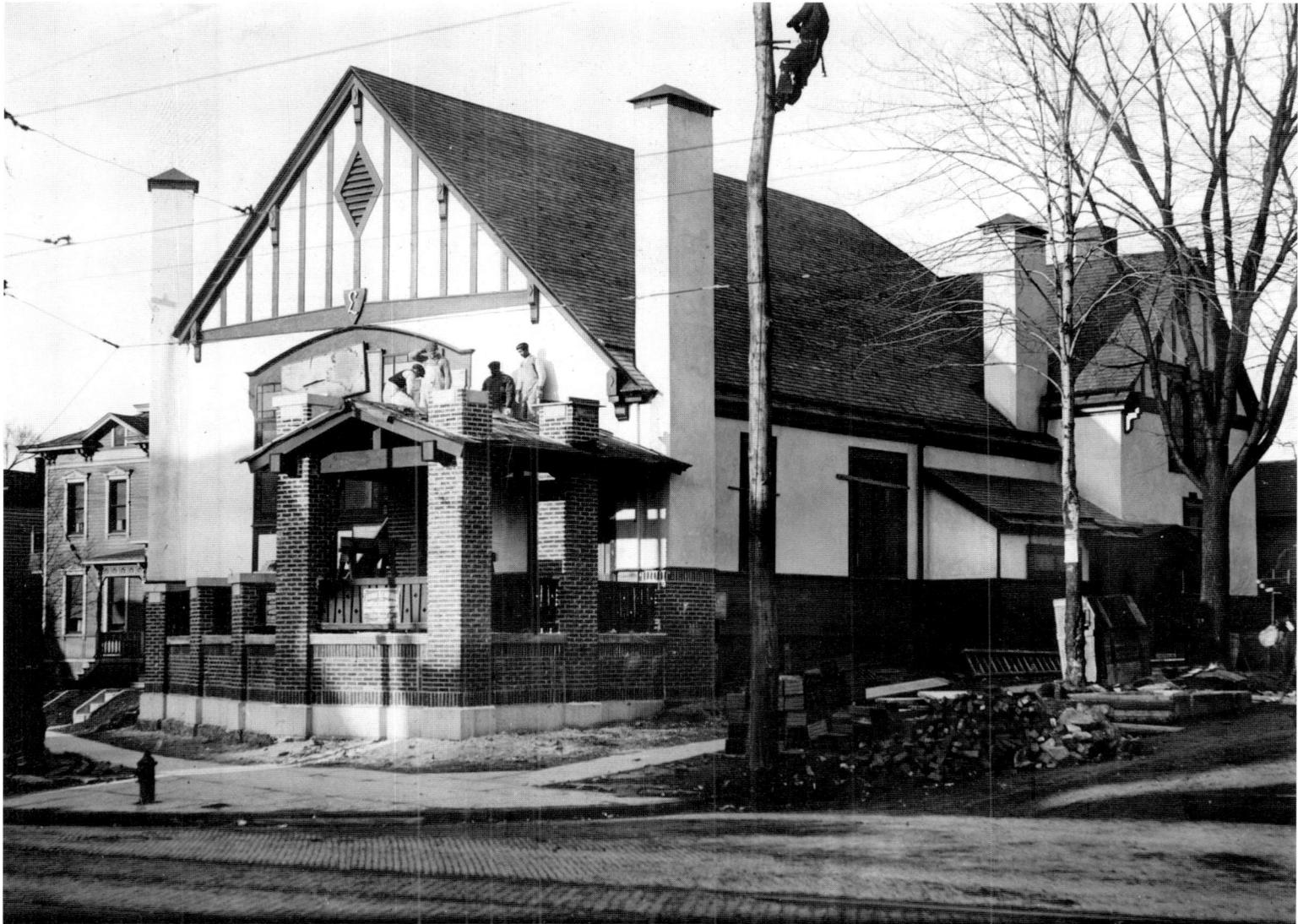

Workmen in 1913 are putting the finishing touches on the new Butternut Street home for the Syracuse Liederkranz, a musical and social club founded in the local German community in 1855. The clubhouse was fashioned from a former church building and used by the Liederkranz until 1974. It then became the Downtown Quarterback Restaurant until 1980. The building was lost the following year in a suspicious fire.

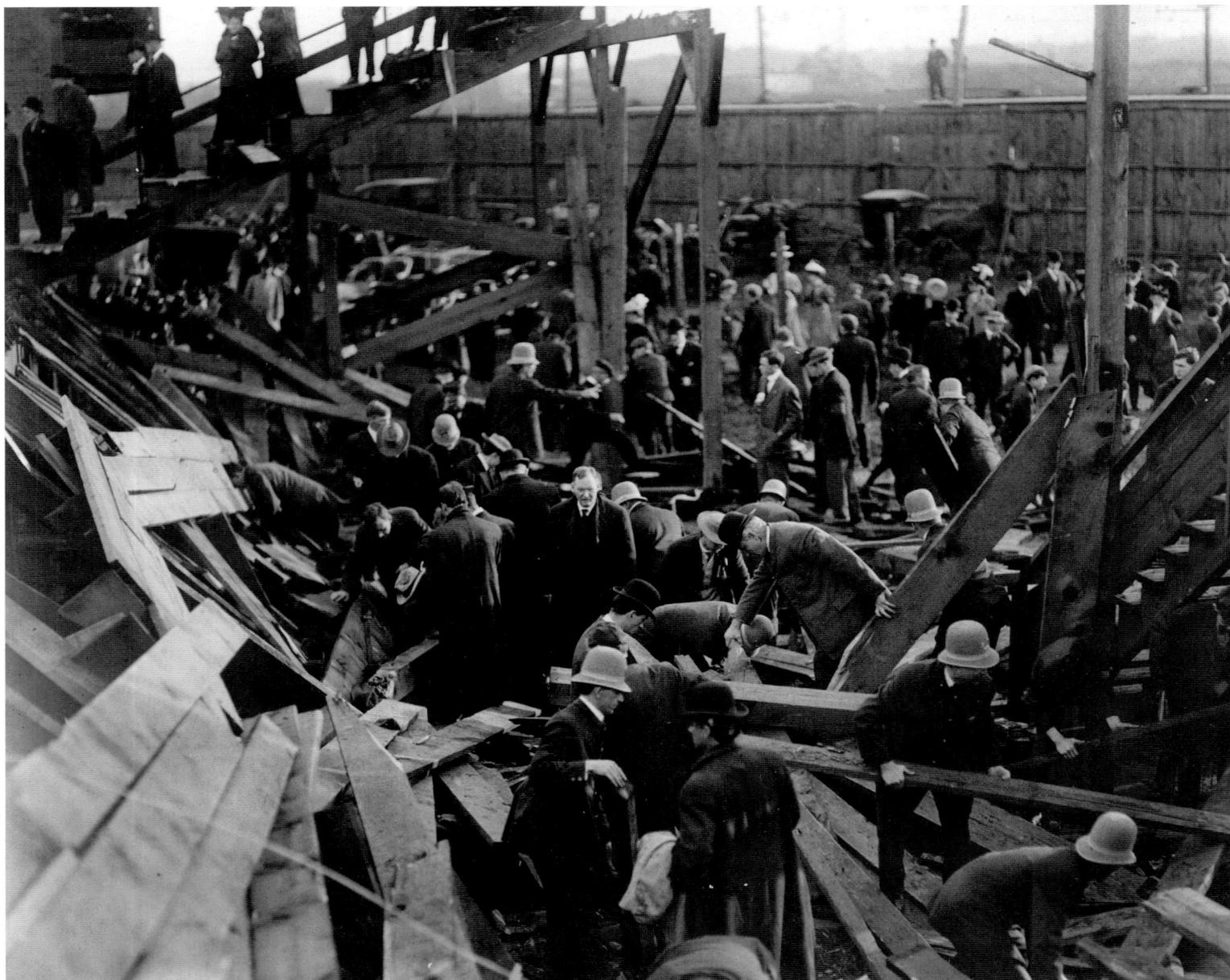

In 1906, Syracuse's Star Park stadium was on the south side of Hiawatha Boulevard, near Pulaski Street. On October 20, during a Syracuse-Colgate football game, a 50-foot section of bleachers collapsed, carrying 400 people into the wreckage and injuring more than 100. C. J. Donigan, one of the injured spectators, eventually died. This rare photograph captures some of the rescue work under way.

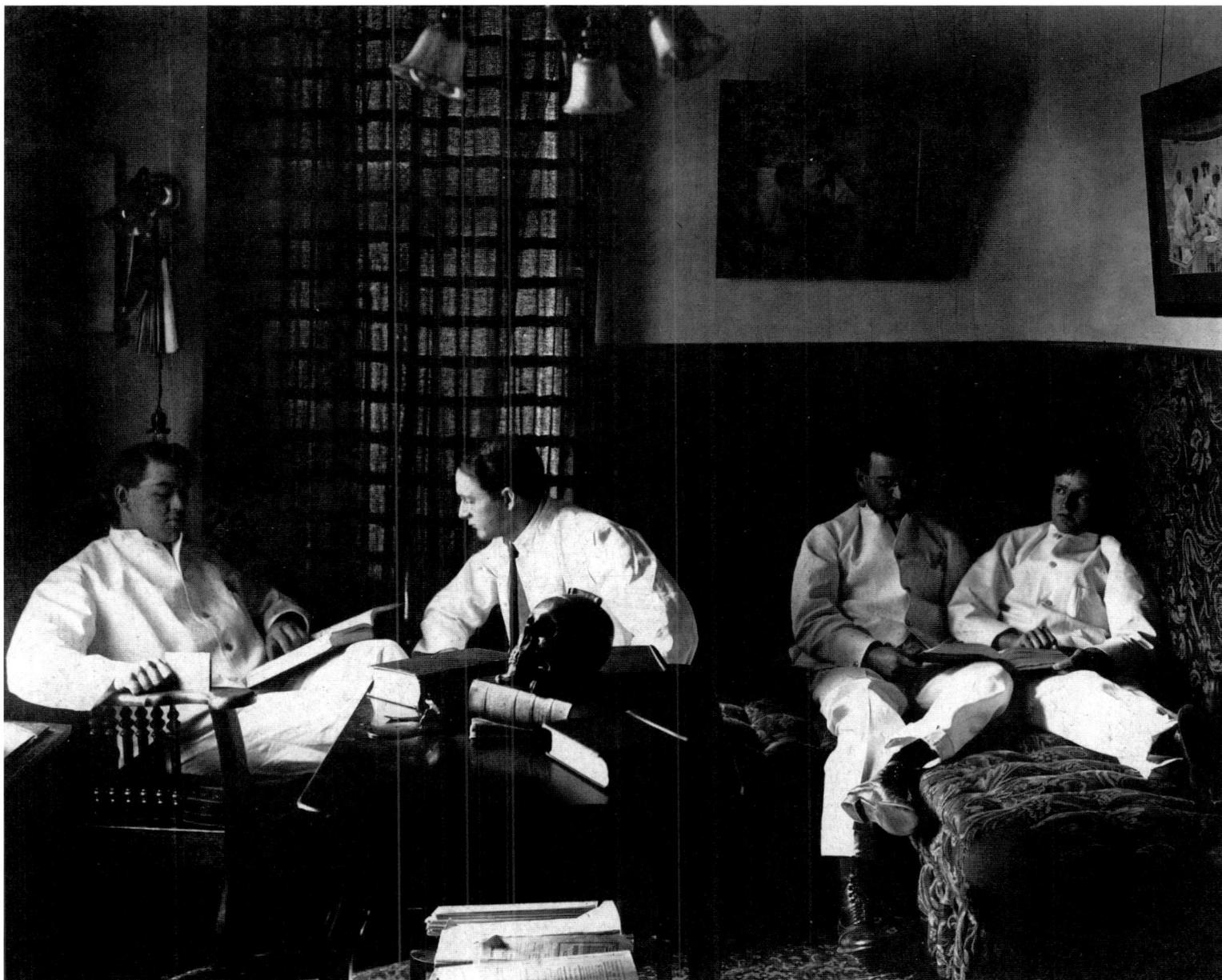

The Hospital of the Good Shepherd was affiliated with Syracuse University as a teaching hospital for its medical college in the early twentieth century. Four interns pose here for a group portrait about 1906.

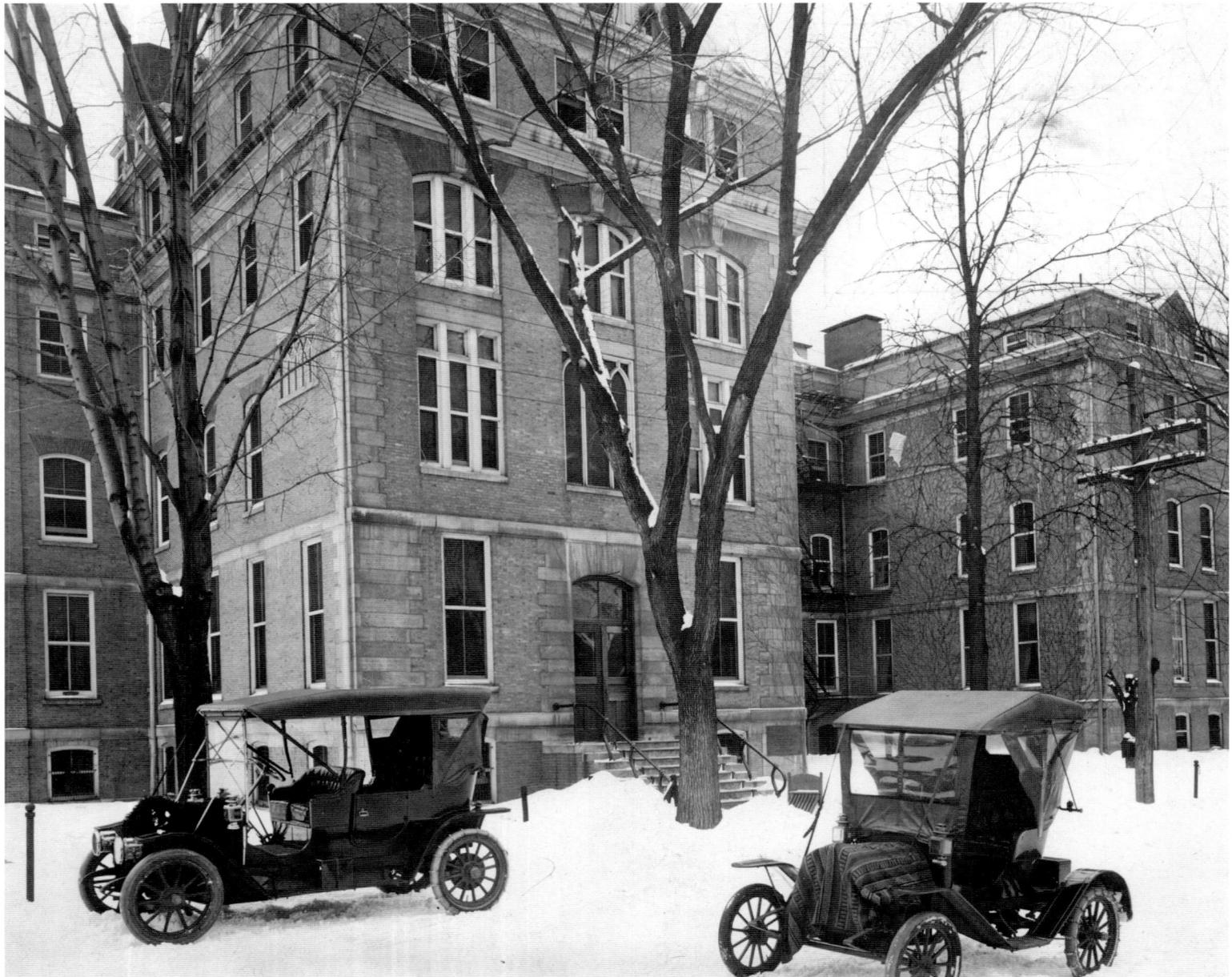

The Hospital of the Good Shepherd was located in this building on Marshall Street in 1910. Today it houses Syracuse University's School of Education. Blankets cover the engines of both vehicles in this January image, in a bid by the owners to prevent the cooling system from freezing.

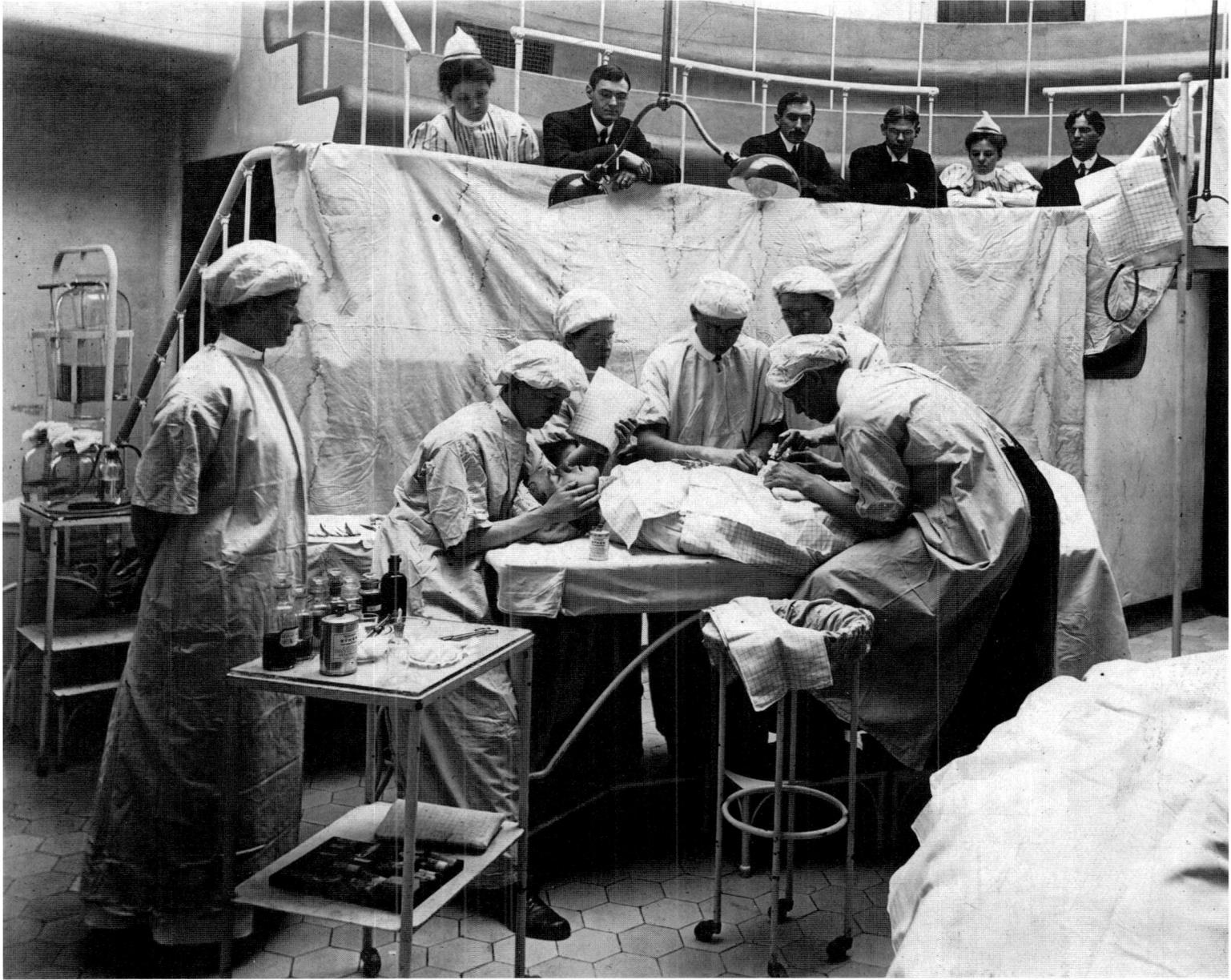

A procedure is under way in the surgical teaching amphitheater at the Hospital of the Good Shepherd, around 1906. A bottle of ether rests beside the patient as a team member peers into his face, perhaps to ensure that the anesthetic has been administered adequately.

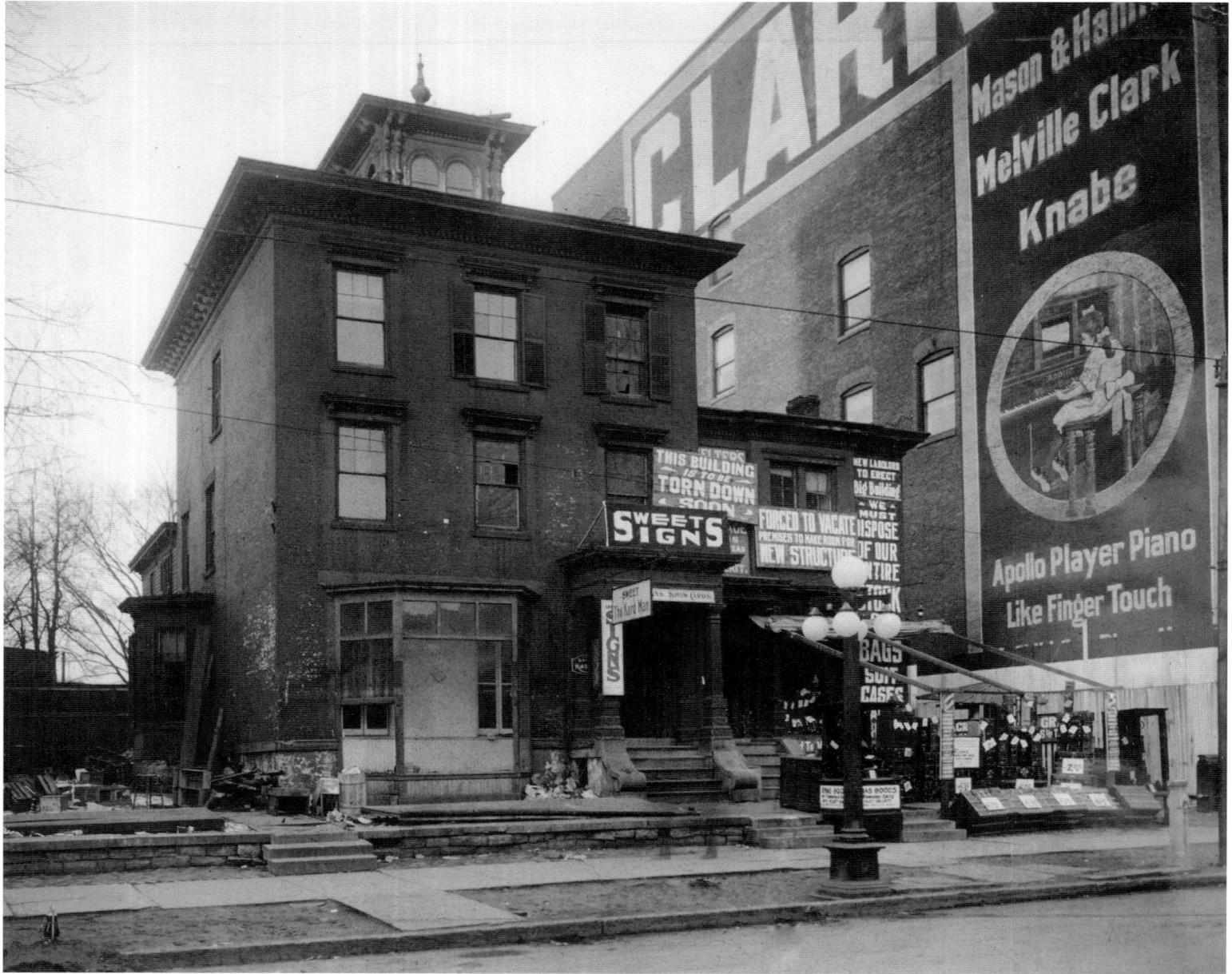

For much of the nineteenth century, South Salina Street beyond Jefferson Street remained residential. As downtown expanded, some of these homes were converted to commercial use, but most gave way by the time of World War I to larger office and retail buildings. Once the home of Dr. Henry Didama, a physician who was chief of staff at St. Joseph's Hospital, this building was torn down in 1911 for construction of a large movie theater.

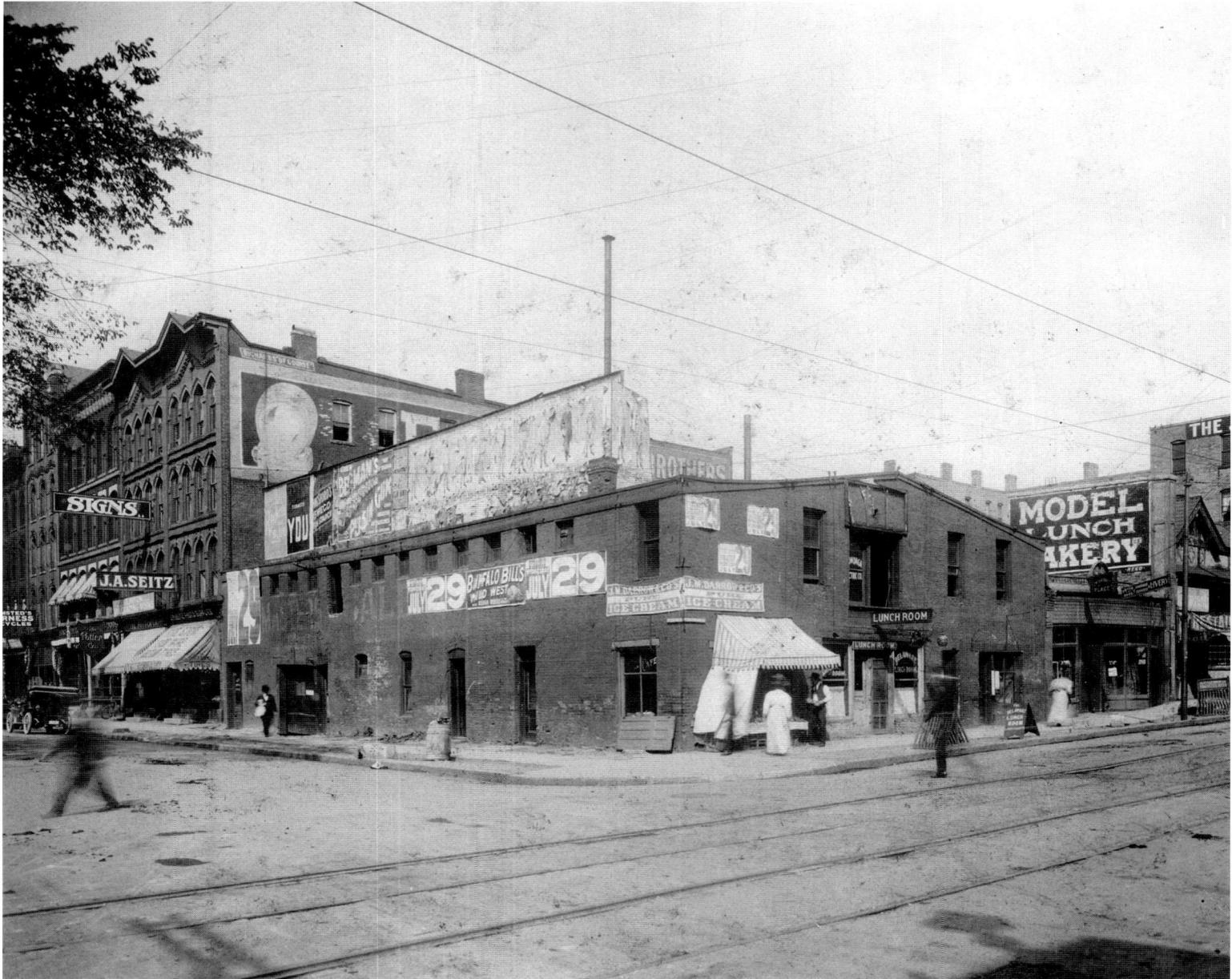

As the twentieth century began, the northeast corner of Jefferson and Clinton still held an interesting vestige of the past, a low-slung brick building that had served as a livery stable. As seen here around 1905, it had been converted into a "Lunch Room." It would soon be demolished for a new commercial building, which, in turn, would be demolished in the 1920s to make way for construction of Loew's State Theater. Signage on the building advertises Buffalo Bill's Wild West show, coming to town July 29.

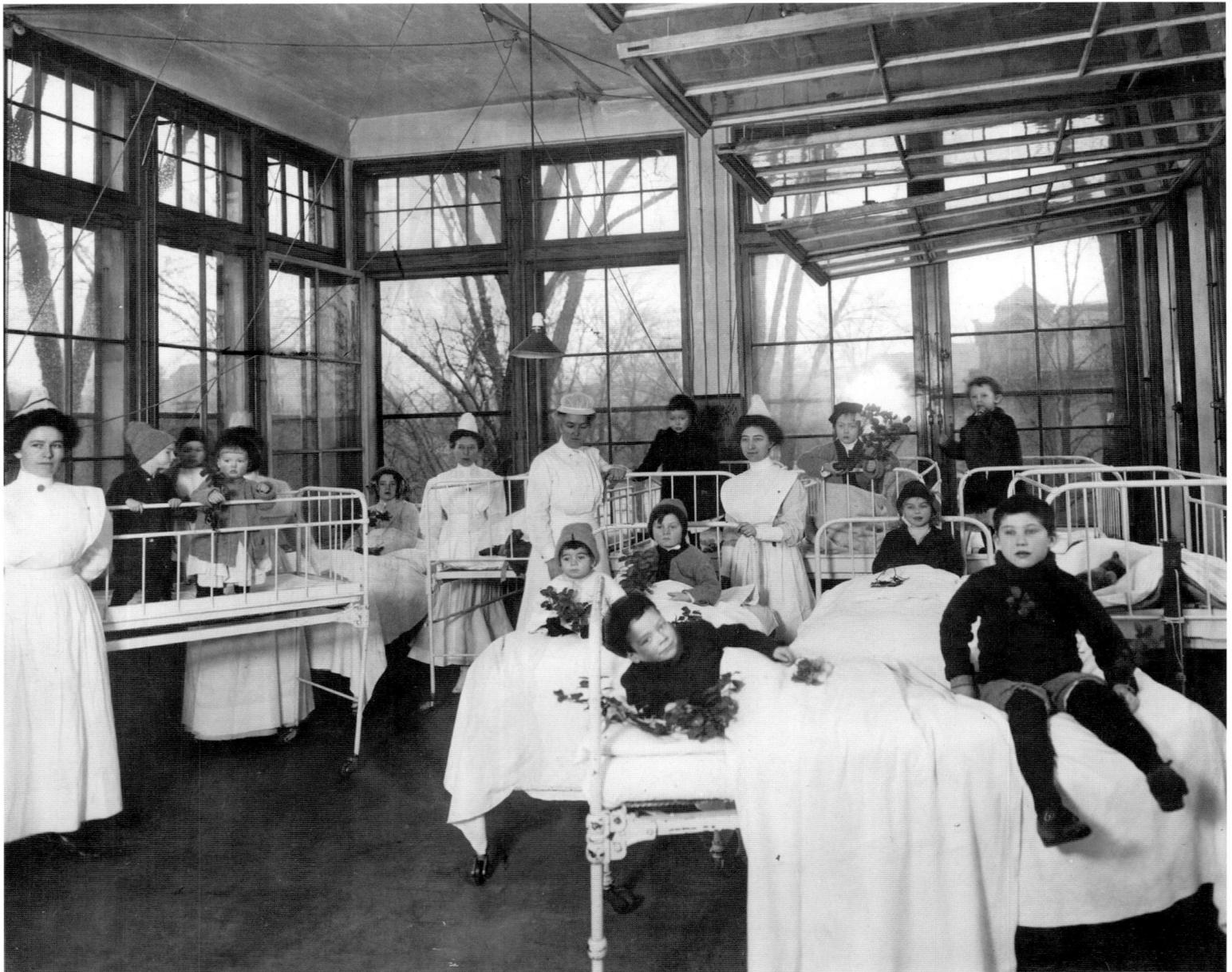

This pavilion was added to the Hospital for Women and Children on West Genesee Street in 1908. For certain illnesses of the era, lots of fresh air was often prescribed as treatment. "Women's and Children's" was the forerunner of Memorial Hospital.

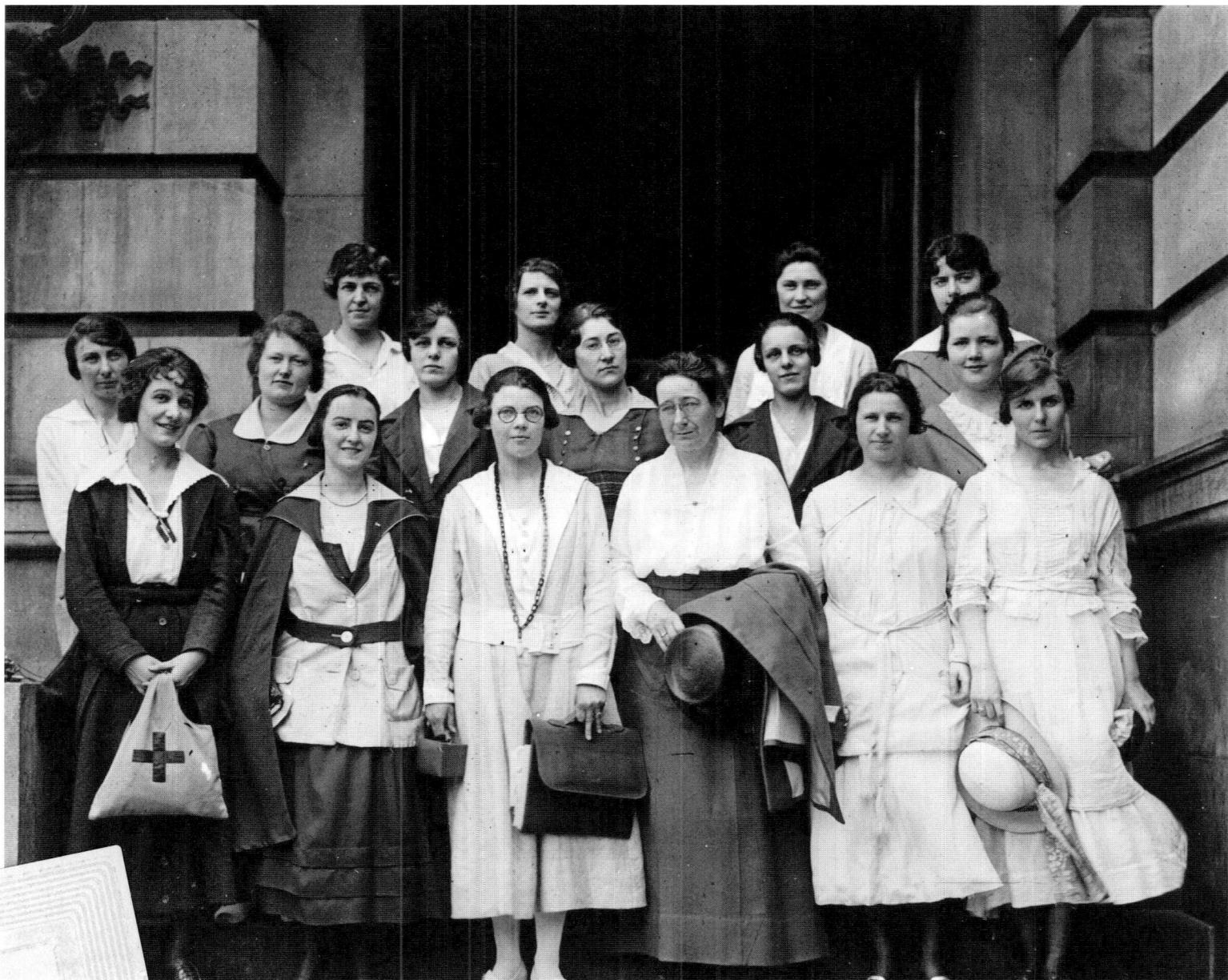

Dora Hazard (fourth from left, first row) organized a unit of hospital volunteers who went to London in 1918 to help tend to wounded soldiers during World War I. By this time she had already established an impressive track record as a leader in the women's suffrage movement and other social and educational reform efforts.

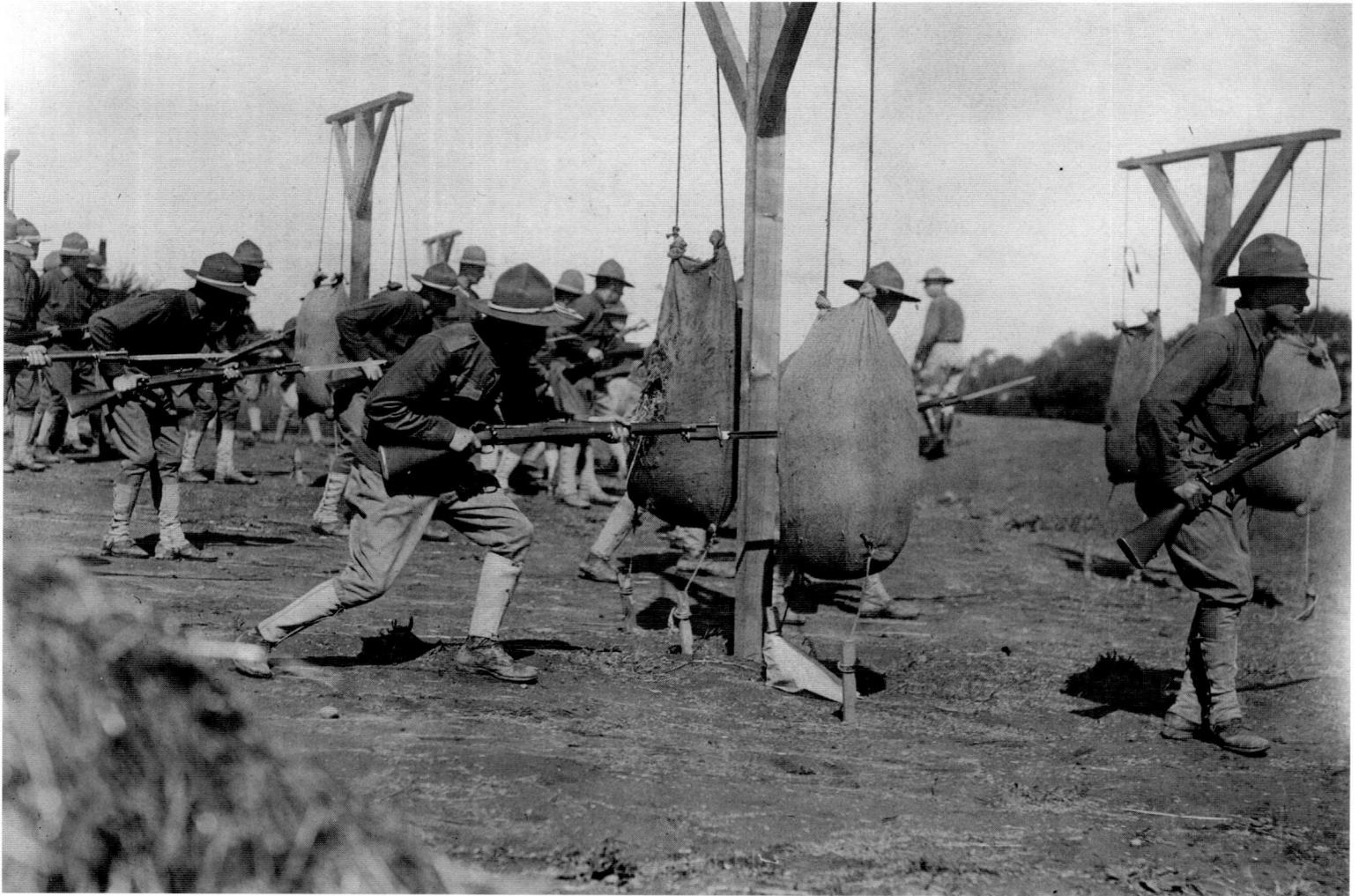

A large training and deployment base for the U.S. Army was established at the State Fairgrounds near Syracuse during World War I. Doughboys are training at the base in the use of their bayonets.

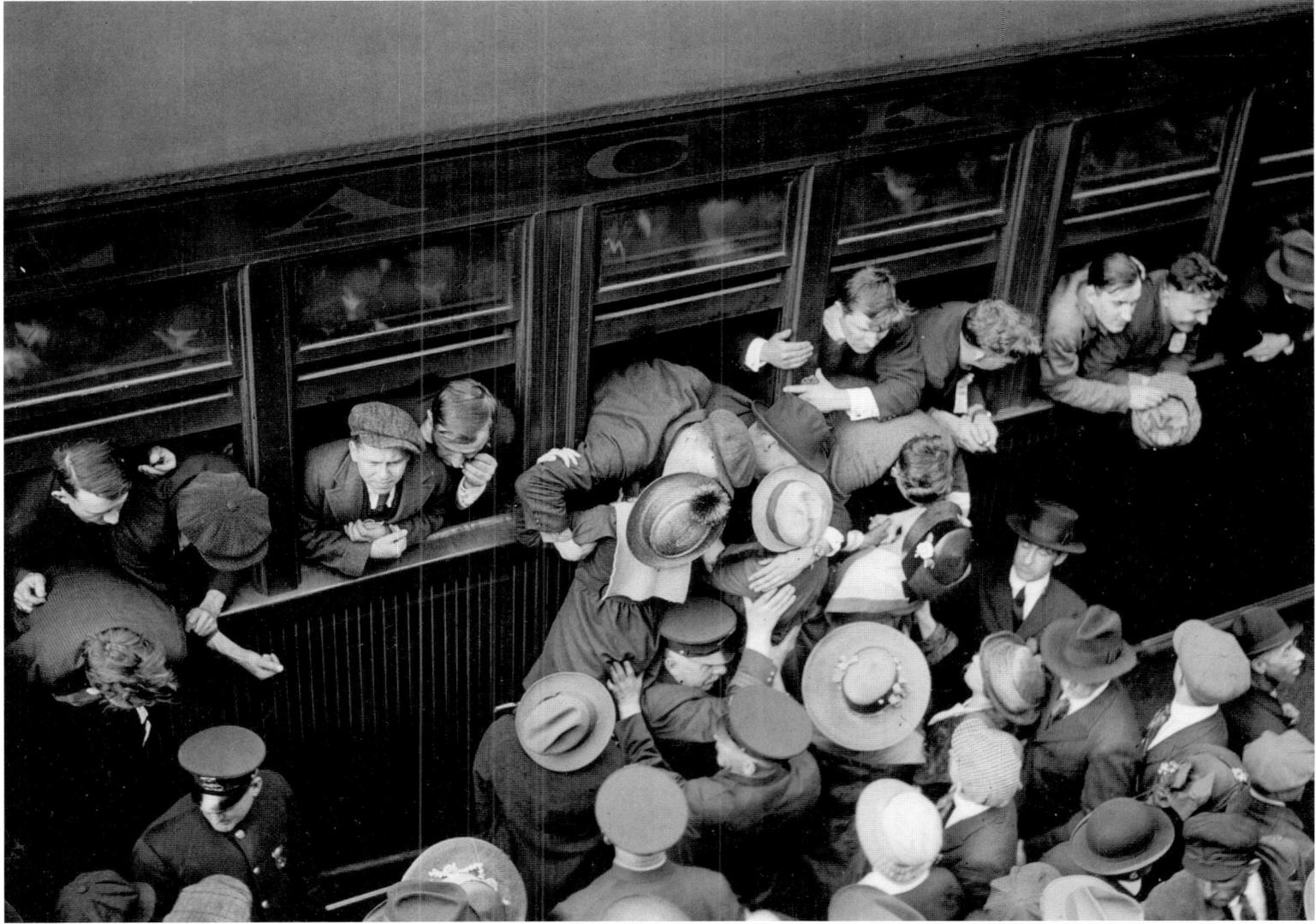

Syracuse's train stations were emotional places when recruits left for basic training and, eventually, the trenches of France. This 1917 scene took place at the DL&W Railroad Station on South Clinton Street.

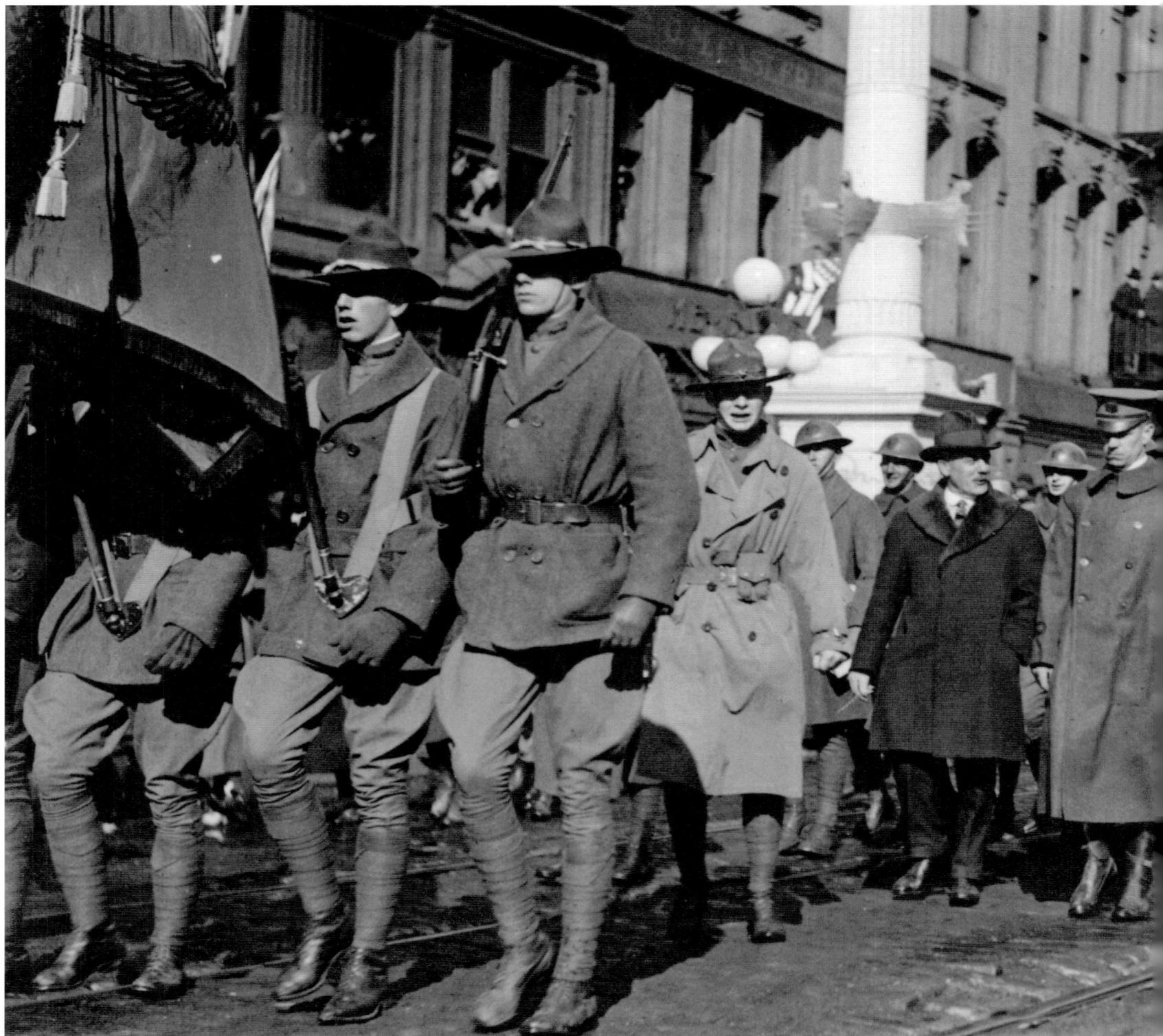

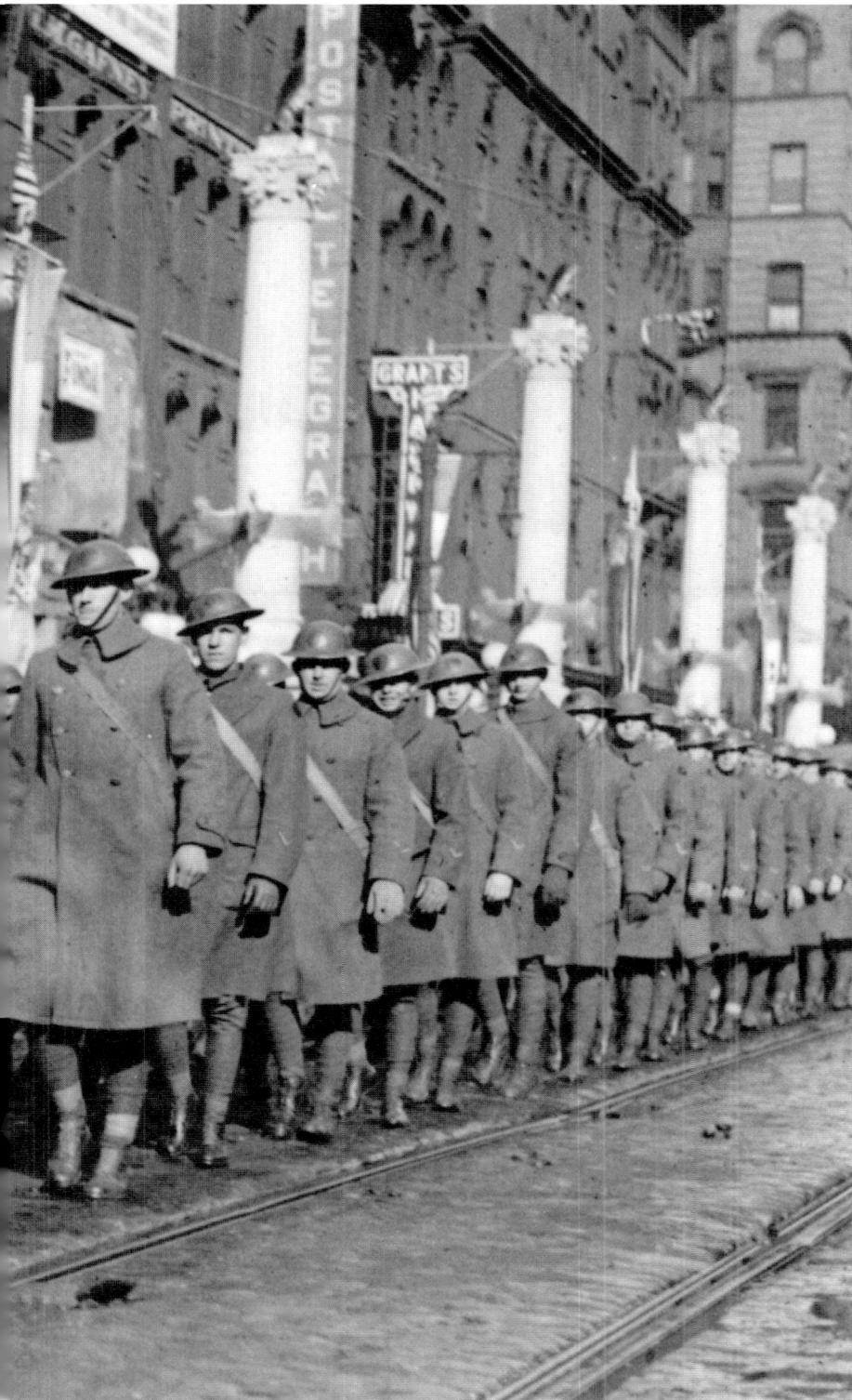

World War I was the last major conflict where entire units might be composed primarily of men from one community. So there was a grand welcoming parade in 1919 when these local men returned from Europe, complete with a giant colonnade erected in Vanderbilt Square. These troops are marching down Washington Street toward Salina Street.

World War I brought a surge in patriotism and an increased effort at what was called "Americanization"—lessons in the English language and American civics aimed at the large number of immigrants who had arrived in the U.S. during the era. A promotional event for Americanization is held in Clinton Square on July 4, 1918. The old Erie Canal is still present but is fast approaching its final days. Beyond the canal are the 1857 County Courthouse and the 1910 Soldiers and Sailors Monument, erected for Civil War veterans.

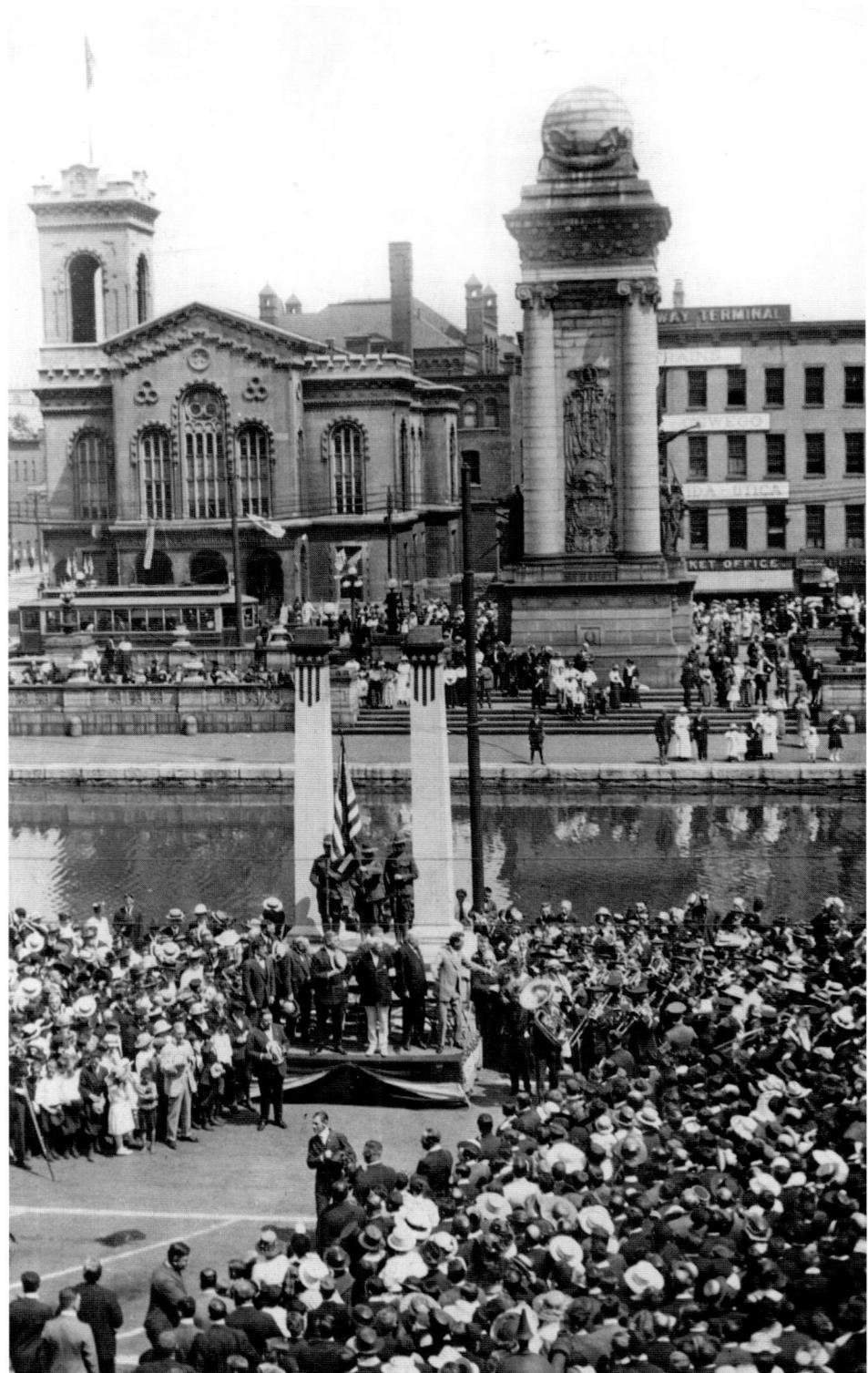

Old Challenges and New Opportunities

(1921–1945)

The headline blared, "BURNING OF BARRIER AT CLINTON SQUARE OPENS CELEBRATION." It was October 28, 1924, and the barrier was symbolic. It marked the removal of the Salina Street bridge over the Erie Canal, made possible by the fact that the city was filling in the old canal bed. The 1825 Erie, and its counterpart, the 1828 Oswego Canal, were now officially obsolete, replaced with the state's new Barge Canal, which ran well north of the city.

By the 1920s, Syracuse was a town firmly focused on the future. It was the Roaring Twenties. Local factories were humming. Automobiles and buses were transforming city life. New towering office buildings, a lavish movie palace, and a stunning 600-room hotel were being planned for downtown. The city's population was approaching 200,000.

The canals, which had snaked through the city for 100 years, had truly put Syracuse on the road to prosperity and growth. Having outlived their commercial usefulness, they were now viewed as annoying barriers, hindering the movement of street traffic and the free flow of retail activity in the downtown shopping core. Over the next few years, fill was added, locks disassembled, and bridges taken down. Syracuse citizens, along with the hundreds of merchants along the grand Salina Street shopping corridor, cheered.

The canals were not the only barriers Syracusans wanted to remove. The city had another challenge left over from the nineteenth century—two main railroad lines running at grade through downtown. After much civic debate, a project to elevate the tracks of the New York Central and DL&W railroads was begun in the 1930s. The timing coincided with the Great Depression, which forced some scaling back of the elevation's architecture but also provided much-needed jobs.

By the 1930s, opportunities for leisure distractions had increased to help counteract the impact of the depression. Offerings ranged from watching the Syracuse Stars play professional hockey to sipping martinis in chic cocktail lounges at downtown hotels. There were grand movie theaters, not only downtown, but also spread throughout many neighborhoods. For pocket change today, one could buy an afternoon or evening of film, newsreels, and a cartoon or two, in settings that transported the viewer to elegant or exotic worlds.

It was a time when the city reigned supreme and everyone wanted to be a part of it.

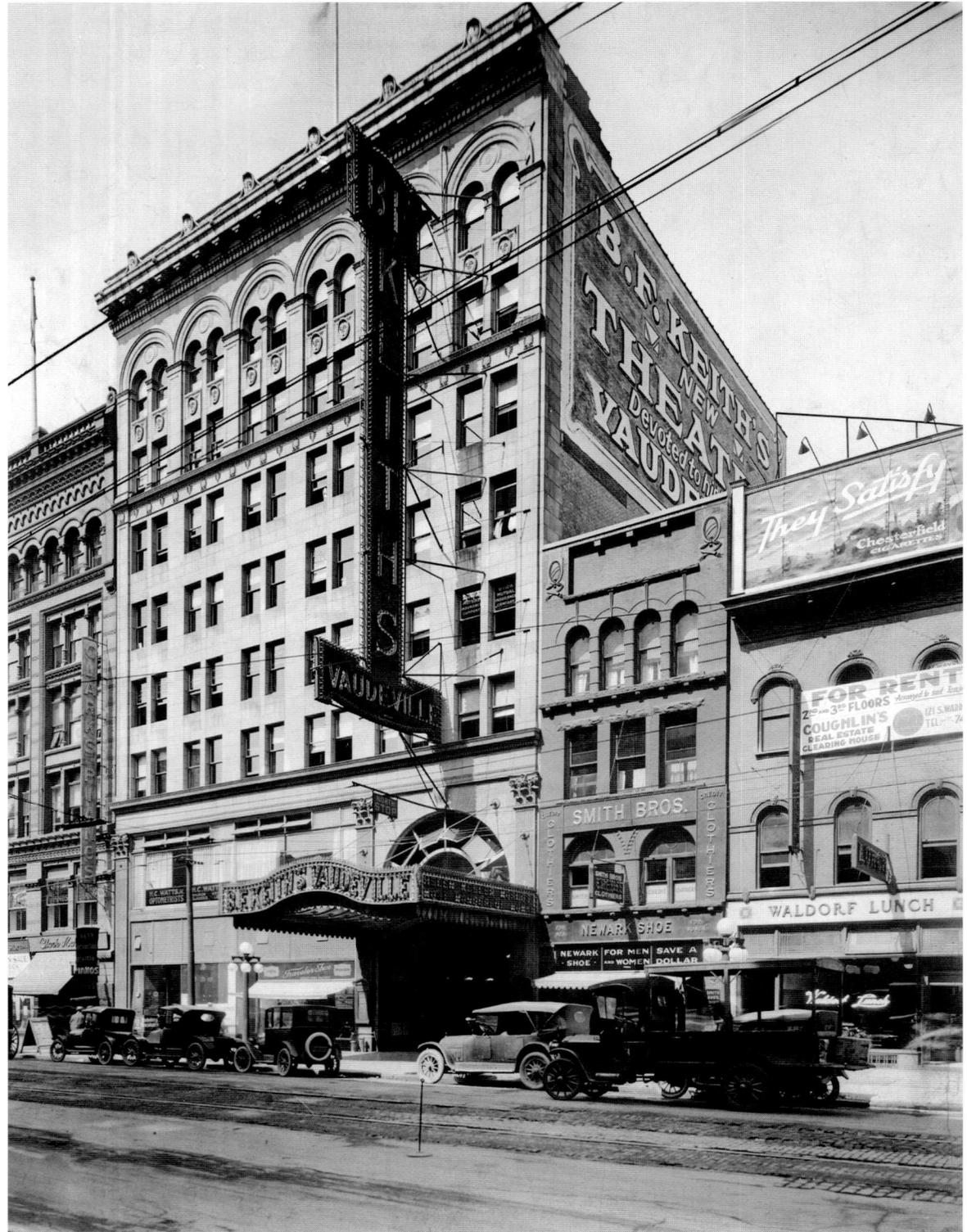

B. F. Keith's theater opened on Salina Street in 1920 as a grand vaudeville house but soon became a motion picture venue as Hollywood cinema took Syracuse and the nation by storm. It lasted until the 1960s, when it was demolished during the urban renewal era.

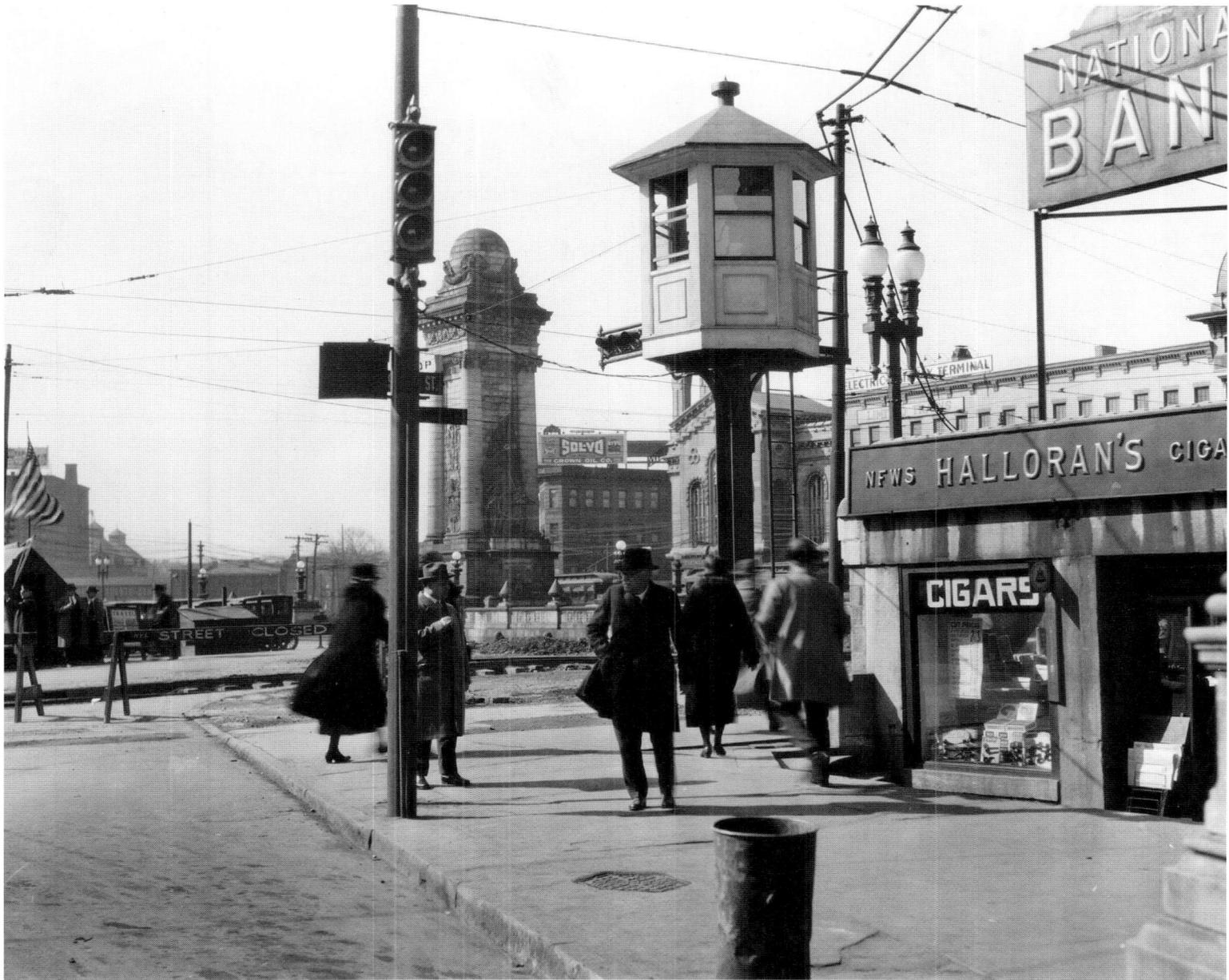

In April 1925, pedestrians pass by the corner of Water and Salina in front of the Gridley Building. The Erie Canal has been filled in behind them and automobiles are coming to dominate downtown traffic. The city dealt with the increasing congestion by installing a traffic control tower at the new intersection of Salina Street and what had become Erie Boulevard.

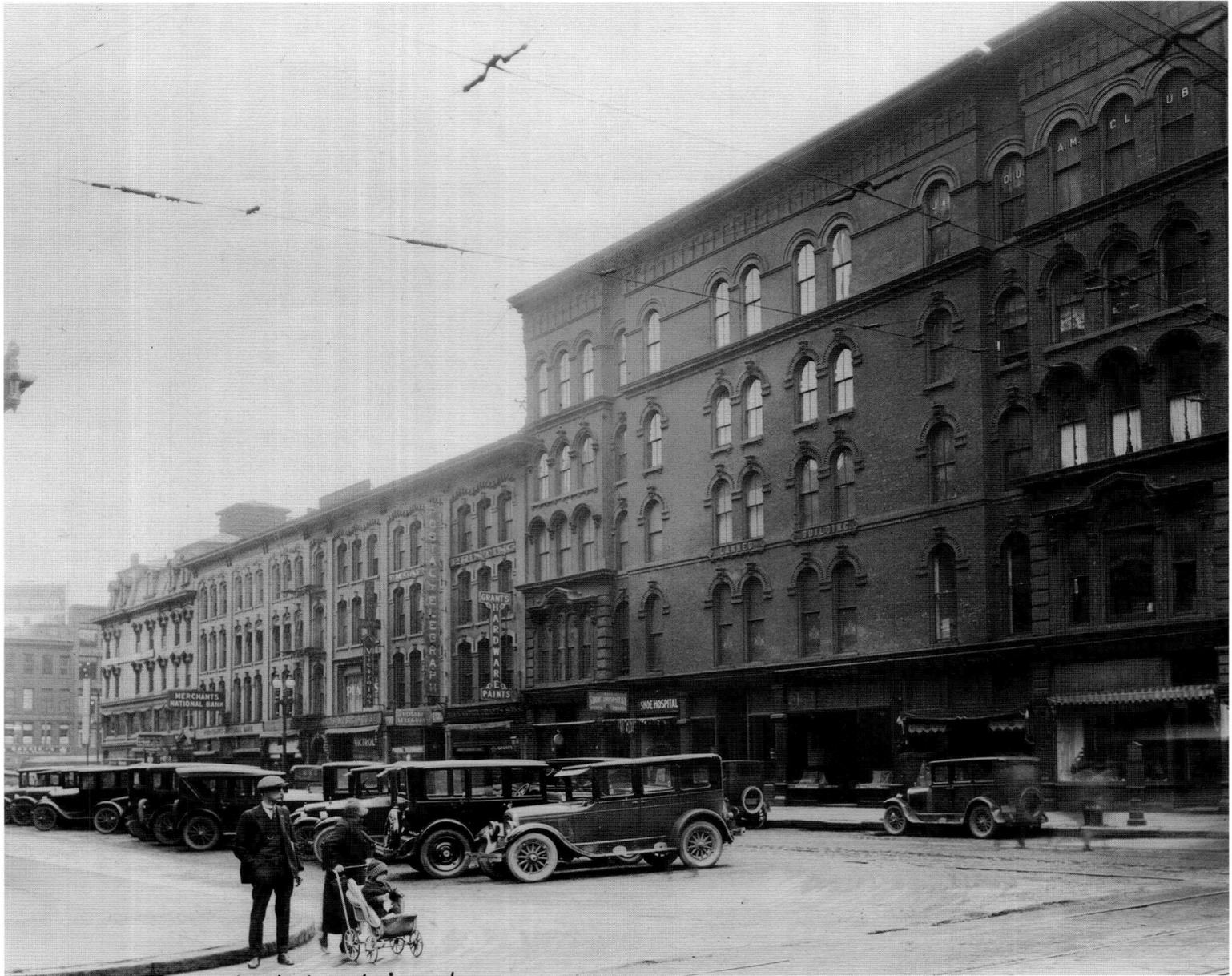

A couple and their child cross Warren Street. Finding a place to park downtown would become a growing issue during the 1920s as this scene in Vanderbilt Square attests. The Larned Building stands on the corner, a landmark dating from the late 1860s that remains standing in 2008.

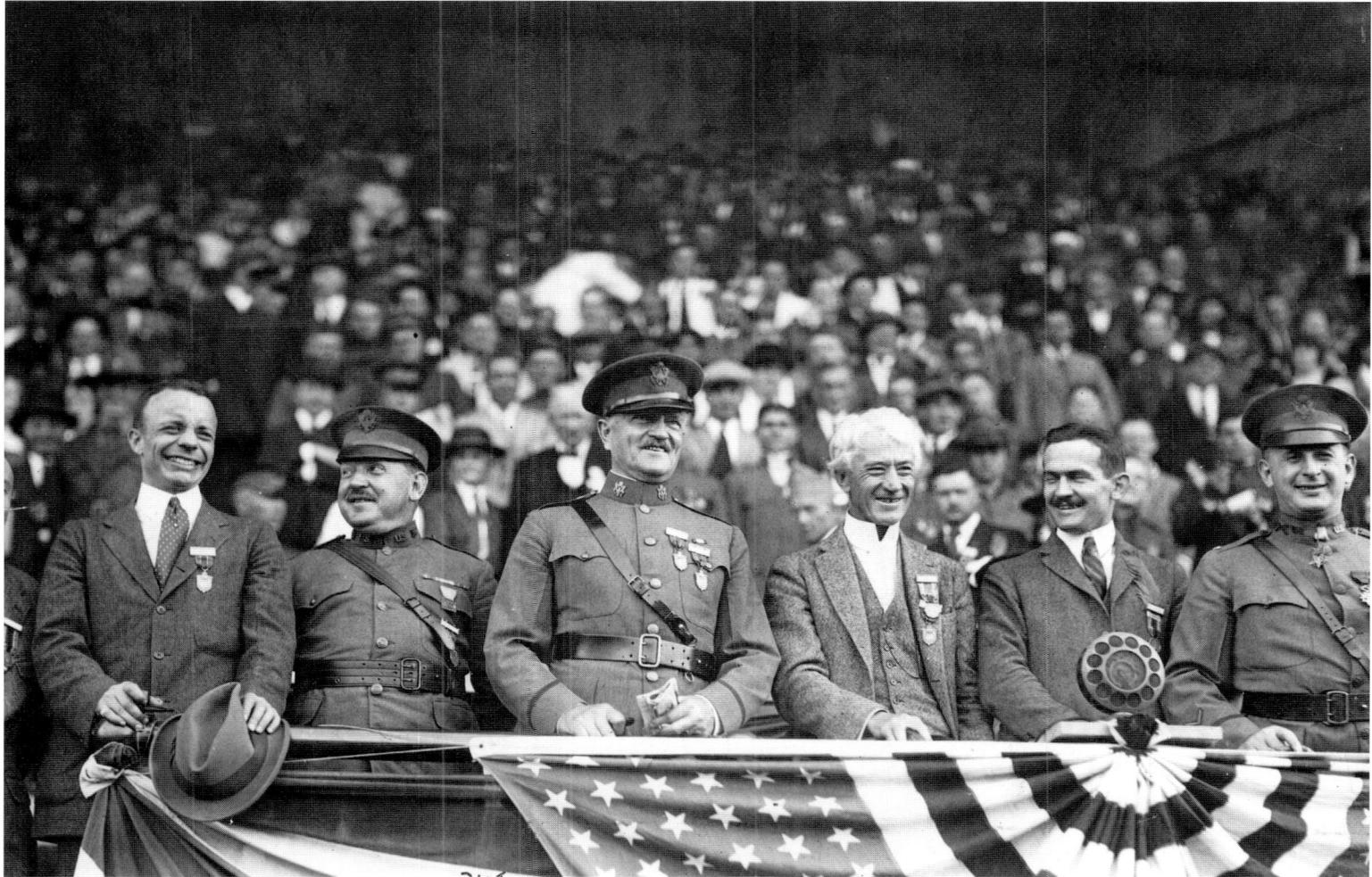

In 1922, the American Legion held a convention in Syracuse. Guests at a major assembly in SU's Archbold Stadium included Theodore Roosevelt, Jr., exhibiting his father's famous grin (at far left), General John J. Pershing, American commander in Europe during World War I (3rd from left), and Kenesaw Mountain Landis (4th from left), a federal judge who was serving as major league baseball's first commissioner. The previous year Landis had issued his famous order forever banning "Shoeless" Joe Jackson and seven other Chicago players from the game for their participation in the infamous "Black Sox" scandal.

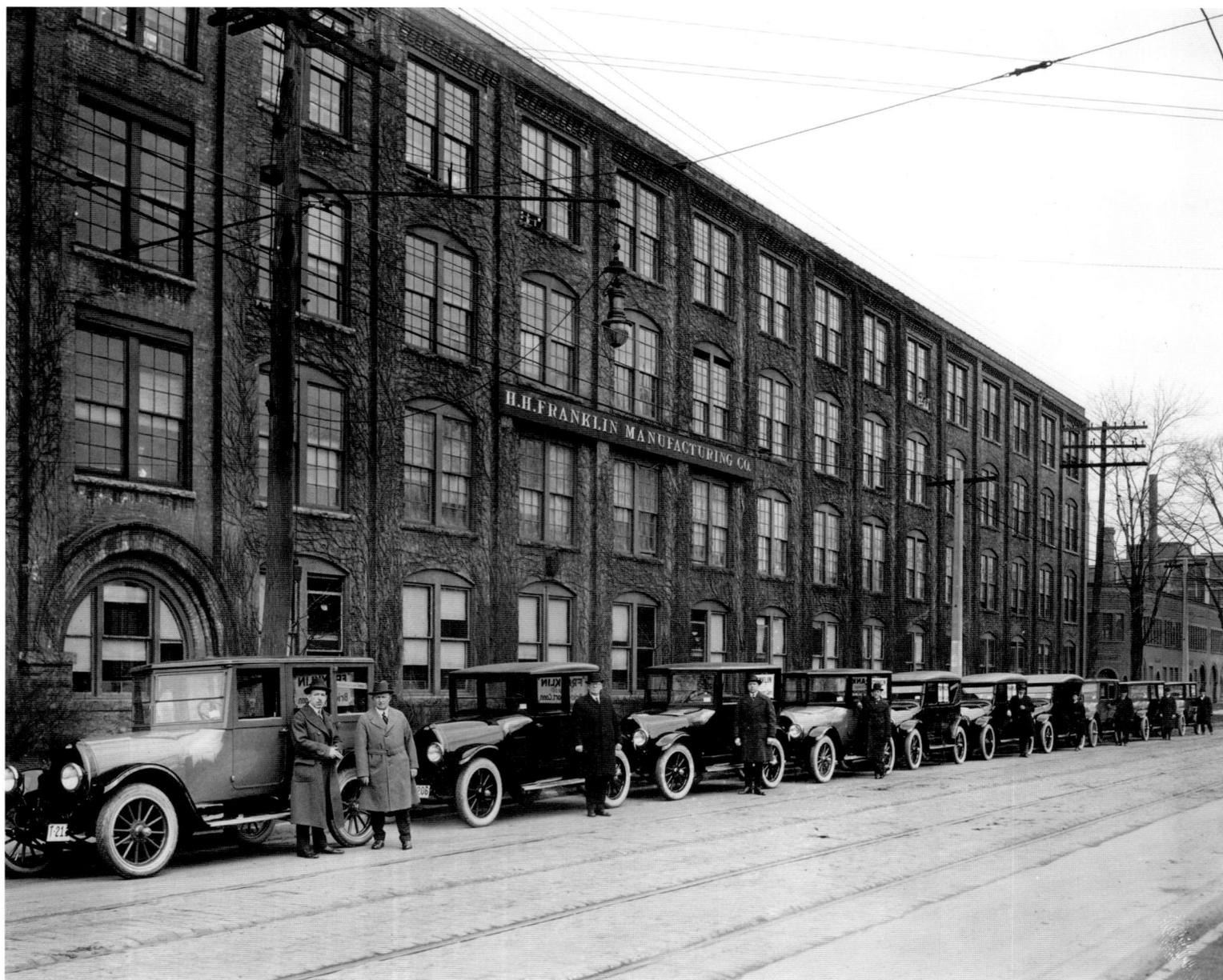

The Franklin firm was located on South Geddes Street near West Fayette as captured here in 1922. It would not survive the Great Depression. In the 1930s, the sprawling plant eventually became the first local home of the Carrier air conditioning company. The structure was razed in the 1970s and Fowler High School was built on the site.

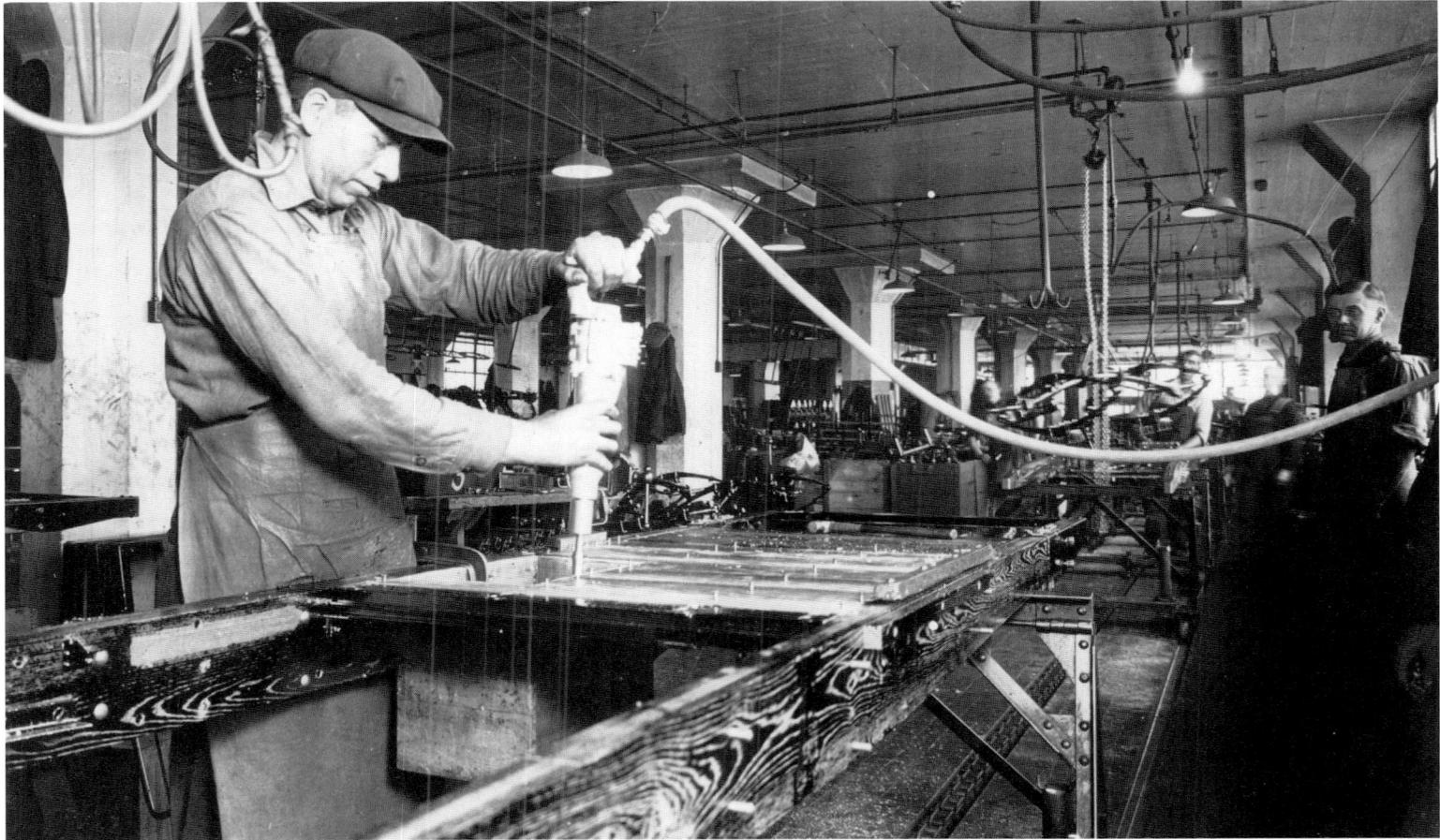

The Franklin factory was buzzing with activity in 1923 as production of its successful air-cooled automobiles was on the increase. The company was one of the city's largest employers at the time A worker is assembling car frames in an early stage of production.

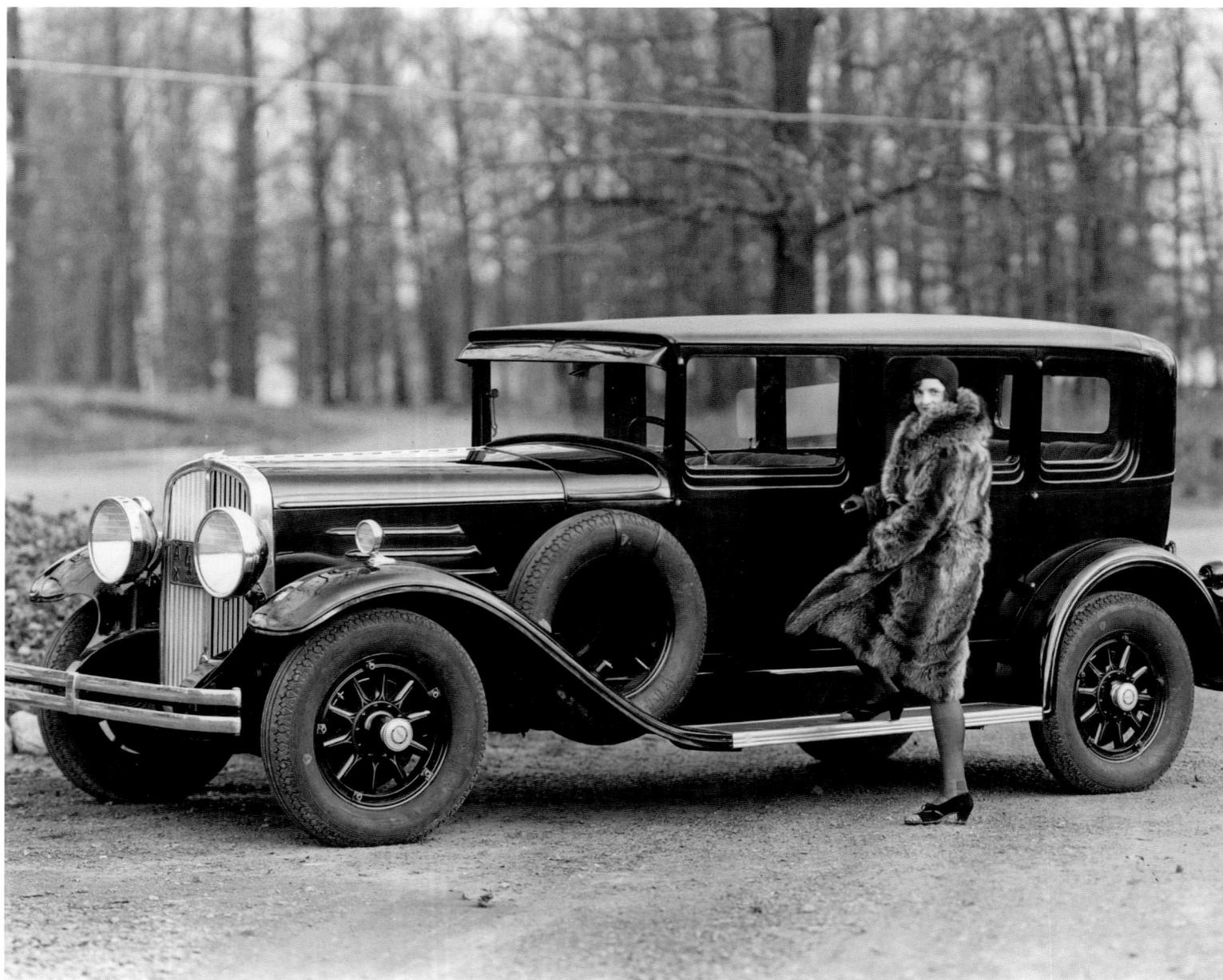

In a classic outfit of the era, a woman poses with a 1930 Franklin Sedan, perhaps in Upper Onondaga Park where the Syracuse auto manufacturer shot many of its promotional pictures.

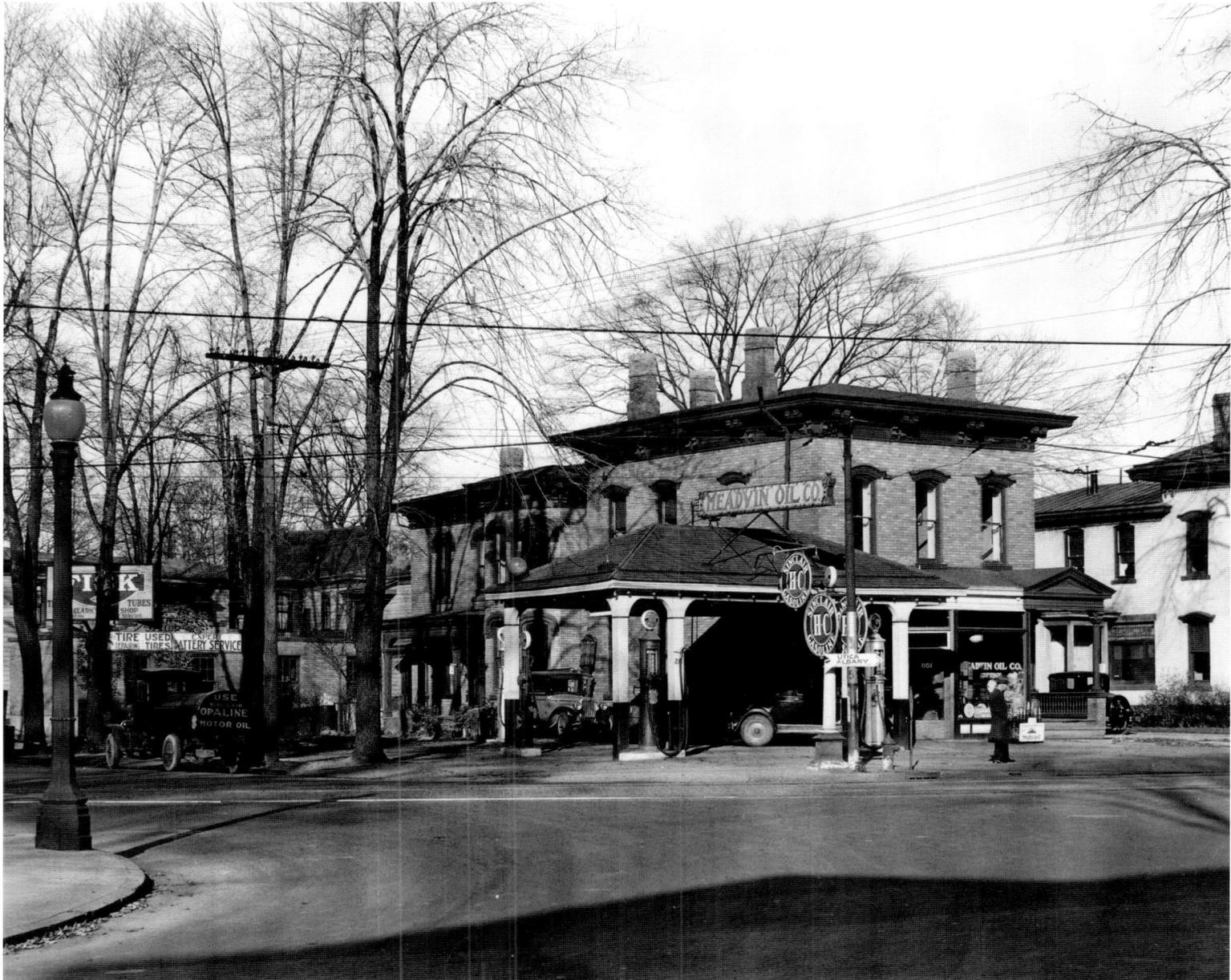

The increasing presence of the automobile wrought many physical changes to Syracuse over the years. One of the first was the arrival of filling stations in various odd locations. In the 1920s, this mid–nineteenth century home at the corner of East Genesee Street and Forman Avenue has become a Sinclair station. The arrow on the corner pole indicates that East Genesee Street at the time was the main route out of Syracuse to Utica and Albany.

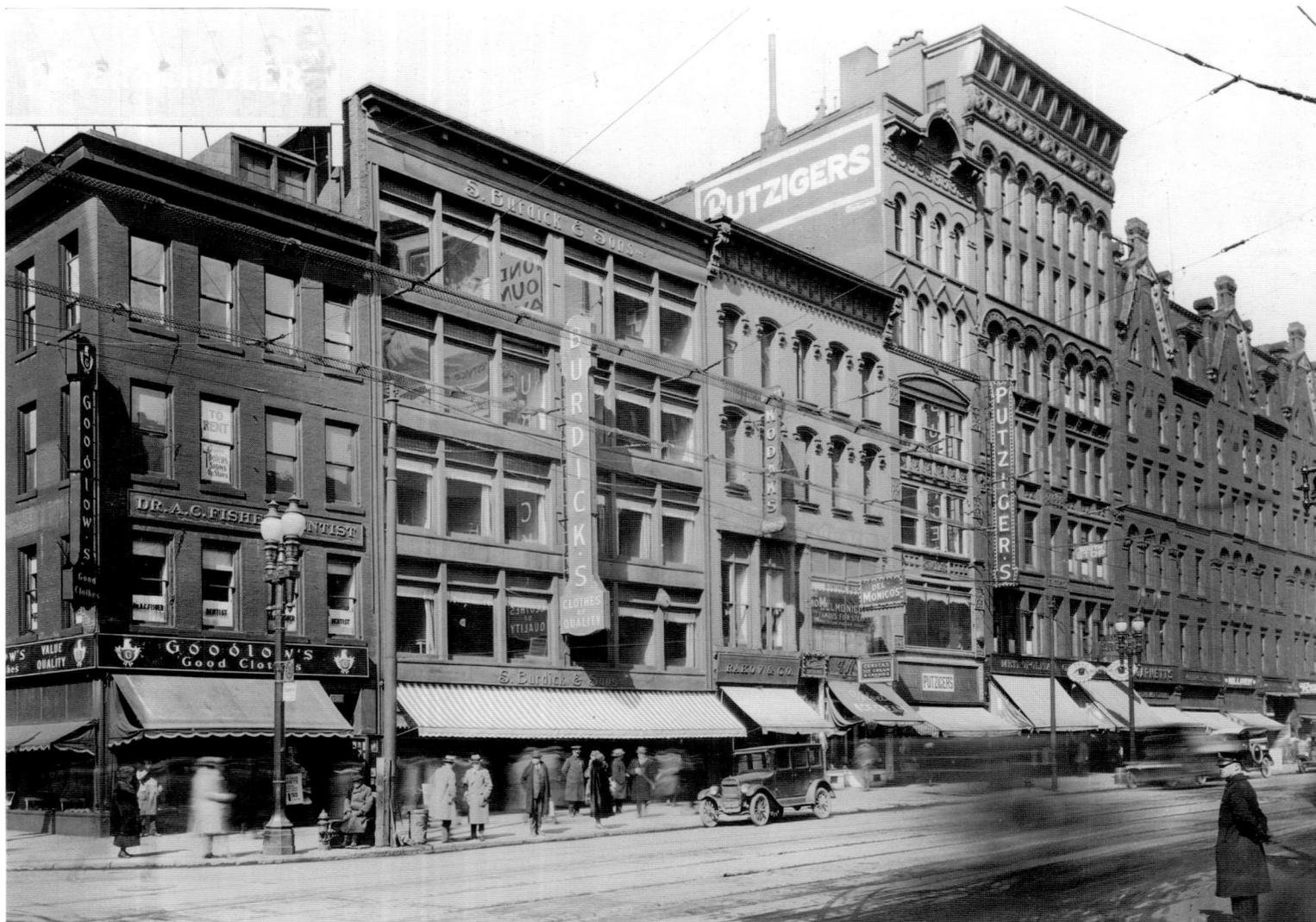

The west side of the 100 block of South Salina Street is lined with numerous businesses and six different buildings in the 1920s. They include the Malcom Block on the far left, which dated from before the Civil War. The site is now home to just one building, the Atrium, which was built in the early 1970s.

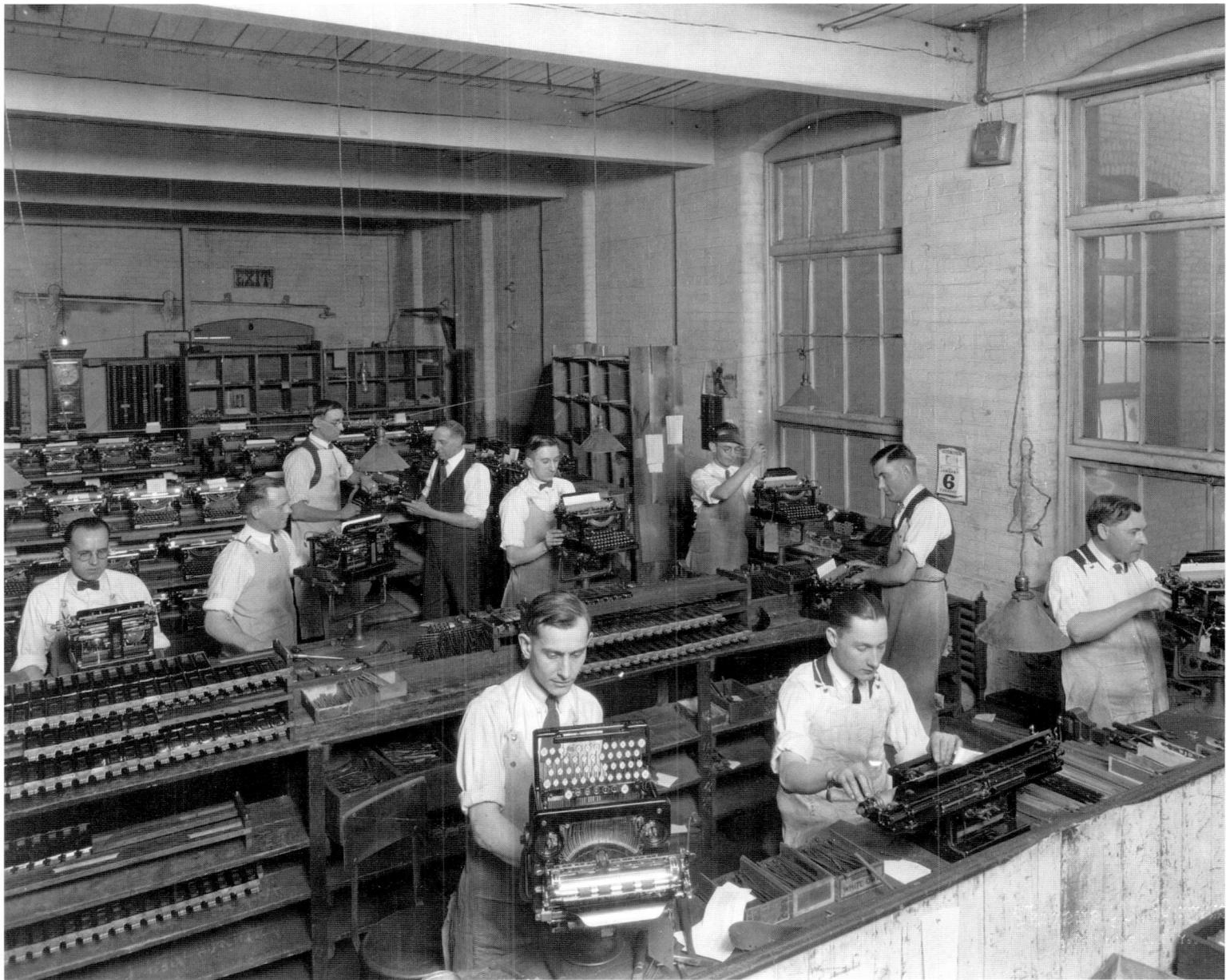

Salt manufacturing in the nineteenth century gave Syracuse its permanent nickname, the "Salt City." By the early twentieth century, however, the industry had shrunk considerably. Some citizens were advocating a new tag line, "Typewriter City," since that industry had become so prevalent. Here workers at the L.C. Smith & Brothers Typewriter Company plant assemble components of the Model #8 during the early 1920s.

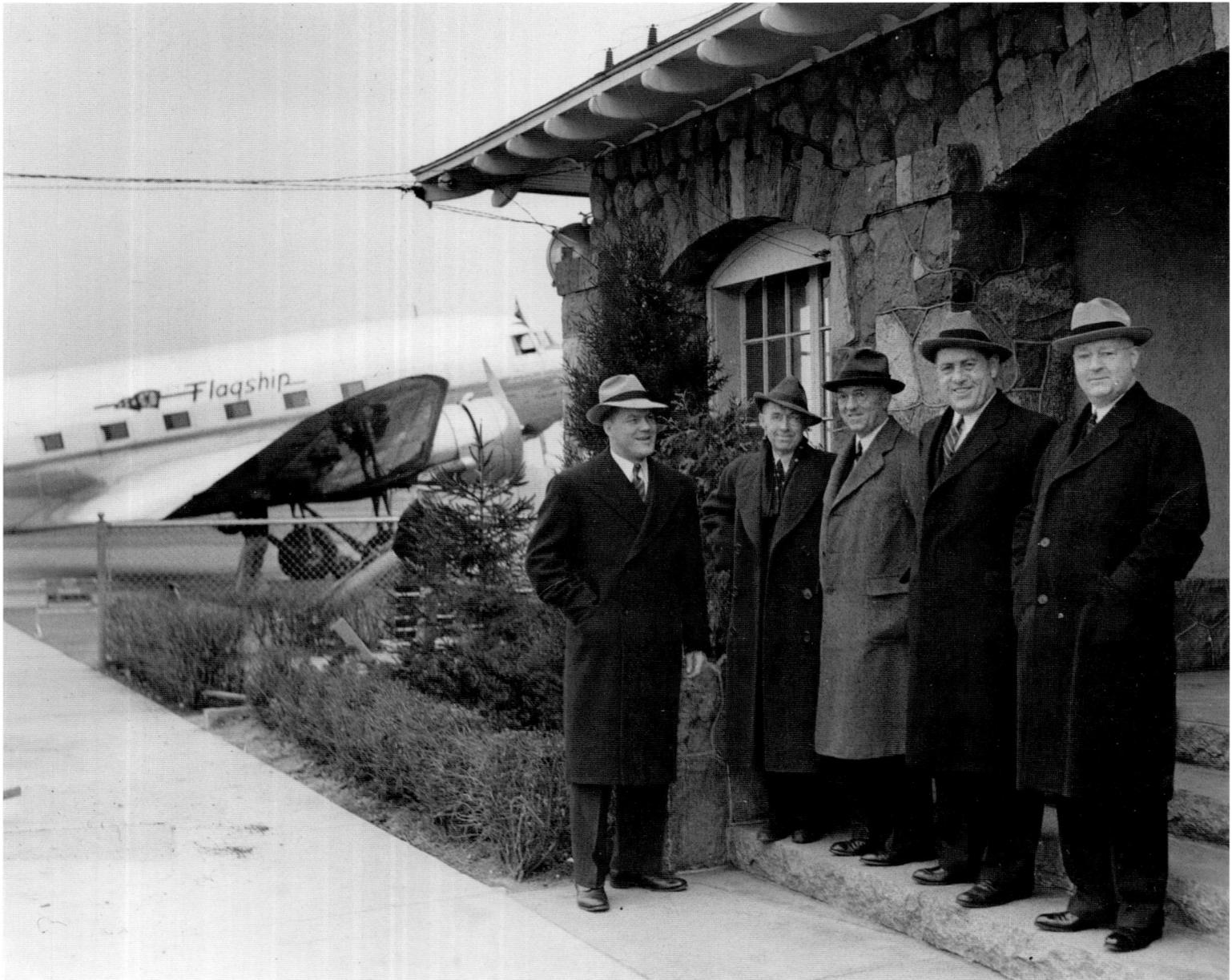

Syracuse's first true municipal airport was located in the little hamlet of Amboy in the Town of Camillus. It served from 1927 until Hancock Airport opened after World War II. Mayor Rolland Marvin (2nd from right) and some of his administration stand at the Amboy terminal in the 1930s with an American Airlines DC-3 in the distance.

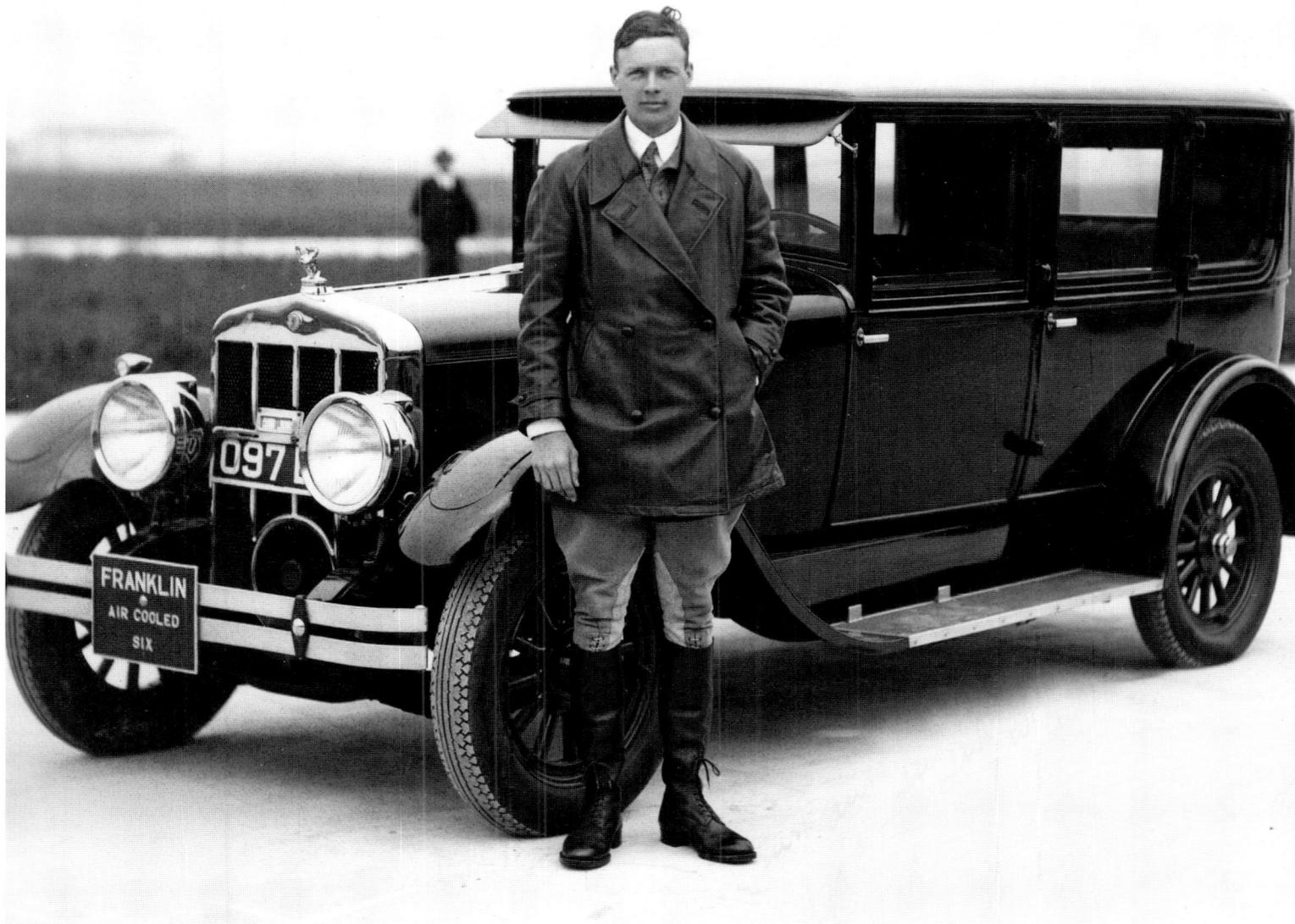

One of the most famous arrivals at Syracuse's Amboy airport was Charles A. Lindbergh, who visited in 1927 following his famous trans-Atlantic flight. A true American hero at the time, he was celebrated and honored wherever he went. In Syracuse, he was gifted with a locally made Franklin auto. Lindbergh treasured it, perhaps in part because it sported an air-cooled engine, like the one in his famous plane, the *Spirit of St. Louis*.

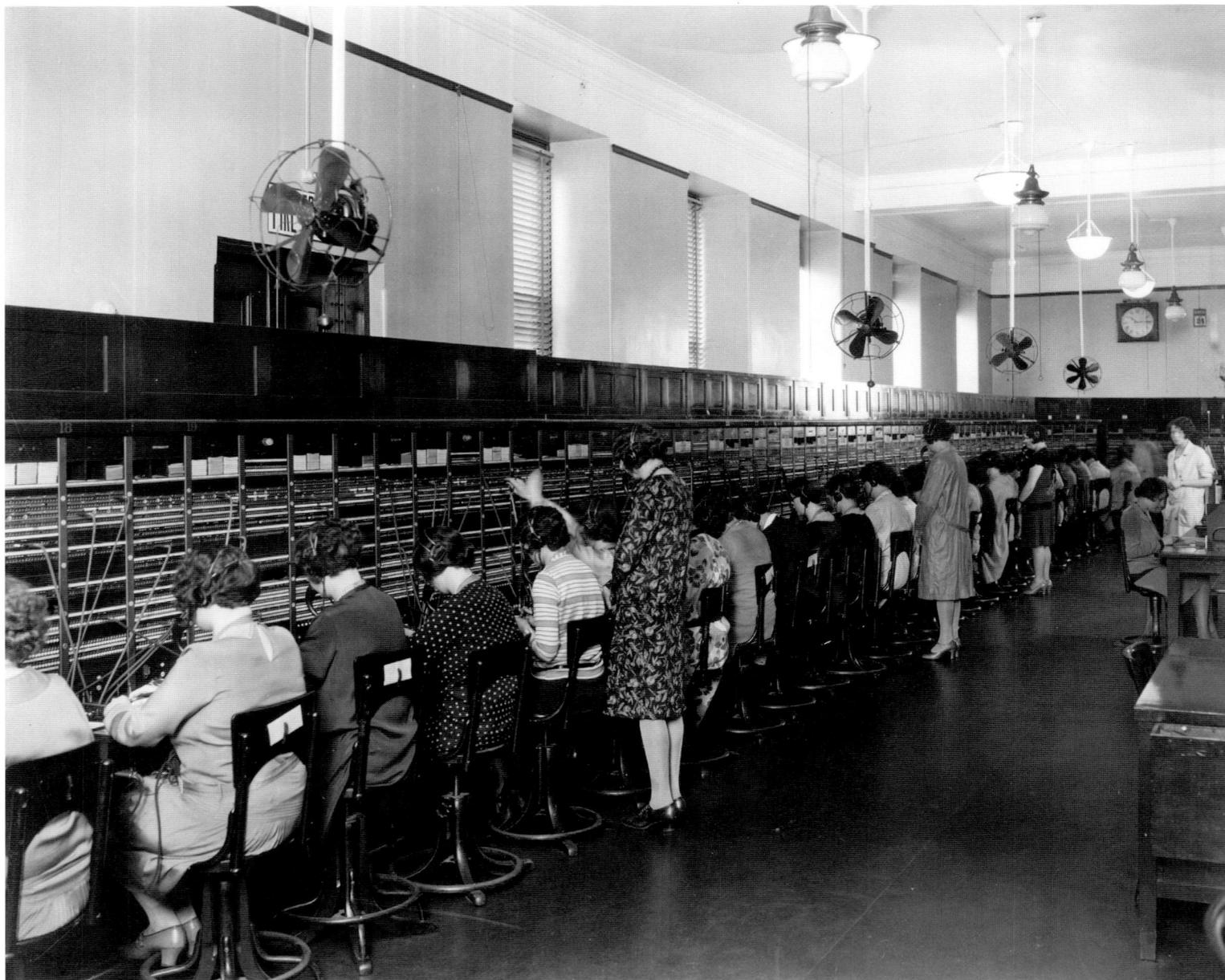

The New York Telephone Company erected a large building at 321 Montgomery Street in 1906 to house their local operations, including the main telephone exchange. Here, around 1930, women employees work their switchboards. This building today houses the museum of the Onondaga Historical Association.

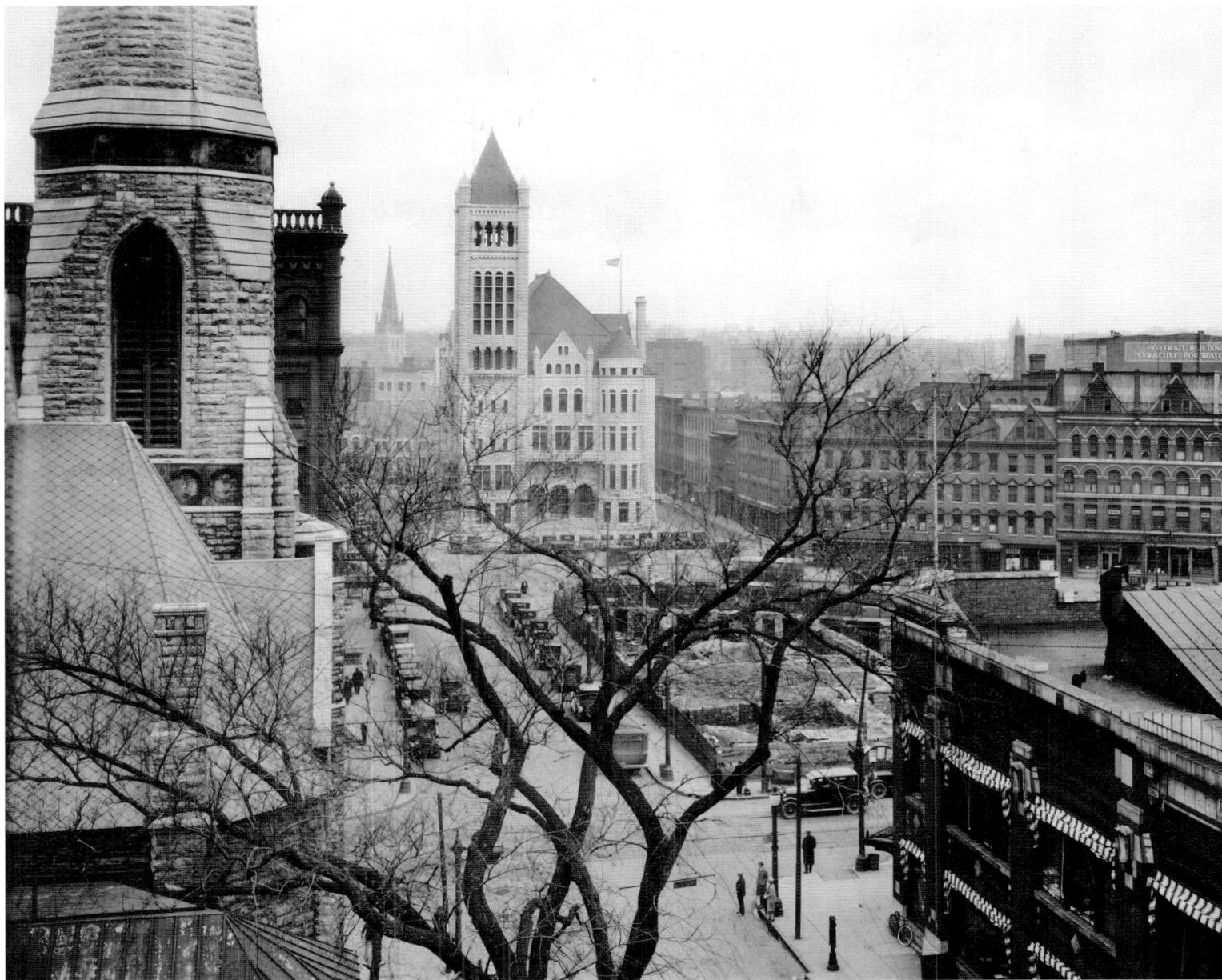

In this view from around 1927, which faces north along Montgomery Street, the distinctive landmark of City Hall is visible. The corner of the Yates Hotel extends just beyond the steeple of St. Paul's Episcopal Church. In the center, in front of City Hall, is a block cleared of nineteenth-century buildings that is about to become the site of the Hills Building.

The Weiler Building went up at 407 South Warren Street in 1928 to house Antoine Weiler's Beauty Salon, and other offices. It featured one of the city's better art deco facades. It still stands today, although the ground floor has been altered.

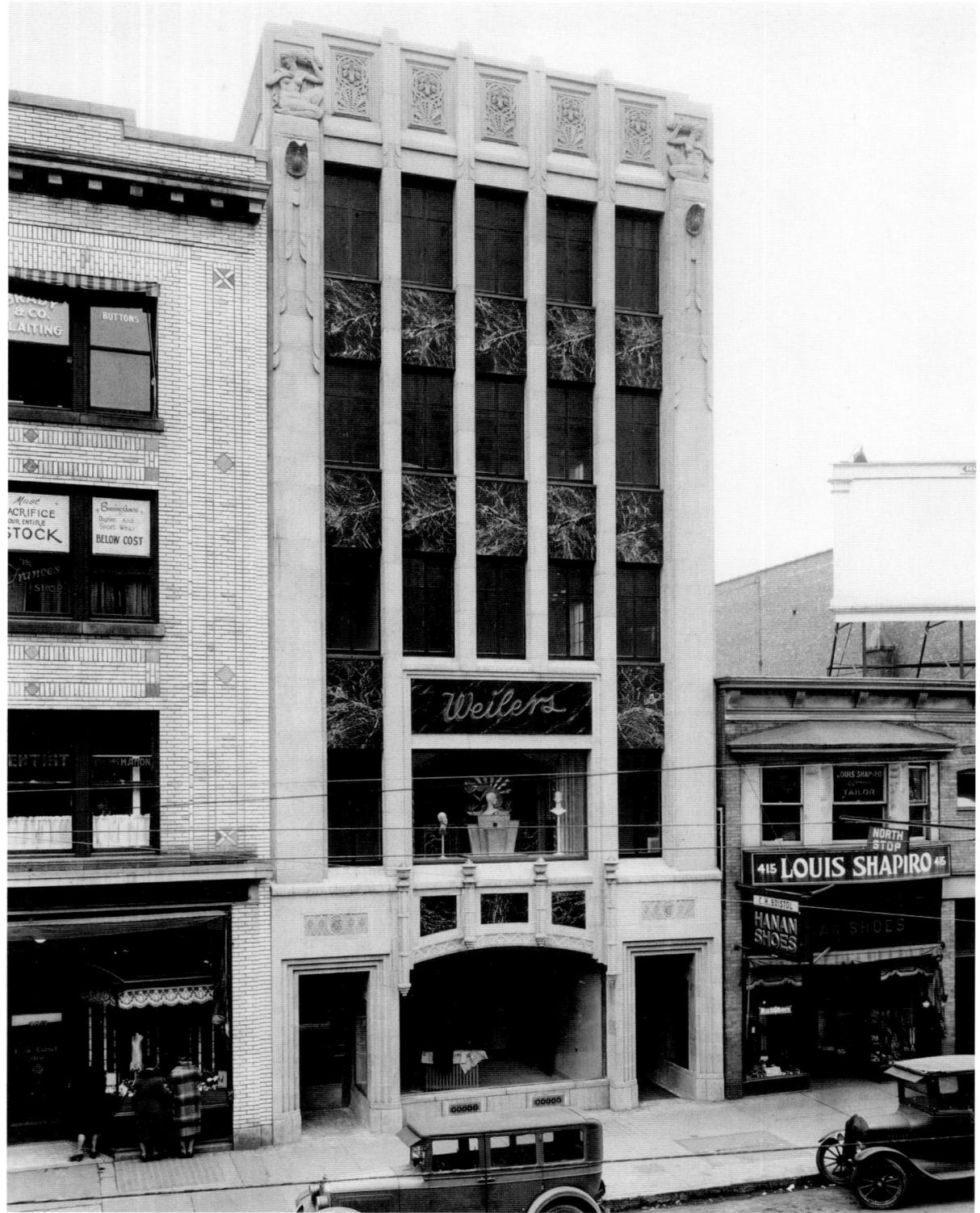

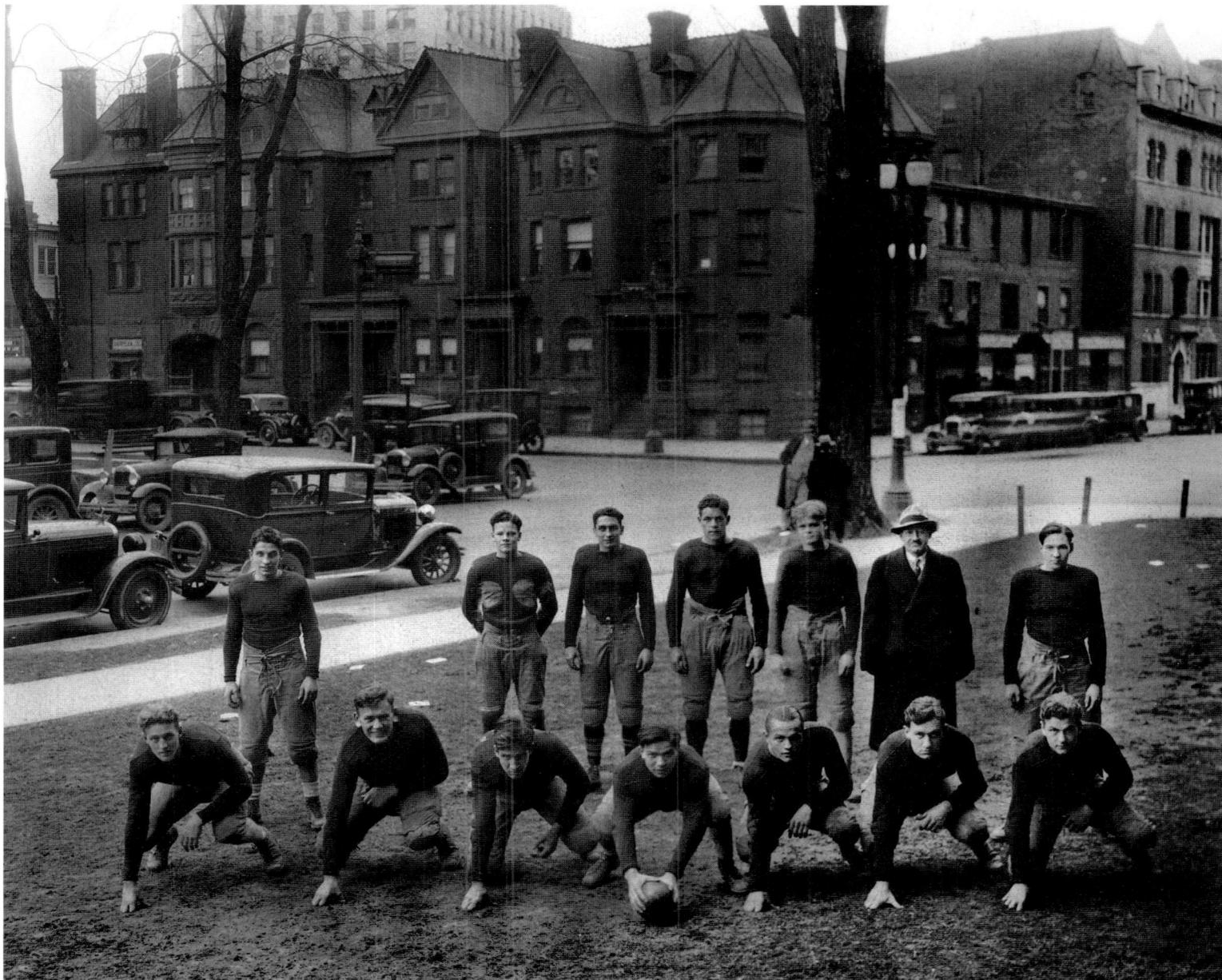

Central High, adjacent to the intersection of South Warren and East Adams Street, served for nearly 75 years as the city's primary high school. A squad from the school's football team poses on the school lawn in 1929.

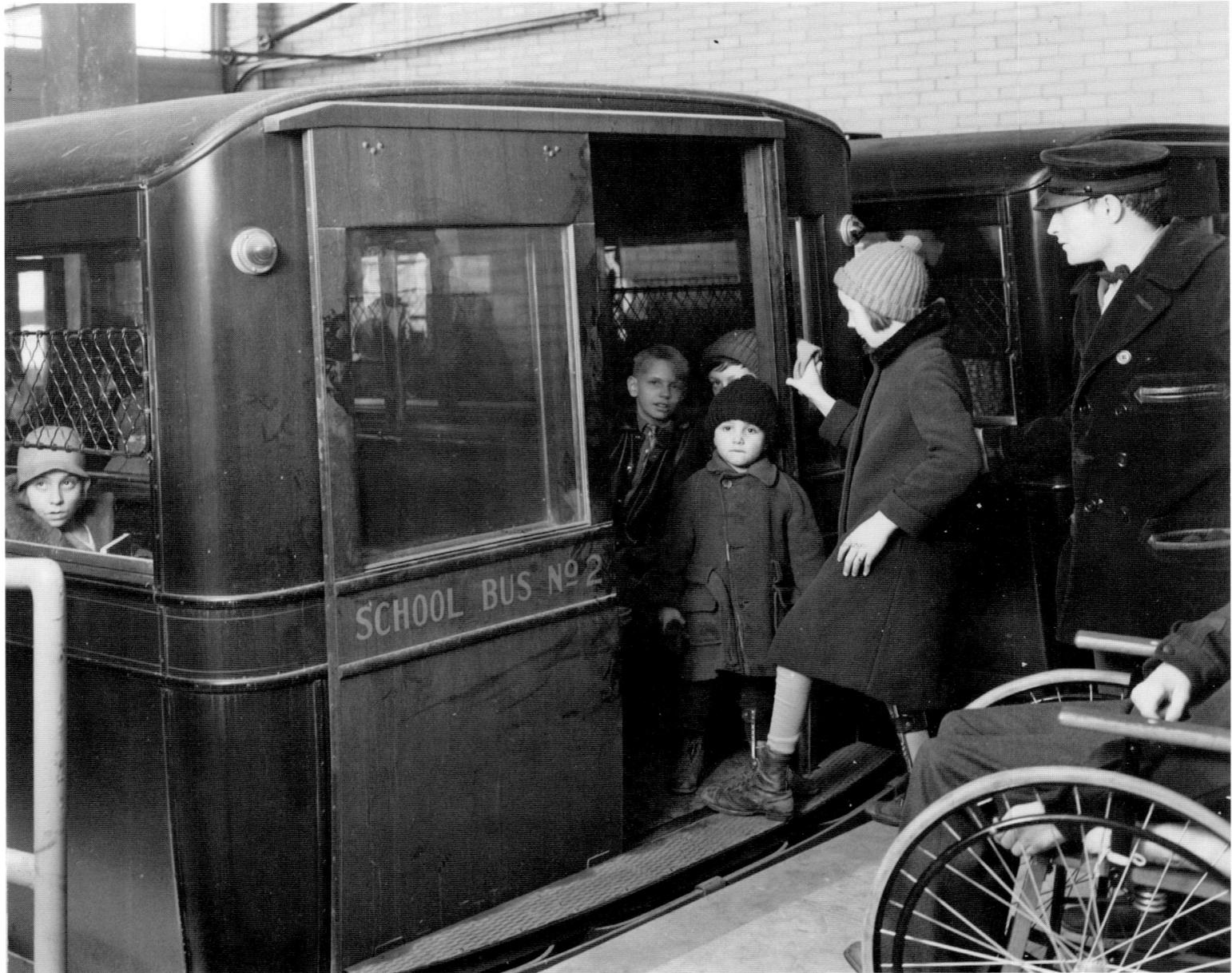

One of the city's innovative educational programs began in 1930 when it opened Percy Hughes School, which included special facilities for children who were sight-impaired or dealing with orthopedic challenges. There were hydrotherapy treatment pools as well as regular swimming facilities. And building adaptations existed for handling wheelchairs.

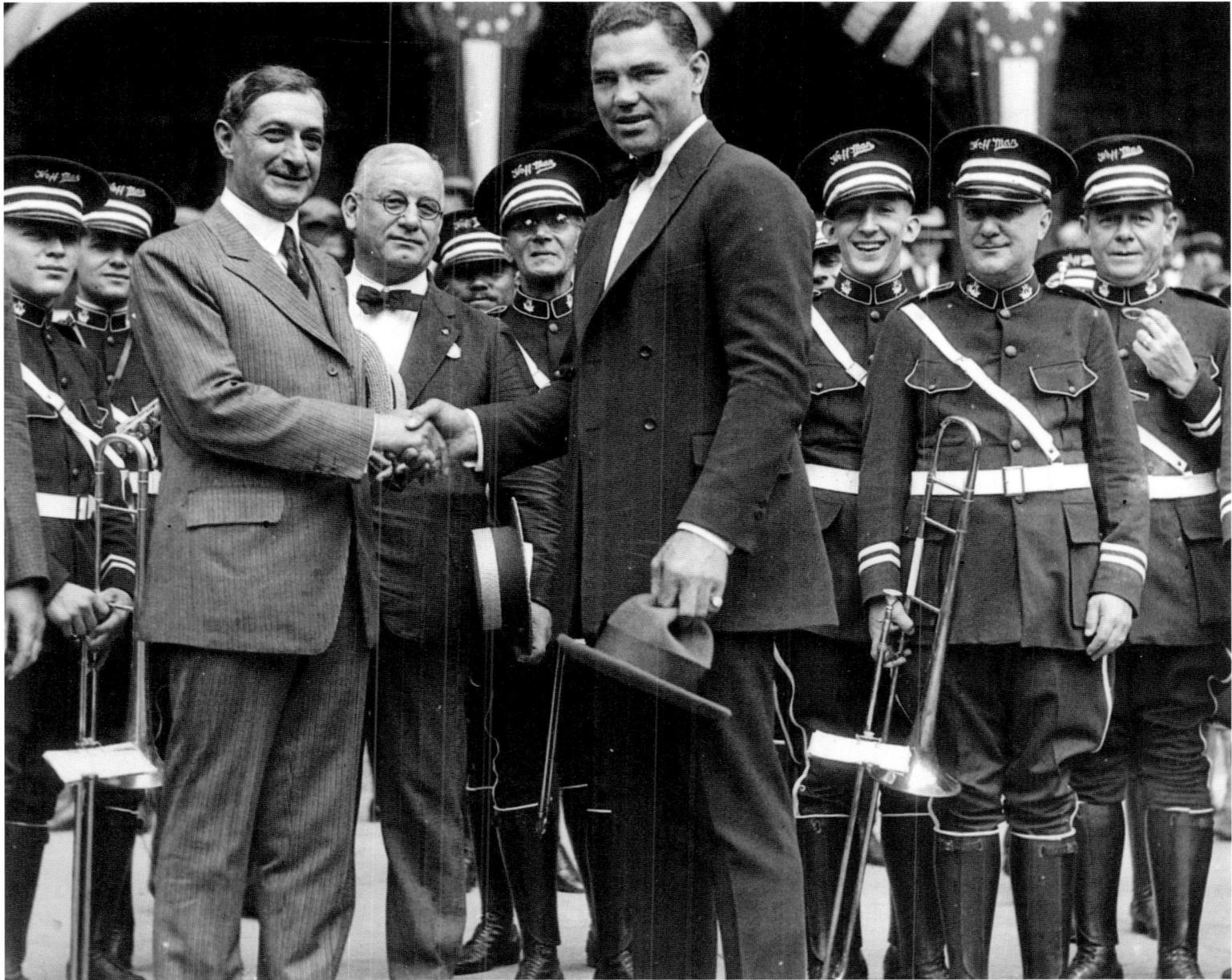

One of the great national celebrities of the 1920s was heavyweight champion Jack Dempsey, photographed here in front of City Hall during a visit to Syracuse. He is shaking hands with John H. Walrath, mayor of Syracuse from 1922 to 1925.

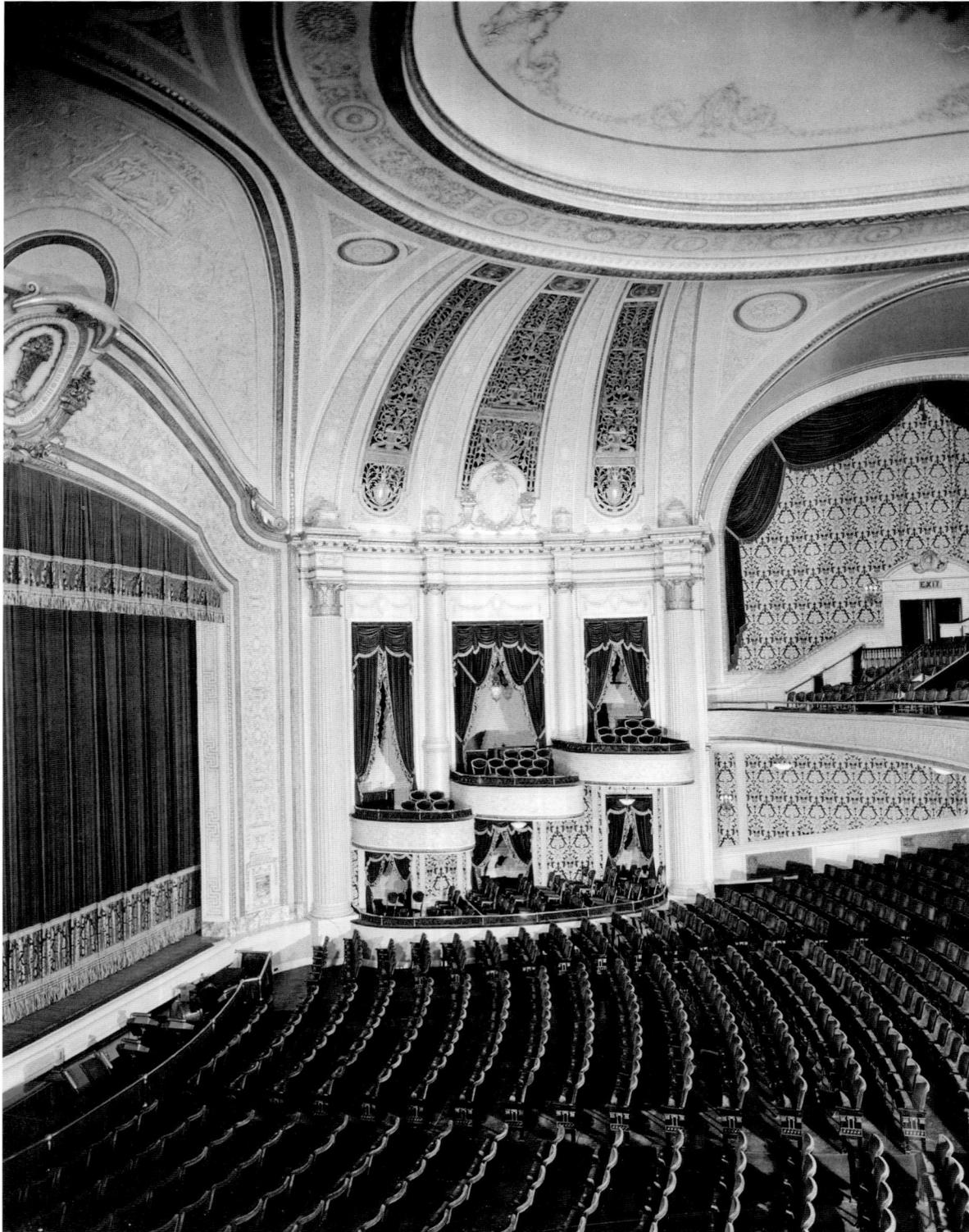

Perhaps nothing exemplified the decades of the 1920s and 1930s as much as the numerous movie houses that populated the city. One of the grandest was RKO Keith's, which stood in the 400 block of South Salina Street.

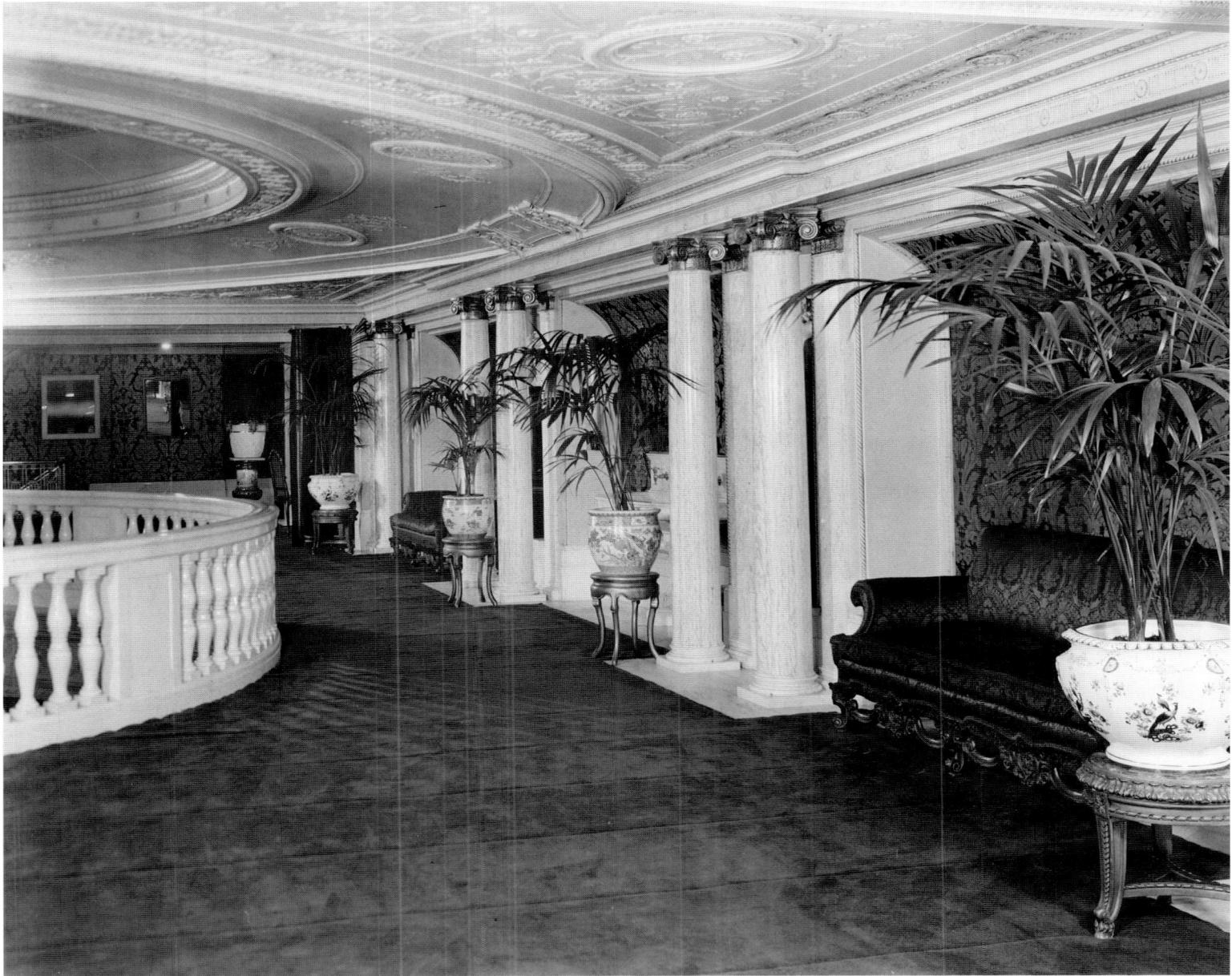

Keith's interior featured elegant classical detailing as seen in this 1920s view of the balcony lobby. The architect was Thomas Lamb, the same designer who would later turn to much more exotic visions for the city's Loew's State Theater, today restored as the Landmark Theater.

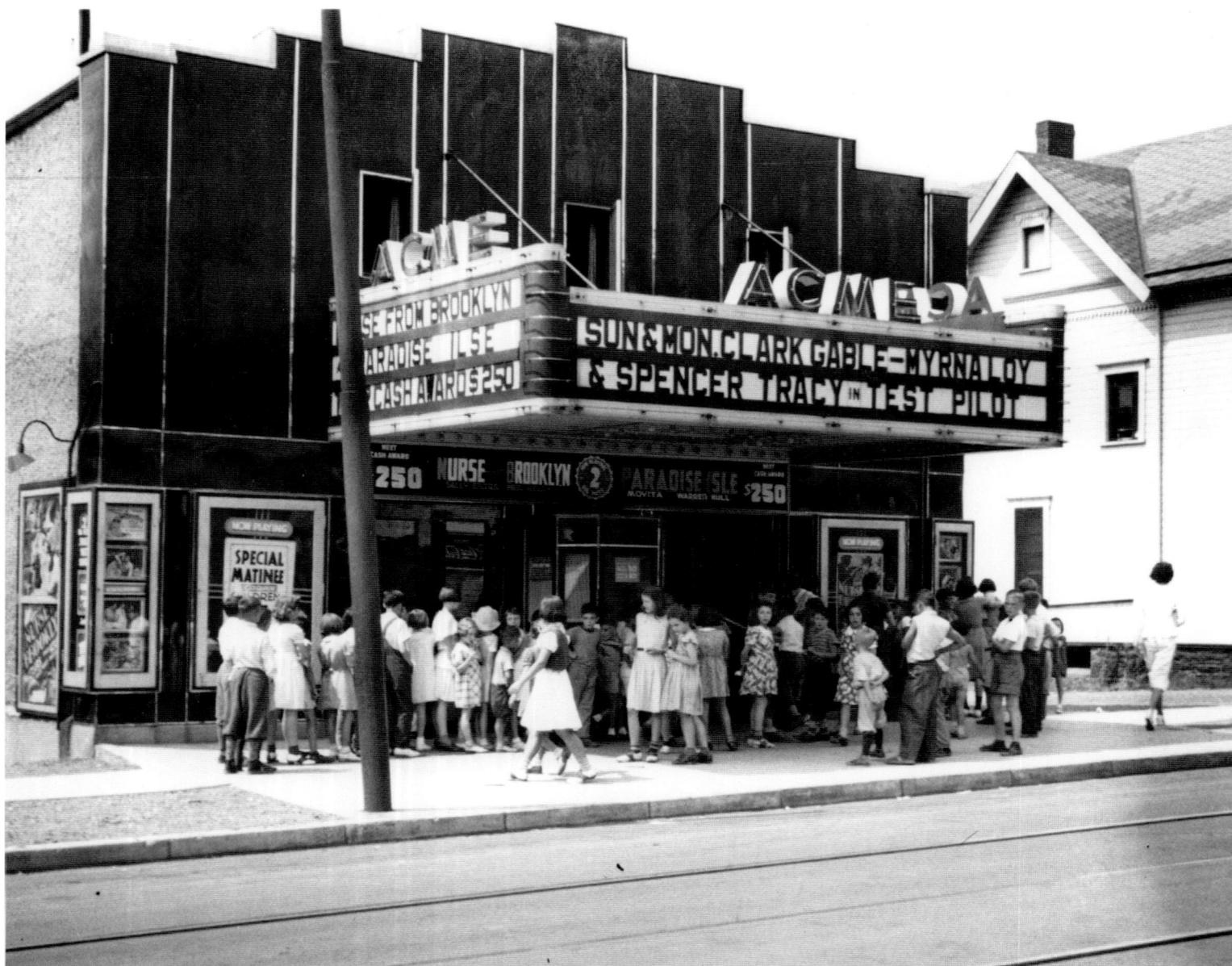

On the city's North Side, the Acme stood on Butternut near Park Street. This view appears to capture a matinee performance in 1938.

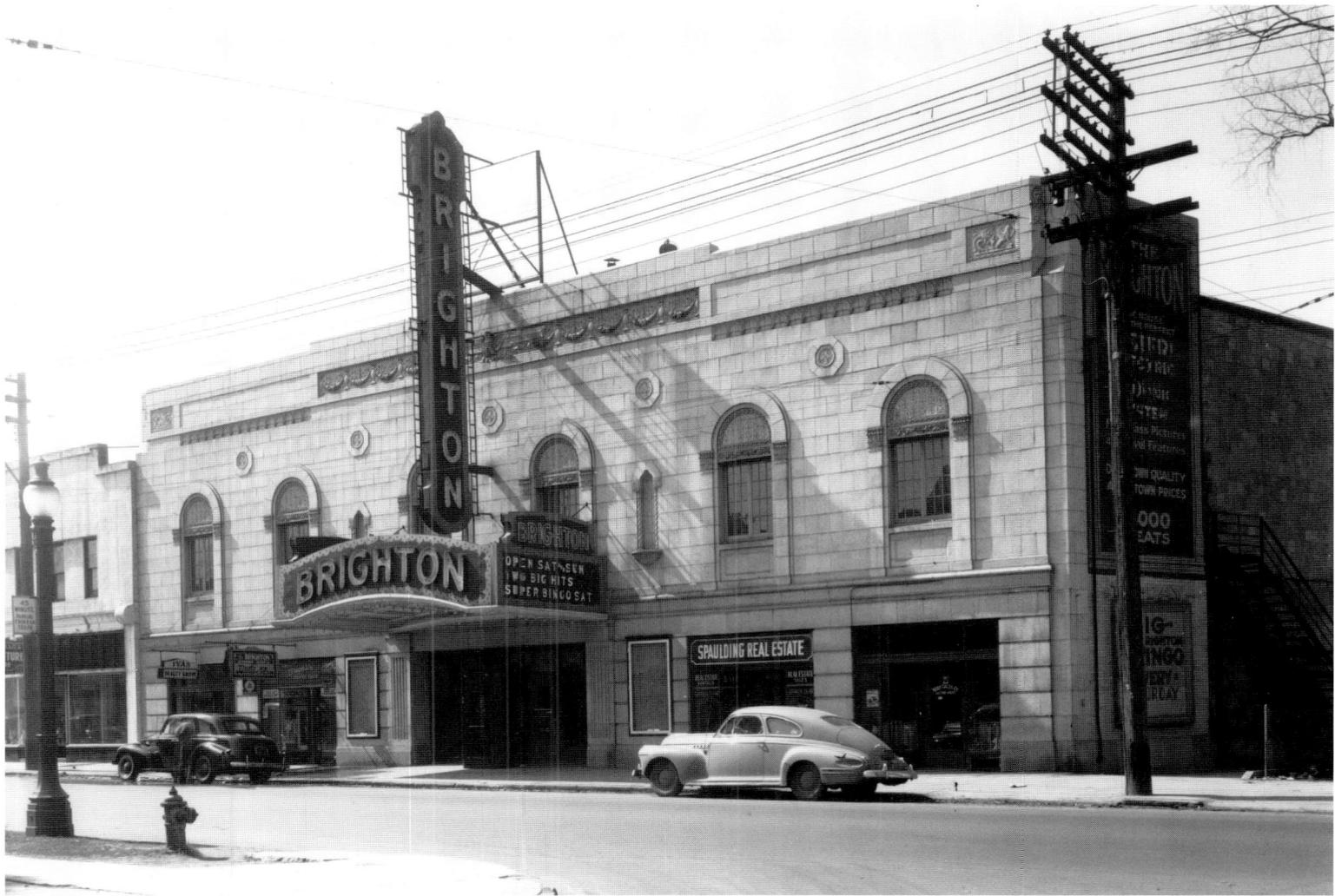

Syracuse neighborhoods boasted several theaters that became the haunts of a whole generation during the era, with double features and Saturday matinees. One of the larger ones was the Brighton on the city's South Side. It opened in 1929 with 1,750 seats. It has now been incorporated into the Dunk & Bright furniture store.

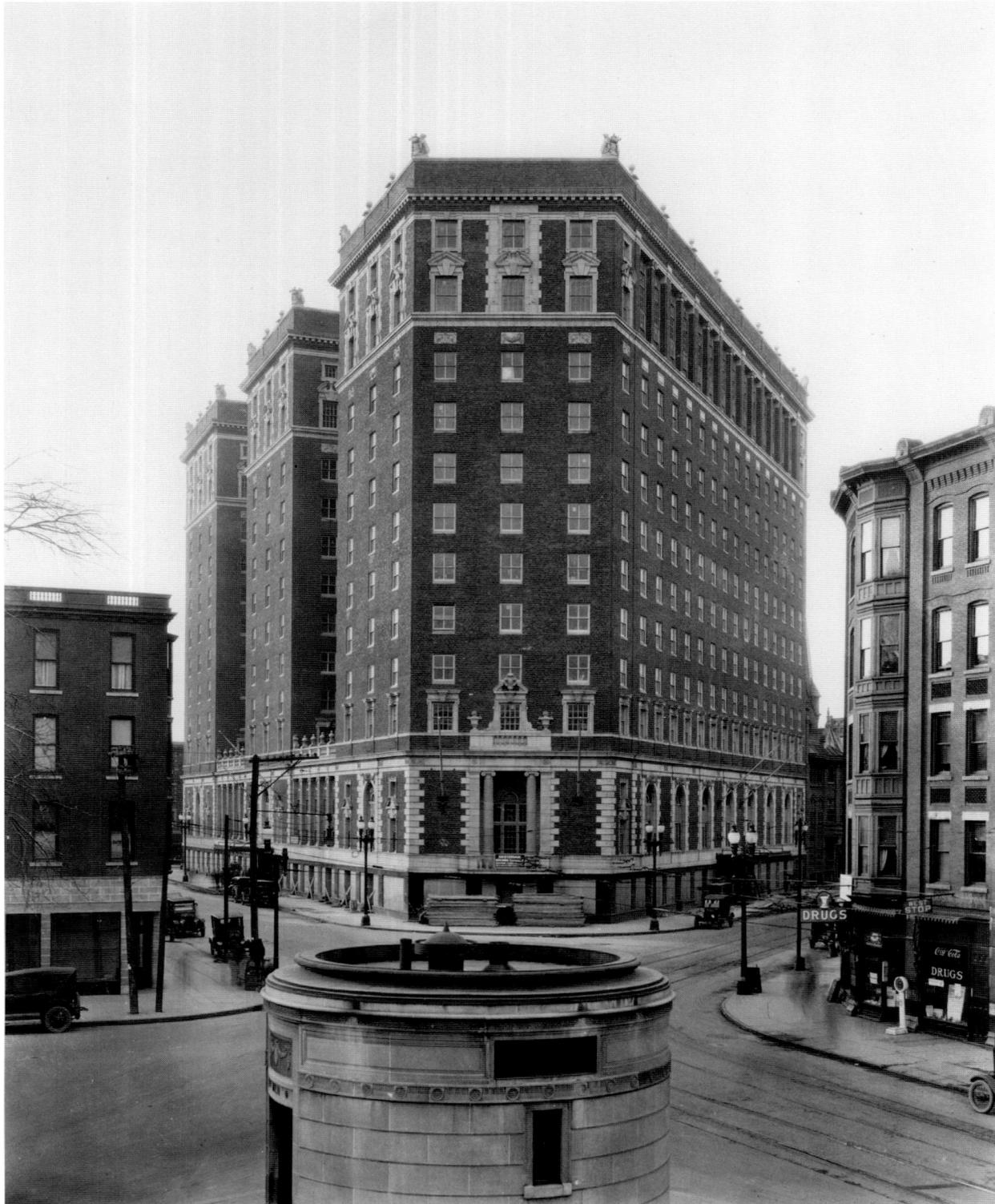

Another landmark that arrived in the 1920s was the Hotel Syracuse, the city's largest ever. It opened in 1924. This photograph shows construction material still piled on the sidewalks. In the foreground is the distinctive round entrance to the city's underground public restrooms that stood at the corner of South Warren and East Onondaga streets.

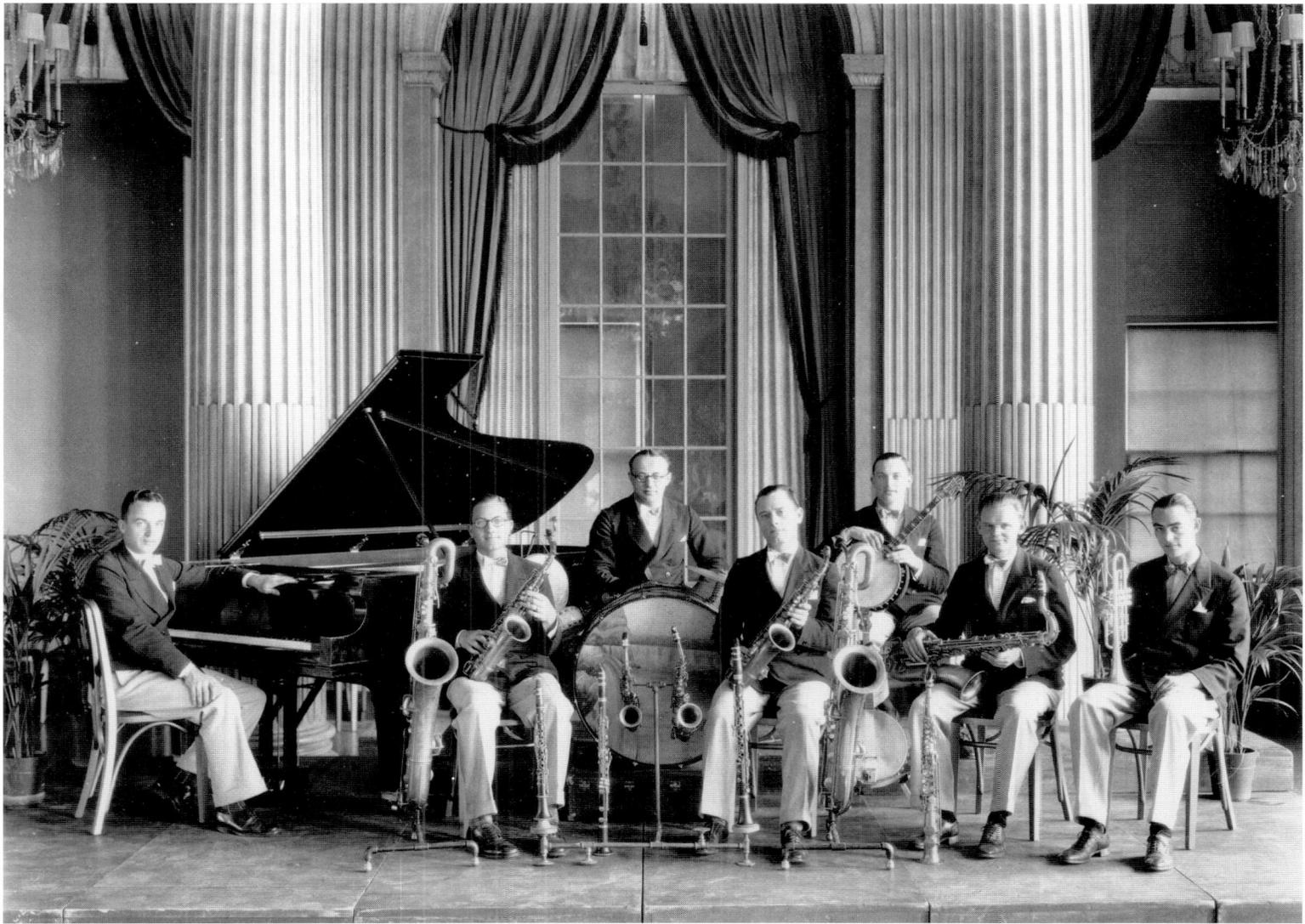

The public rooms of the Hotel Syracuse were often the venue for dance bands during the twenties, thirties, and forties.
This orchestra poses for a photograph in the Grand Ballroom about 1938.

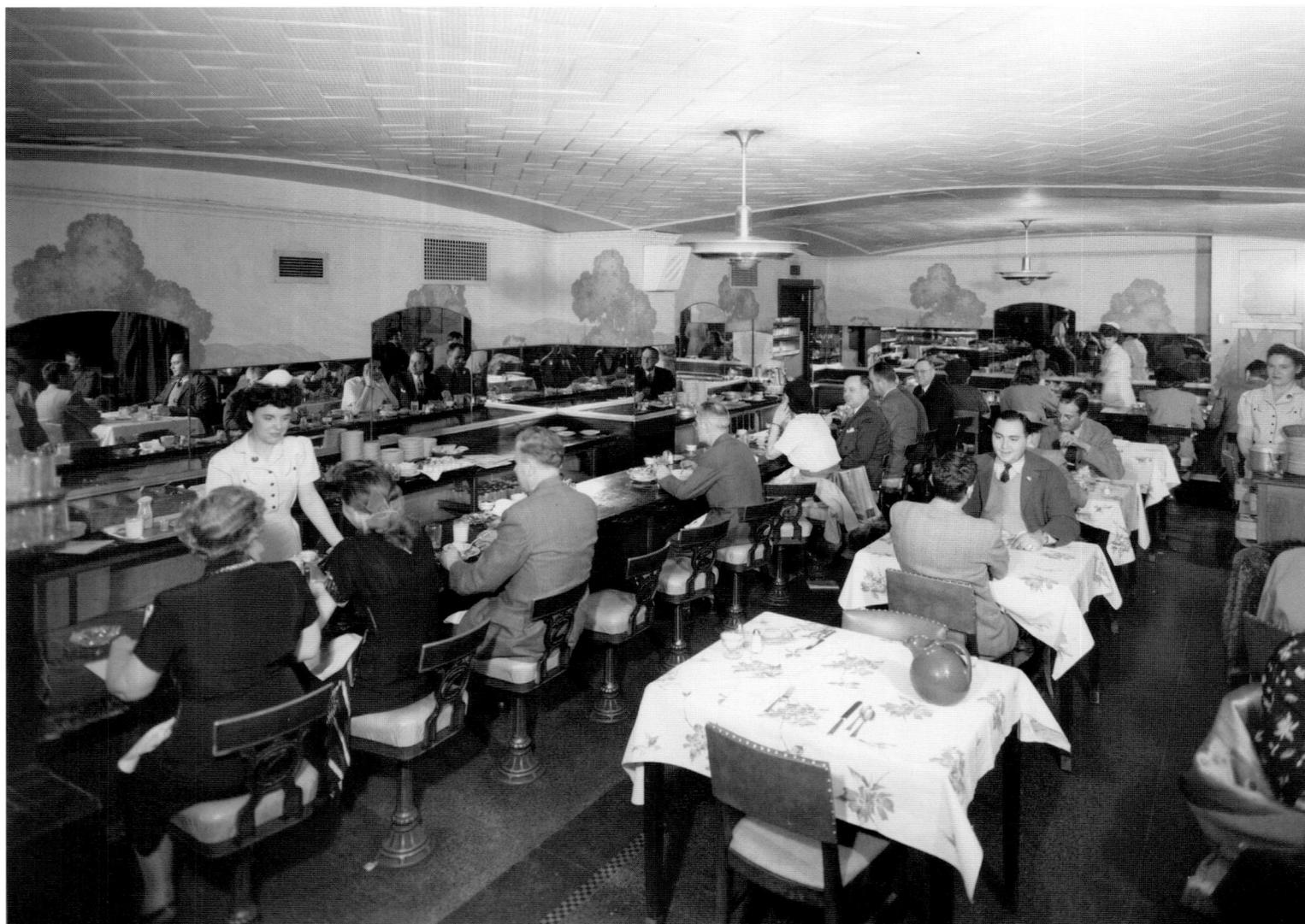

The Hotel Syracuse was a much-used facility in its heyday. In addition to offering lodging and large meeting places for events or conferences, it featured several restaurants, including this ground-floor cafeteria, photographed in 1948. It was used by many locals for lunch.

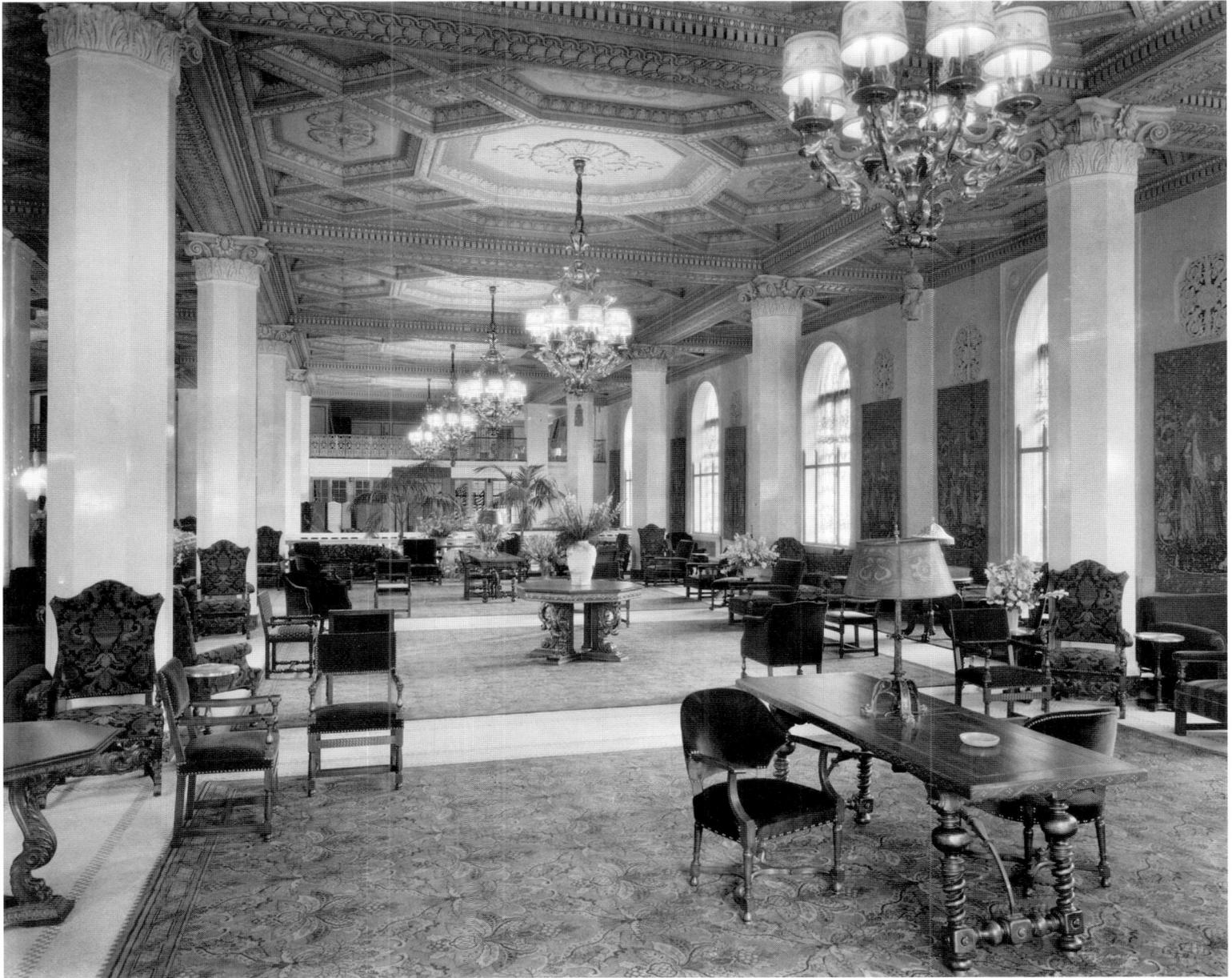

The Hotel Syracuse lobby was impressive. Visitors could feel that they had arrived at one of the great hotels of Europe or New York City upon entering. Its continuing presence in Syracuse today offers the city a valuable asset.

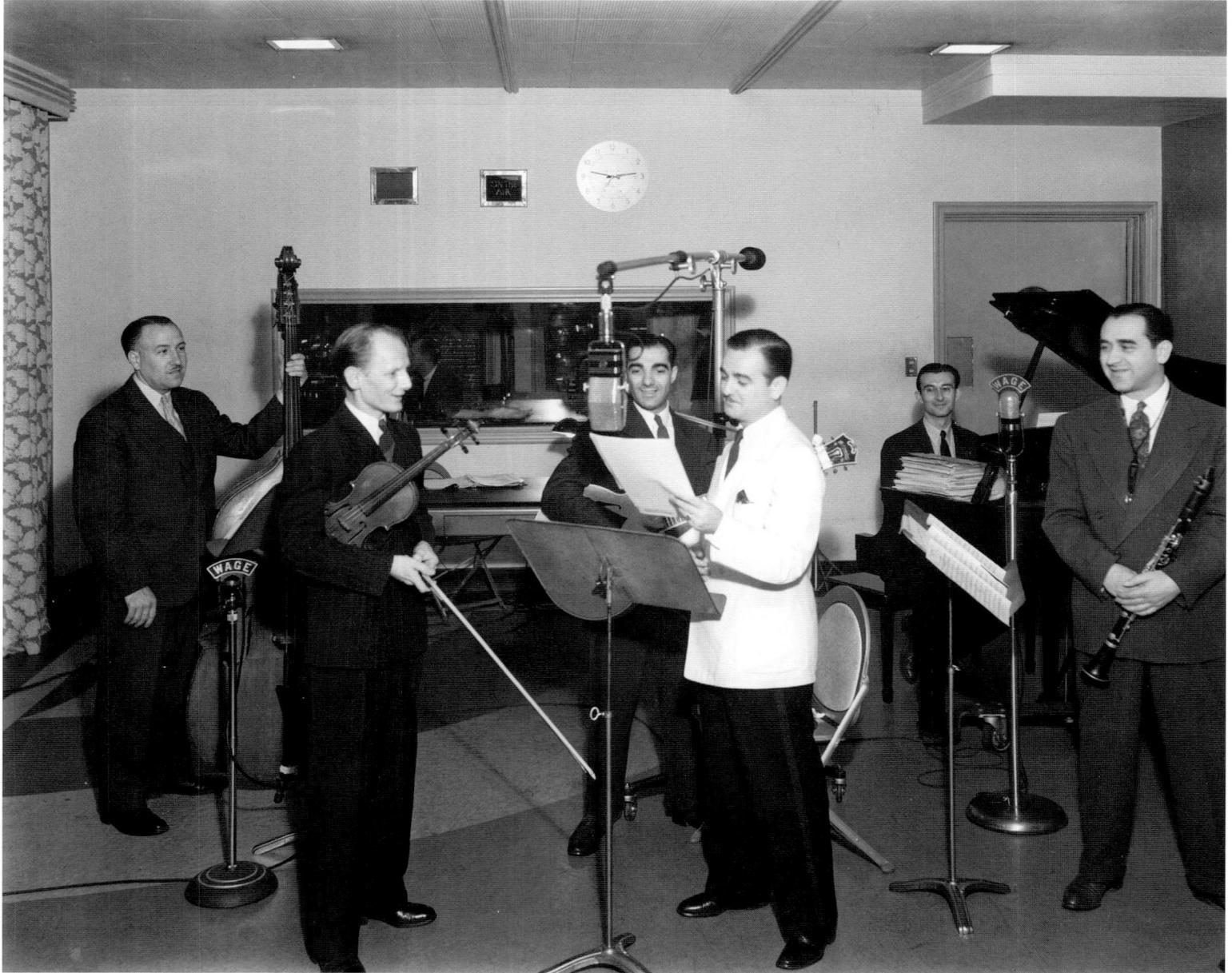

WAGE was one of the early radio stations in the city, going on the air in 1941 and eventually becoming WHEN. Its studios were in the Loew Building, where this orchestra is about to perform.

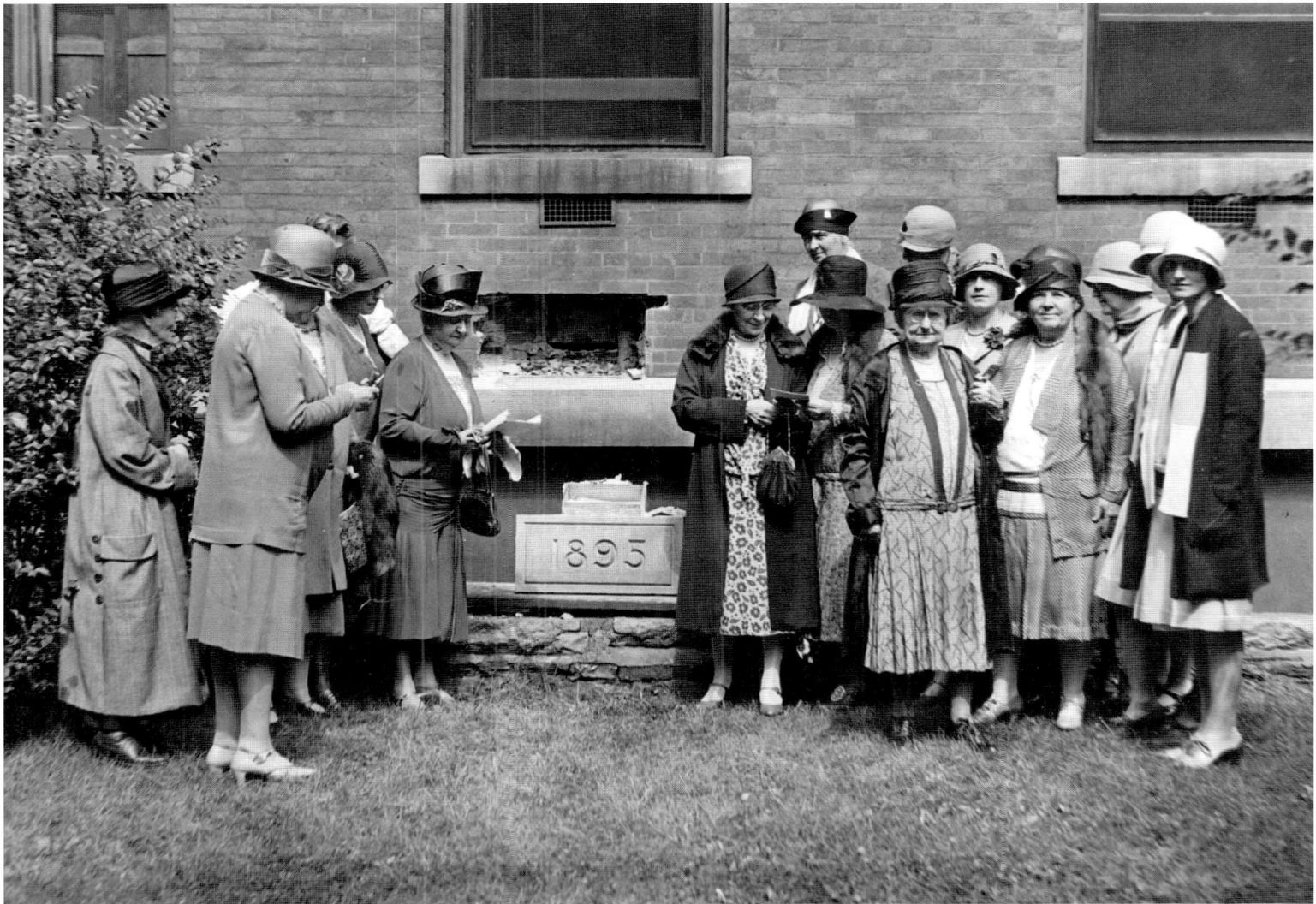

In 1929, as construction neared an end on the new Memorial Hospital on University Hill, members of its board held a ceremony at their old hospital on West Genesee Street, removing various historical documents sealed behind its cornerstone 34 years earlier. Mrs. James Crouse is seen standing in front (6th from right) facing the camera. In 1887, she had transported the first patients to the hospital in her carriage.

The new Memorial
Hospital, now part of
Crouse Hospital, was
designed with classical
details by architect
Dwight James Baum.
Baum had married
into a local family
who were longtime
supporters of the
hospital. He worked
on this commission
with John Russell
Pope, who went on to
design the Jefferson
Memorial in the
nation's capital. Baum
also designed circus
impresario John
Ringling's home in
Sarasota, Florida.

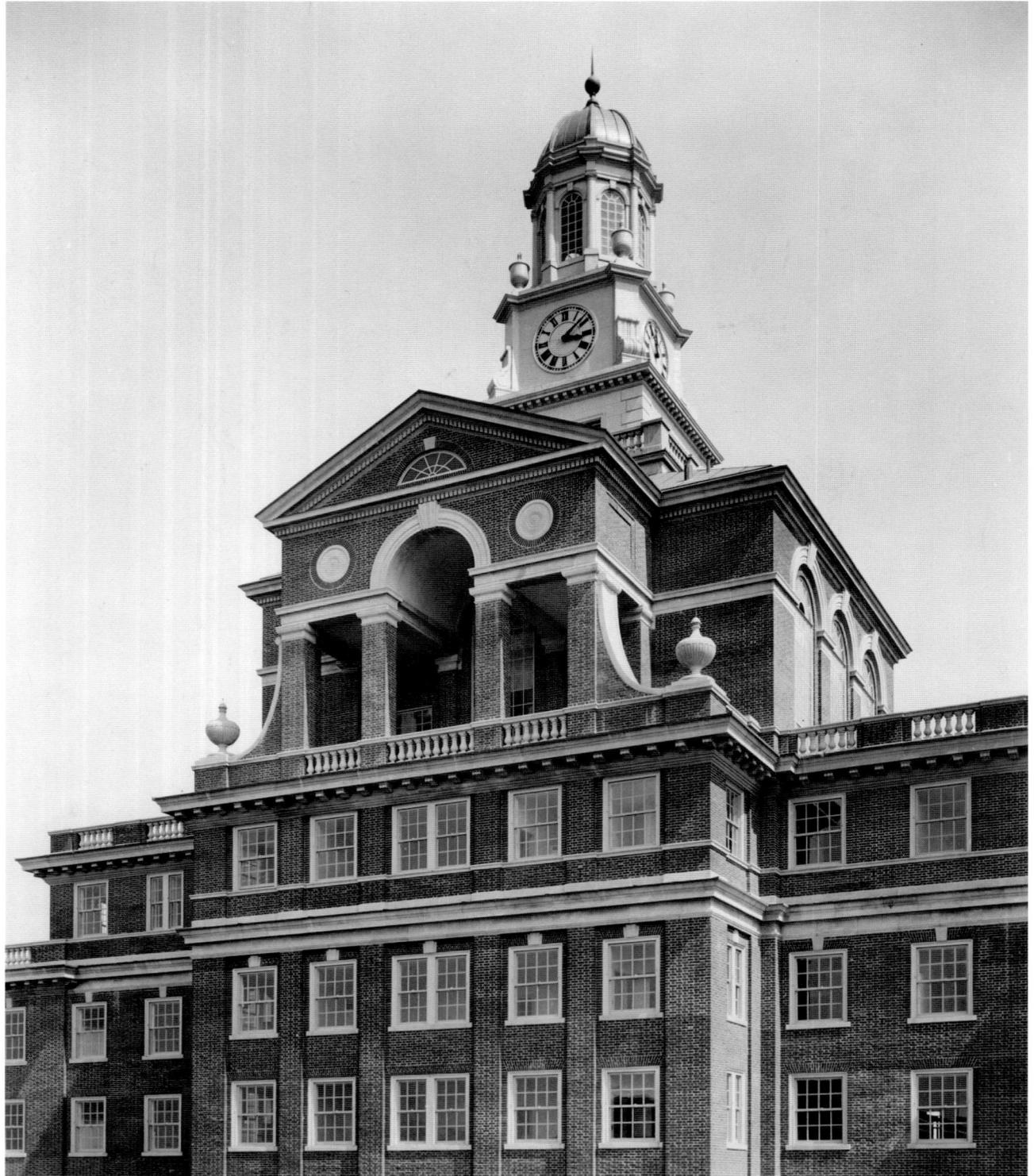

Leaving downtown, South Salina Street in 1932 held many residential structures as this view near Castle Street documents. A big change, however, had occurred. In 1929, a new Sears, Roebuck and Co. store opened nearby, boasting 500 employees at the time. Long closed, the building still exists and re-use plans periodically surface.

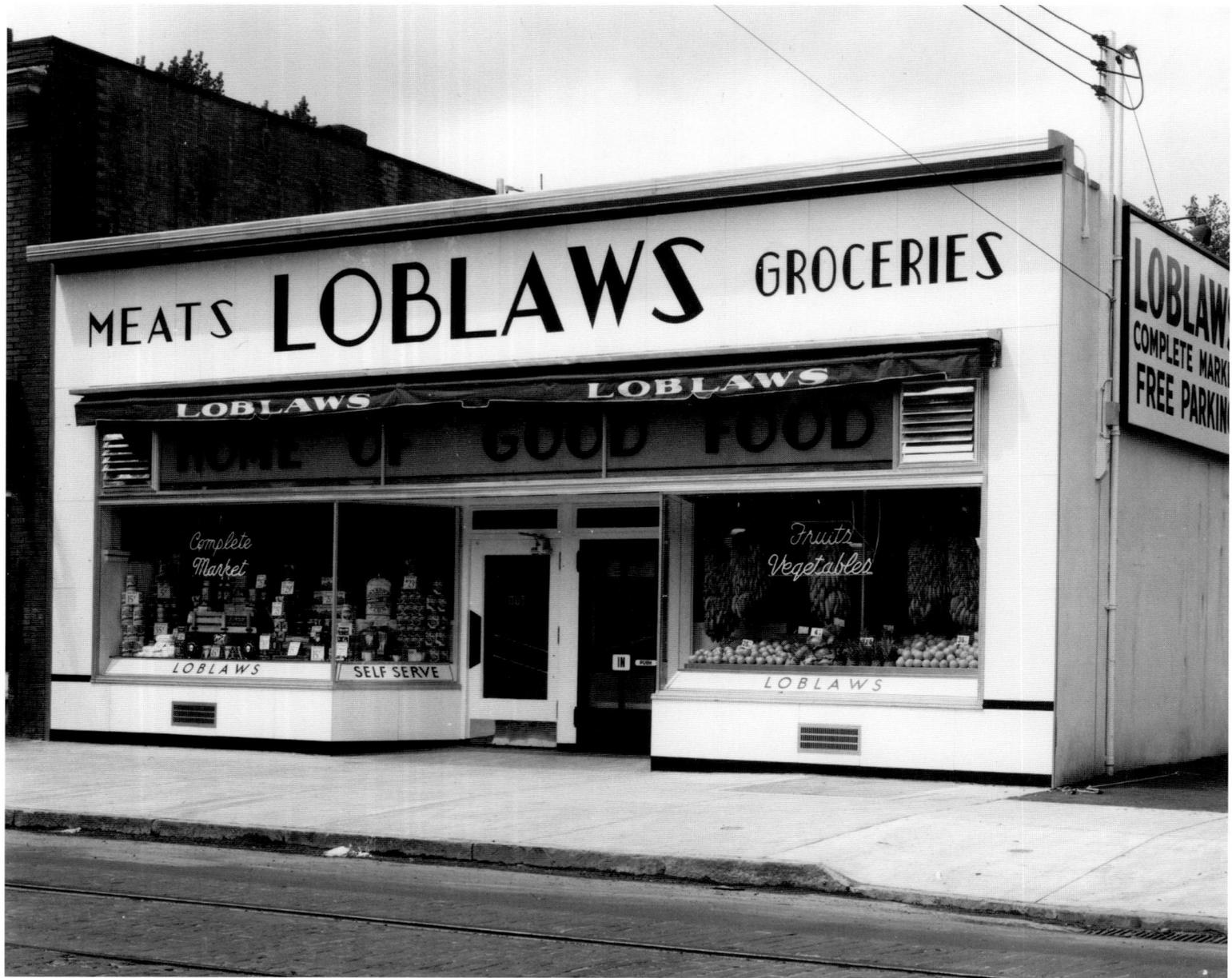

Loblaws was a supermarket chain based in Canada that had opened stores in upstate New York by 1940. One was located on South Avenue near Colvin Street. This kind of retail outlet was a transition between the locally owned neighborhood corner grocery and the large, suburban markets of today.

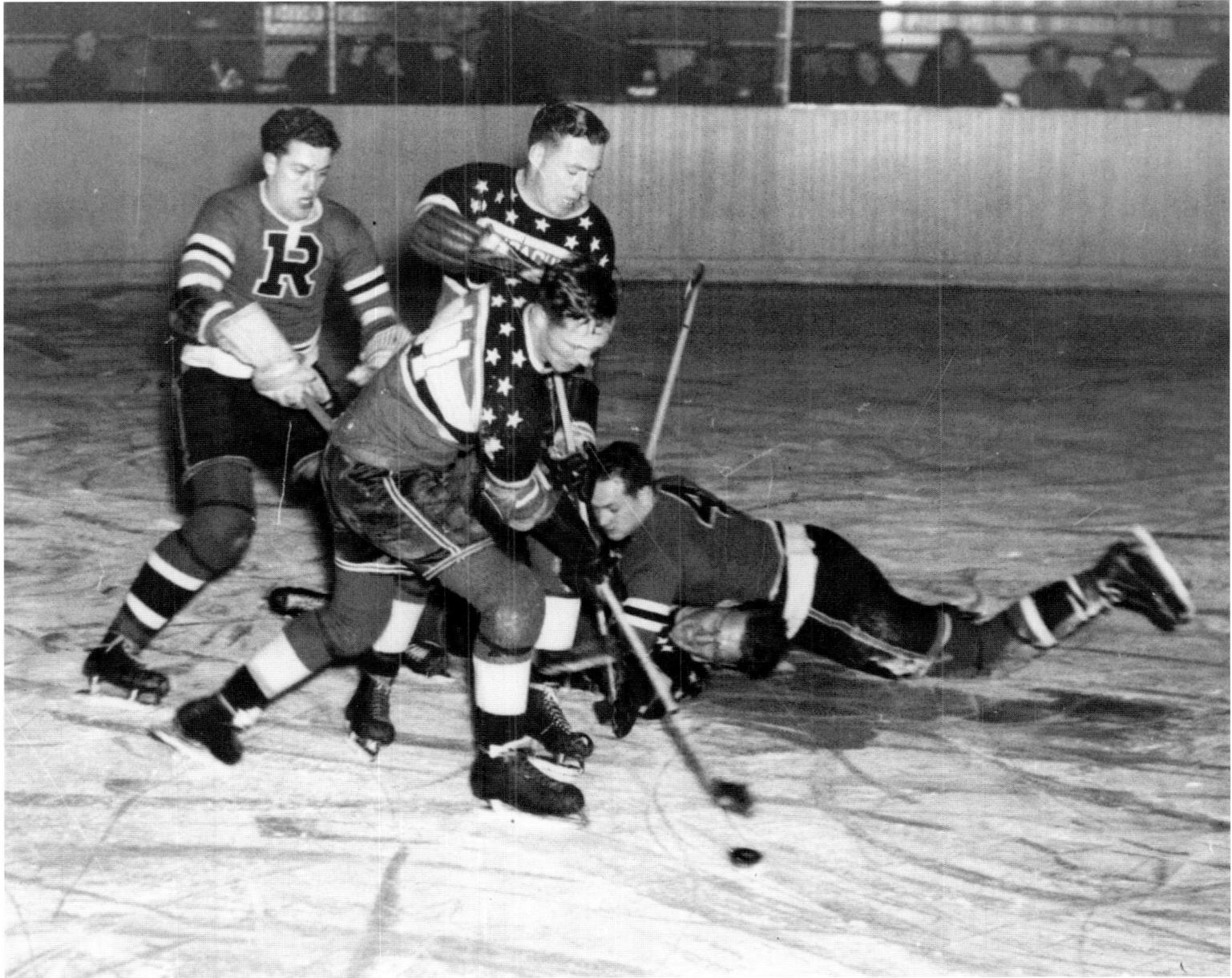

Professional hockey has a long, though sometimes erratic history in Syracuse. The much-loved team in the 1930s was the Syracuse Stars, who played at the State Fair Coliseum. In 1937, the Stars became the first team to win the American Hockey League's championship Calder Cup Trophy.

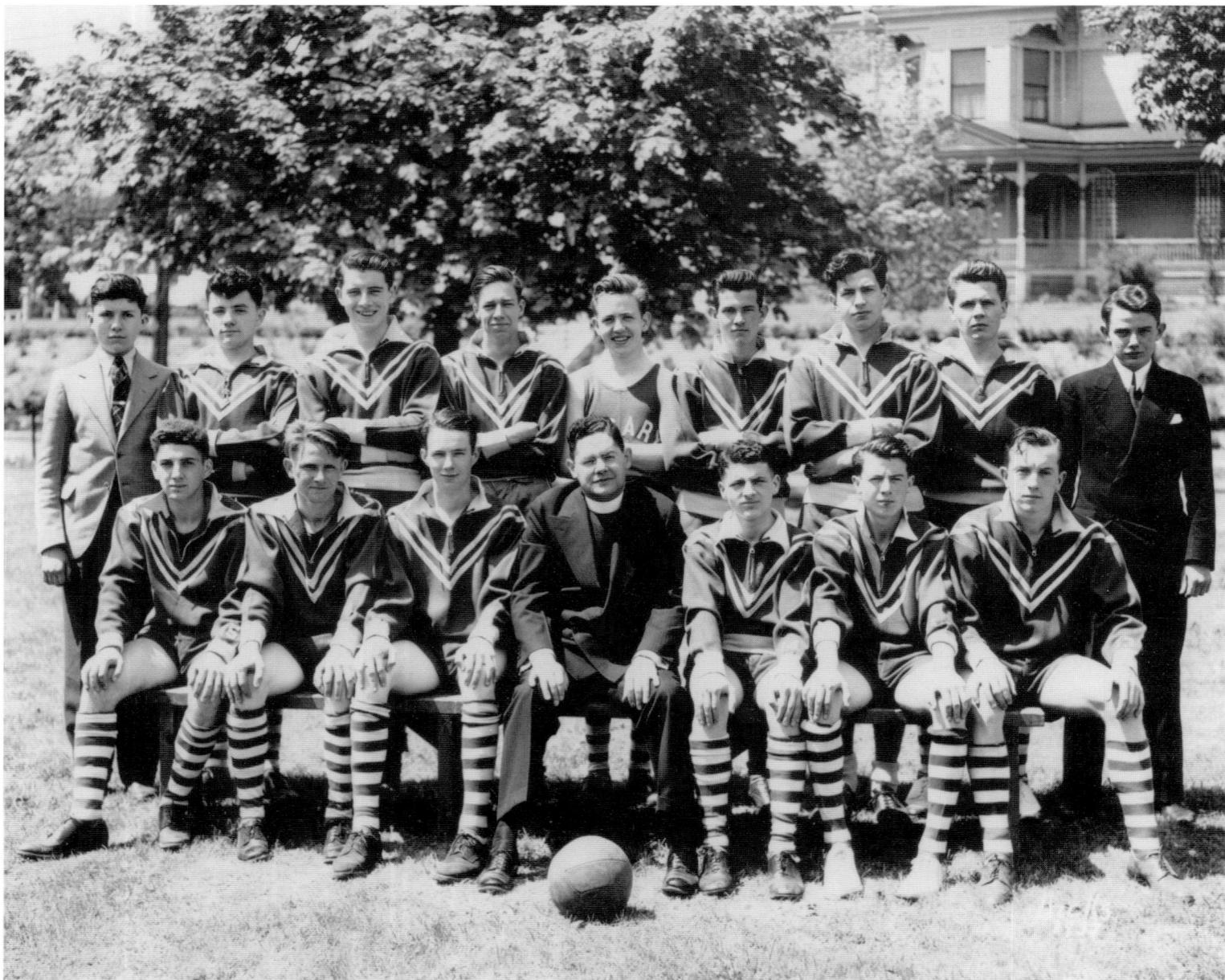

Widely popular today, soccer was a sport of small repute in the 1930s. Most Holy Rosary High School, however, on Roberts Avenue, fielded a team during the era.

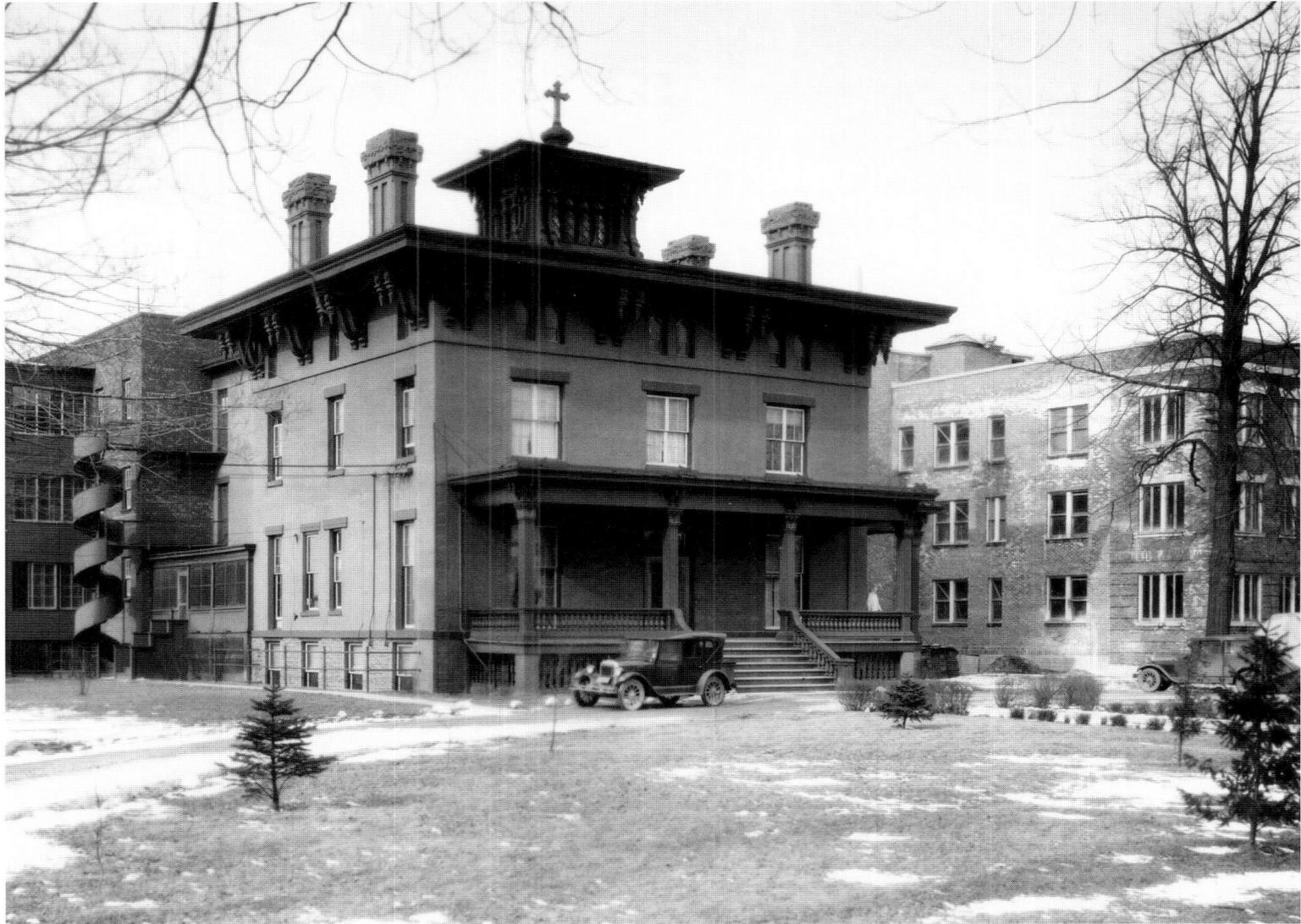

This majestic Italianate house on Court Street had been converted by this time in 1928 into St. Mary's Maternity Hospital. The complex was eventually sold, and this house, including its original decorative plaster and woodwork interiors, was demolished in 1975. It was built in the mid–nineteenth century as the home for Elizur Clark, a local salt manufacturer and lumber dealer.

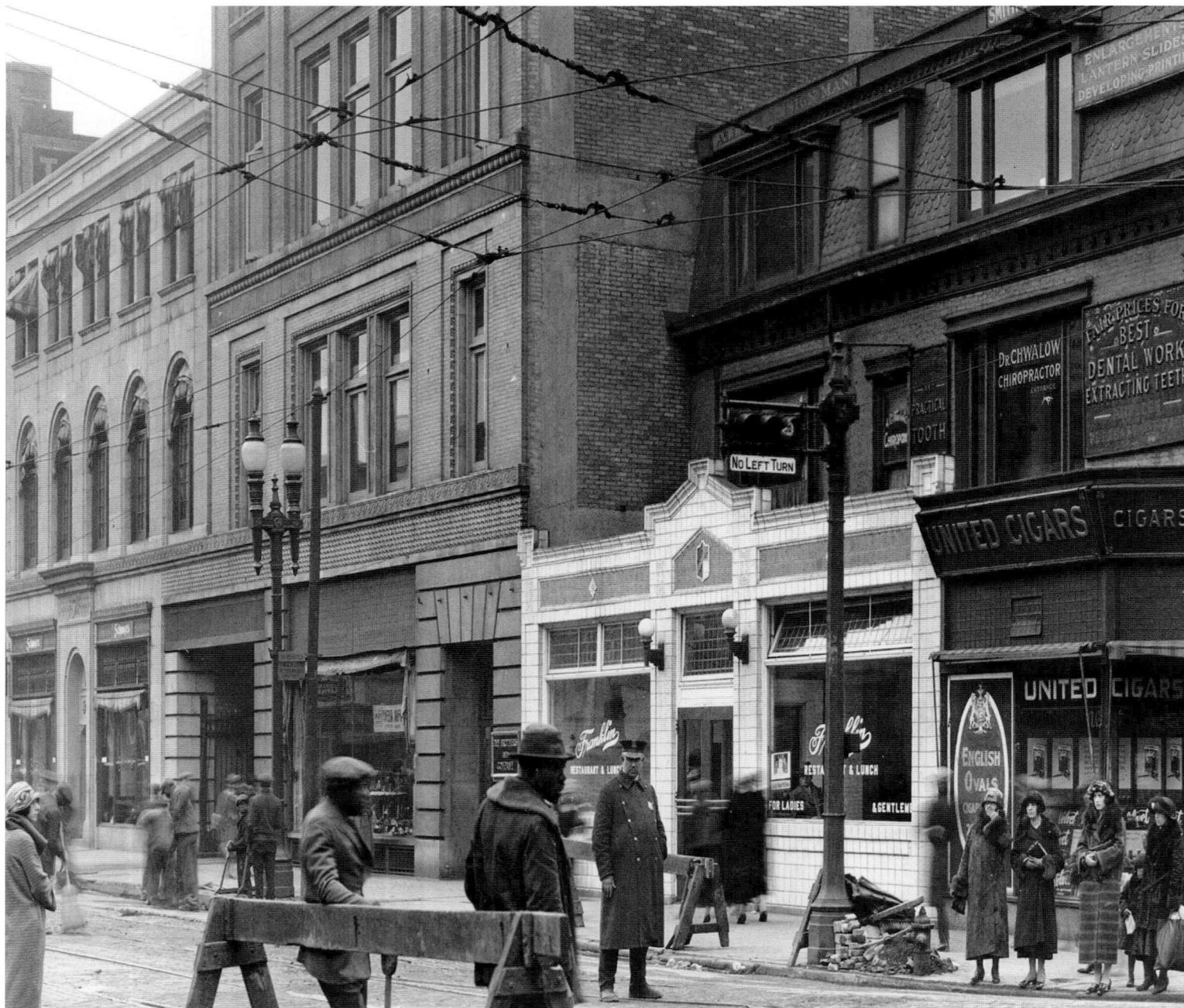

In the 1920s, the southwest corner of Jefferson and Warren streets contained a cigar store, dental offices, a chiropractor's clinic, and a lunchroom dubbed the Franklin, which even used the local car company's distinctive logo. On the third floor were the studios of Smith & Lindsey Photographers, many of whose images are included in this book.

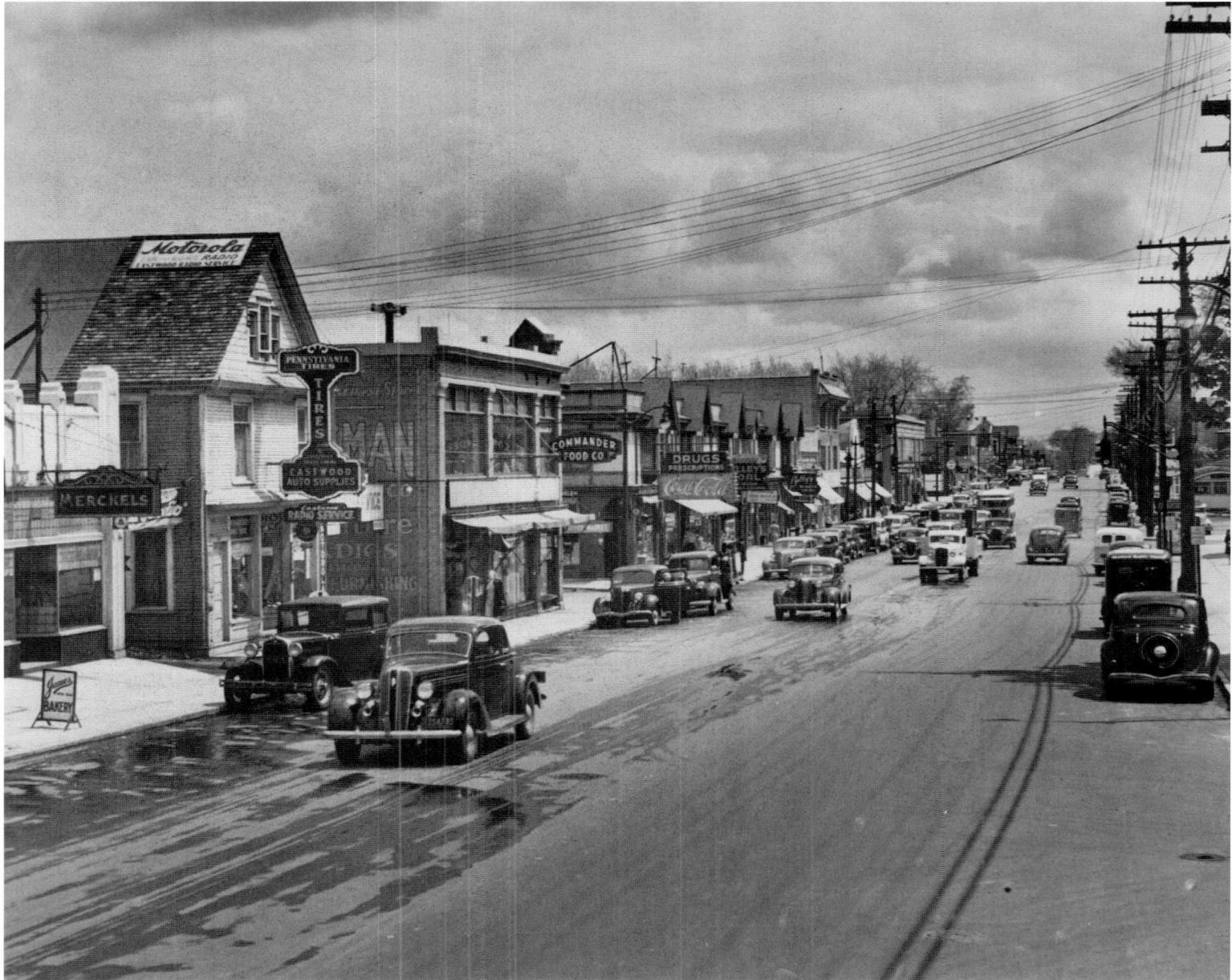

Eastwood developed as a separate village but was absorbed into the city of Syracuse in the 1920s. James Street served as its main commercial thoroughfare, a bustling place in the 1930s, like today.

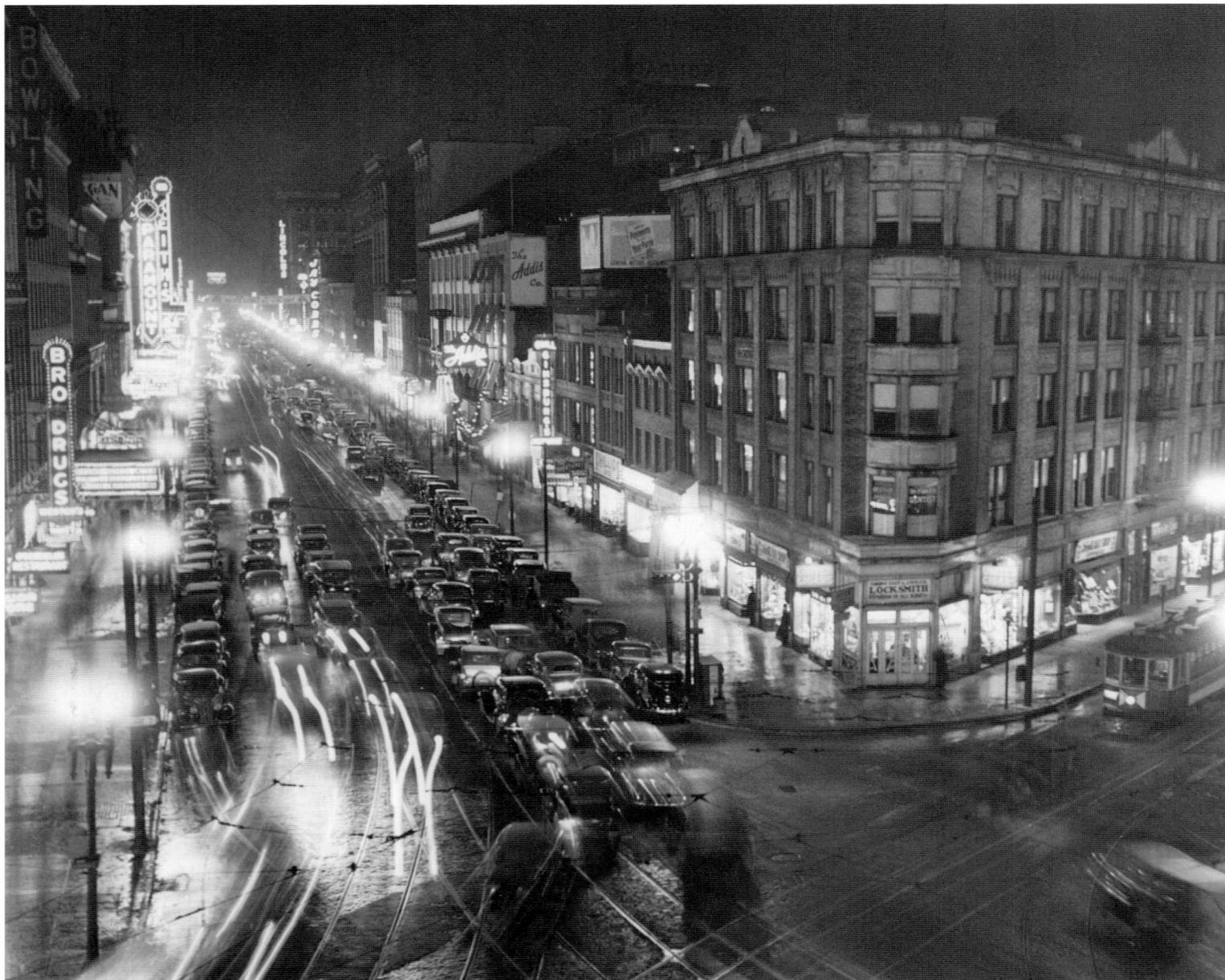

In 1936, South Salina Street glowed at night with its numerous movie theaters, department stores, and shops. A streetcar on East Onondaga Street approaches the intersection.

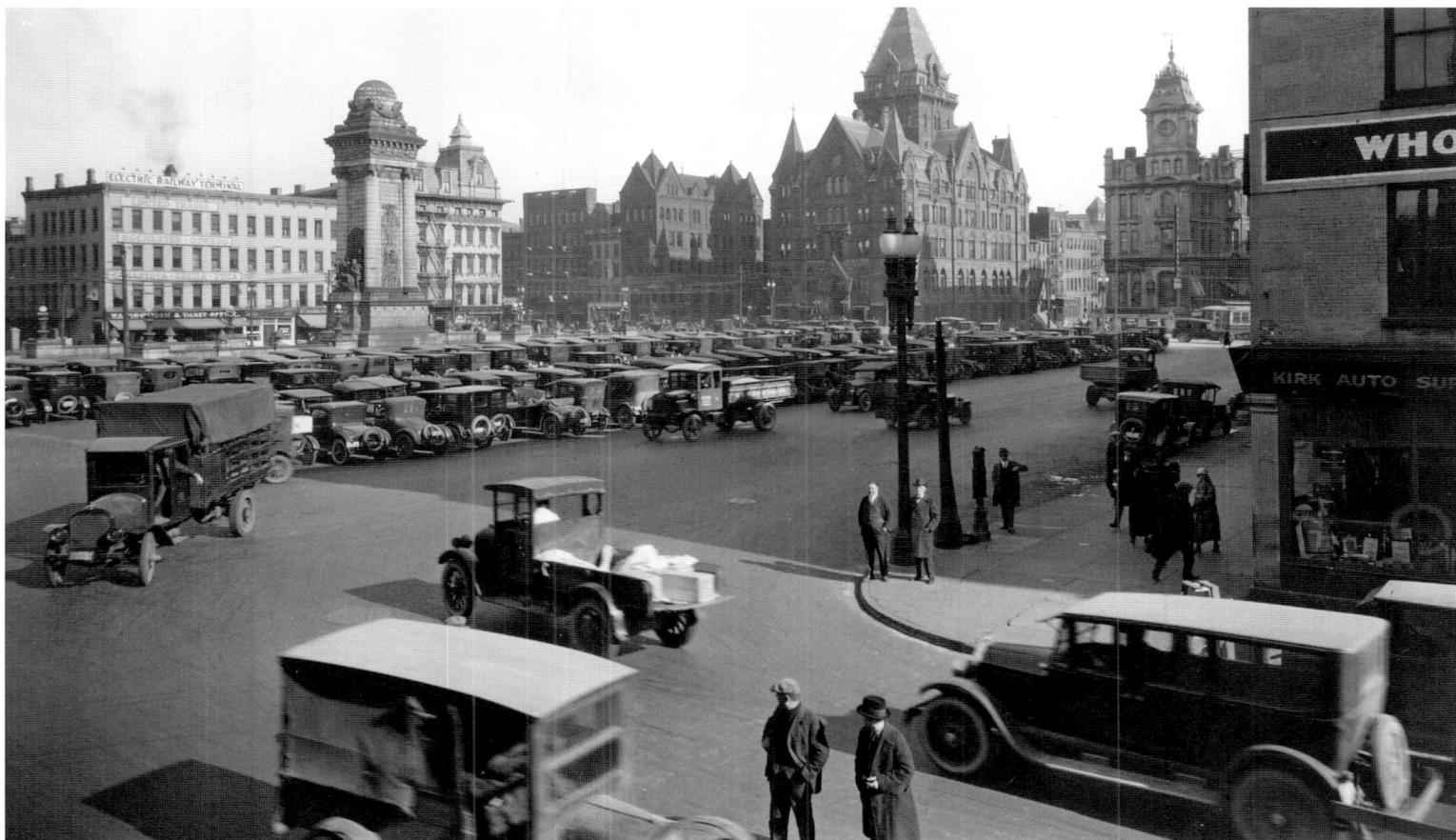

The replacement of the Erie Canal with the New York State Barge Canal meant that the old canal's path through the city could be filled and paved in the early 1920s, an improvement welcomed by most citizens because it eliminated all the troublesome bridges that had to be lifted or swung out of the way for canal traffic. Clinton Square thus became a large parking lot.

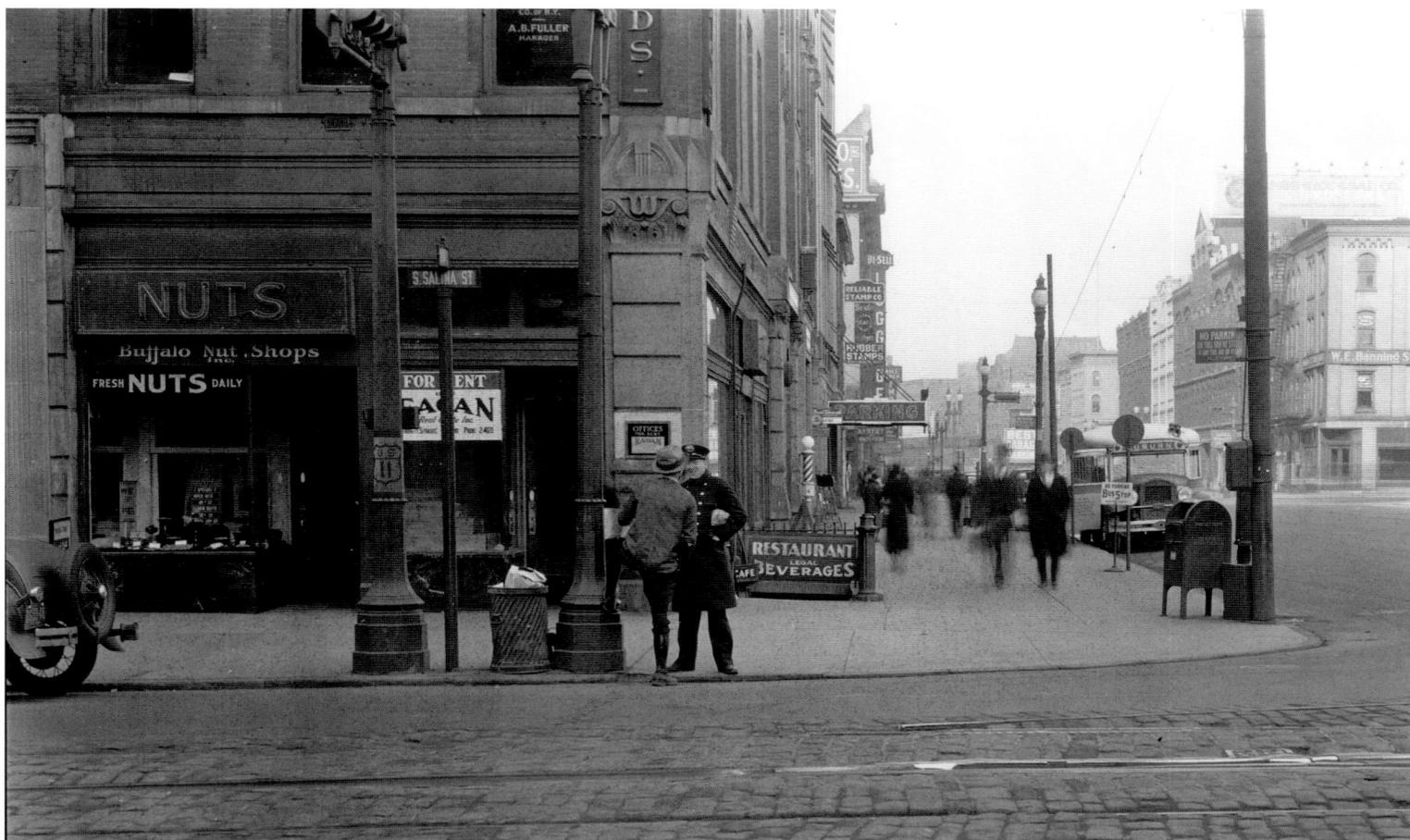

A sidewalk conversation is captured in this 1934 image at the southwest corner of Water and Salina streets. The "W" on the column behind the two men marks the Weiting Building. A sidewalk stairway provides access to a basement-level restaurant as a bus prepares to debark for its route between Taunton, Split Rock, Marcellus, Skaneateles, and Auburn. Behind the pole-mounted "No Parking" sign, the facade of the Amos Building is visible, the only structure in this photograph still standing.

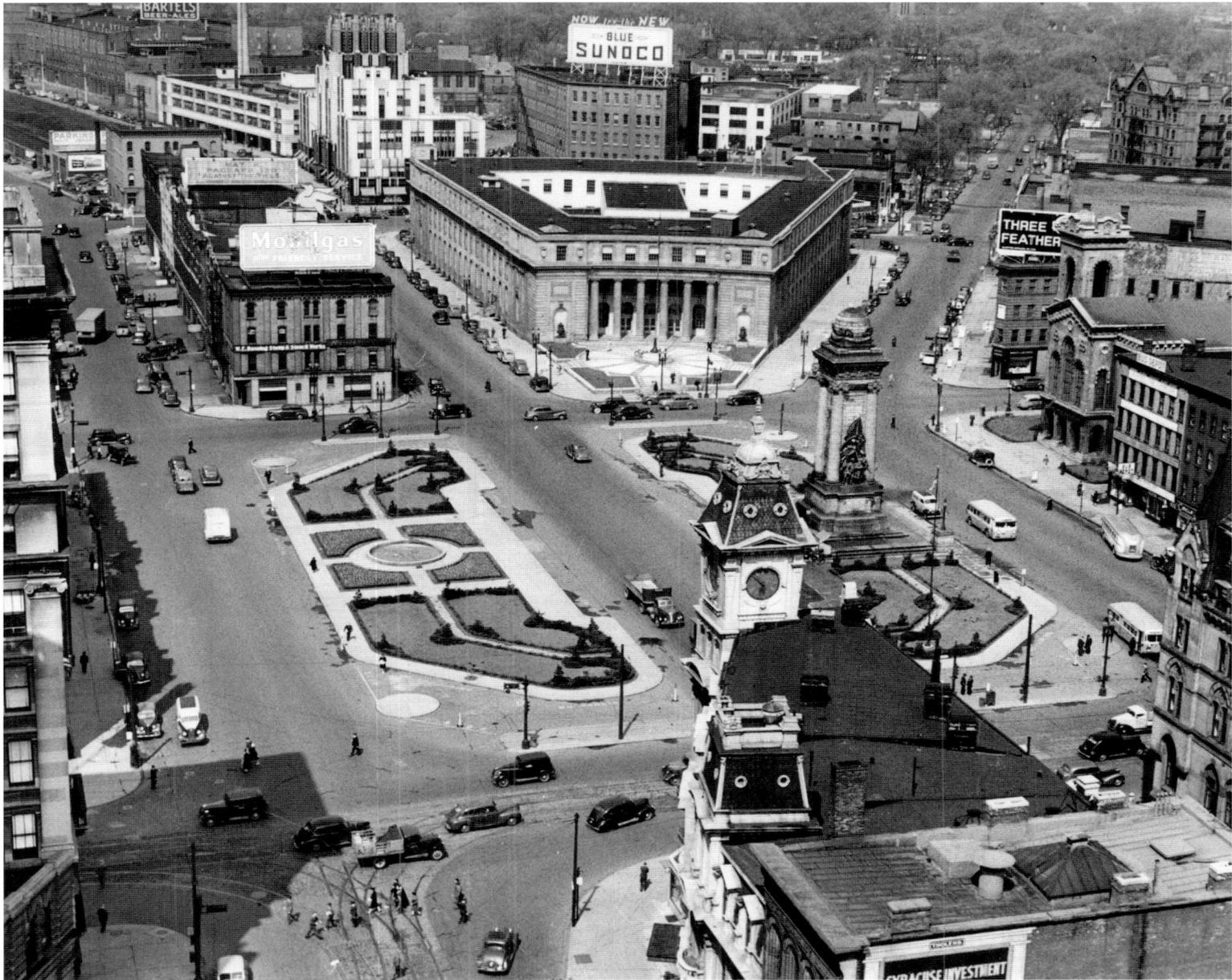

By the mid-1930s, a public works project had transformed Clinton Square from an open parking lot into a more formally landscaped urban space. At this time, the square was still surrounded by nineteenth-century buildings except for the wedge-shaped federal Post Office (upper-center), built in 1928.

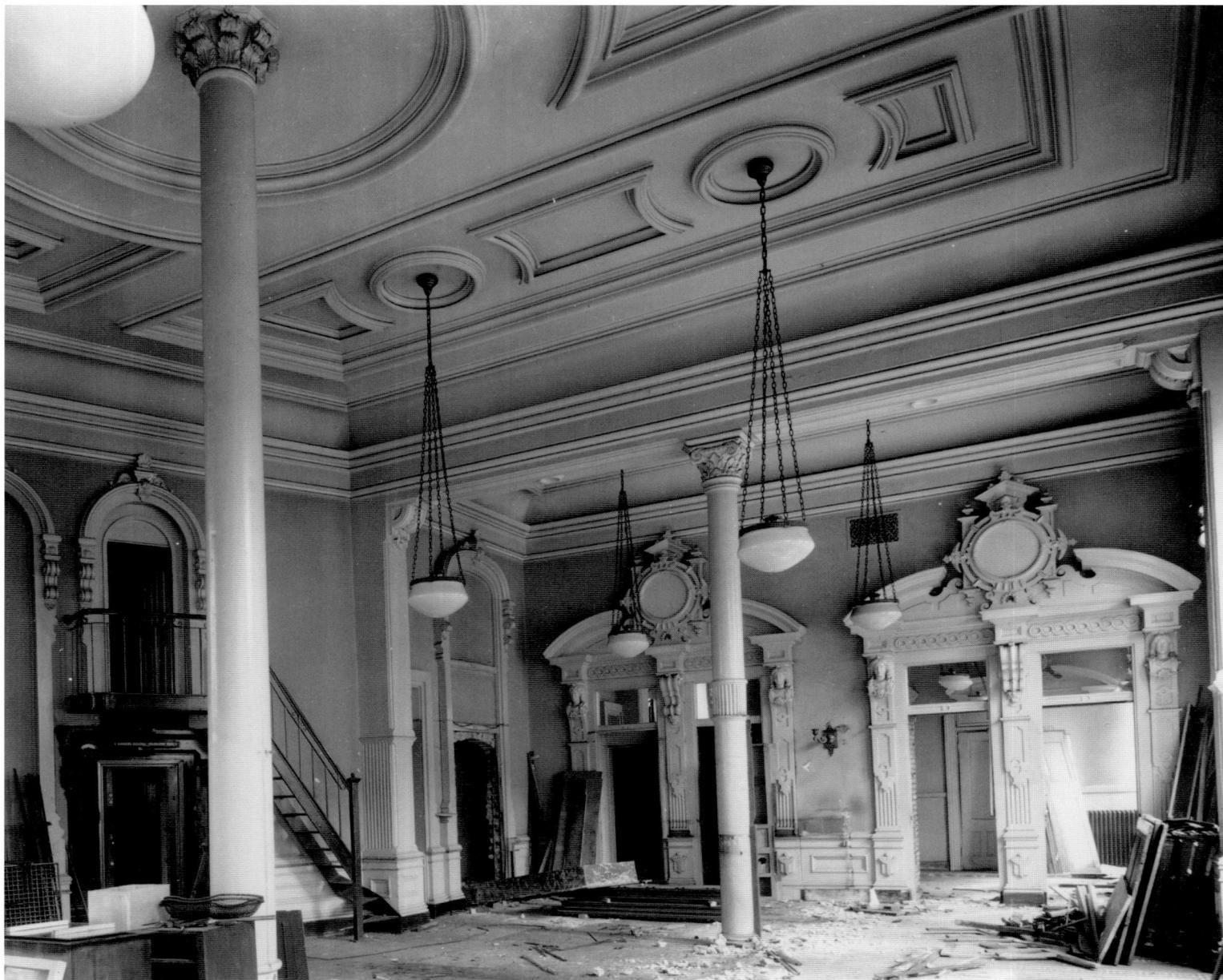

In 1936, downtown's Gridley Building was more than 65 years old and owners wanted to modernize the interior. This construction photo documents the details of what had originally been floor space for a bank. All of this molding and trim would be removed during the remodeling.

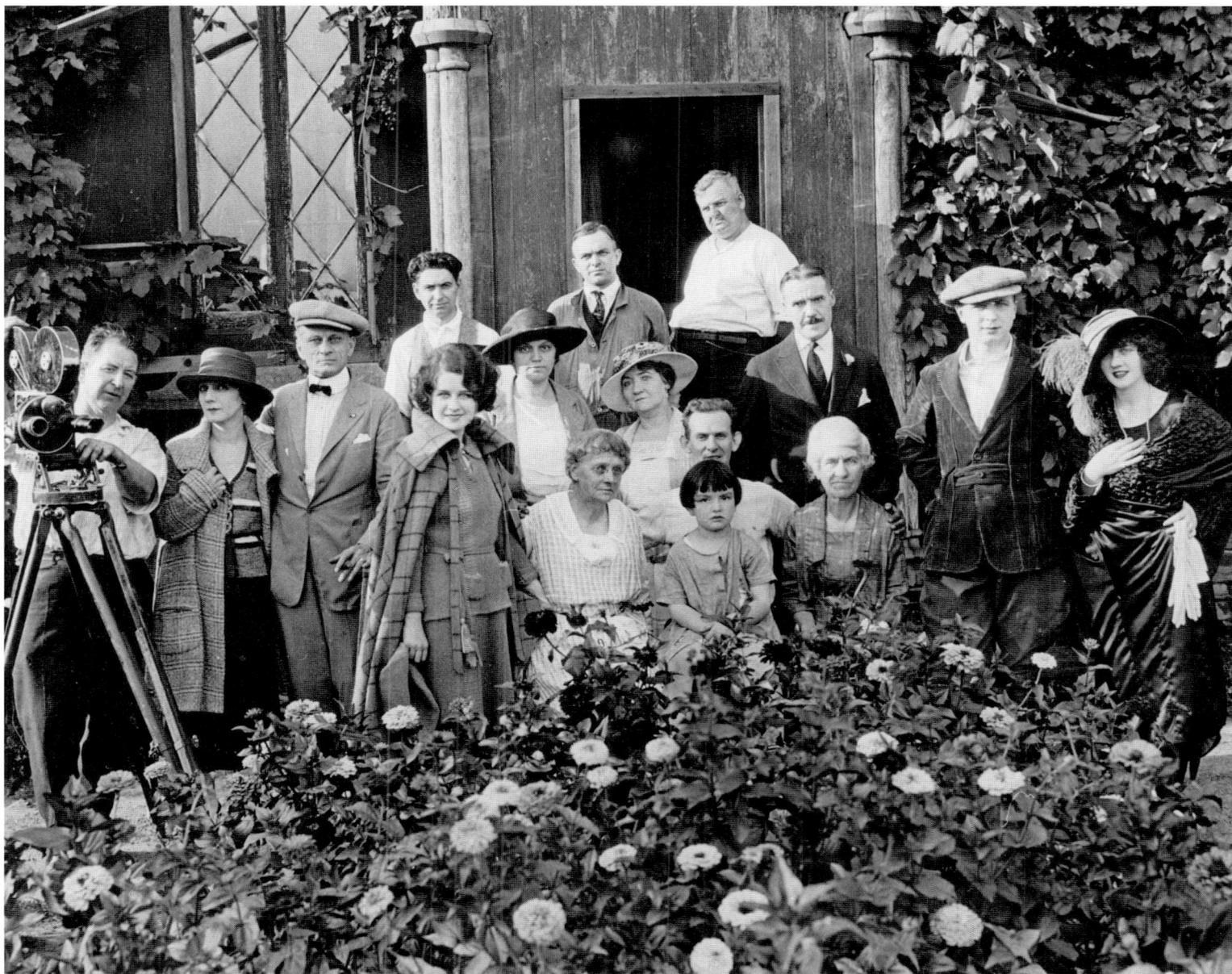

An ambitious effort in early local cinema centered on Eugene W. Logan, standing with the camera at left. In 1923, he produced and filmed a silent melodrama called *A Clouded Name,* with scenes shot around Syracuse. Logan cast a New York unknown named Norma Shearer as a romantic lead. She stands 4th from left in this still of the cast. Shearer would use this performance to help launch a fabled Hollywood career and become one of MGM's biggest stars of the 1930s.

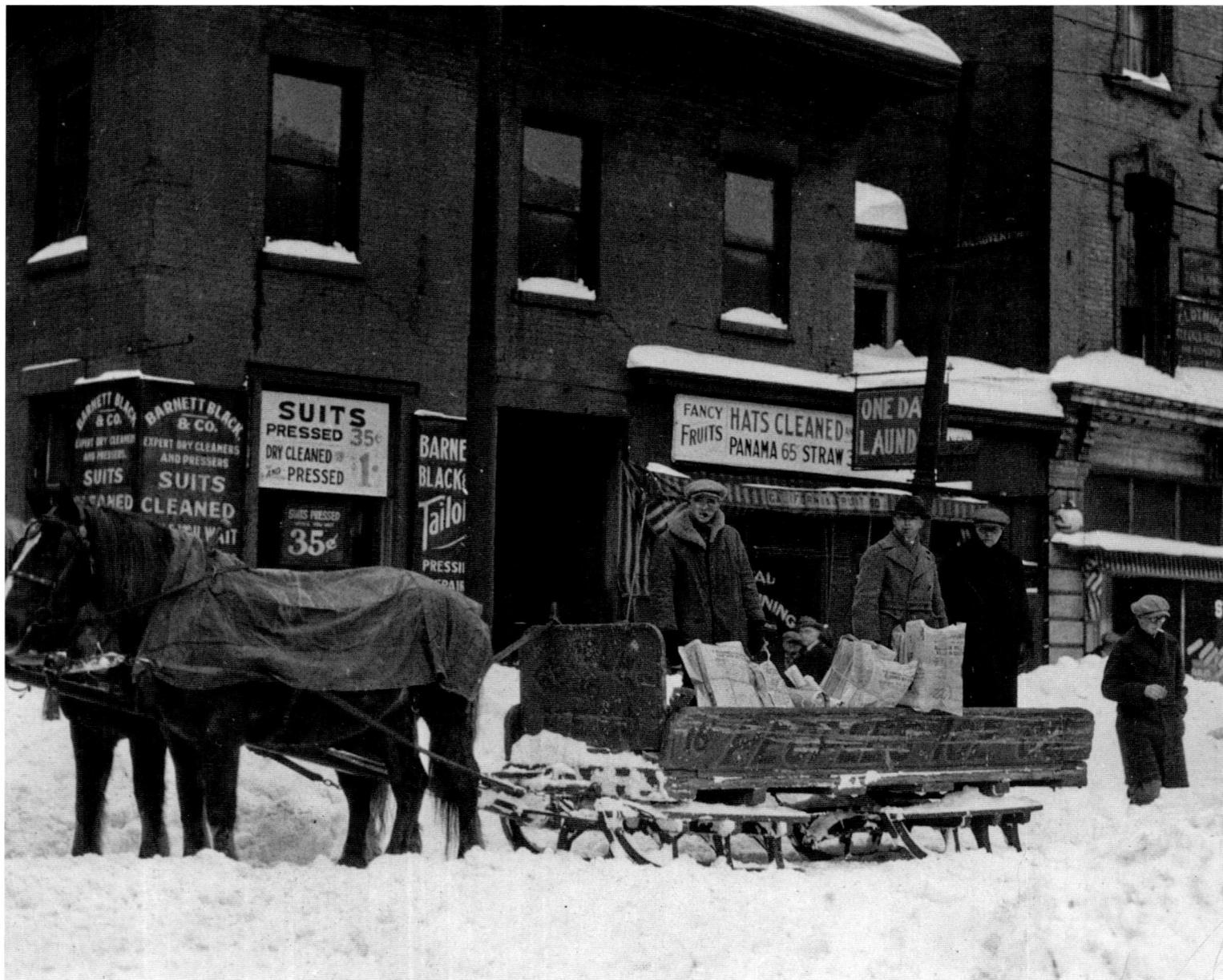

After a 1925 snowstorm, some of the delivery crew for the *Syracuse Journal* used a horse-drawn sled, borrowed from the Peoples Ice Company, to deliver newspapers. In this image, the sled is stopped at the intersection of Montgomery and East Fayette Street.

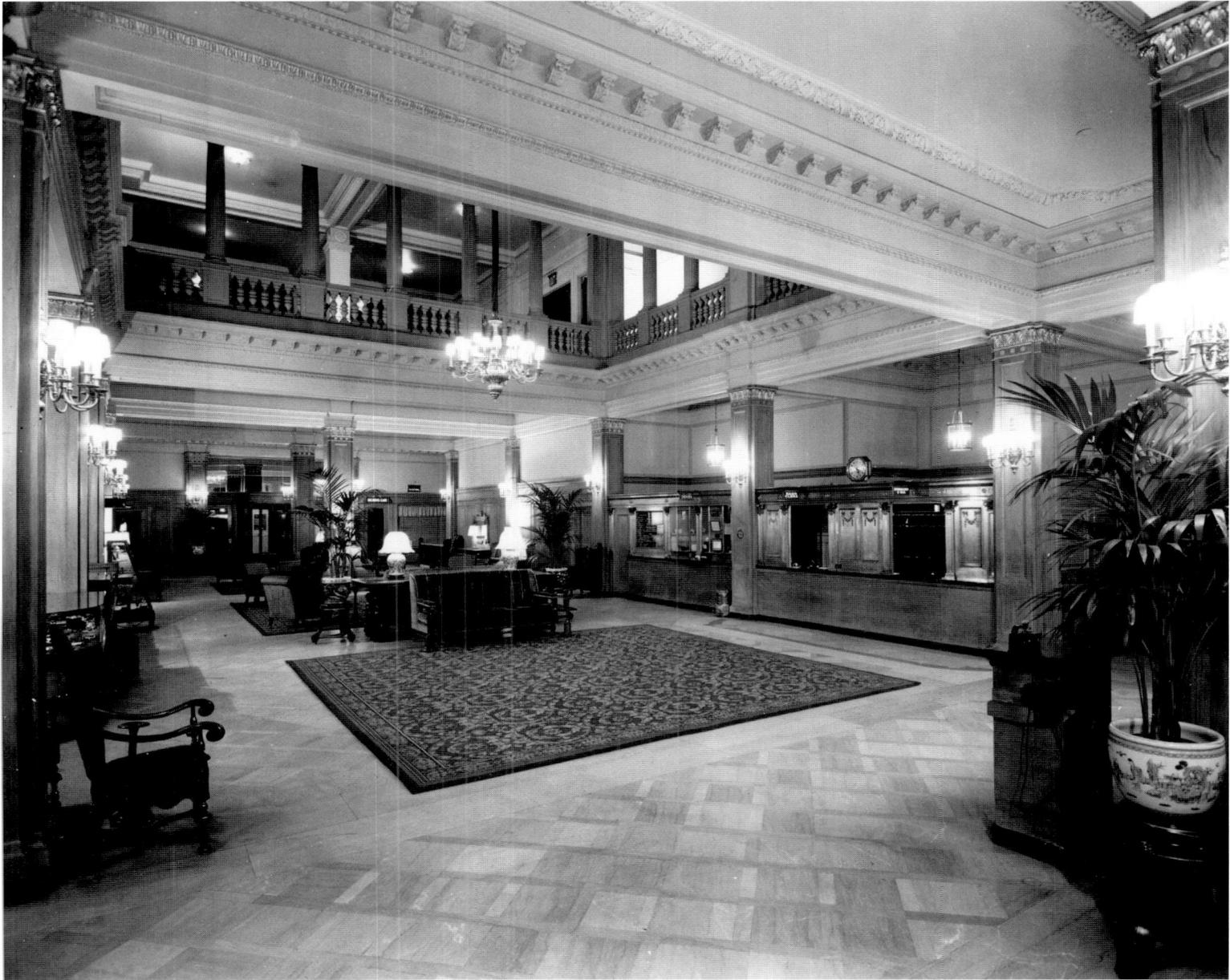

There once was another grand hotel downtown that rivaled the Hotel Syracuse. This was the Onondaga Hotel, opened on South Warren Street in 1910. A portion of its classical lobby rose two floors, photographed here in 1937, and was originally illuminated in daytime with a large skylight. The hotel was demolished in 1970.

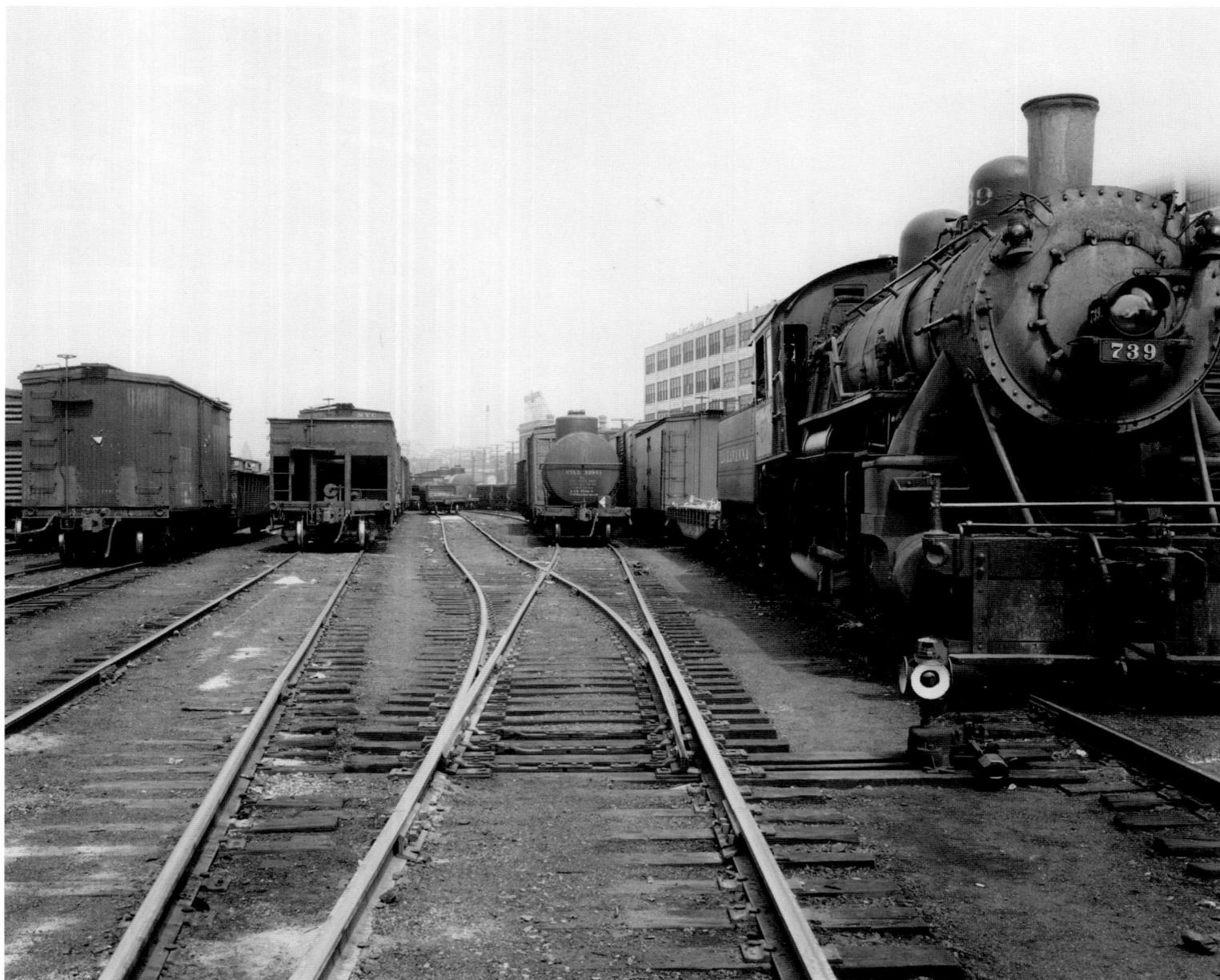

Railroads remained a big physical presence throughout the city well into the twentieth century. Besides two main passenger lines running through the middle of town, dozens of sidings served the many factories once located inside the city. Both the New York Central and DL&W also maintained large freight and staging yards on the Near West Side. These trains are lined up in the DL&W yard near Geddes and Fayette streets, probably in the 1920s or 1930s.

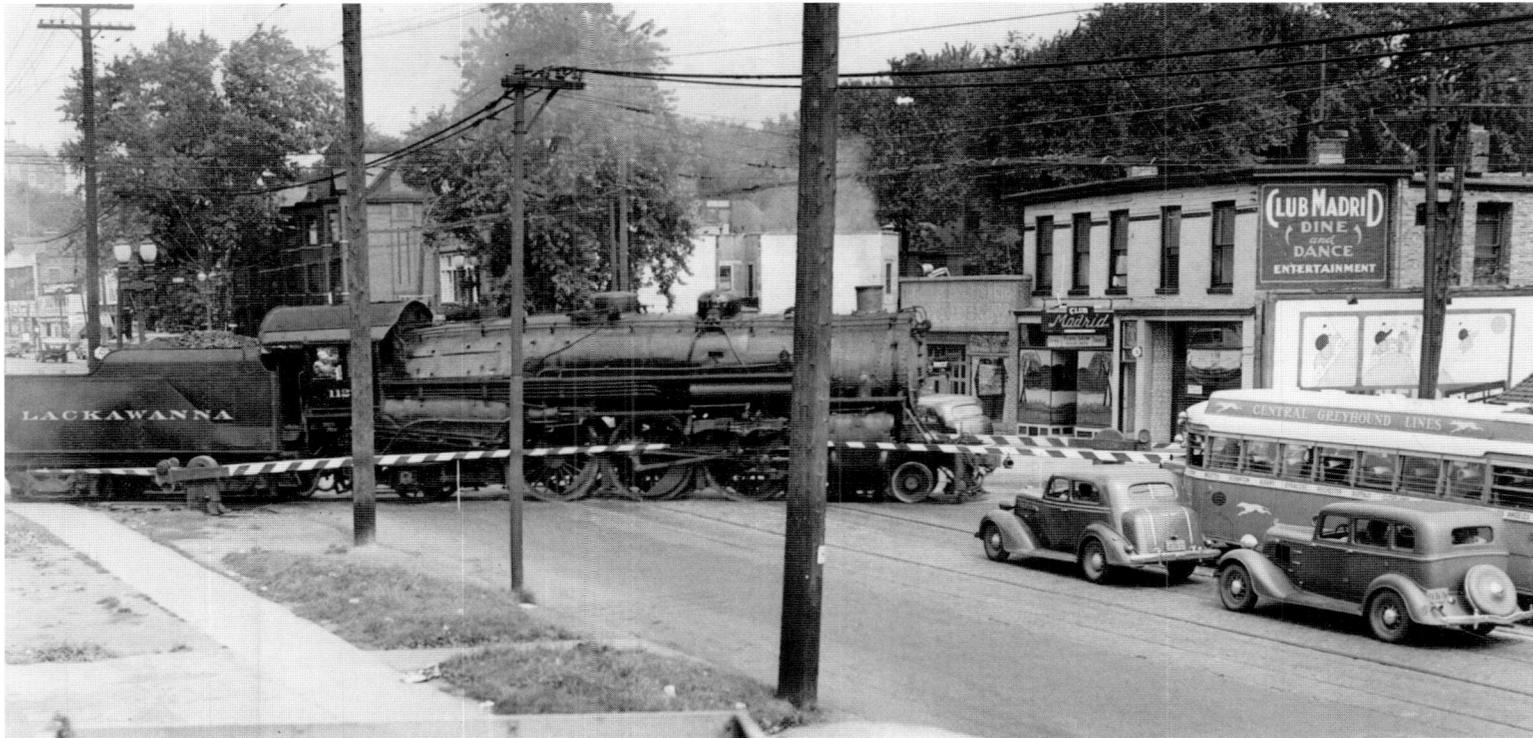

One of the great civic challenges debated in Syracuse throughout the 1920s and into the 1930s was how to free the city from dozens of dangerous grade-level crossings by both the New York Central and Delaware, Lackawanna, and Western railroads. This DL&W locomotive is crossing South Salina Street near Taylor.

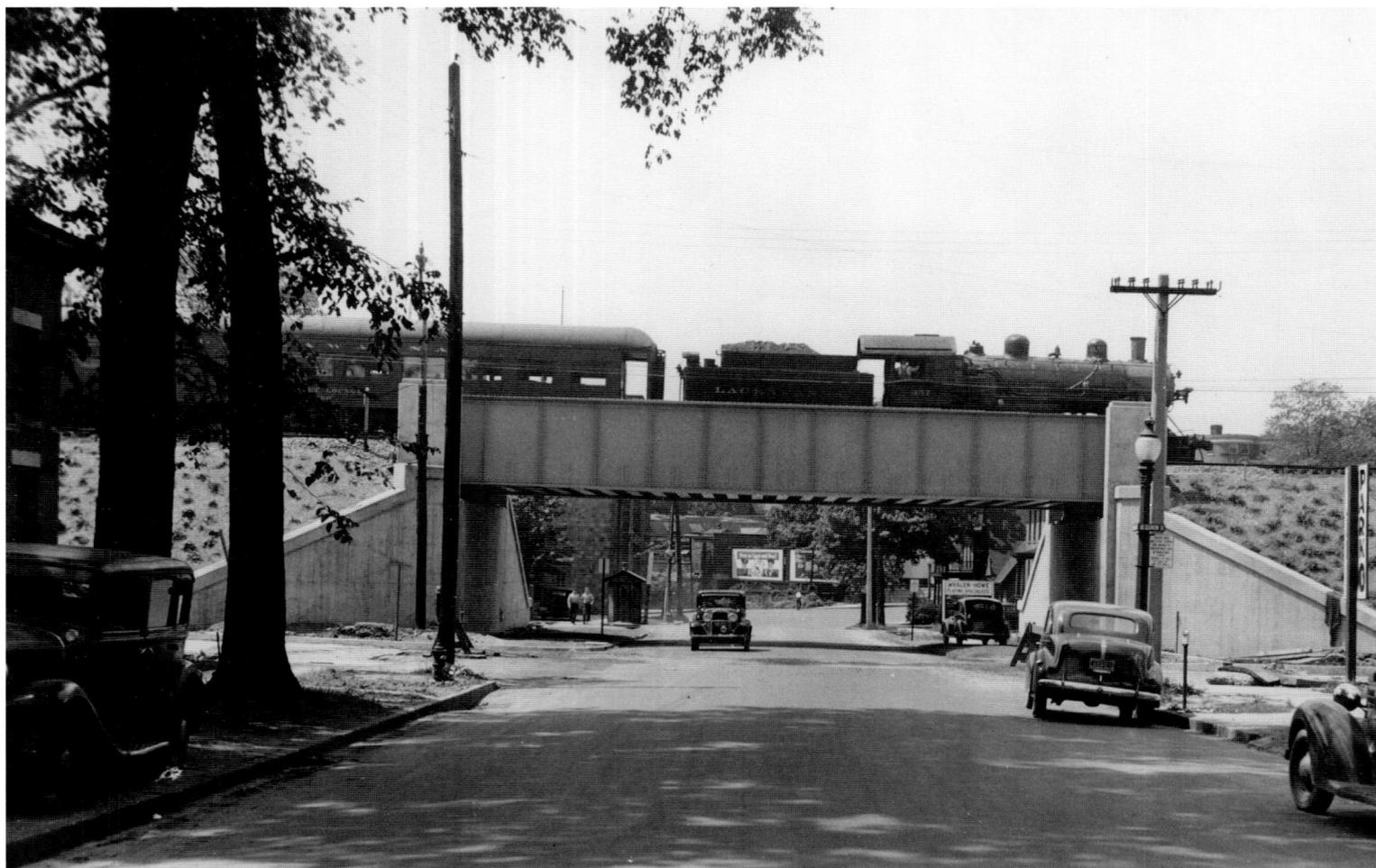

By 1940, the tracks of the DL&W were also elevated. A passenger train crosses over Adams Street at South Clinton. The DL&W elevation, including this bridge, is still in use today by rail traffic.

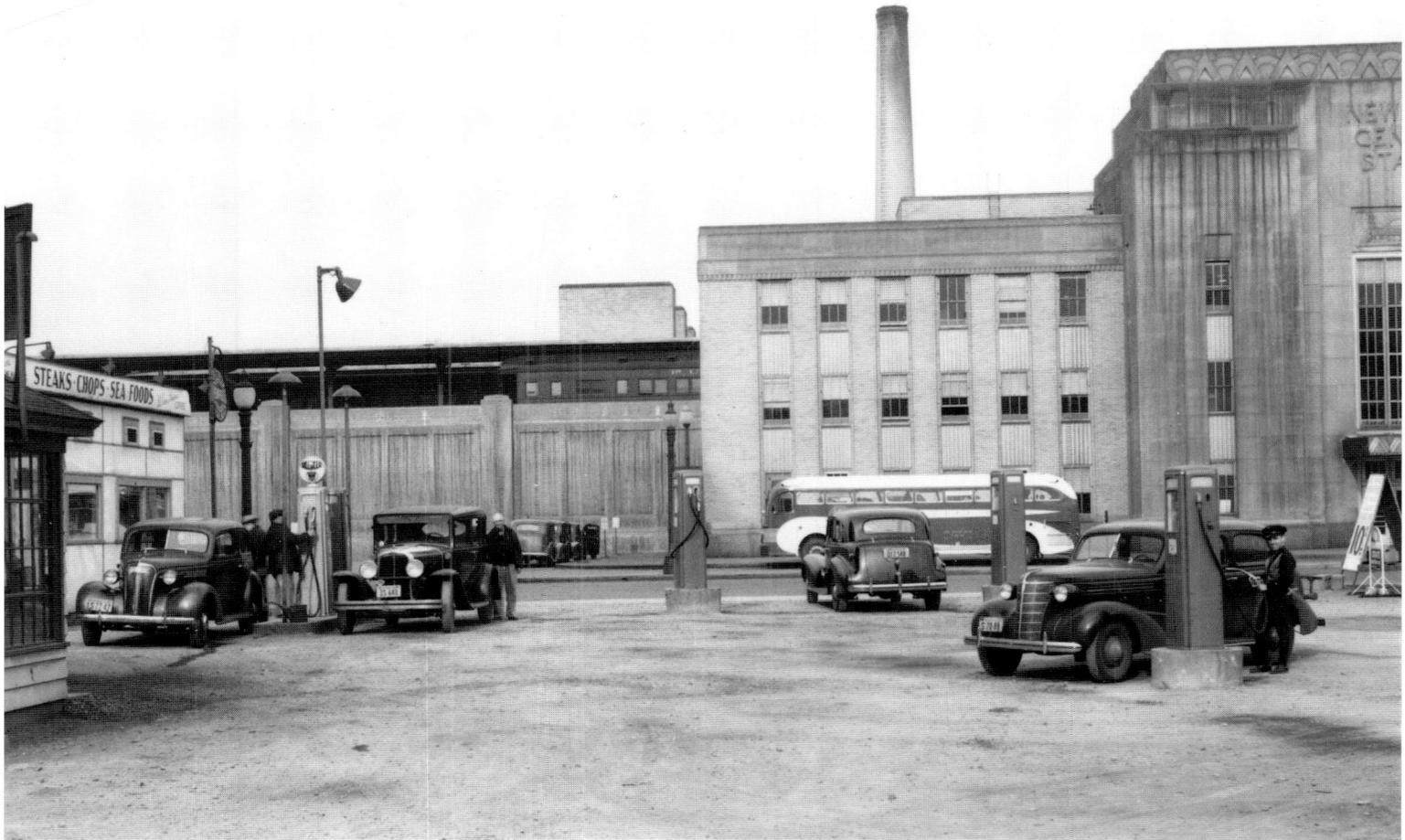

The nuisance of grade-level railroad crossings was solved for the New York Central by elevating the tracks through the city, a project completed in 1936. This required construction of a new passenger terminal on Erie Boulevard, photographed here in 1939 from a filling station across the street. Today the building houses Time Warner cable news TV.

The South Warren Street block between Jefferson and Fayette in the mid-1940s was a busy place, dominated by the Onondaga Hotel and boasting a variety of architectural styles that represented nearly 100 years of the city's growth.

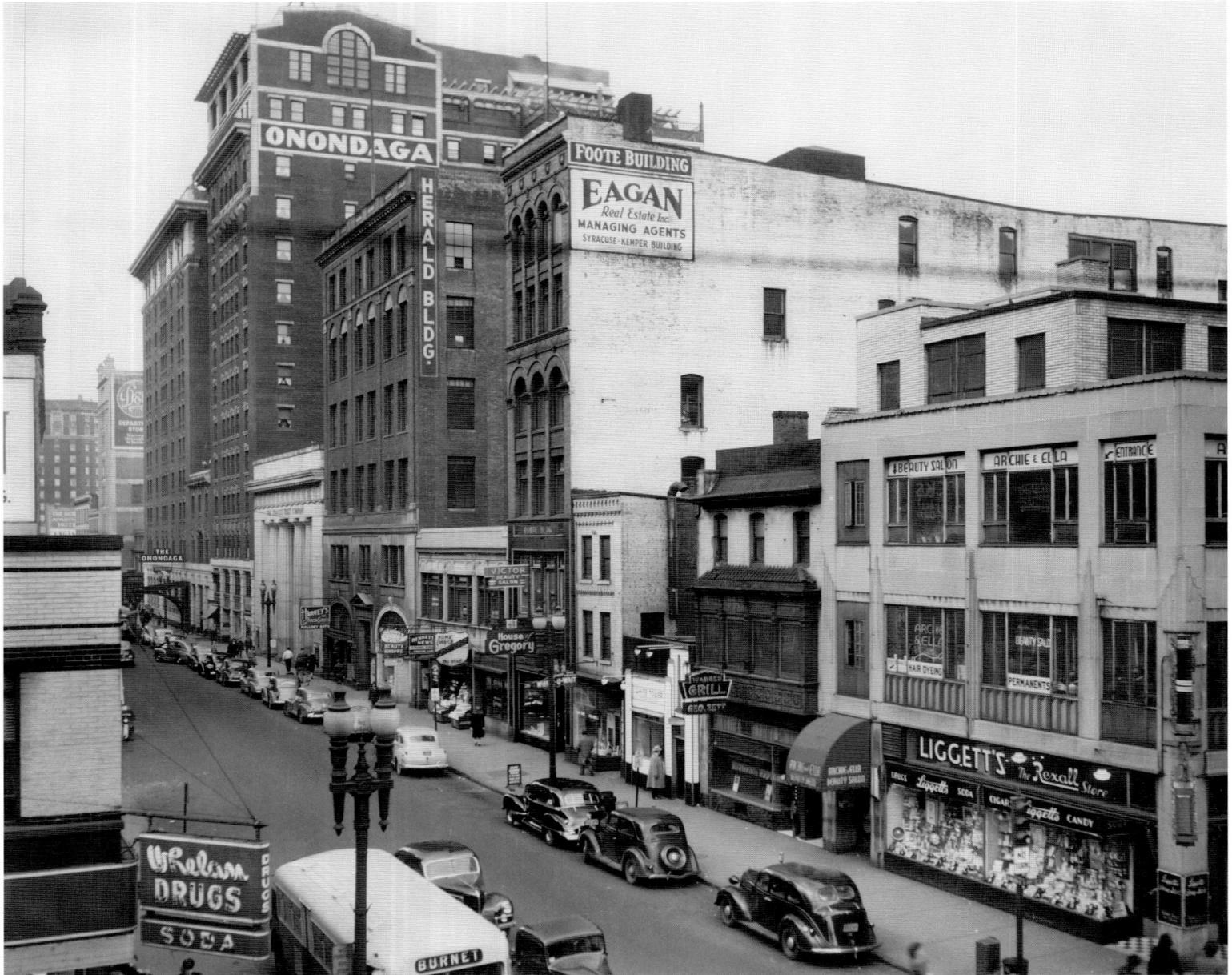

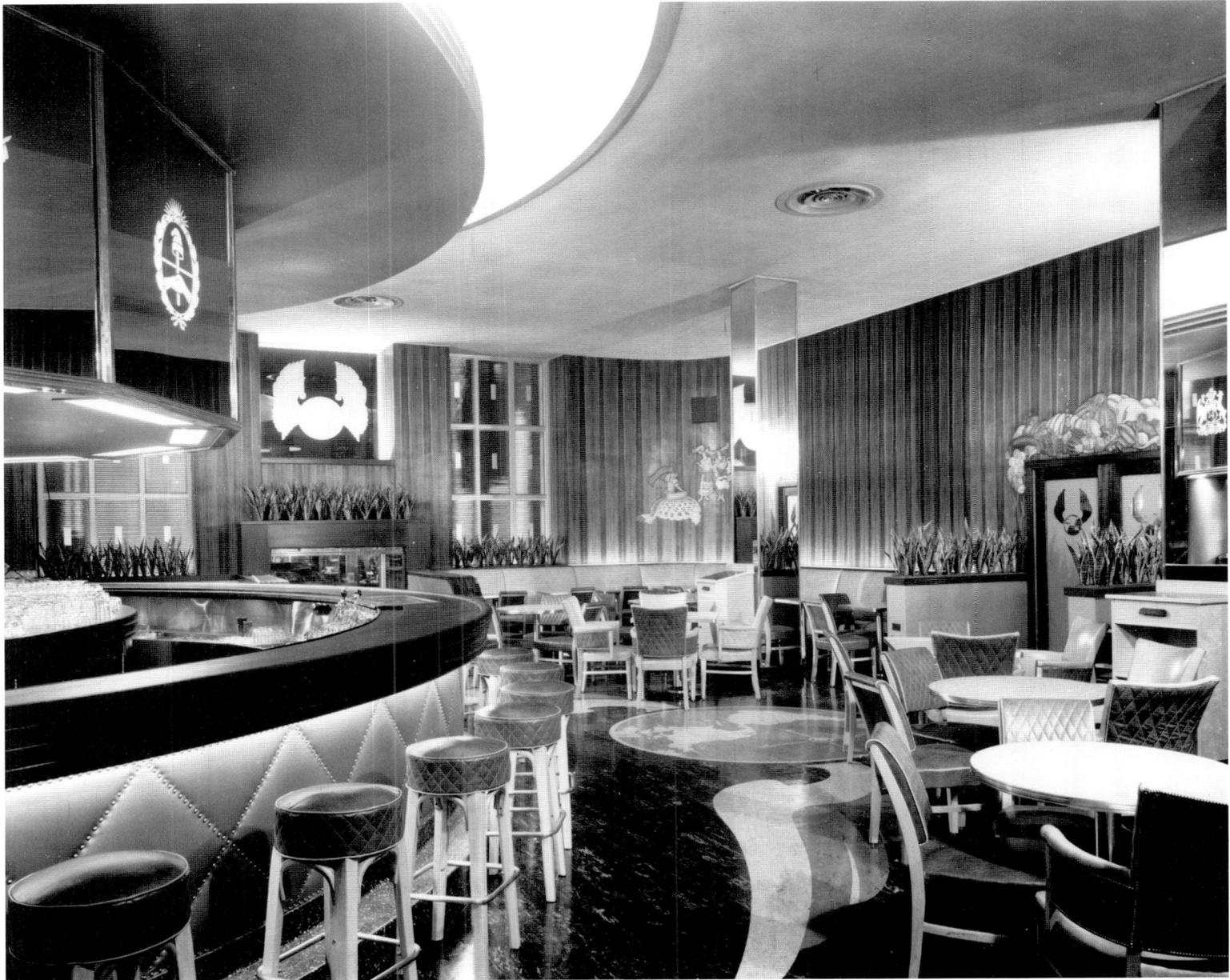

One of the great interior spaces of the 1940s was the Onondaga Hotel's Travel Room. It embodied the sophisticated look of those elegant nightspots so often featured in Hollywood movies of the era.

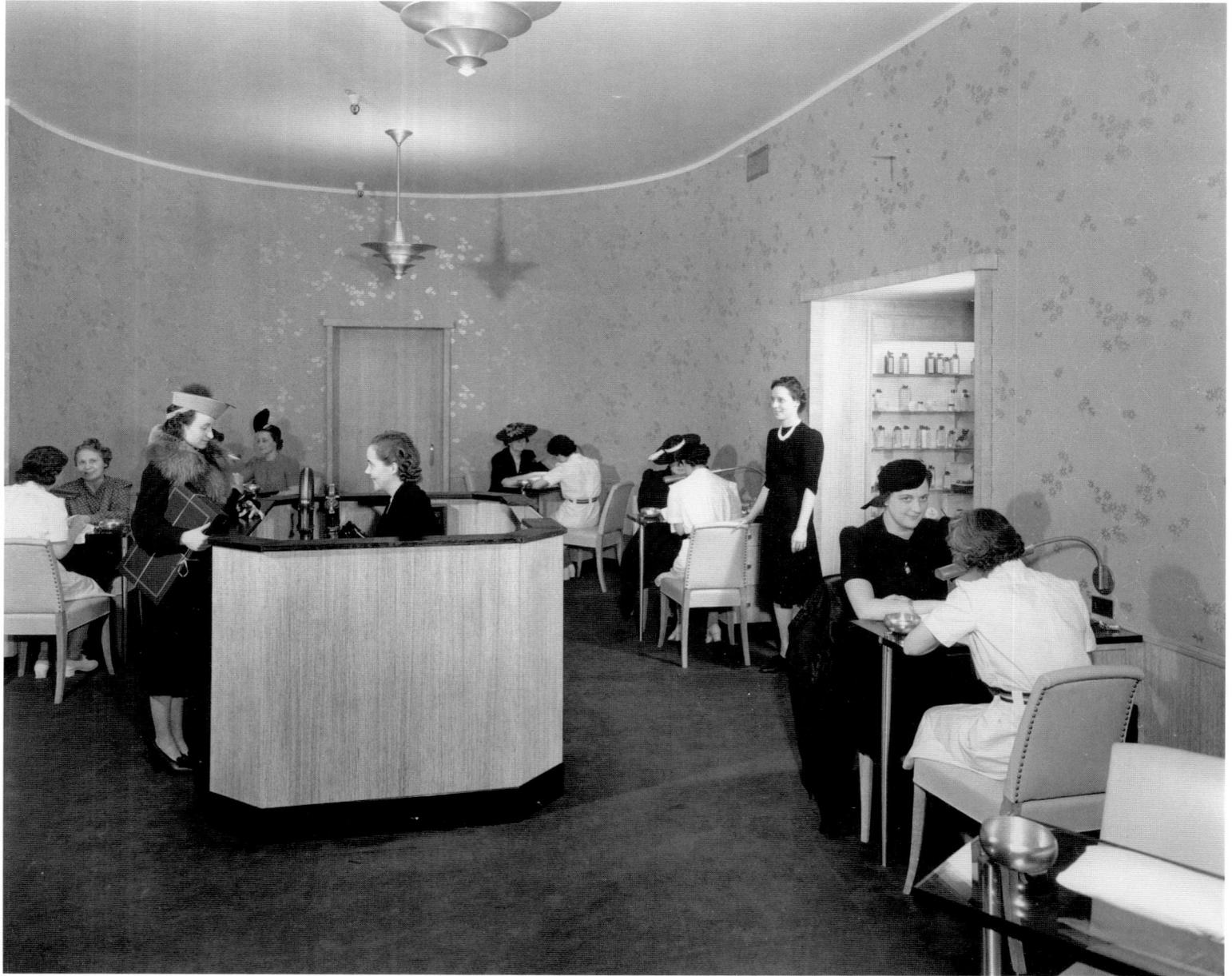

Downtown in the 1940s could boast an array of large department stores, offering a variety of restaurants and other services, in addition to shopping. This is the beauty salon at Addis.

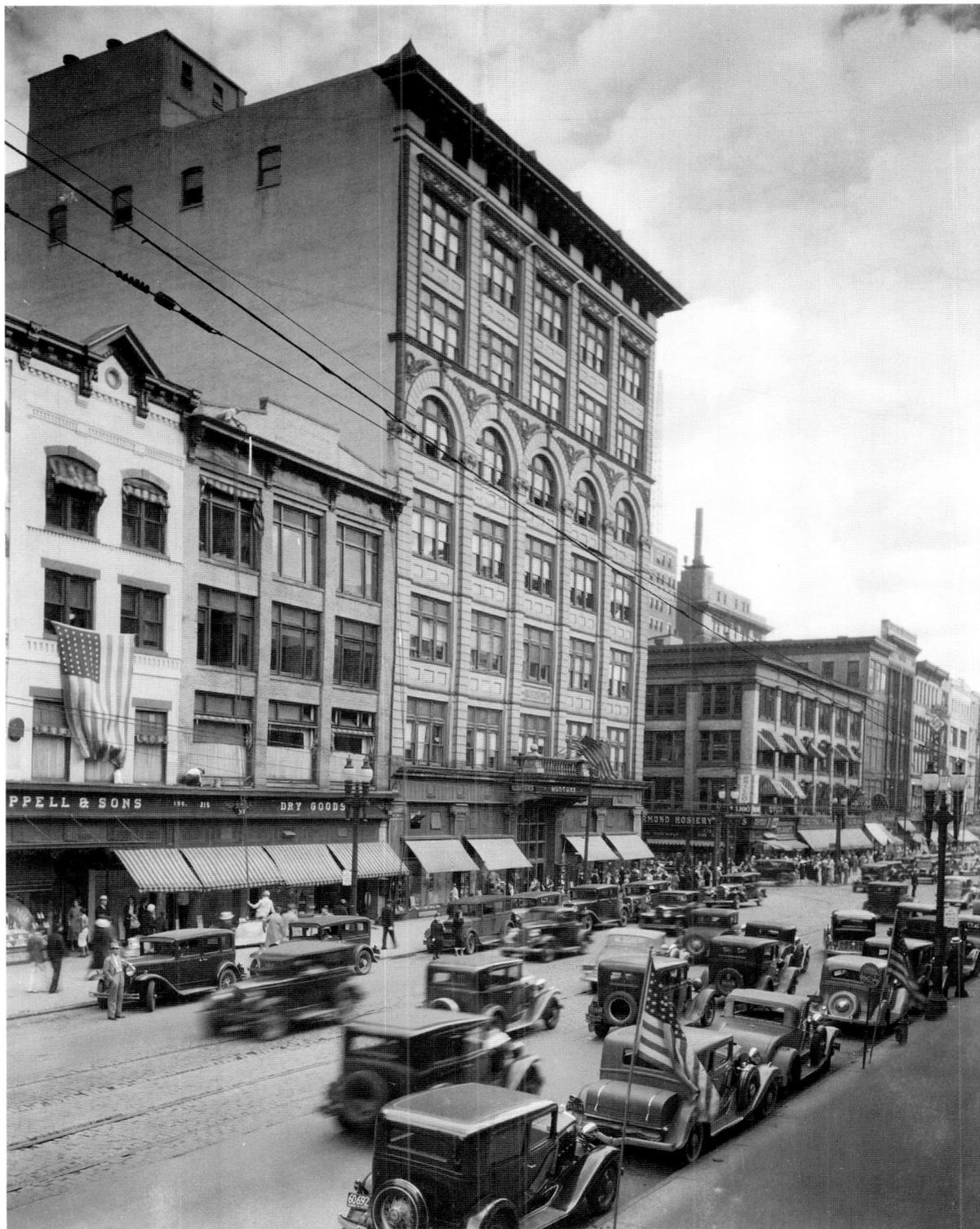

One of the oldest of the great retail buildings downtown was the 1894 McCarthy's Store at the corner of Fayette and South Salina streets. Here in 1934, it is occupied by Hunters Department Store, and next door is the original Chappell & Sons Department Store. Both buildings remain, although today they serve primarily as office space.

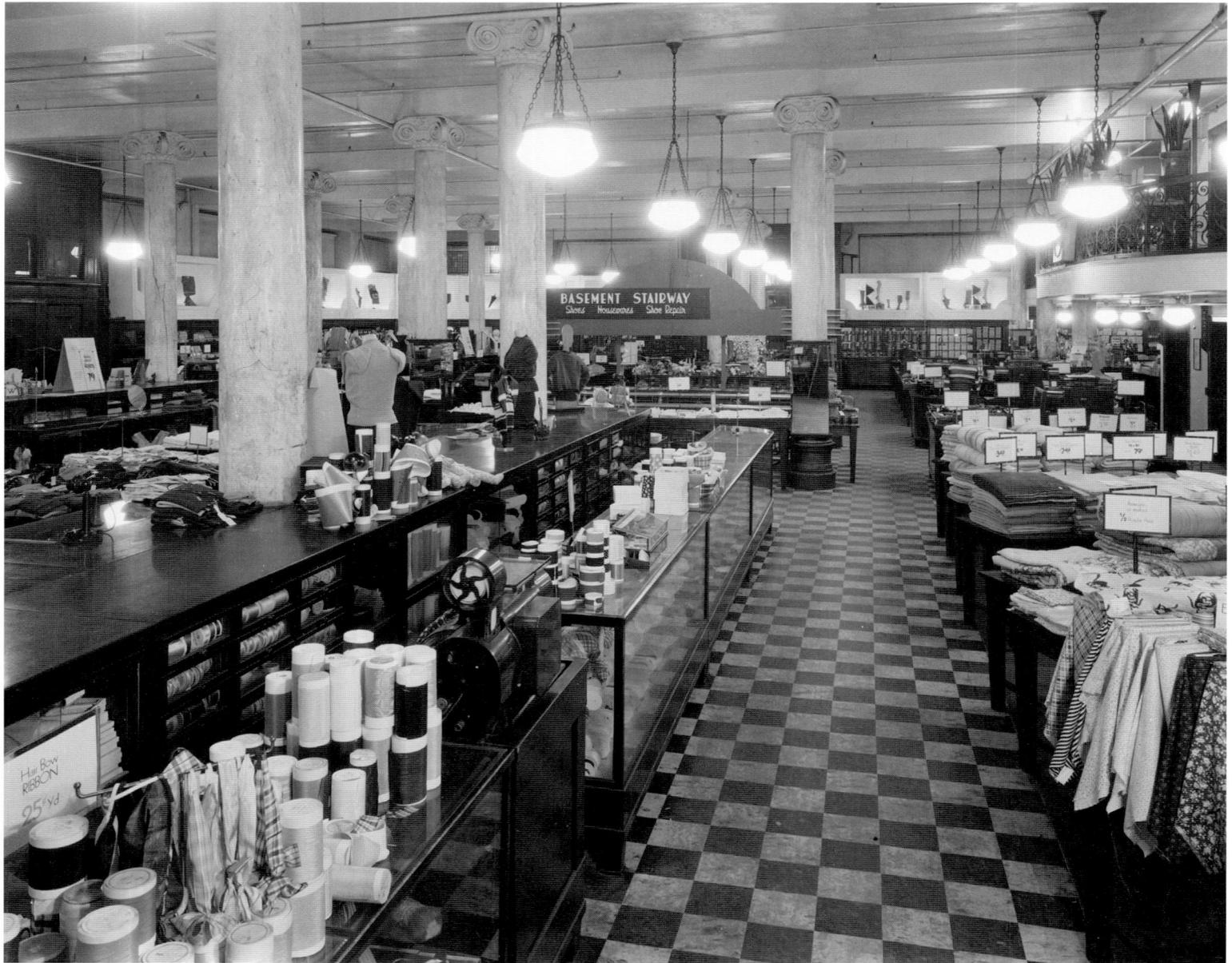

The first-floor interior of Hunters Department Store in 1934 included a large fabrics department. A mezzanine overlooks the floor on the right and ornate classical columns support what must be a 14-foot ceiling.

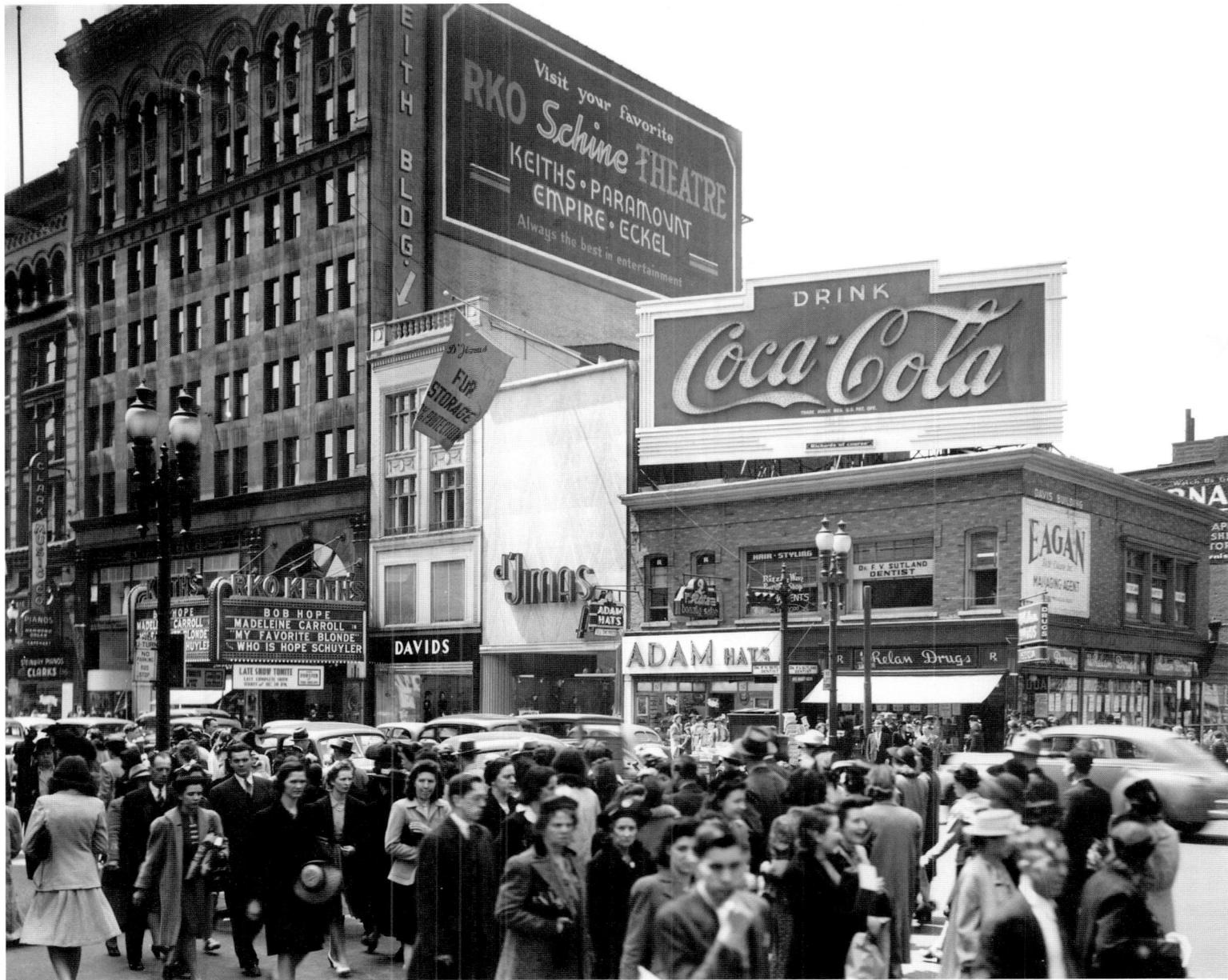

There was no place in Central New York that could compare to the retail and entertainment opportunities available in downtown Syracuse when this photo was taken in 1942. Salina Street is crowded with shoppers as they cross Jefferson Street. This corner would be cleared in the 1960s for the construction of a new Sibley's Department Store, itself long since converted into office space.

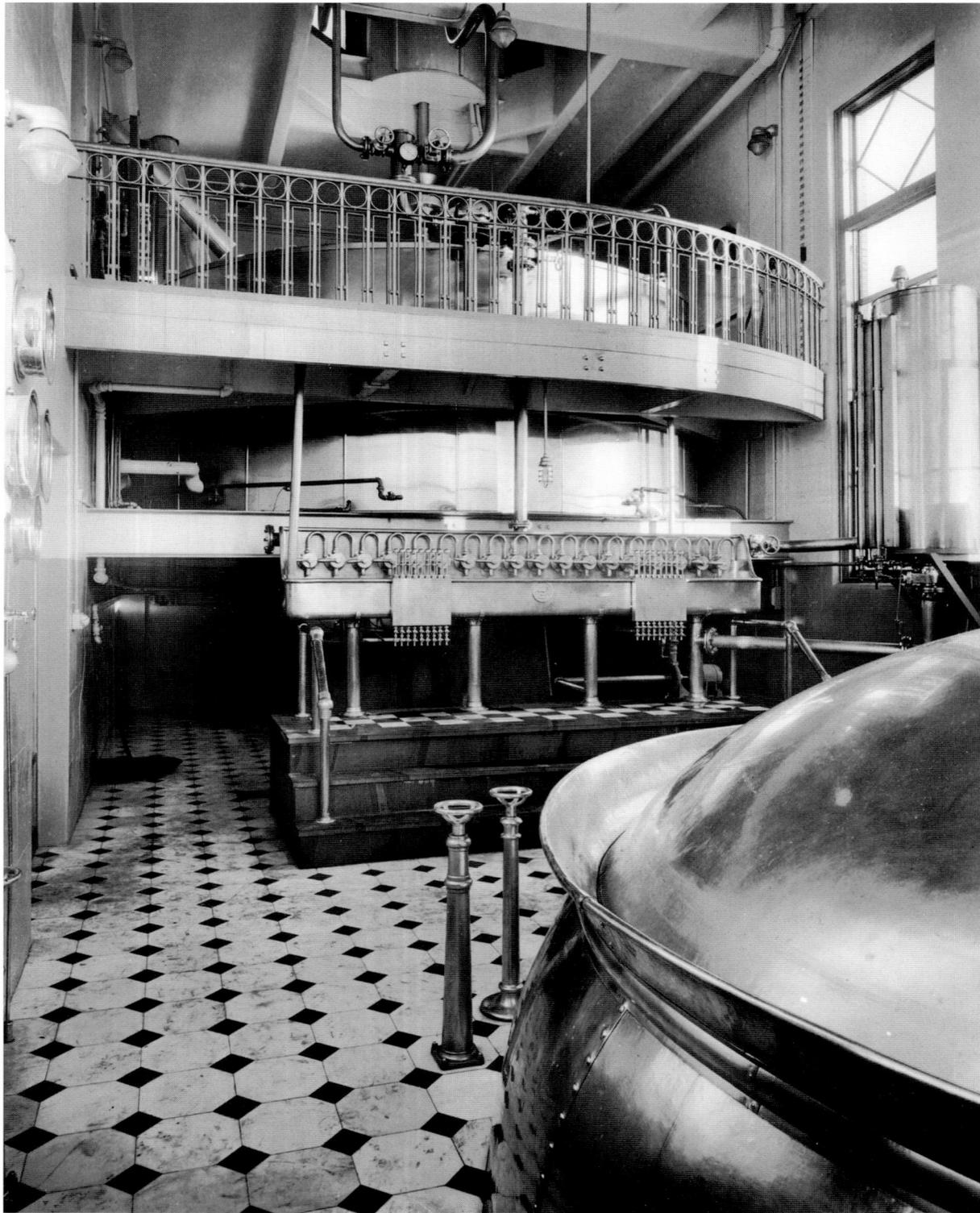

Haberle's beer brewing kettles and tanks are shown here in 1938. The brewery was started by Prussian immigrant Benedict Haberle in 1857 and operated until 1962. The Butternut Street plant was razed in 1964.

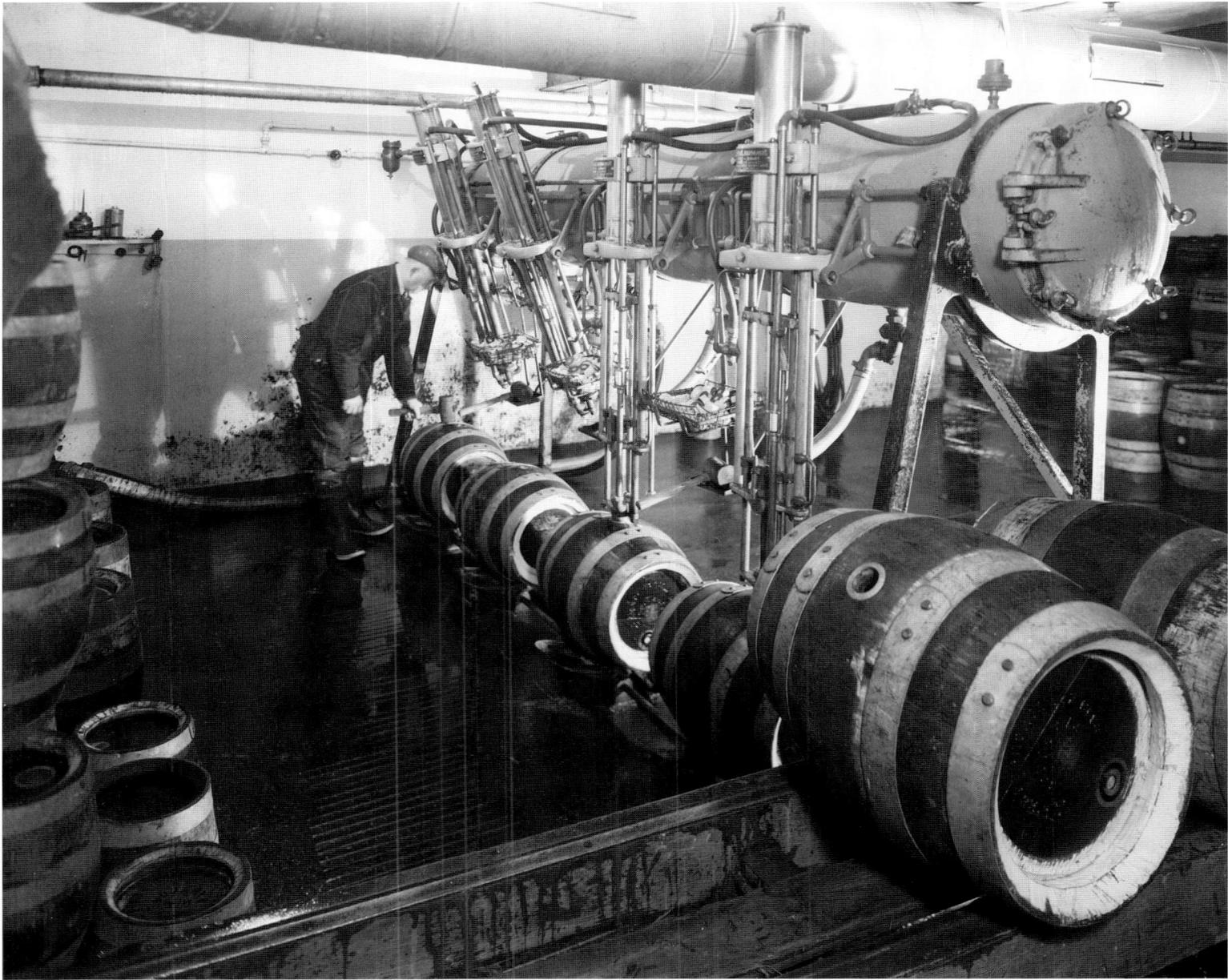

Several breweries were based in the city during the first half of the twentieth century. A handful survived prohibition, including the North Side's Haberle Brewery on Butternut Street. Wooden kegs are being filled in this 1937 image.

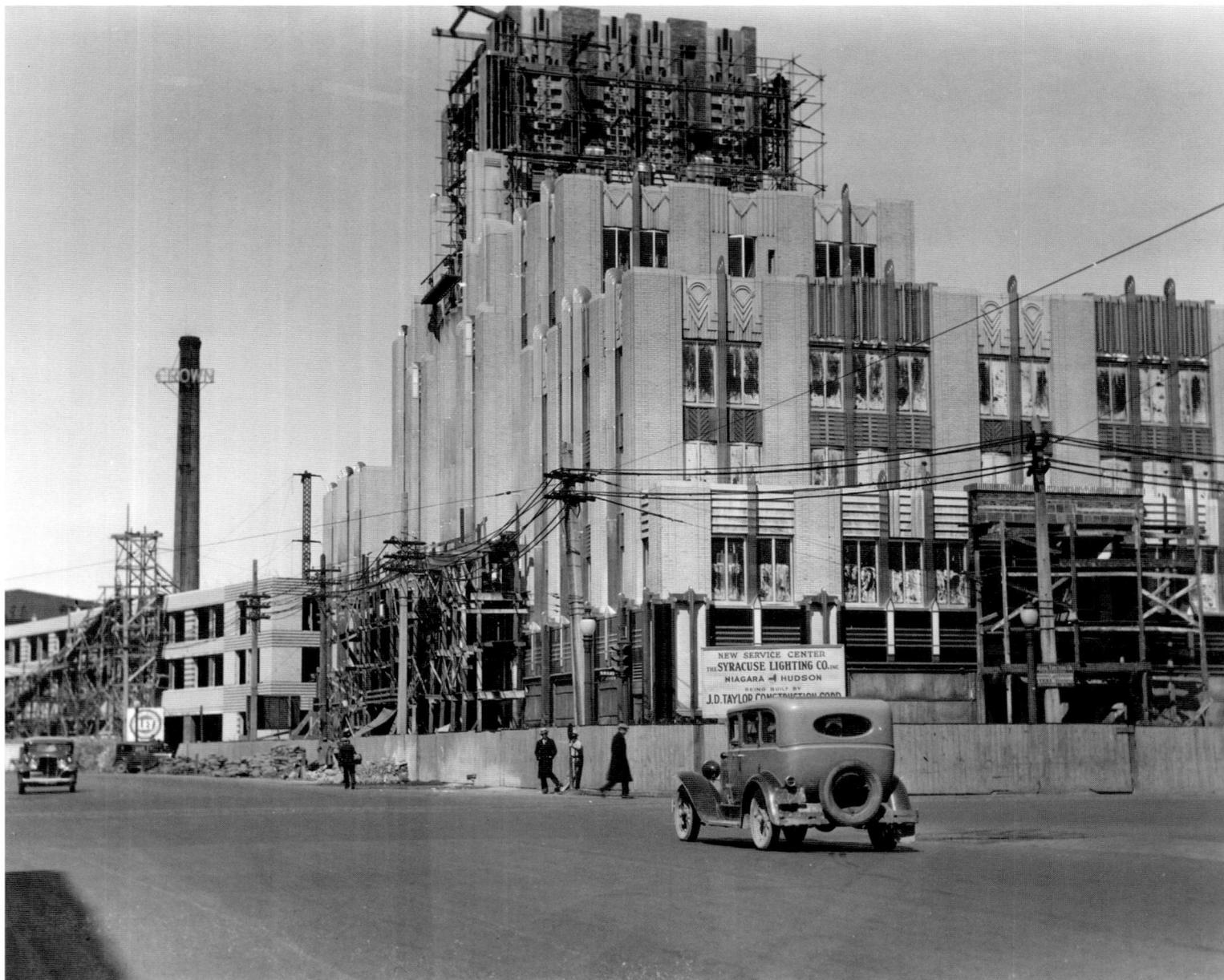

Despite the presence of the Great Depression, Syracuse gained one of its most dramatic pieces of architecture in 1932 when the Niagara Hudson Power Corporation completed its new headquarters on Erie Boulevard. The company later became Niagara Mohawk, the name that became synonymous with this art deco gem.

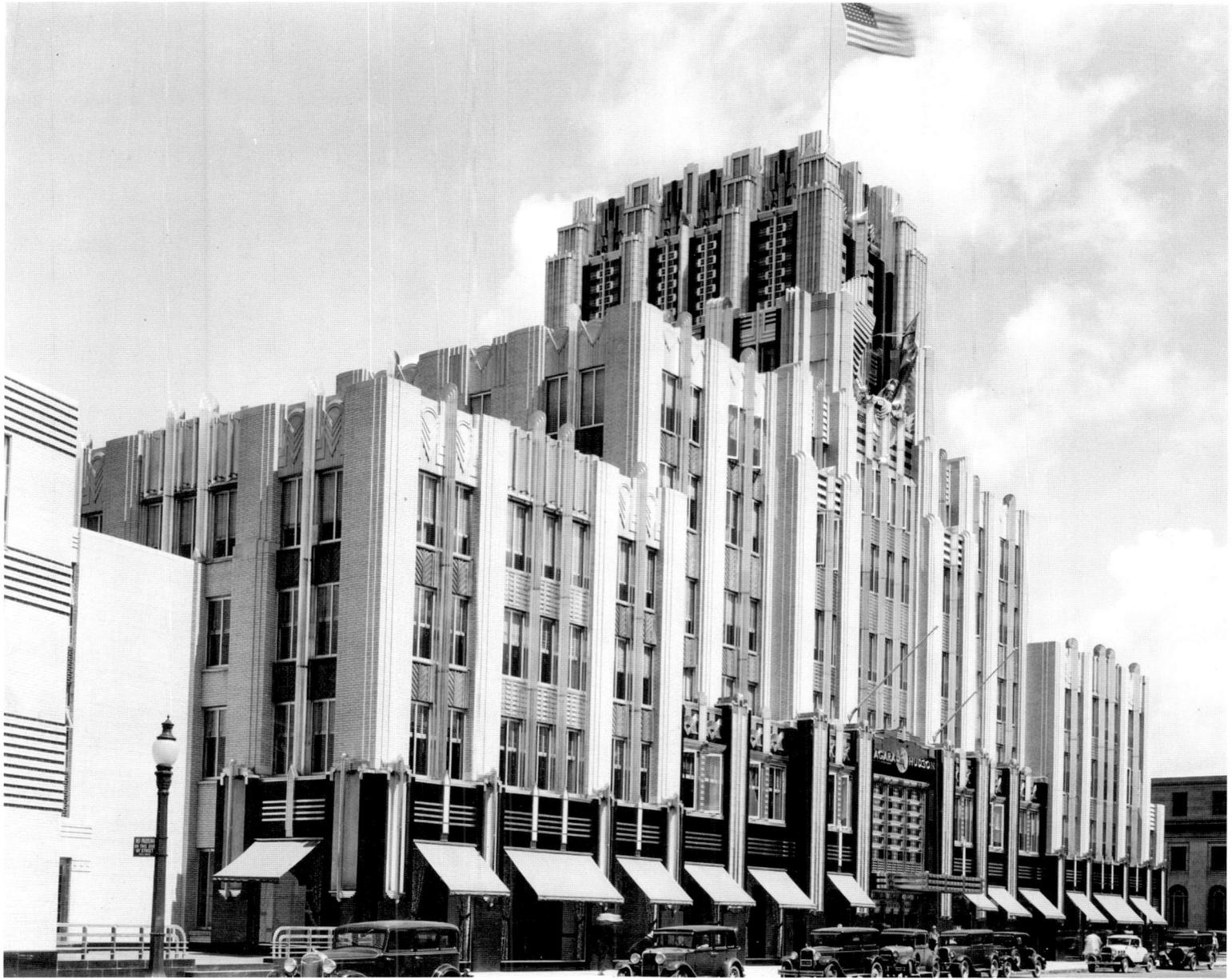

The Niagara Mohawk building today houses the local offices of the National Grid power company. In the 1930s its streamlined detailing, metal finishes, integrated lighting system, and stainless steel sculpture *Spirit of Power* made it a bold modern addition to the city's skyline.

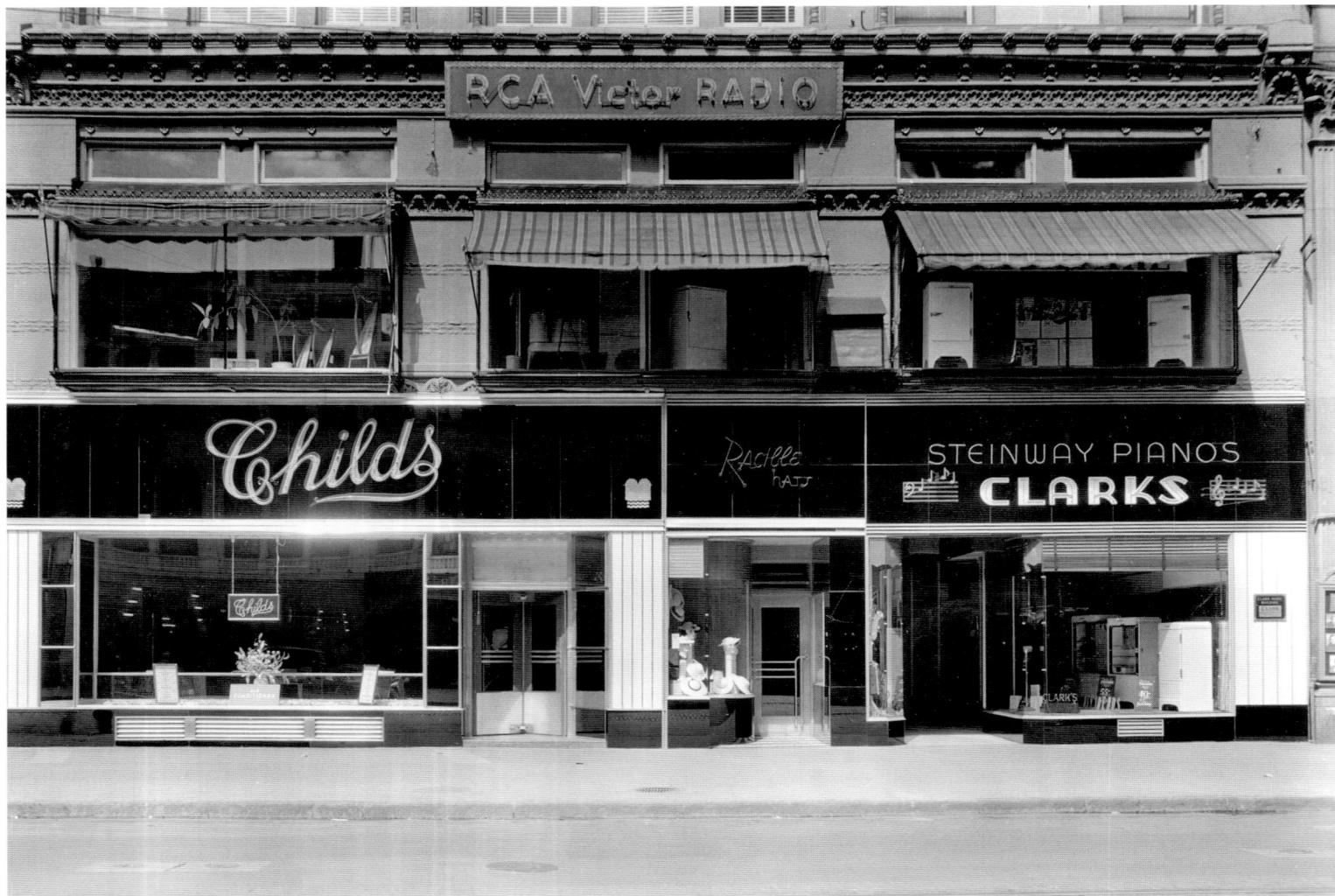

The 1920s and 1930s were decades when the ground floors of many older downtown buildings were "modernized" with a variety of newly available materials, including aluminum and stainless steel framing elements, tinted glass, and neon. The results were often creative reflections of the period, such as these storefronts on downtown's Clark Music Building, photographed in 1936. Childs was a popular restaurant of the time.

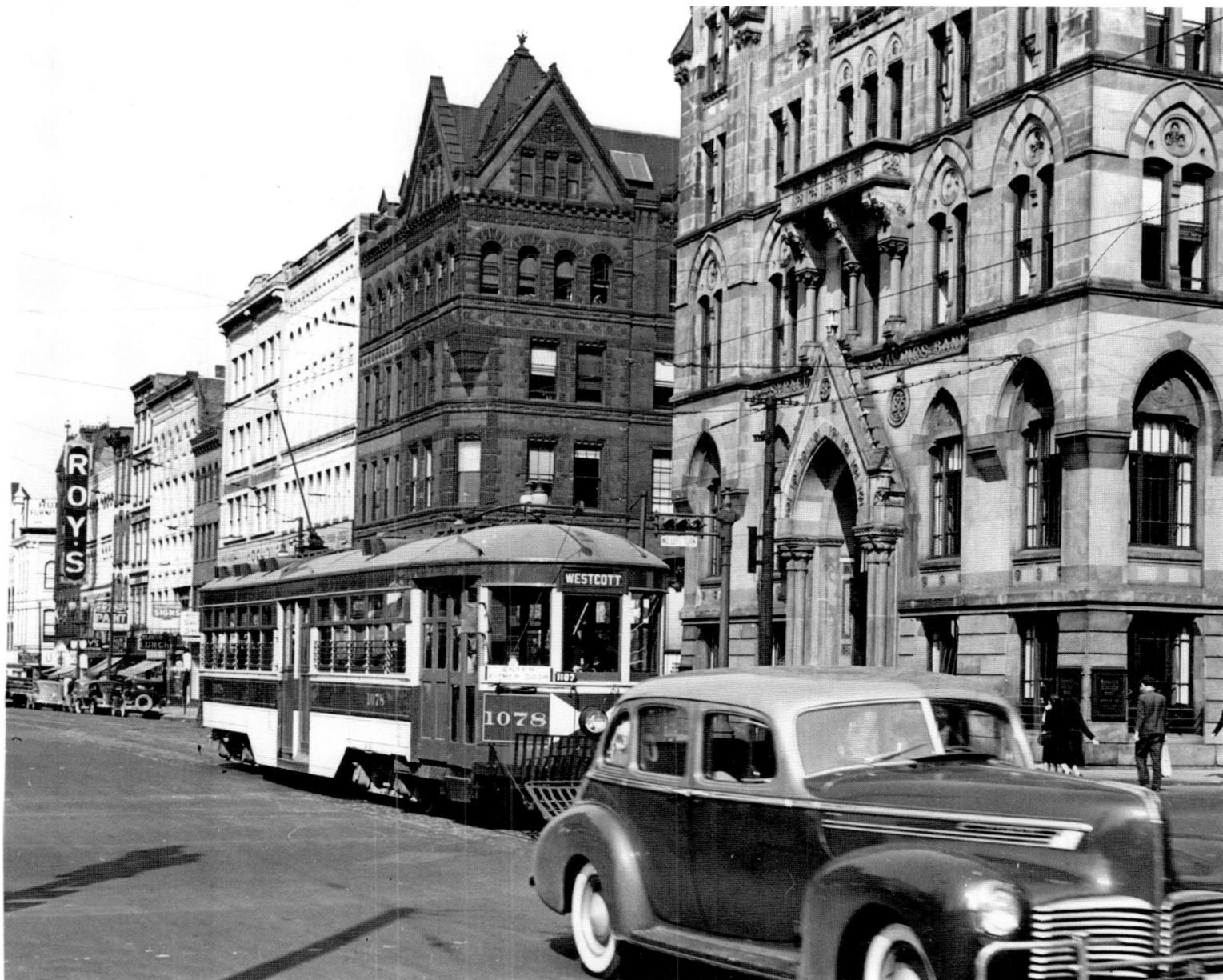

A streetcar rolls down Salina Street in front of the Syracuse Savings Bank as it makes its way toward Westcott Street in this 1940 photo by Ted Schulke. Buses were already being substituted on many of the streetcar routes. The city's last electric streetcar would make its final run the following year.

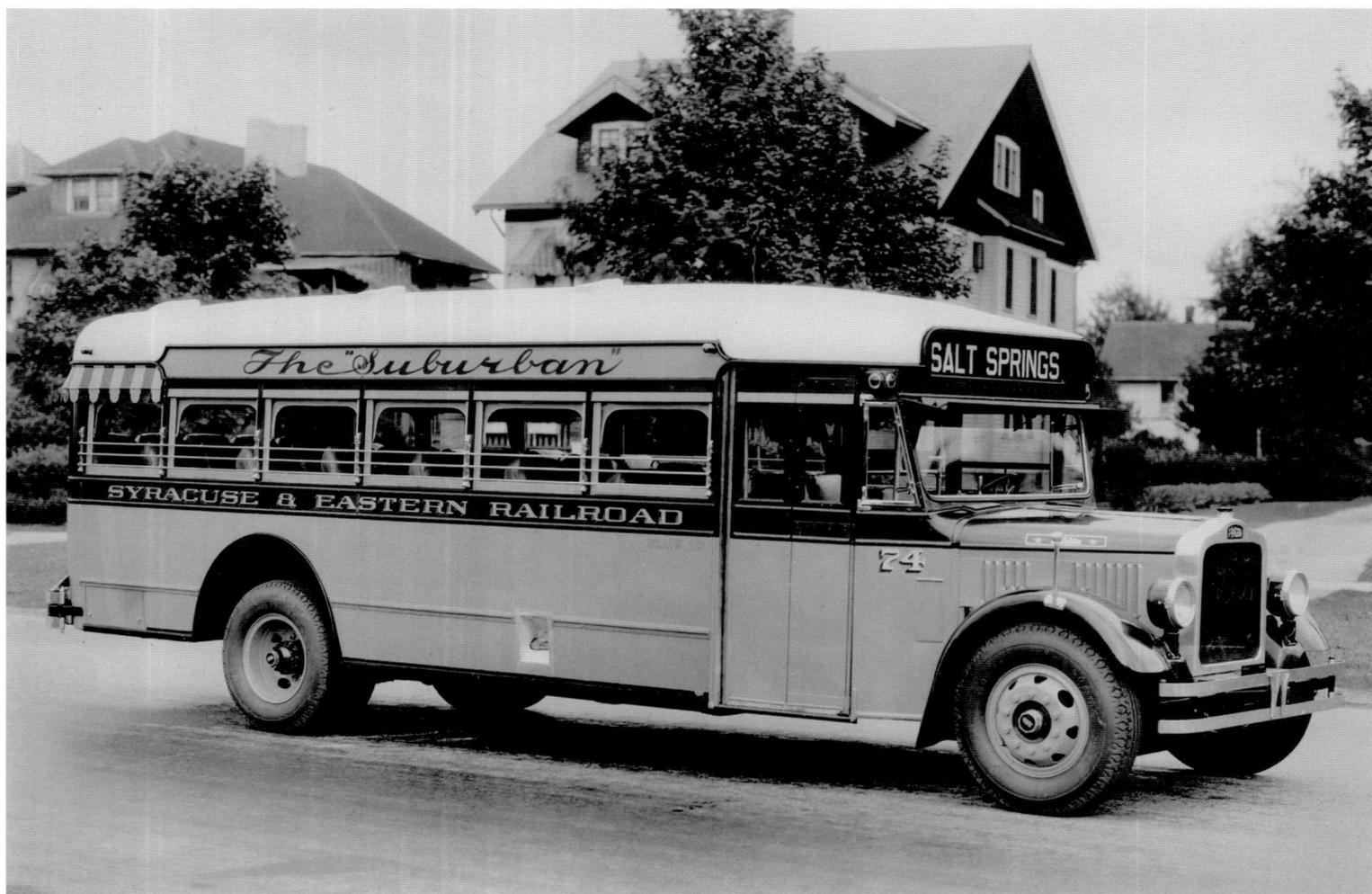

A privately owned electric interurban railway system was developed in the late nineteenth century that linked Syracuse with many of its surrounding communities. By the 1930s, these fixed rail lines were being replaced with buses. This one served the towns of Dewitt and Manlius in 1931 but still carried the company's older "Syracuse & Eastern Railroad" name.

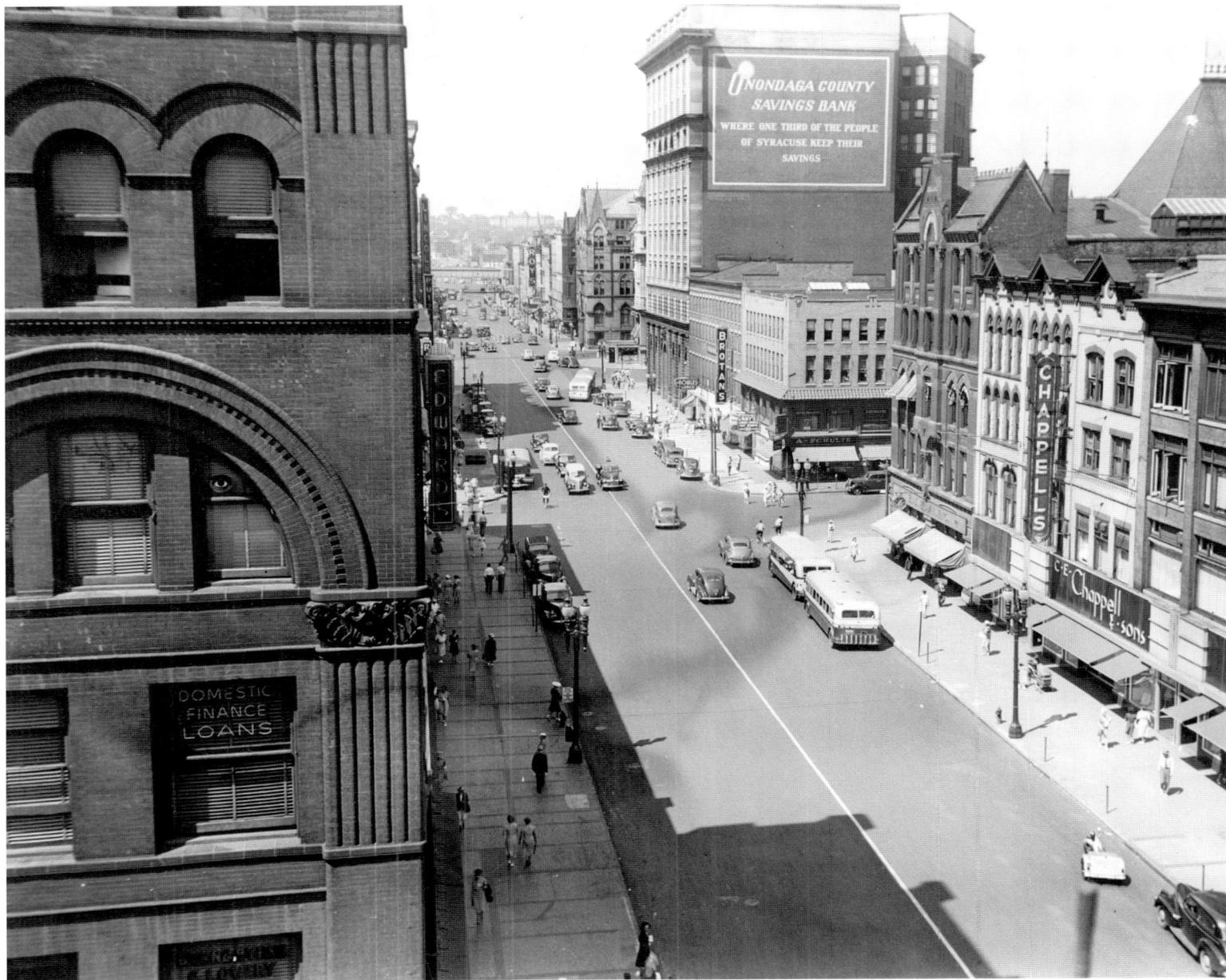

Downtown and Salina Street appear reasonably quiet in this late afternoon image captured around 1940, perhaps on a Sunday. The corner of the Kirk Block is on the left, now the site of the One Lincoln Center building. On the brink of World War II, life in Syracuse would soon undergo a ground swell of change.

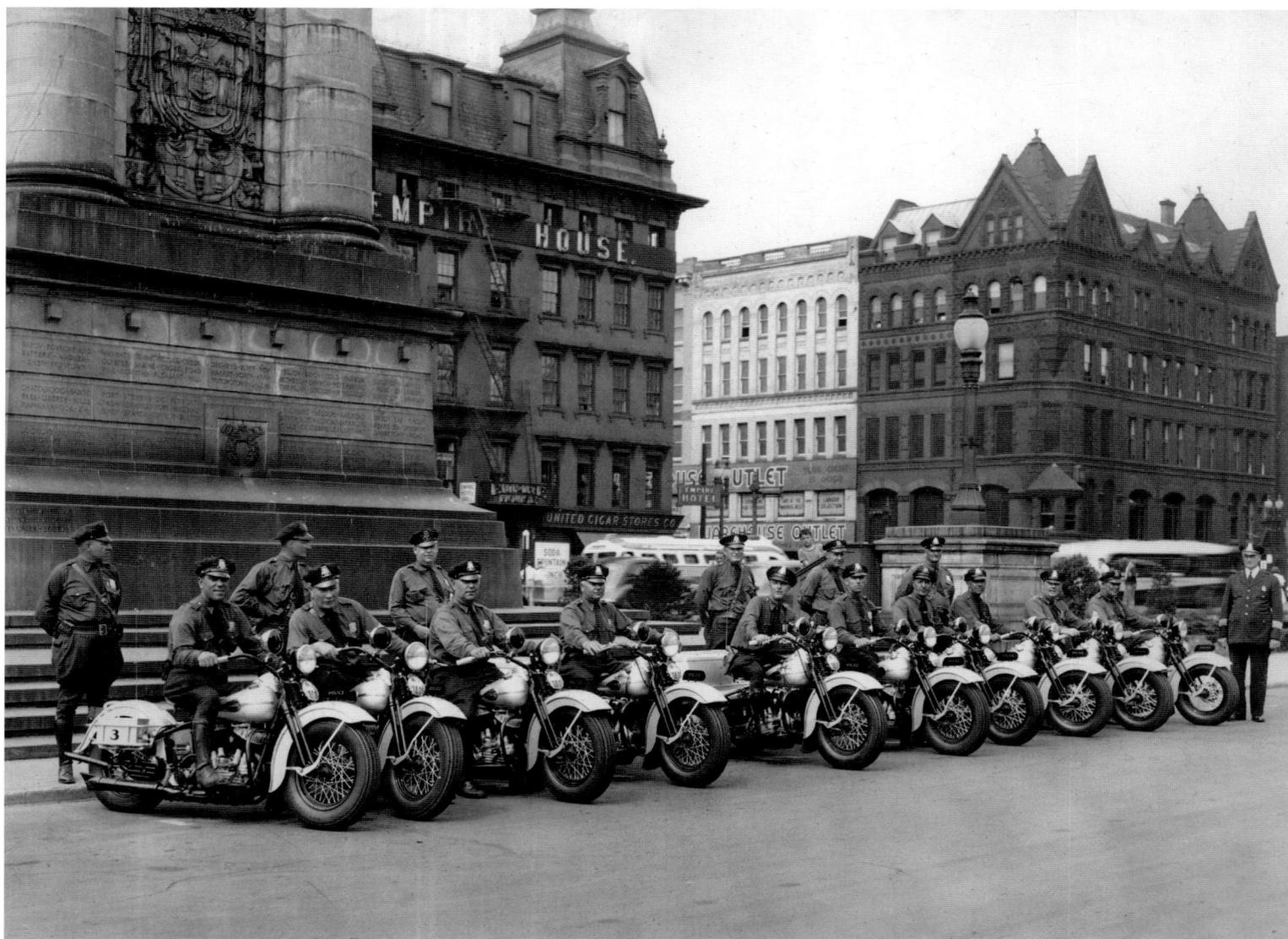

In 1941, members of the Syracuse Police Department's motorcycle squad pose in Clinton Square with their equipment. The Soldiers and Sailors Monument rises behind them and farther to the rear is the Empire House, a hotel that dated to the 1840s. The Empire House would suffer a deadly fire the next year and be demolished. The site is now home to the *Syracuse Post-Standard* newspaper offices.

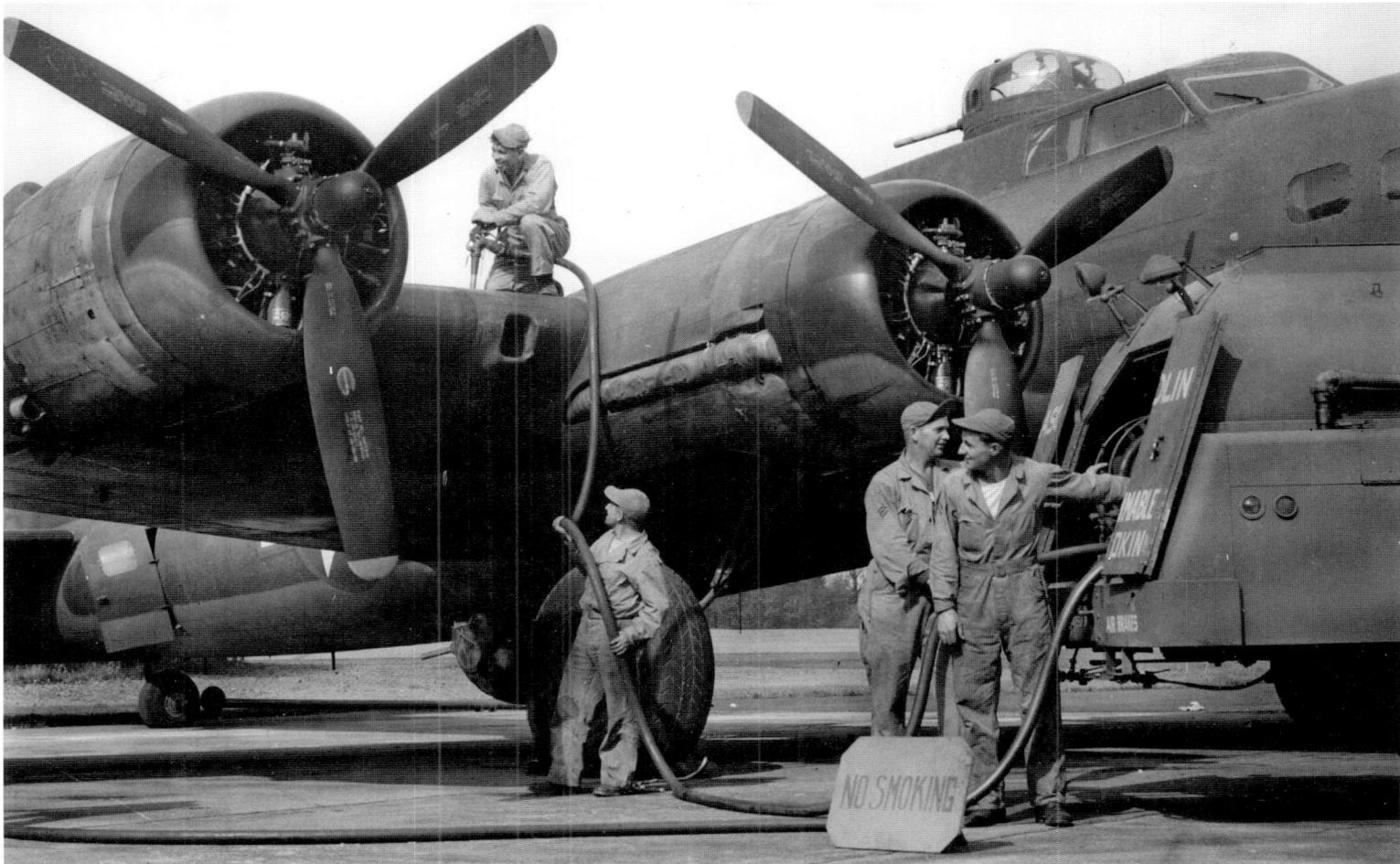

On December 31, 1941, twenty-four days after the bombing of Pearl Harbor, the Army Air Force authorized the construction of an air base at Syracuse. A 3,500-acre parcel located north of the city was selected. The base was used as a testing, training, and deployment area for preparing B-24 and B-17 bombers for the European Theater. Ground crews refuel a B-17 Flying Fortress in this view.

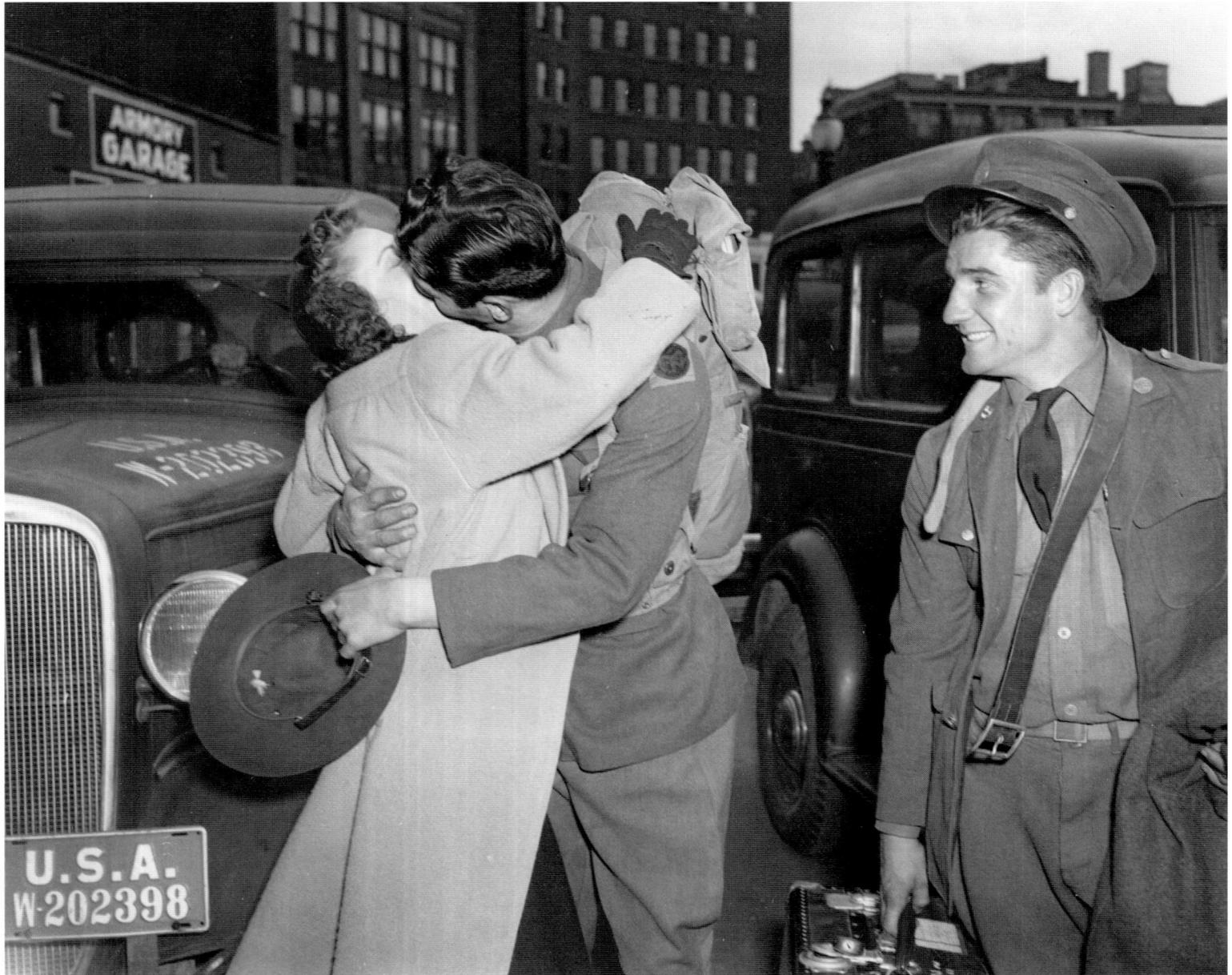

Activity at downtown's Jefferson Street Armory increased during World War II with many servicemen passing through its doors. The surrounding sidewalks were the scene of many emotional farewells. In the center background is the Jefferson-Clinton Hotel, today a fashionable all-suite hotel in the Armory Square Historic District.

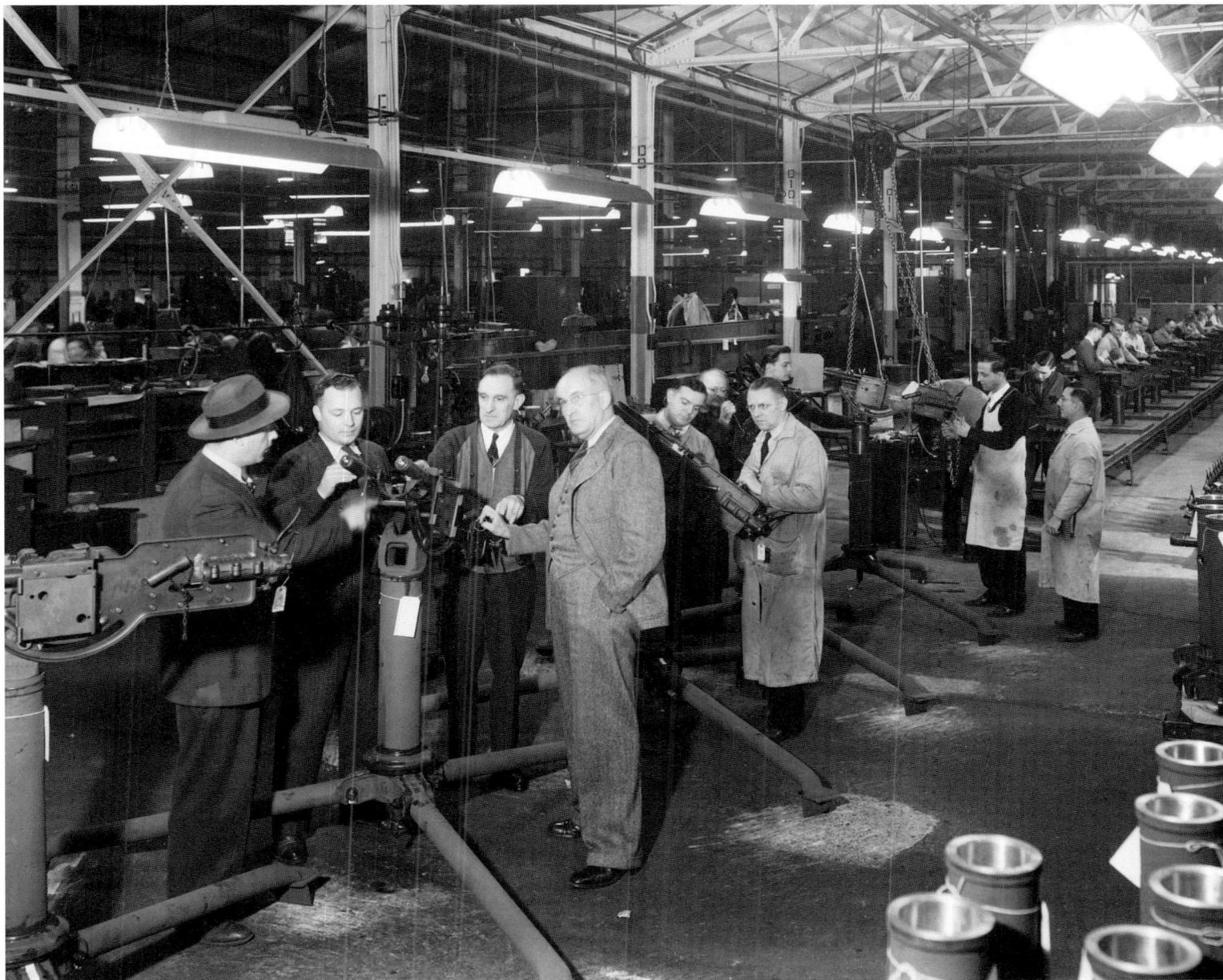

Many of the city's diverse industries shifted to the production of armaments during World War II. The Syracuse Washing Machine Corporation, which produced the Easy Washer brand, began manufacturing tripod mounts for anti-aircraft machine guns. The factory was located along North Clinton Street near Spencer, and the company even built an entire new plant for its war work.

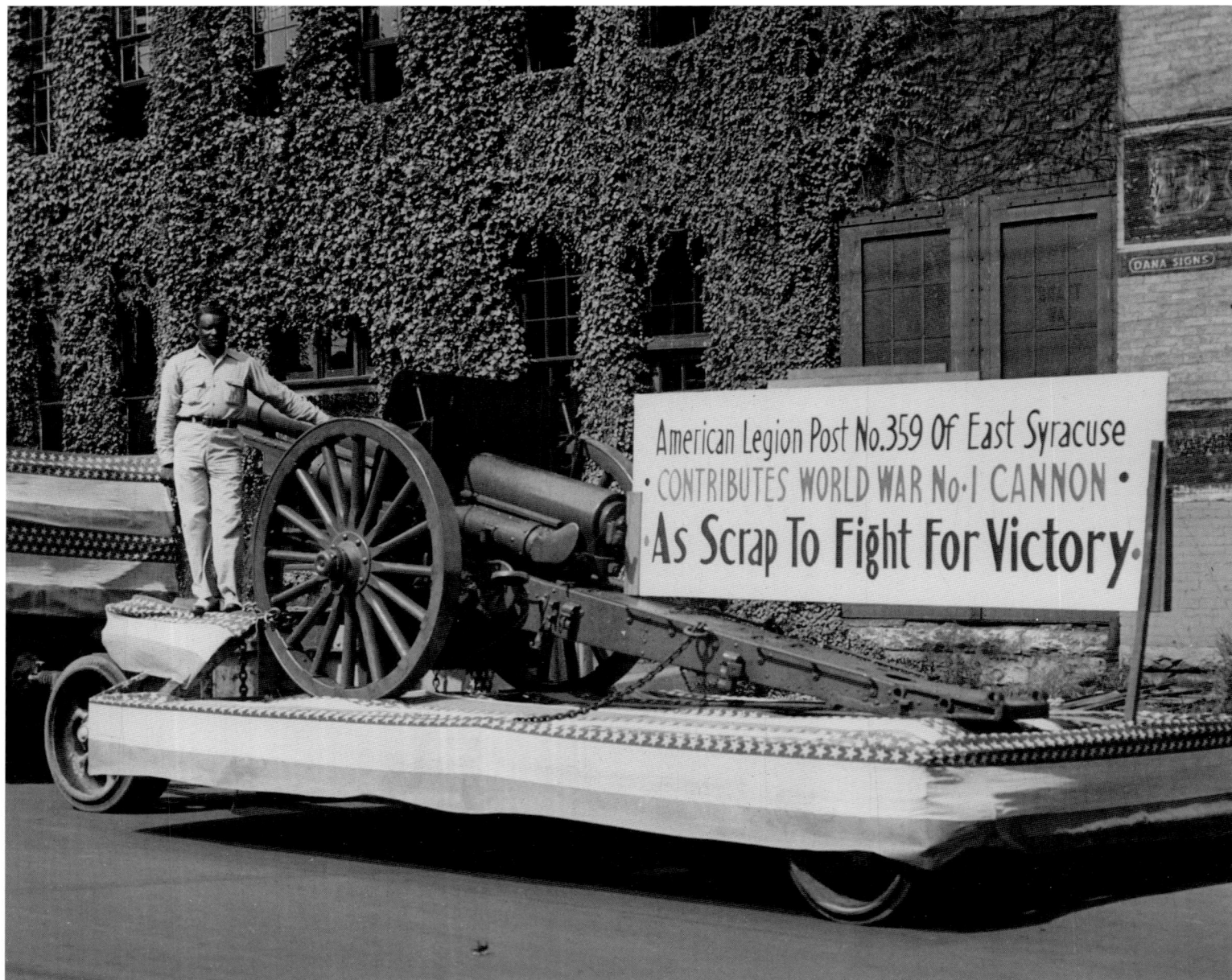

Scrap drives were important activities on the home front during World War II. They provided important raw materials and also boosted civilian morale. This float was used in a Syracuse parade to promote a local scrap drive.

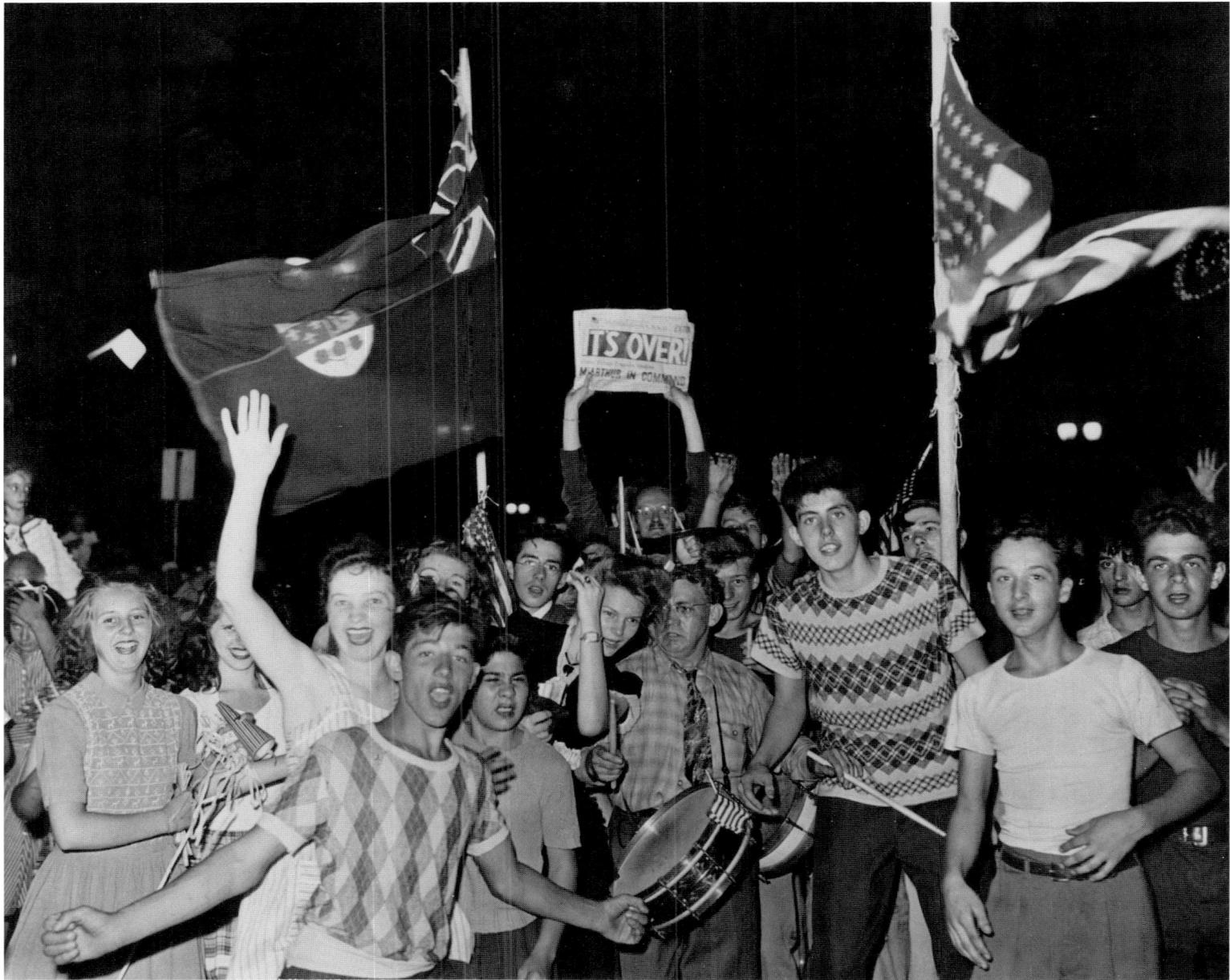

When news of Japan's surrender reached Syracuse on August 14, a spontaneous celebration broke out in the city, as it did across America. Syracusans flooded downtown streets. This group of happy revelers form an impromptu parade with American and Canadian flags. A man holds a local newspaper with the headline, "IT'S OVER: MACARTHUR IN COMMAND."

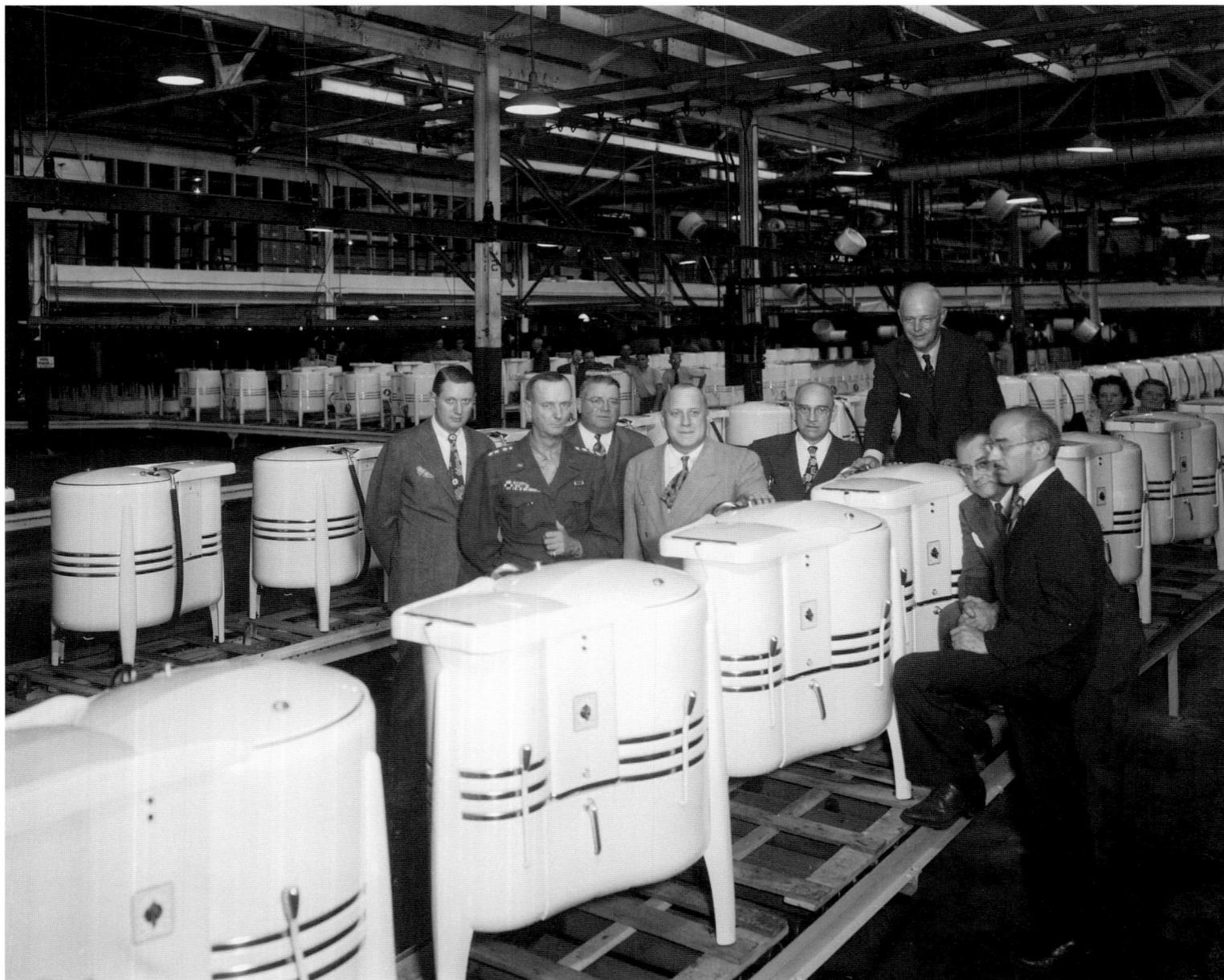

With World War II over, Syracusans wanted their lives to return to normal as soon as possible. The Easy Washer firm quickly retooled for producing their "Spindrier" model, the first machine brought to market after the war. As a promotional event, the firm asked General Jonathan Wainwright, a noted war hero whose family had local connections, to visit the factory in the fall of 1945.

CHANGING TIMES

(1946–1980)

It was unusual not to have any snow on the ground, but it was still early December 1956 and there would be plenty of winter yet to come. As downtown shoppers hustled into the Dey Brothers department store to continue their quest for the ideal holiday gift, they could glance across the street at two of the city's largest movie houses, RKO Keith's and the Paramount. They were luxury affairs, built around the time of World War I, and had hosted many of the great Hollywood classics of the 1930s and 1940s. But the marquees were now showcasing movies called *The Wild One, Rock Around the Clock,* and *Shake, Rattle & Rock* with stars named Marlon Brando, Bill Haley and His Comets, and Fats Domino. It was not the same old downtown. The fifties had arrived.

The fifties and sixties were a coming-of-age time for a generation, and those years left fond memories of a new layer of unique places, persons, and events that are now a part of the long heritage of Syracuse. There were the dramatic sporting moments of SU football or Syracuse Nationals basketball, the treat of visiting downtown at Christmas, or the fun of watching the *Magic Toy Shop* and other local programs on TV.

The post–World War II era would also bring new forces to bear on the city: urban renewal, competition from the suburbs, national and worldwide market shifts posing a challenge to the local economy, and two main highways slicing through downtown in ways that even the railroad and canal builders could not have imagined.

Although the city has always been evolving, with new structures and landscapes replacing past ones, the decades of the 1950s and 1960s seemed to bring an unprecedented urgency to transform the aging city overnight by sweeping away much of the old. Change can be good, but too often urban renewal and commercial redevelopment stole key elements of the community's links to its own past. Over the years, a new appreciation for the city's historic resources has emerged and these assets are playing an ever more vital role in its future.

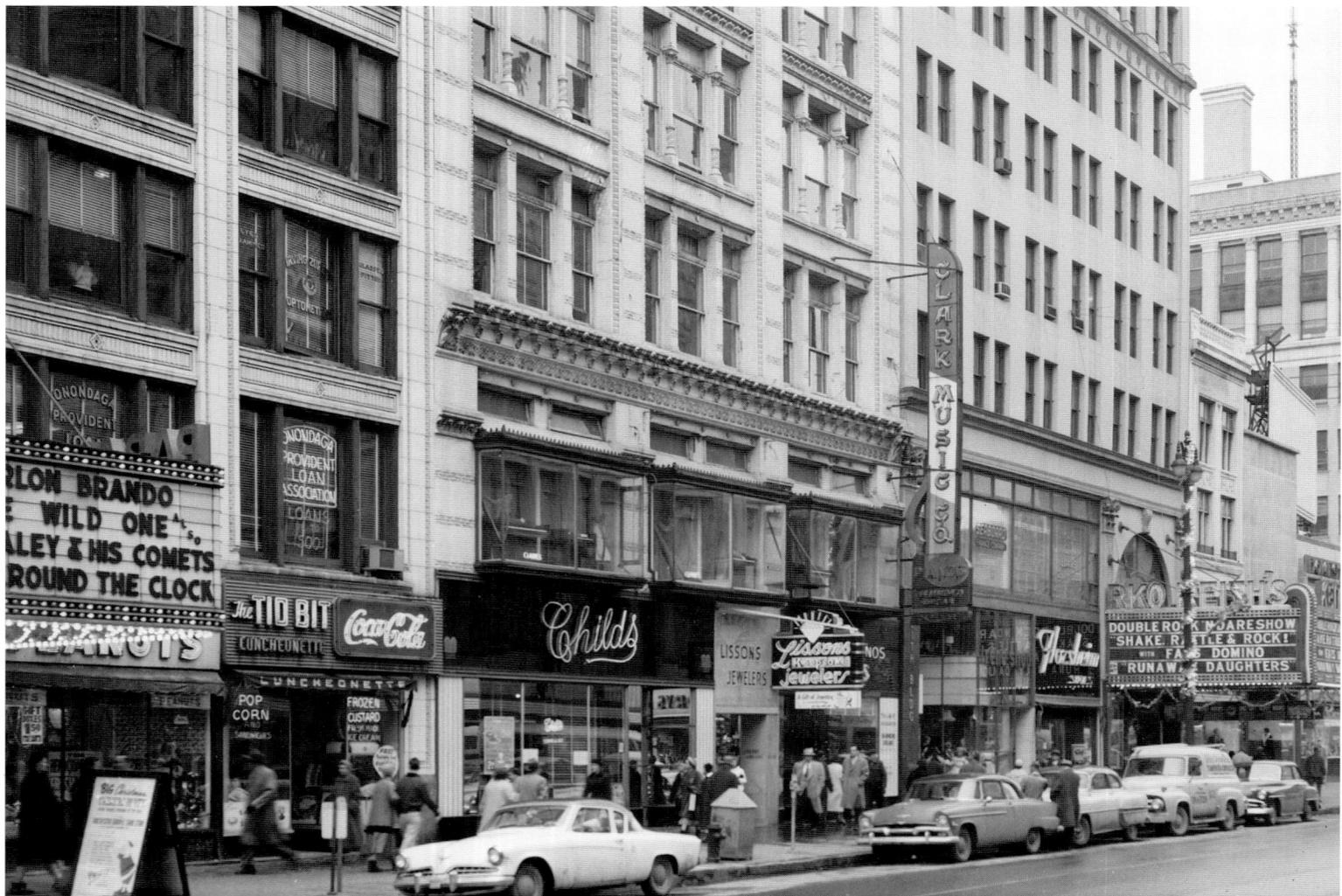

Many of the movie theaters on Salina Street remained active through the 1940s, 1950s, and even into the early 1960s. Eventually, however, television and the arrival of suburban theaters offering free parking cut into their business. Urban renewal projects removed the block shown here. The Paramount and Keith's were showing classic fifties fare in December 1956.

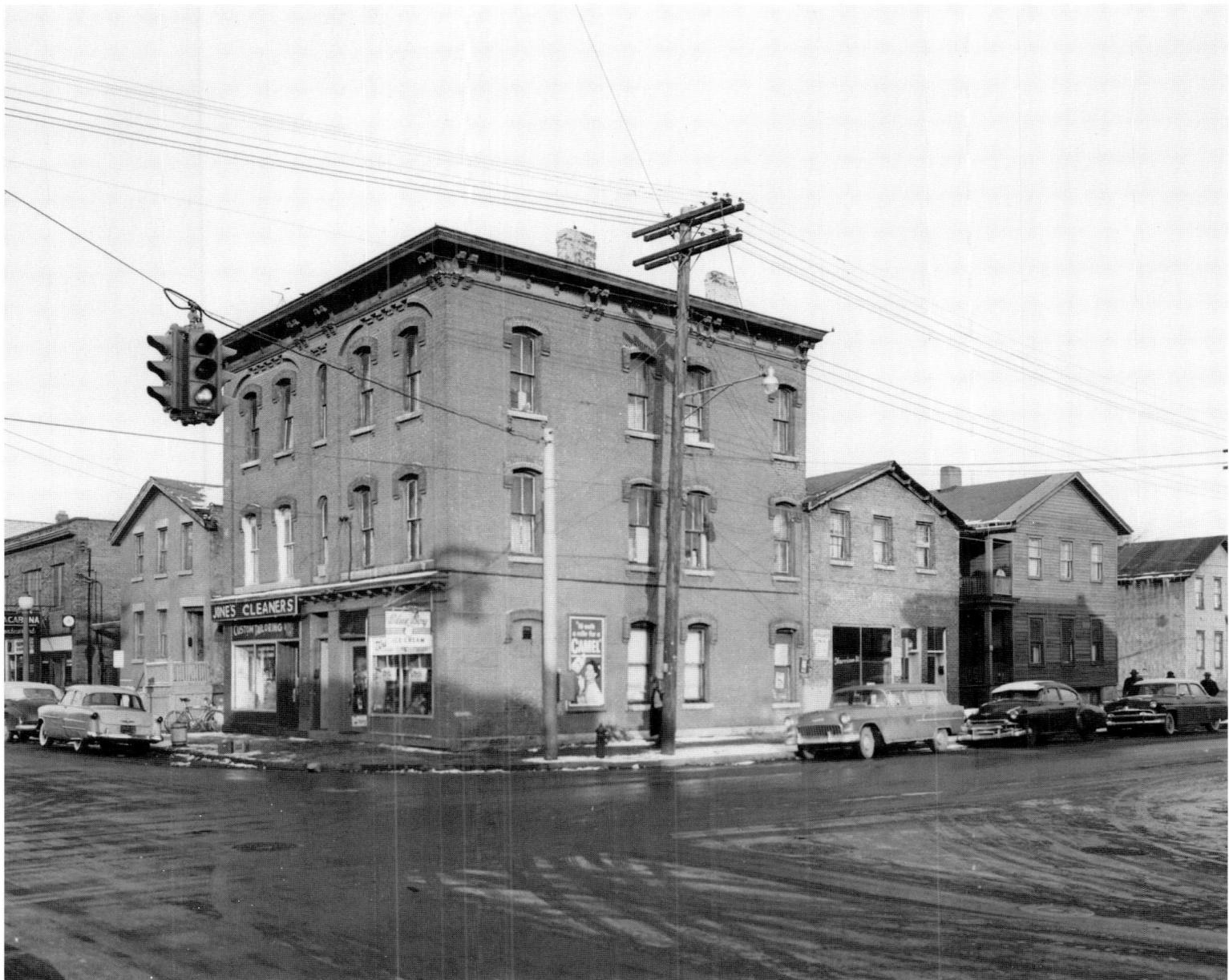

The corner of Townsend and Harrison streets in the 1950s was in the heart of the old Fifteenth Ward. This had been the Jewish quarter of Syracuse since the nineteenth century, but after World War II it increasingly became the center of the city's African-American community, owing at least in part to housing discrimination. This corner and much of the surrounding area would be leveled for urban renewal in the 1960s.

In this promotional photo for the 1948 Syracuse Centennial, a model poses atop the State Tower Building with official balloons. Just beneath the balloons, on the street below, is one of the 1936 art deco bridges from the New York Central Railroad elevation project. It would be demolished in the 1960s for construction of the Route 690 and Interstate 81 interchange.

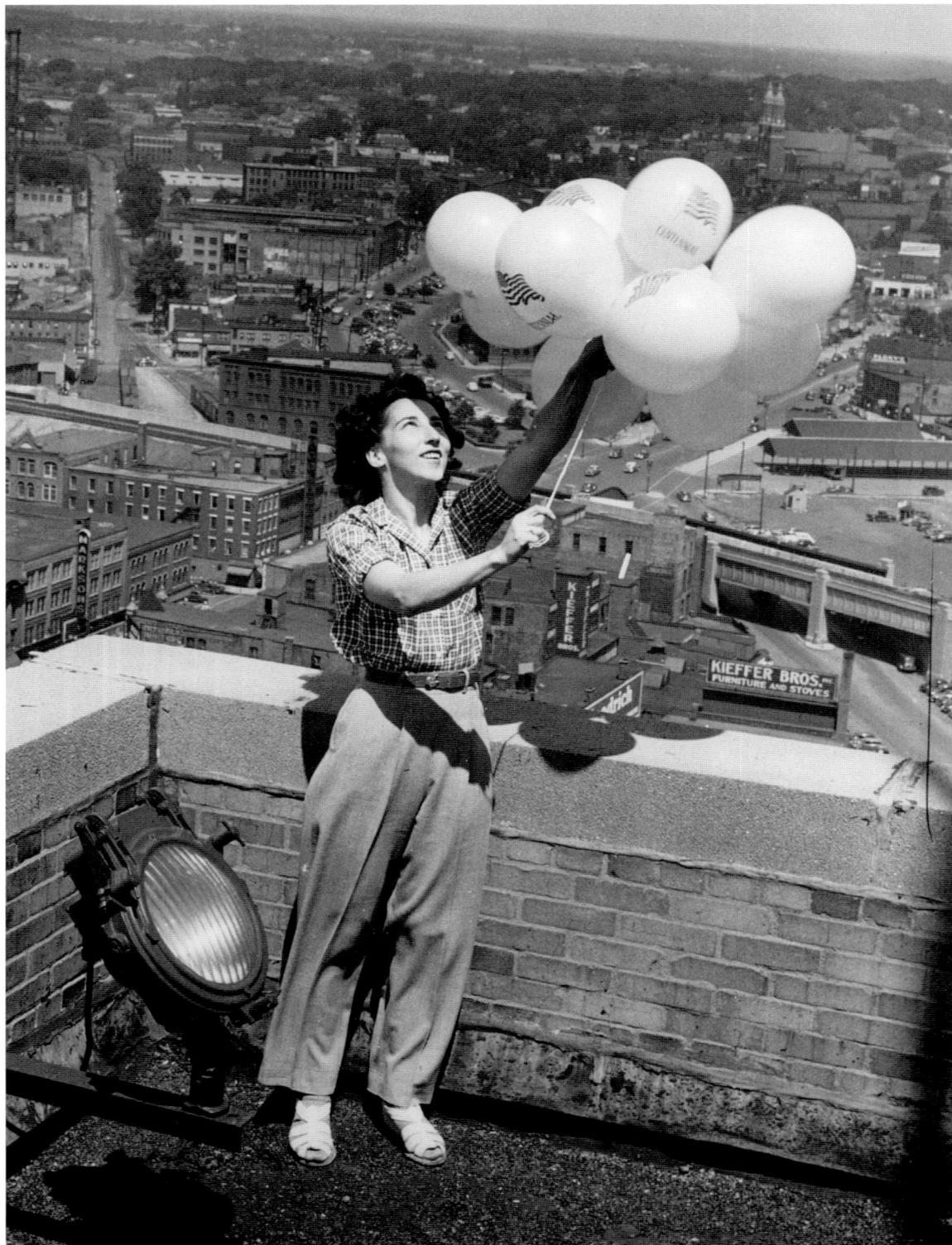

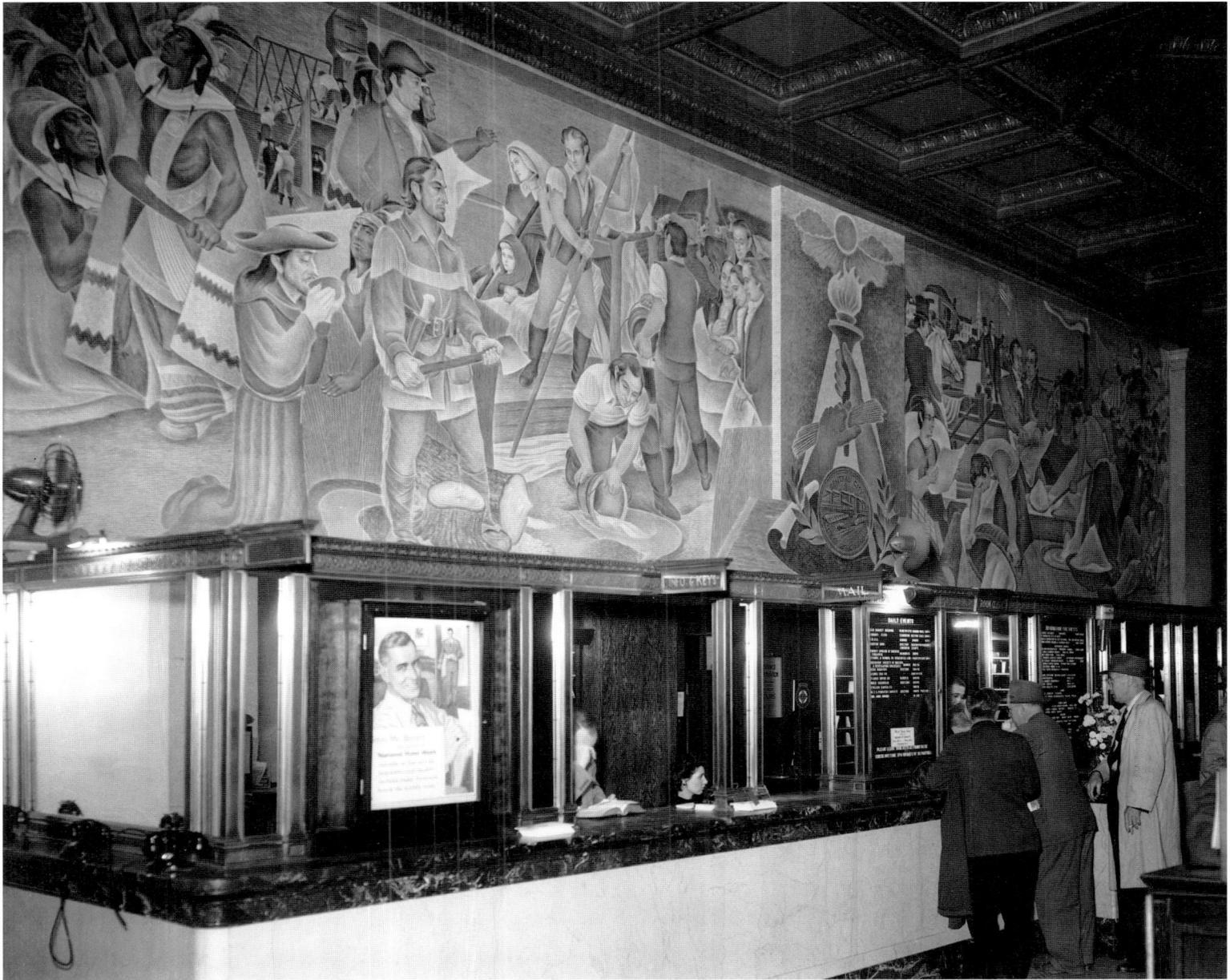

The city of Syracuse celebrated its centennial in 1948 with parades and pageants. The Hotel Syracuse participated by commissioning Carl Roters to create a historical mural for its lobby, completed in a style reminiscent of famous artist Thomas Hart Benton. The mural was hidden from view during late 1970s renovations. Hope is that it can be restored in the near future.

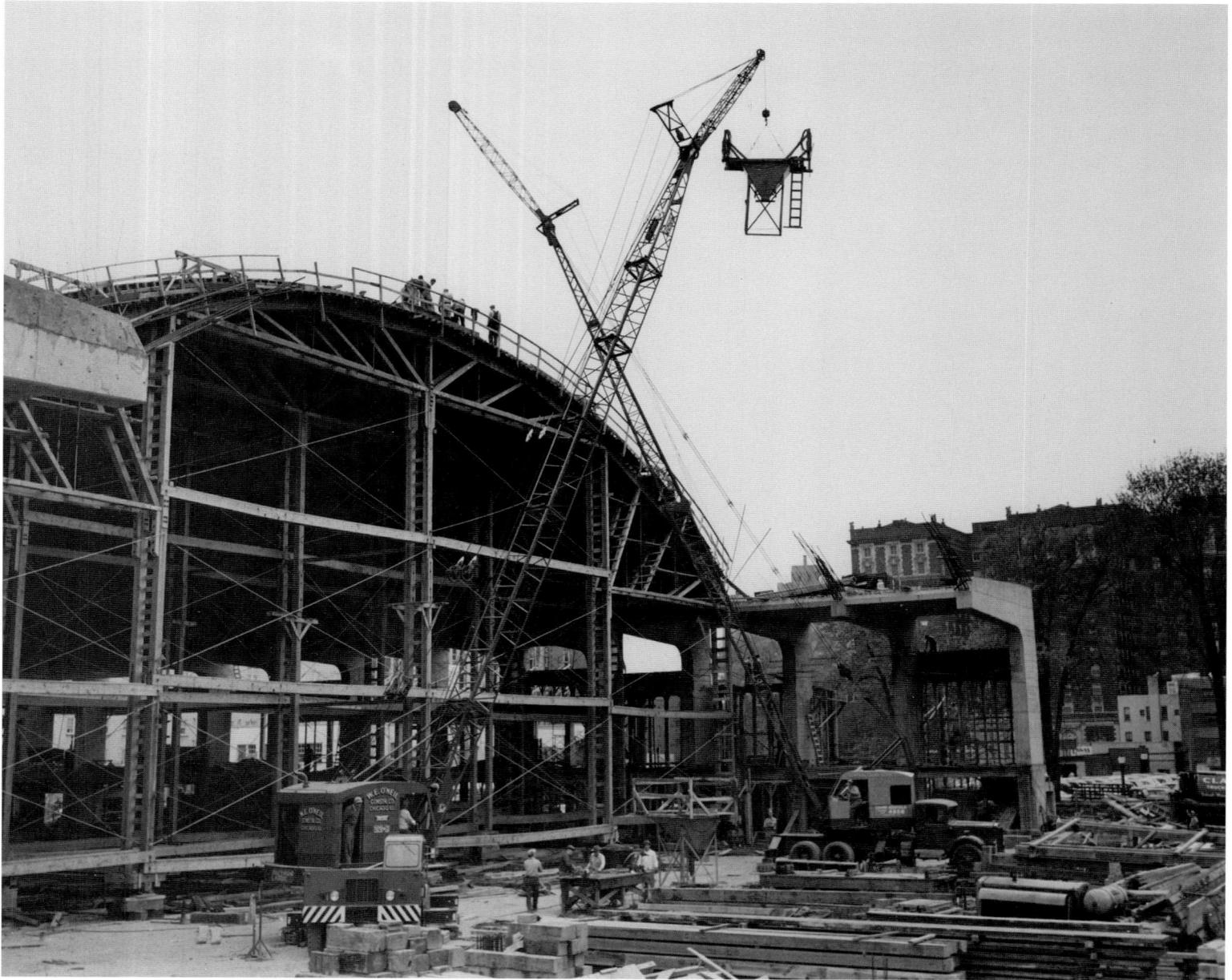

The Onondaga County War Memorial, under construction in 1950, was the long-sought civic auditorium that Syracuse had talked about since the 1920s. It has remained a multi-use facility for nearly 60 years, hosting events ranging from professional hockey games to high school graduations.

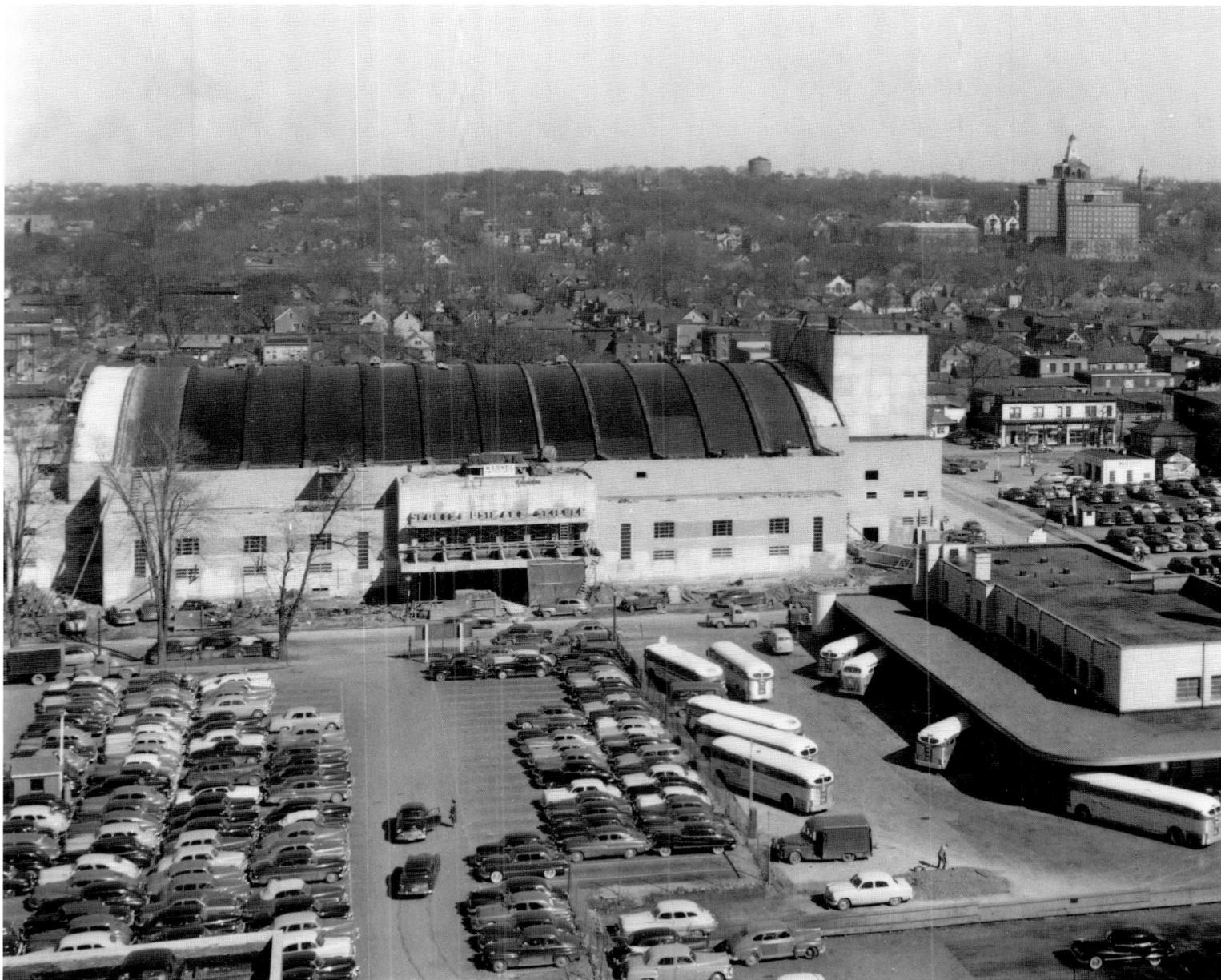

The War Memorial nears completion in April 1951. The Greyhound bus station sits on the corner and beyond it is much of the old Fifteenth Ward, several blocks of which would be removed in the 1960s by urban renewal and the construction of Interstate 81. Memorial Hospital and SU's Crouse College are landmarks on the distant skyline.

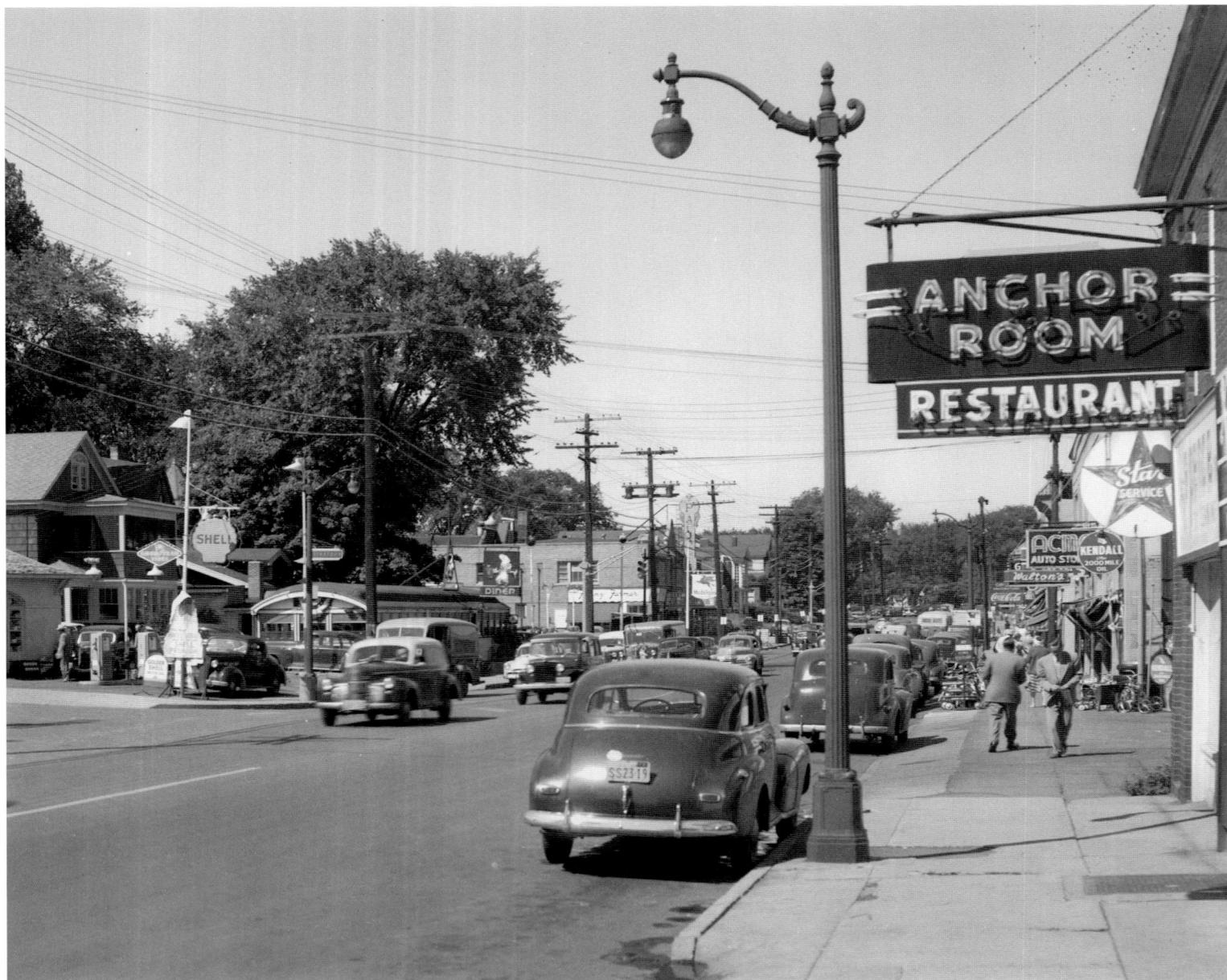

The Eastwood shopping district along outer James Street hums with activity in 1949. This view faces west toward the Palace Theater.

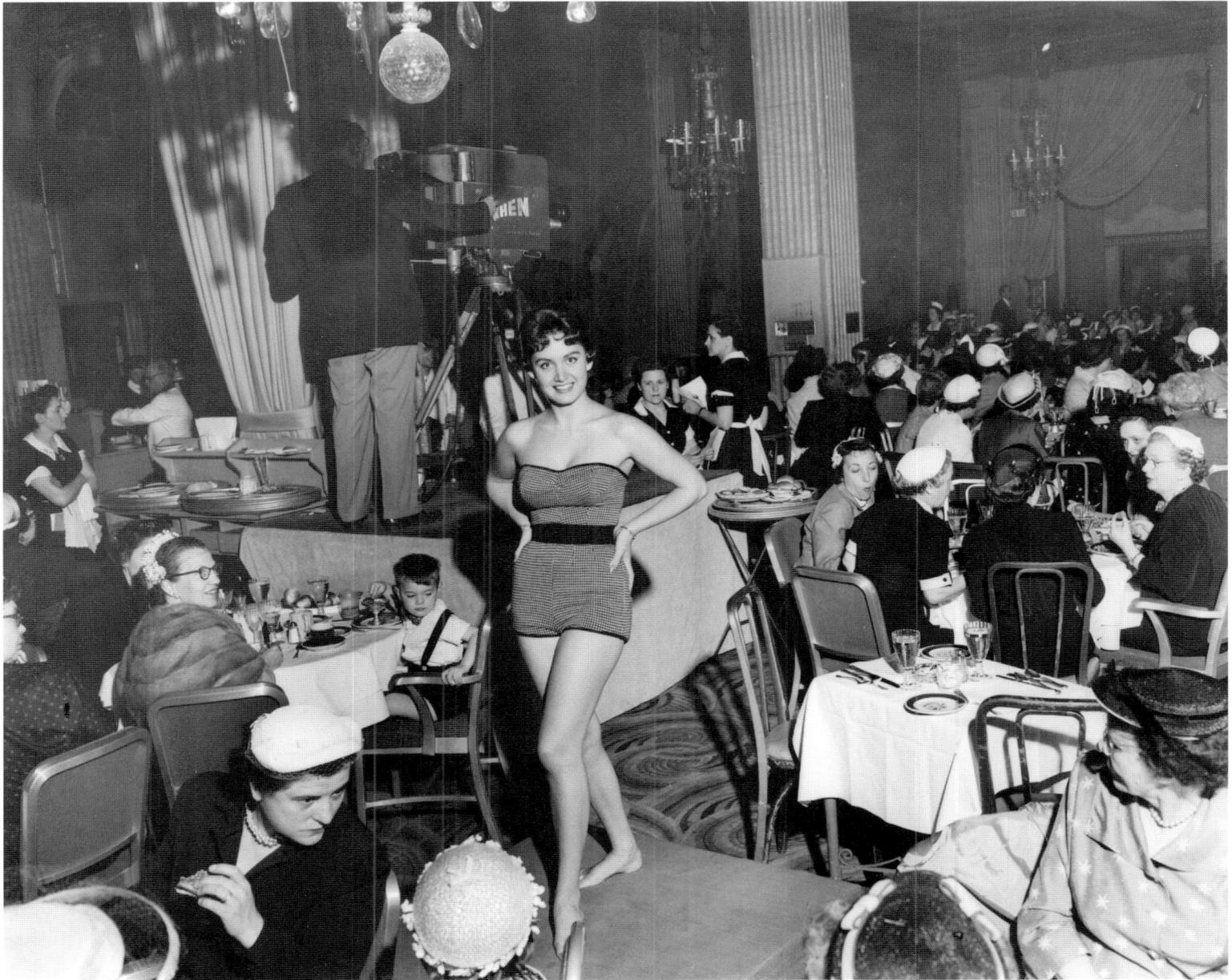

During the late 1950s and early 1960s, WHEN TV broadcast a live afternoon fashion show every week from the Persian Terrace of the Hotel Syracuse. It was sponsored by the Addis department store, which provided the clothes, and by the hotel, which prepared a luncheon for the audience.

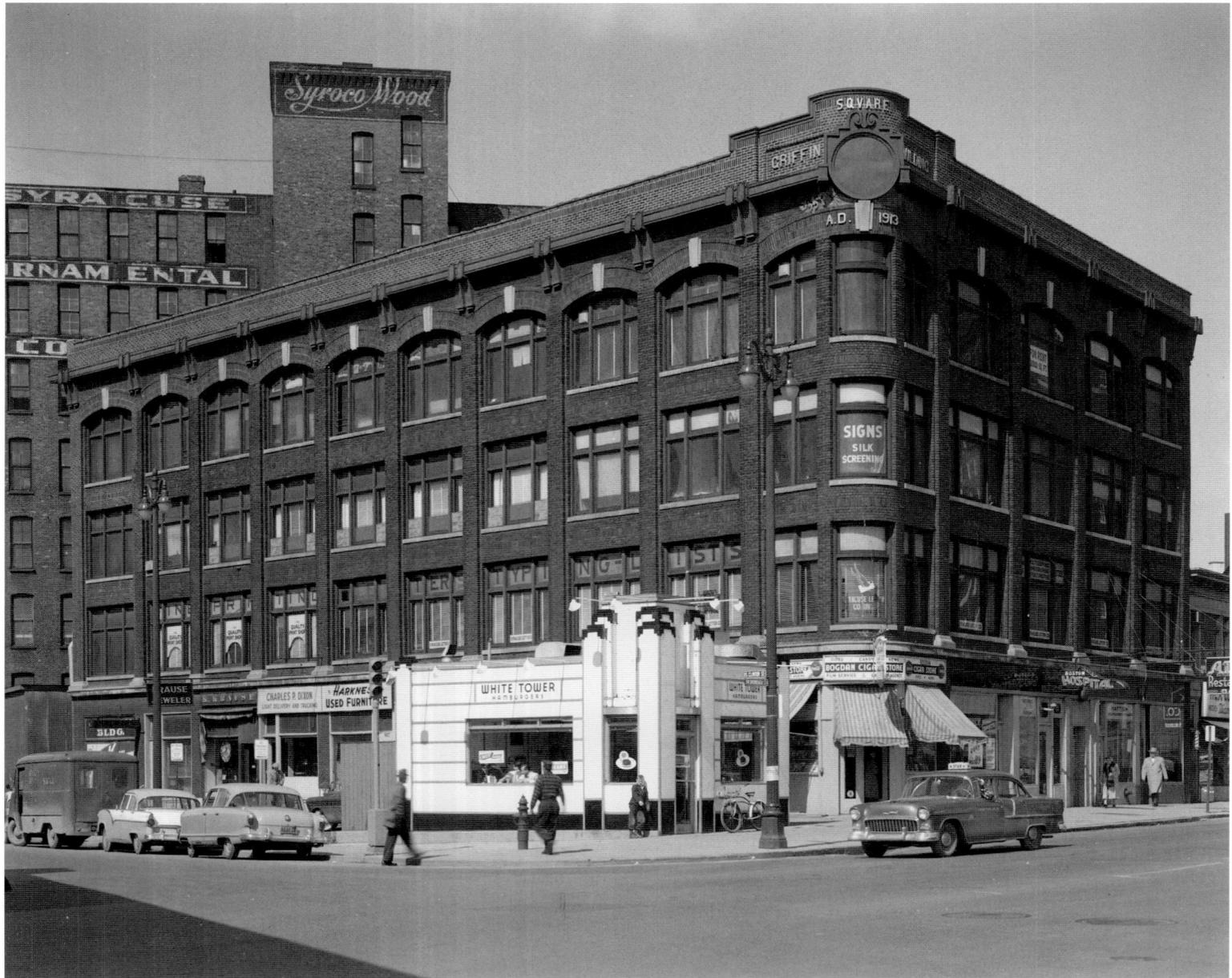

The northeast corner of Clinton and West Onondaga streets as it appeared in 1956. The White Tower restaurant was one of more than 200 in the national chain at the time. Its porcelain-enameled building is fully streamlined, in sharp contrast to the older structure behind it. Farther to the rear is the Syracuse Ornamental Company, better known as Syroco. Like many local firms following World War II, it would eventually relocate its factory to the suburbs. All these buildings are now gone.

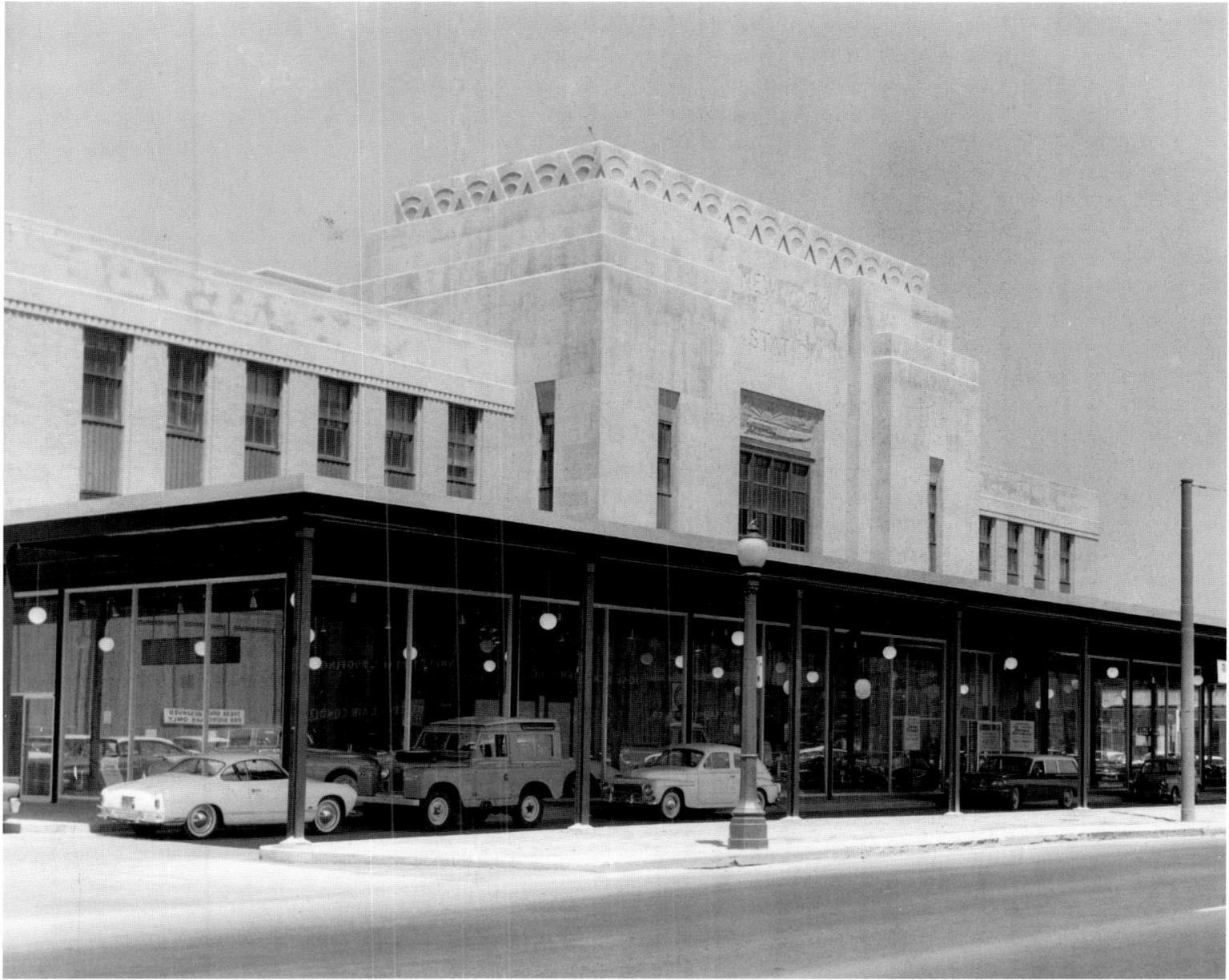

In 1962, declining passenger rail traffic forced the New York Central to close its 26-year-old Erie Boulevard station. The following year, the station briefly became part of an auto sales complex. A disfiguring "awning" was added to create a showroom for imported cars. In 2003, following a long run as a bus station, the building was sympathetically rehabilitated as a home for an all-news TV station.

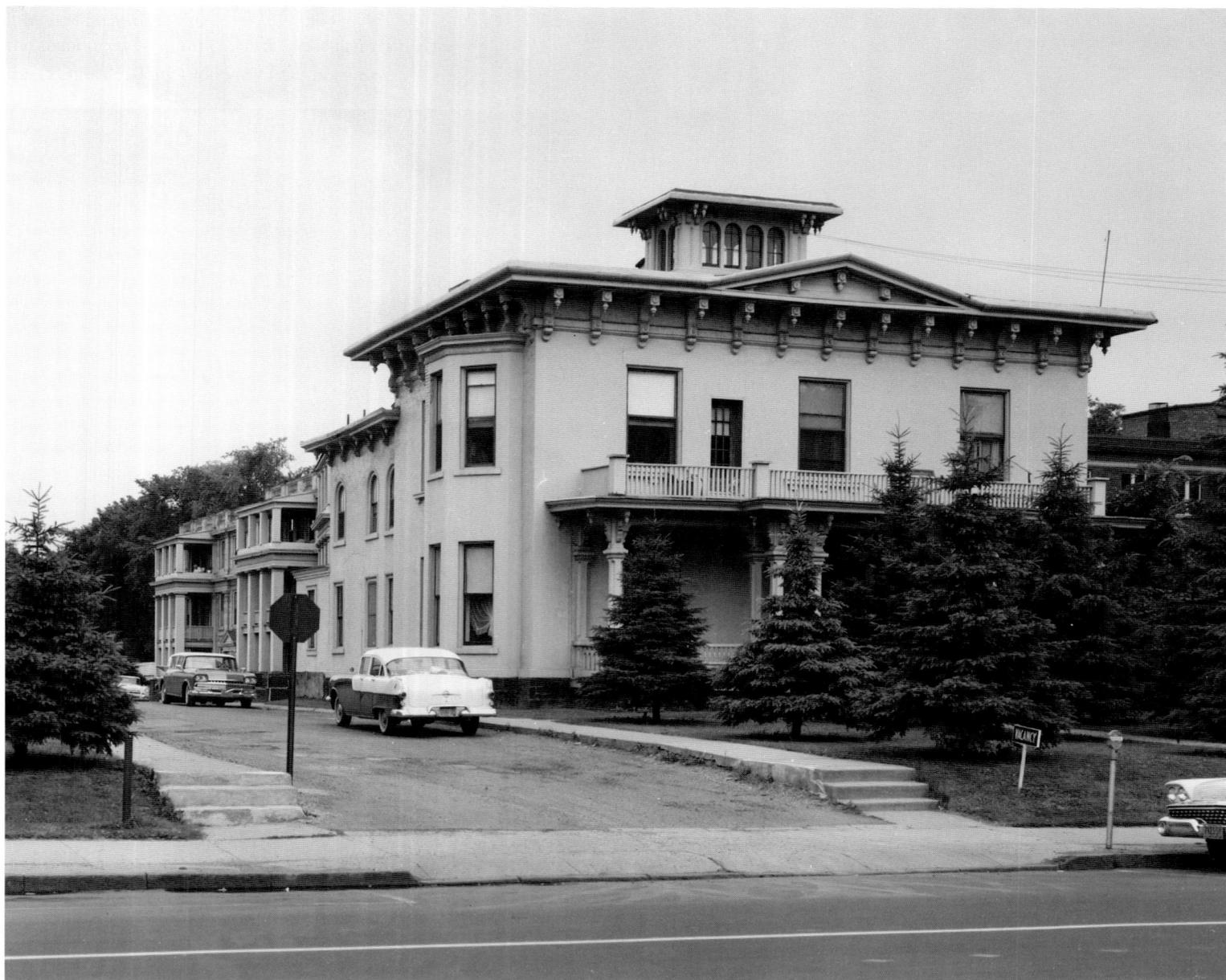

The Onondaga Place Apartments on West Onondaga Street began life as a private mansion in the mid–nineteenth century, complete with two acres of gardens and fruit trees. Records are sketchy, but it appears to have been the home of William A. Robinson, a hotel proprietor, around the time of the Civil War. A row of townhouse-like apartments was added to the rear, early in the twentieth century, as seen here in 1956. Eventually the original house, extensively altered, and the whole complex were demolished.

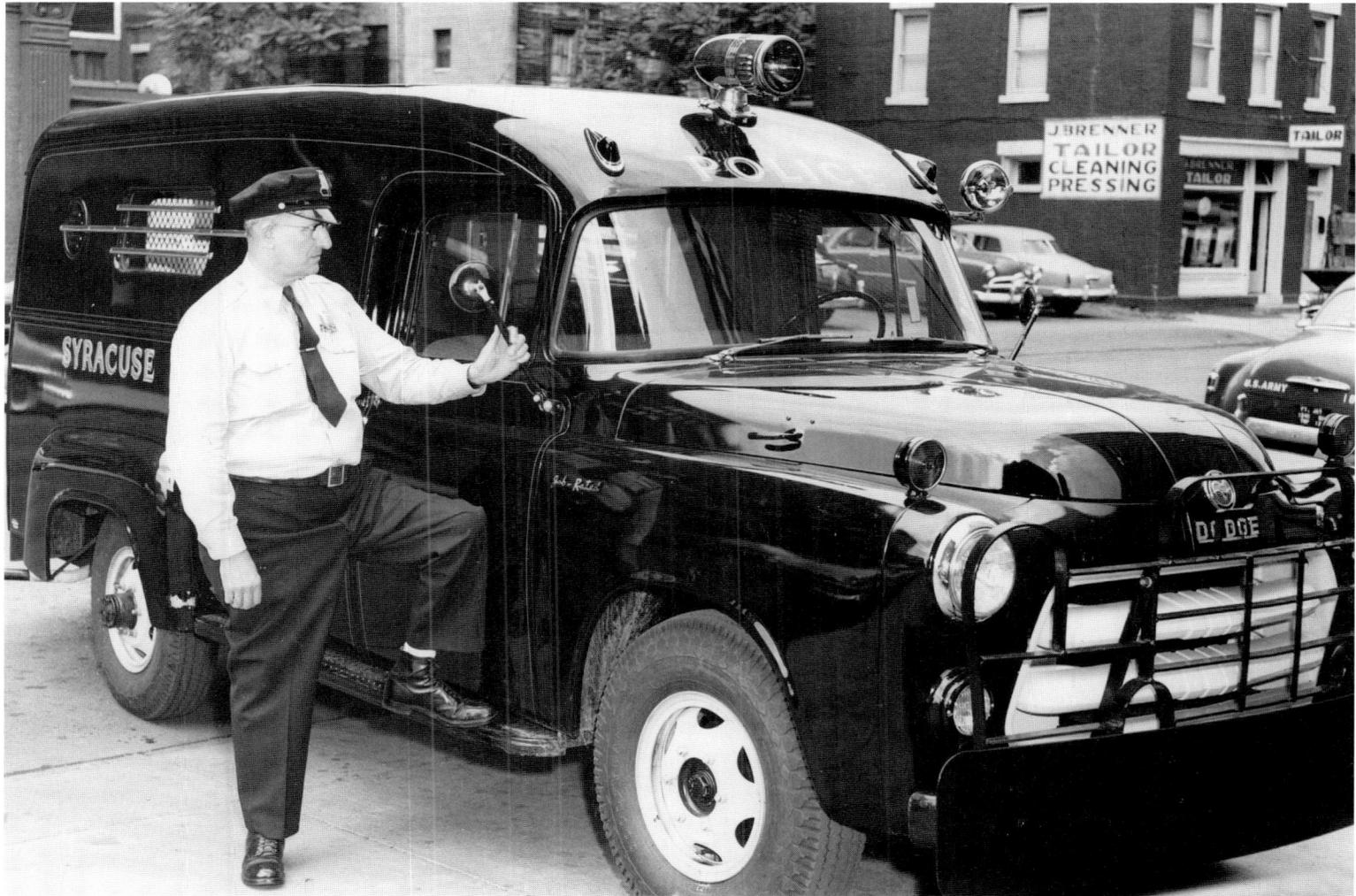

The Syracuse Police Department acquired a $4,000 "paddy wagon" in 1955 to transport prisoners. Patrolman John Armbruster, the driver, poses with his shiny new equipment.

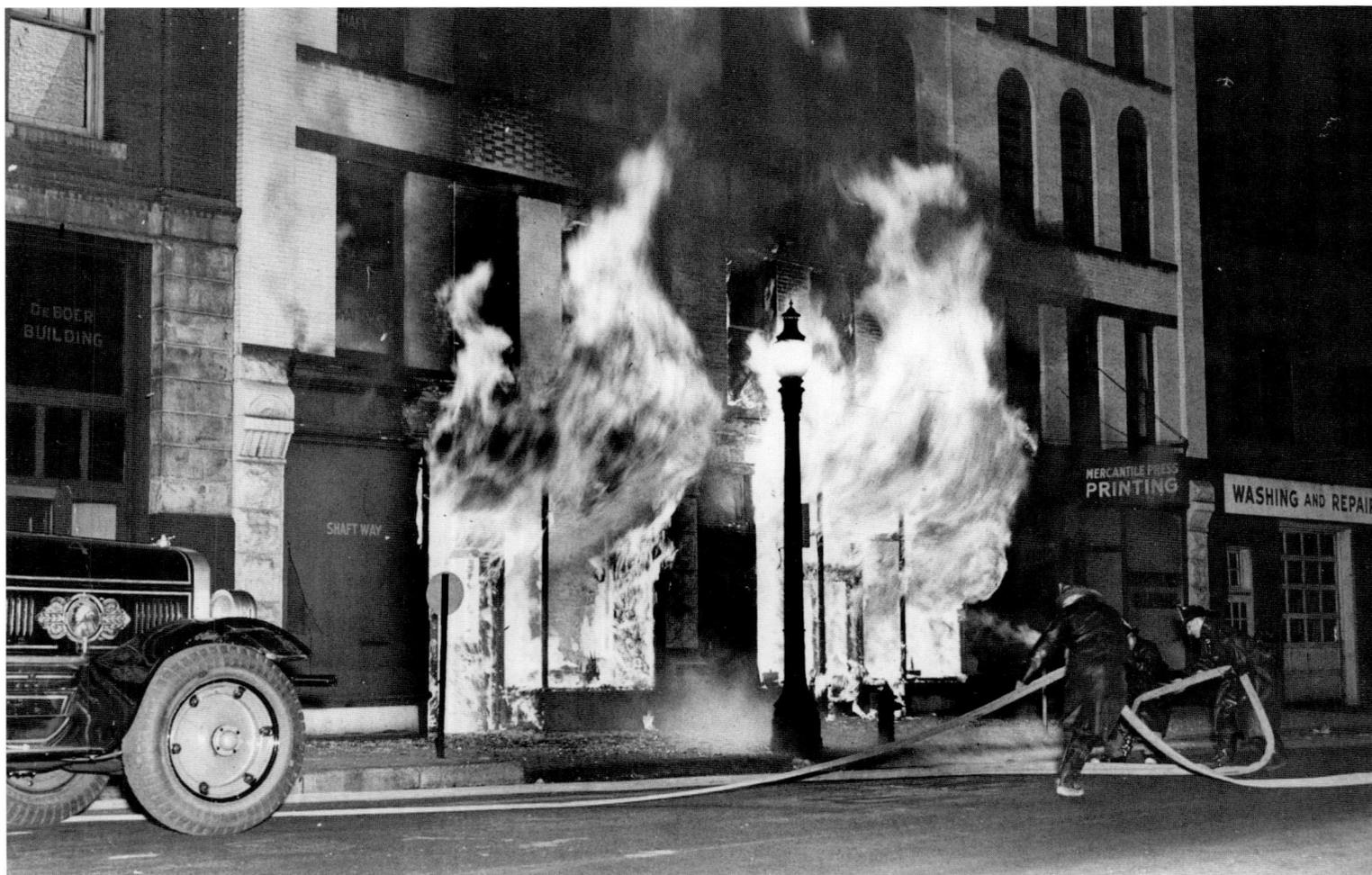

Syracuse fire fighters tackle a roaring blaze at the Labor Temple Building on South Franklin Street in 1948. Fortunately, they saved the structure—35 years later its visionary restoration would prove to be a catalyst for launching the revitalization of downtown's entire Armory Square Historic District.

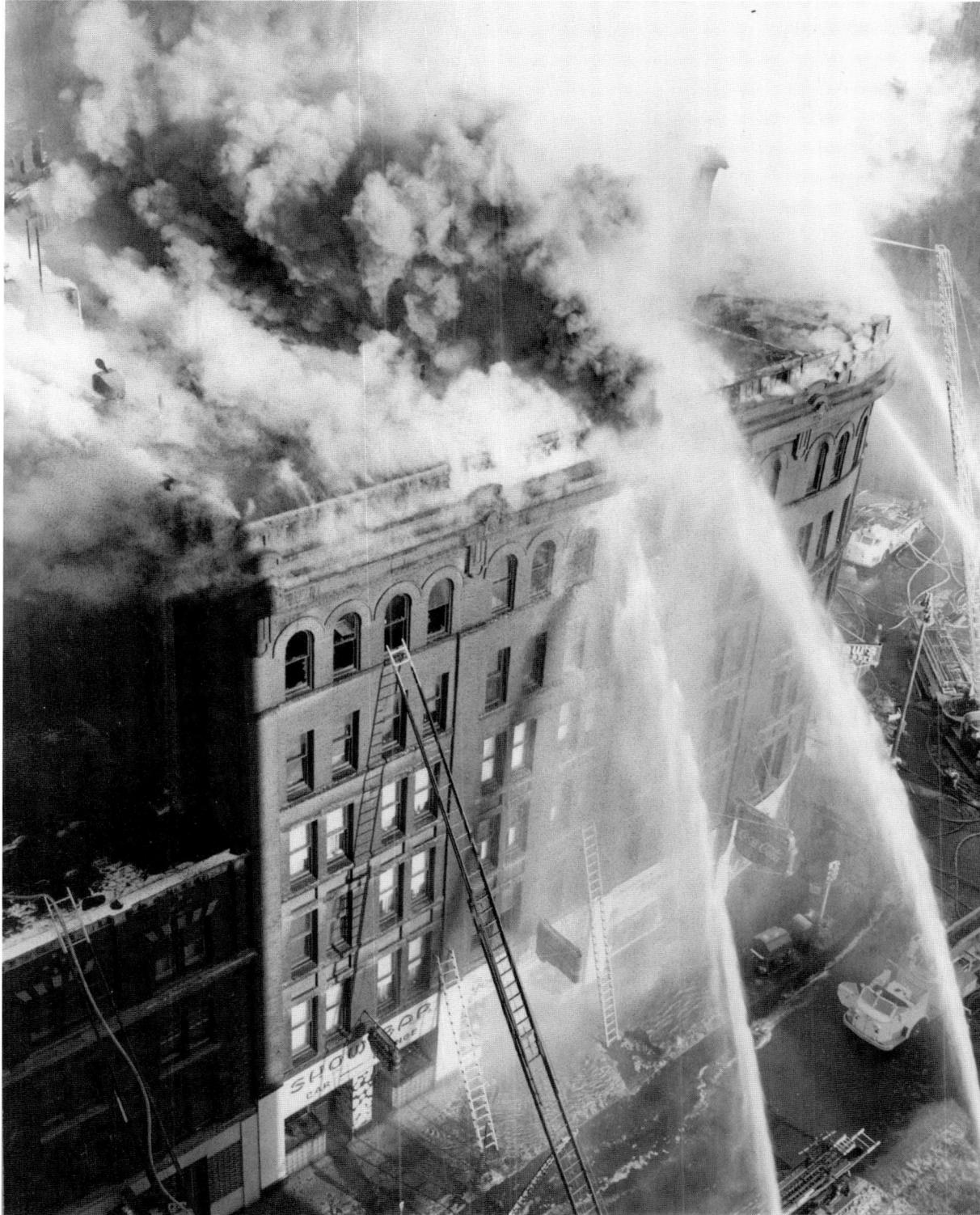

One of the city's most dramatic fires of the postwar period was the March 1953 blaze that hit the Mowry Apartment Building at South Salina and Onondaga streets. More than 100 occupants had to flee, and although there were a handful of injuries, no one was killed.

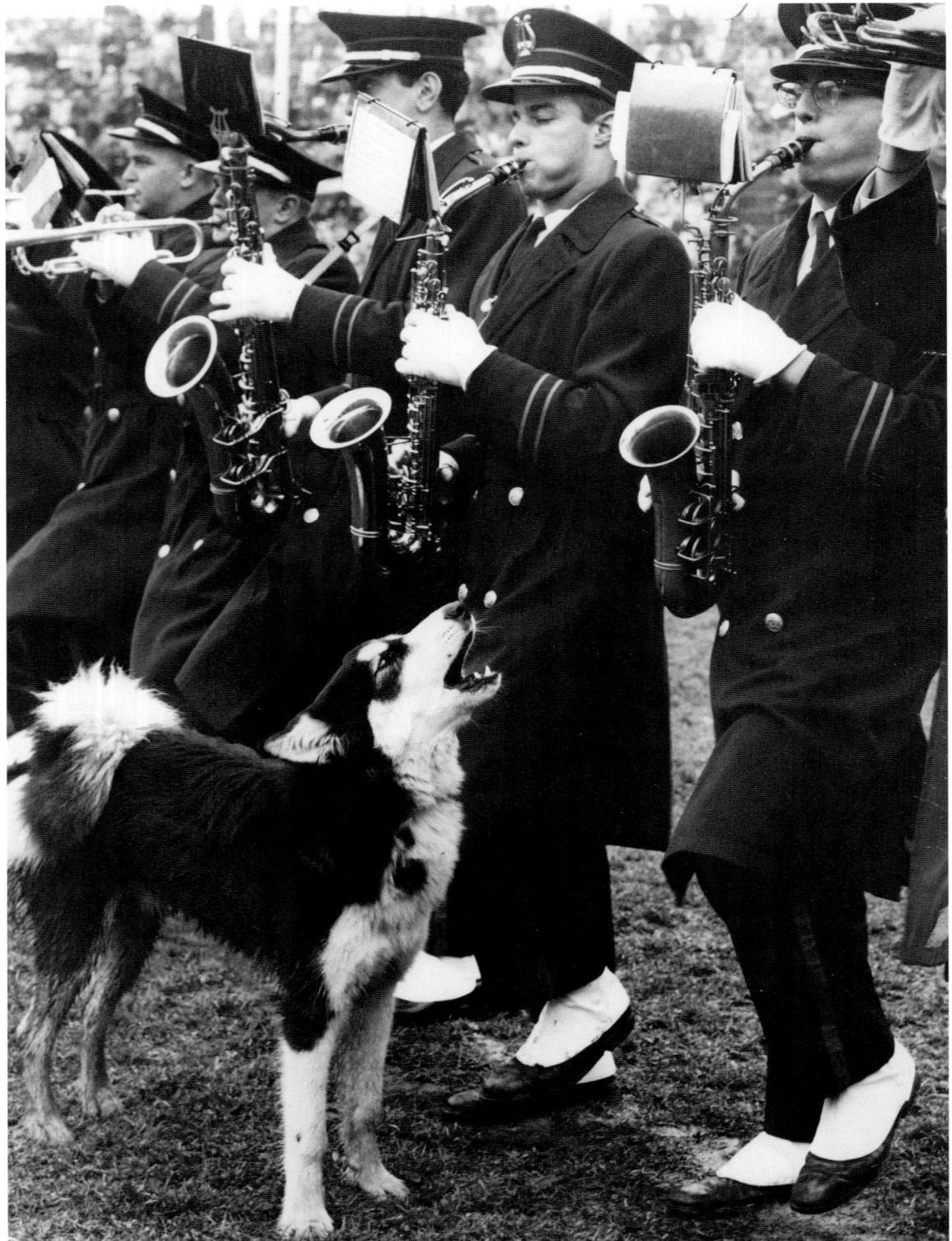

Syracuse University's marching band has an extra "vocalist" in this 1961 photo.

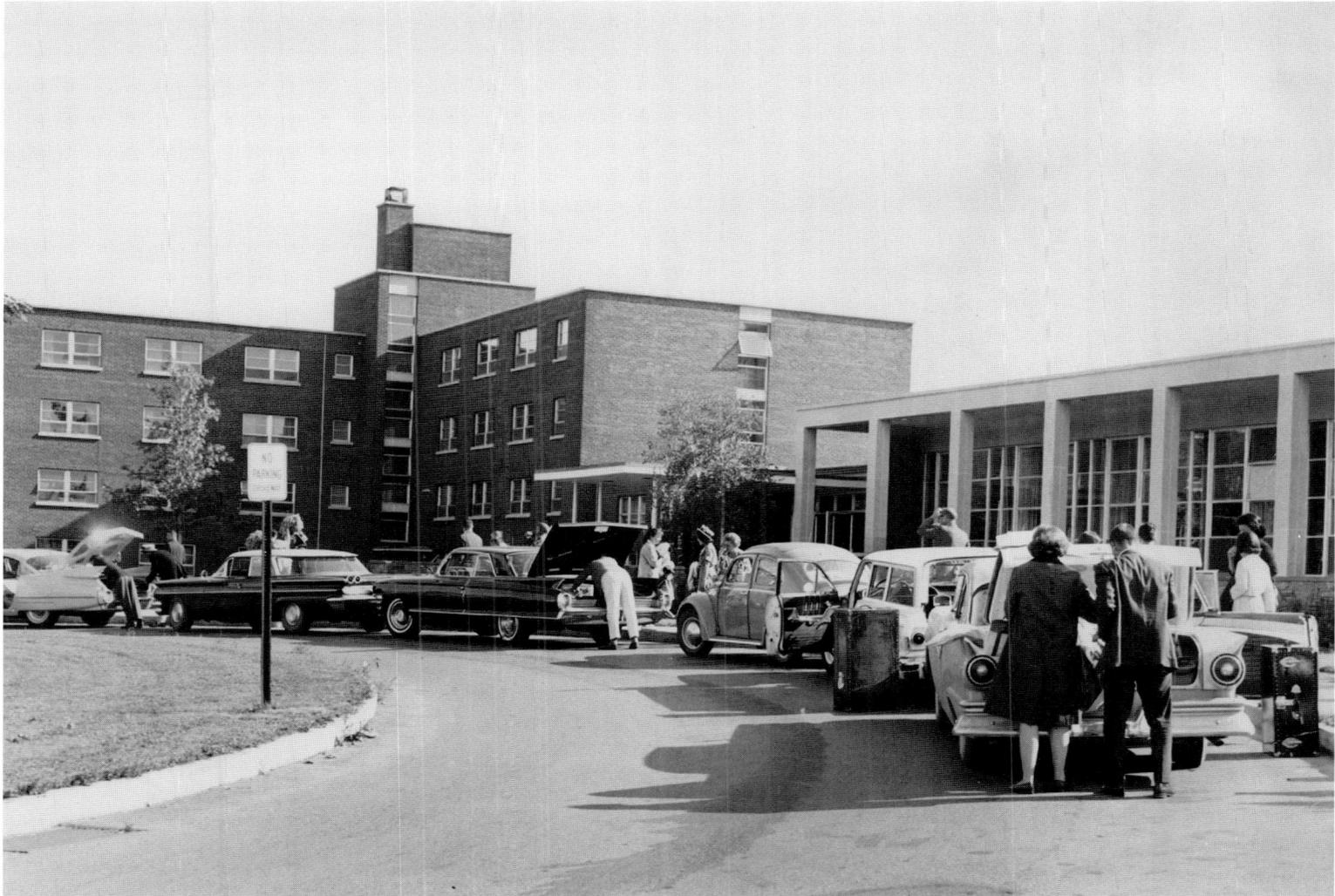

Syracuse University, a local institution since 1870, underwent a great expansion after World War II. Today it is one of the city's largest employers. In 1963, incoming freshmen and their parents line up at a dormitory on Mt. Olympus to unload.

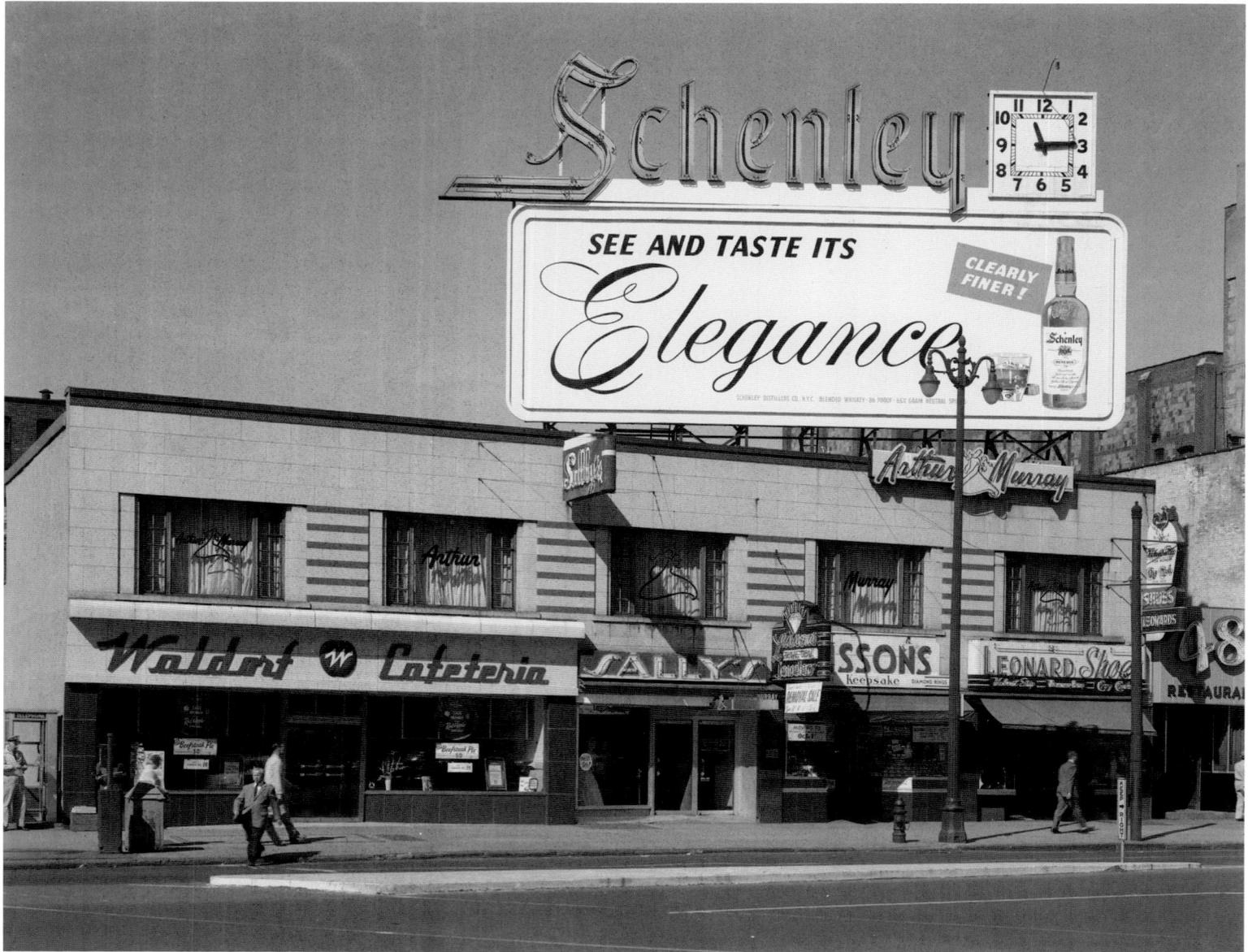

Adjacent the Mowry Apartment Building on South Salina Street was this small building, photographed in 1956. At the time, it housed specialty stores for shoes, jewelry, and women's bridal apparel, along with a Waldorf Cafeteria and an Arthur Murray Dance Studio. Waldorf was a chain of restaurants throughout the Northeast. On this day the menu includes lamb stew for 55 cents and a slice of pumpkin pie for 20 cents.

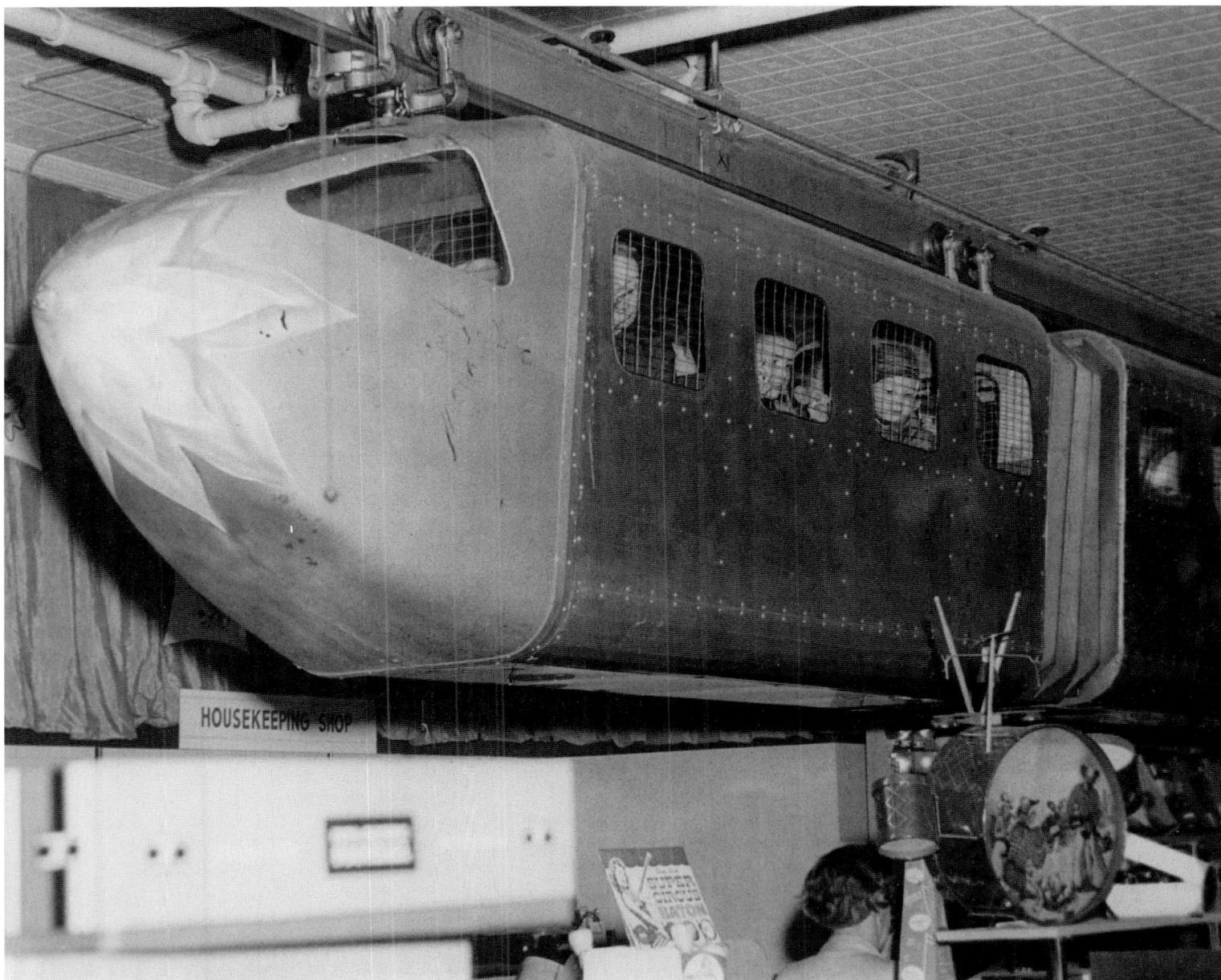

HOUSEKEEPING SHOP

Christmas in Syracuse during the fifties and sixties was not complete for a child without a trip downtown to wonder at the decorations and visit Santa in the toy departments of Dey's or Edwards. Edwards offered a special treat with its "Rocket," a series of enclosed cars suspended on a ceiling track that offered rides around the store.

191

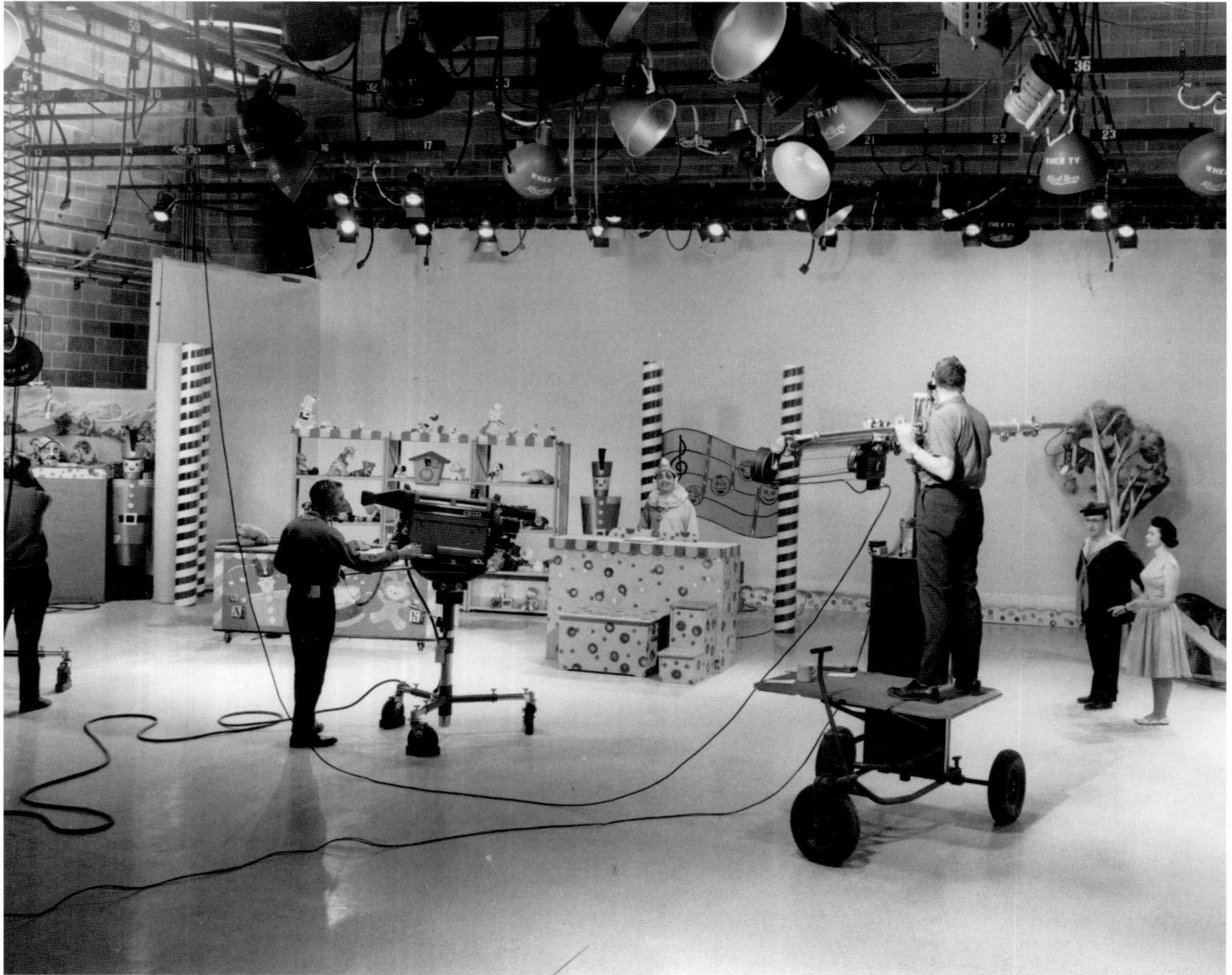

One of the longest-running local children's TV shows in the nation was the *Magic Toy Shop,* whose characters became much-loved "celebrities" for a generation of Syracuse Baby Boomers. In this view of the studio from around 1960, Mr. Trolley's story-telling set is on the left, Twinkle the Clown's magic piano is at center, and hosts Eddie Flum Num and Merrily stand on the far right.

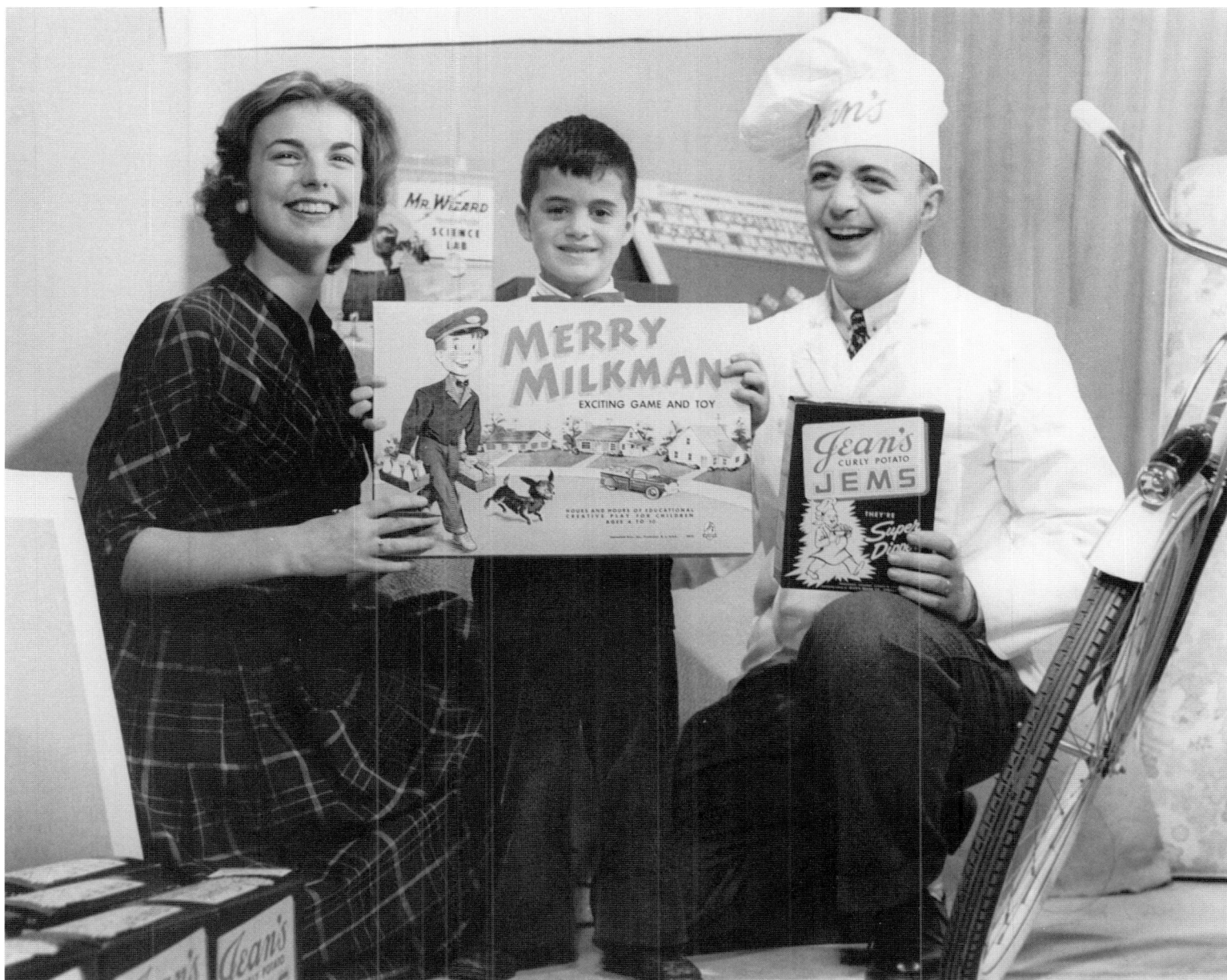

In the early years of television, there were many shows produced by individual stations that lent a distinct local flavor to daily TV. In the late 1950s, WHEN presented *Jean's Junior Auction* on Saturday afternoons. The children in the audience bid on toys by using points accumulated in purchasing Syracuse-made Jean's Jems, a kind of potato chip. Merry Milkman was a popular game of the era.

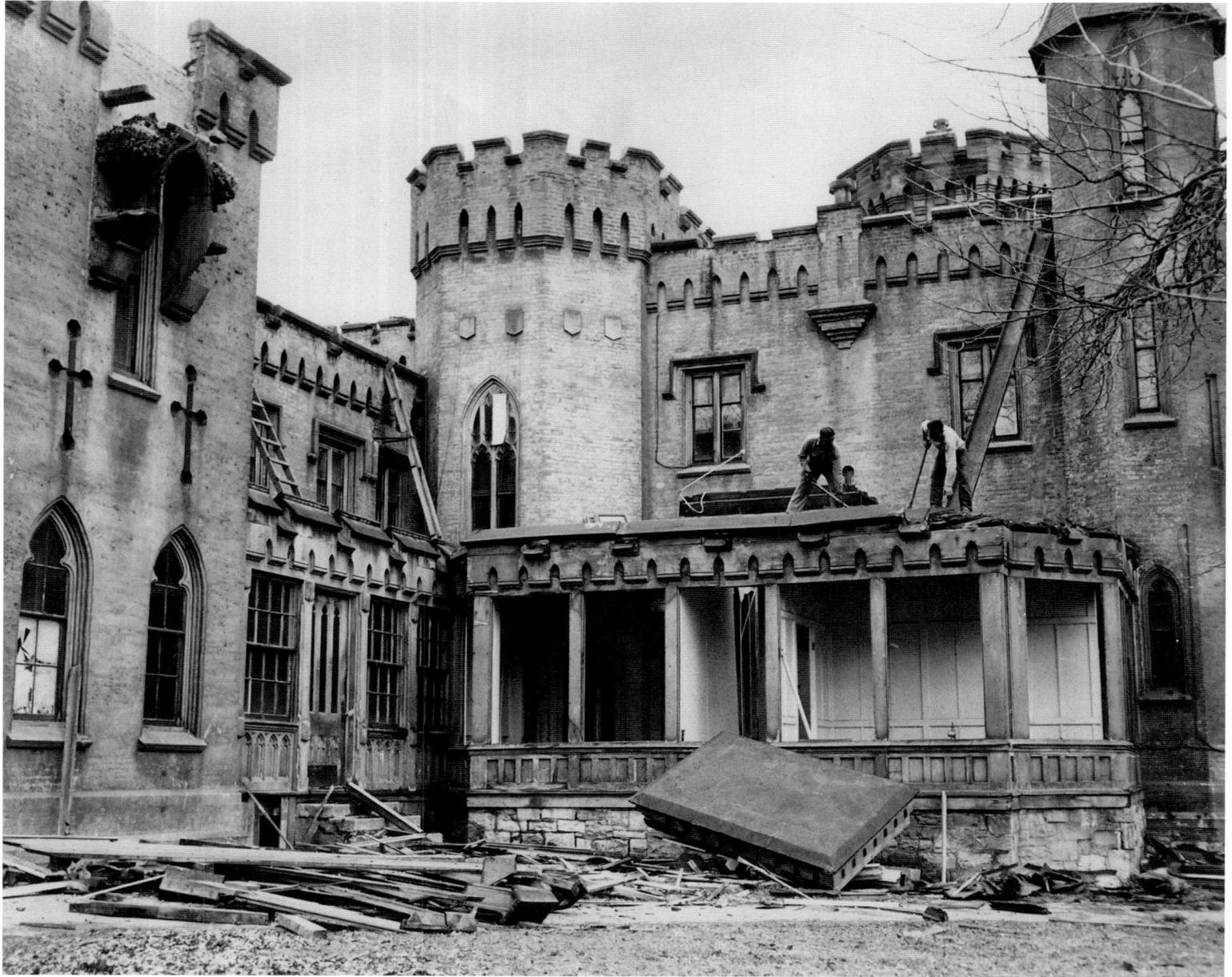

The various hospitals, educational institutions, and Syracuse University's facilities located on the hill just southeast of downtown have steadily expanded since the end of World War II, becoming a vital part of the city's economy. One of the casualties of this expansion was the 1954 demolition of Yates Castle, in the nineteenth century considered the city's grandest residence.

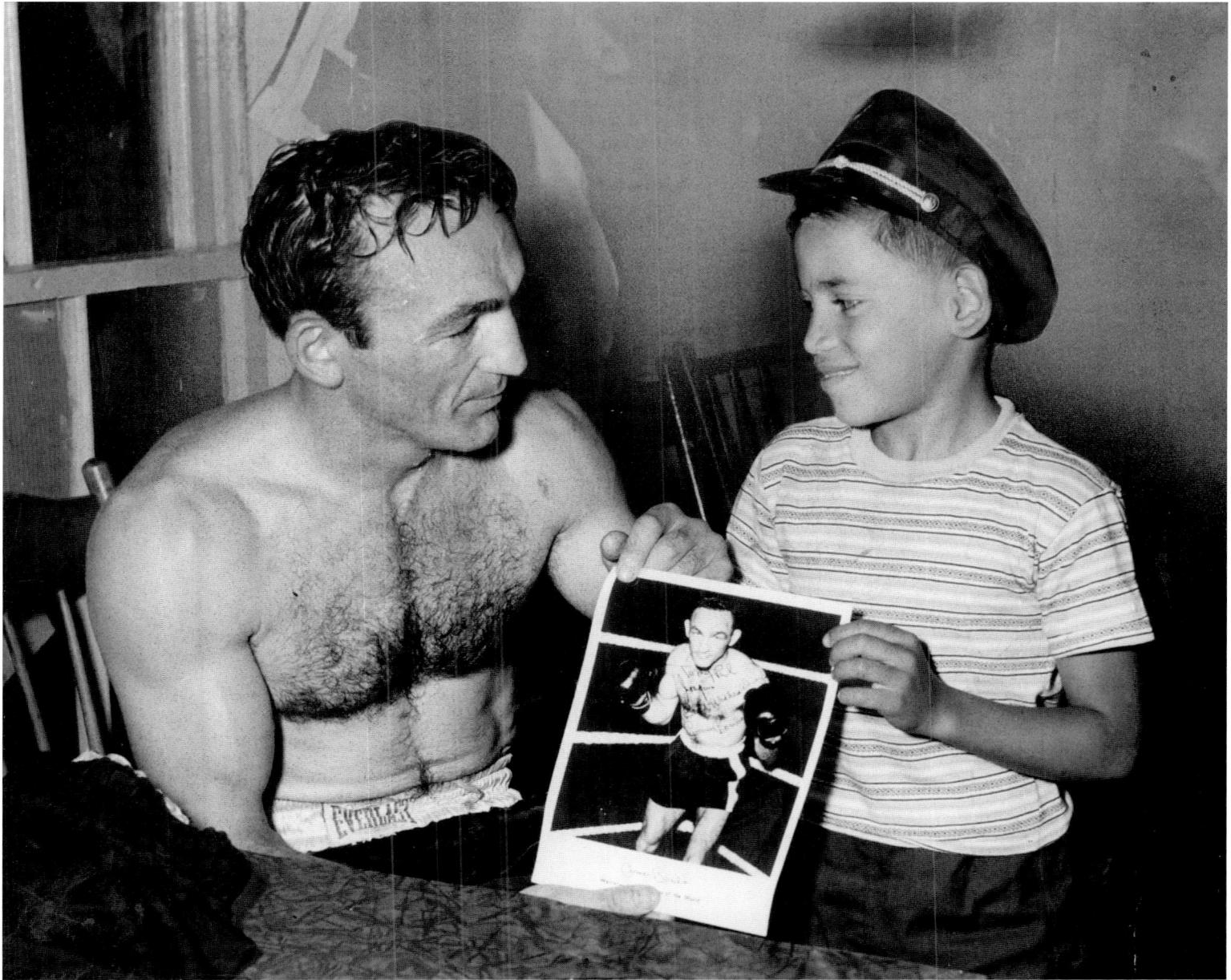

Syracuse scored some major sports moments in the 1950s with an NBA championship for its Syracuse Nats, a national collegiate football title for the SU Orangemen, and the world welterweight and middleweight victories of Central New Yorker Carmen Basilio. Here Basilio autographs a photo for a young fan.

The other main highway built through downtown in the 1960s was the Route 690 arterial. It primarily used the abandoned New York Central passenger train elevation of 1936 and had less of a physical impact on the city than Route 81. This 1966 view faces northeast.

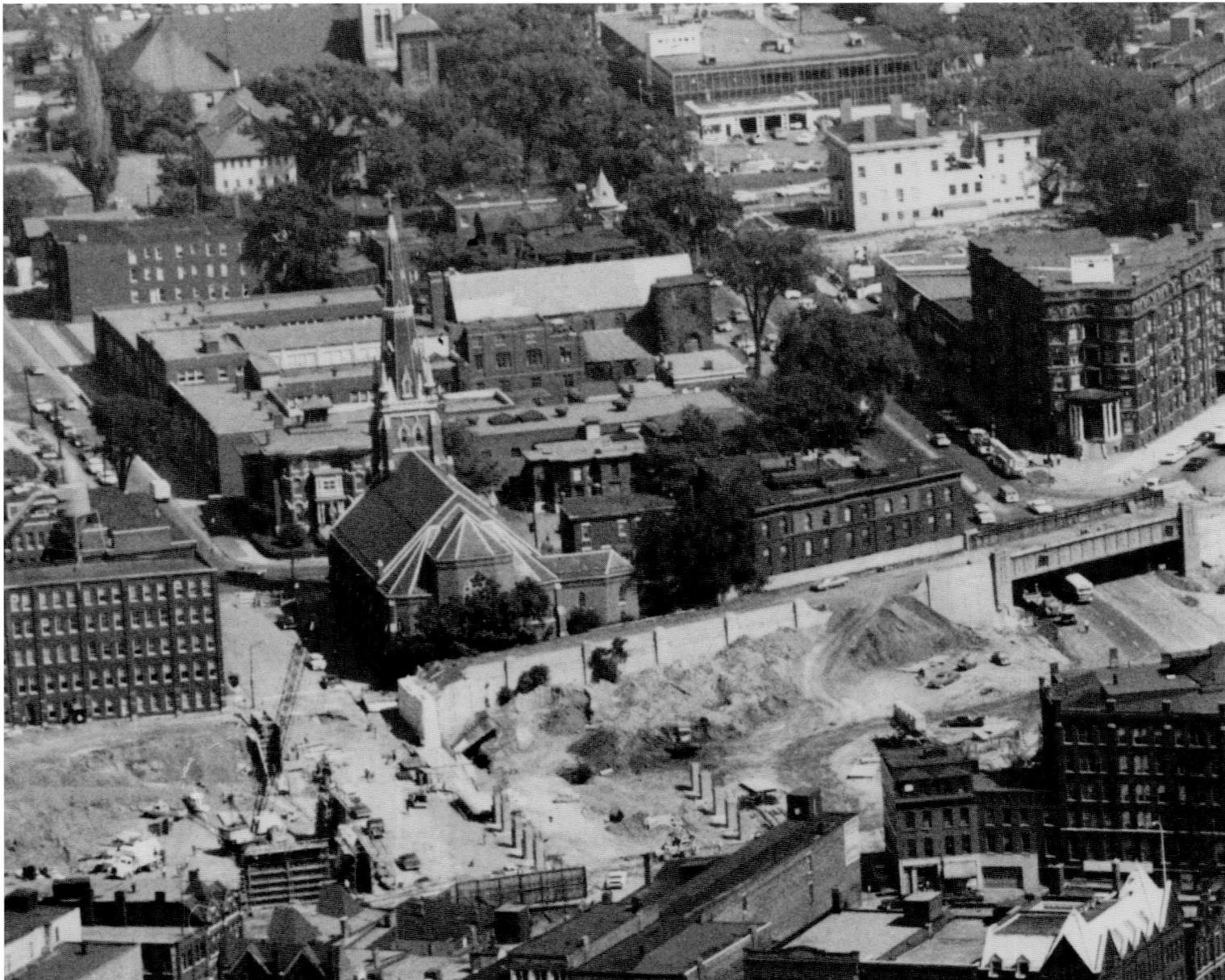

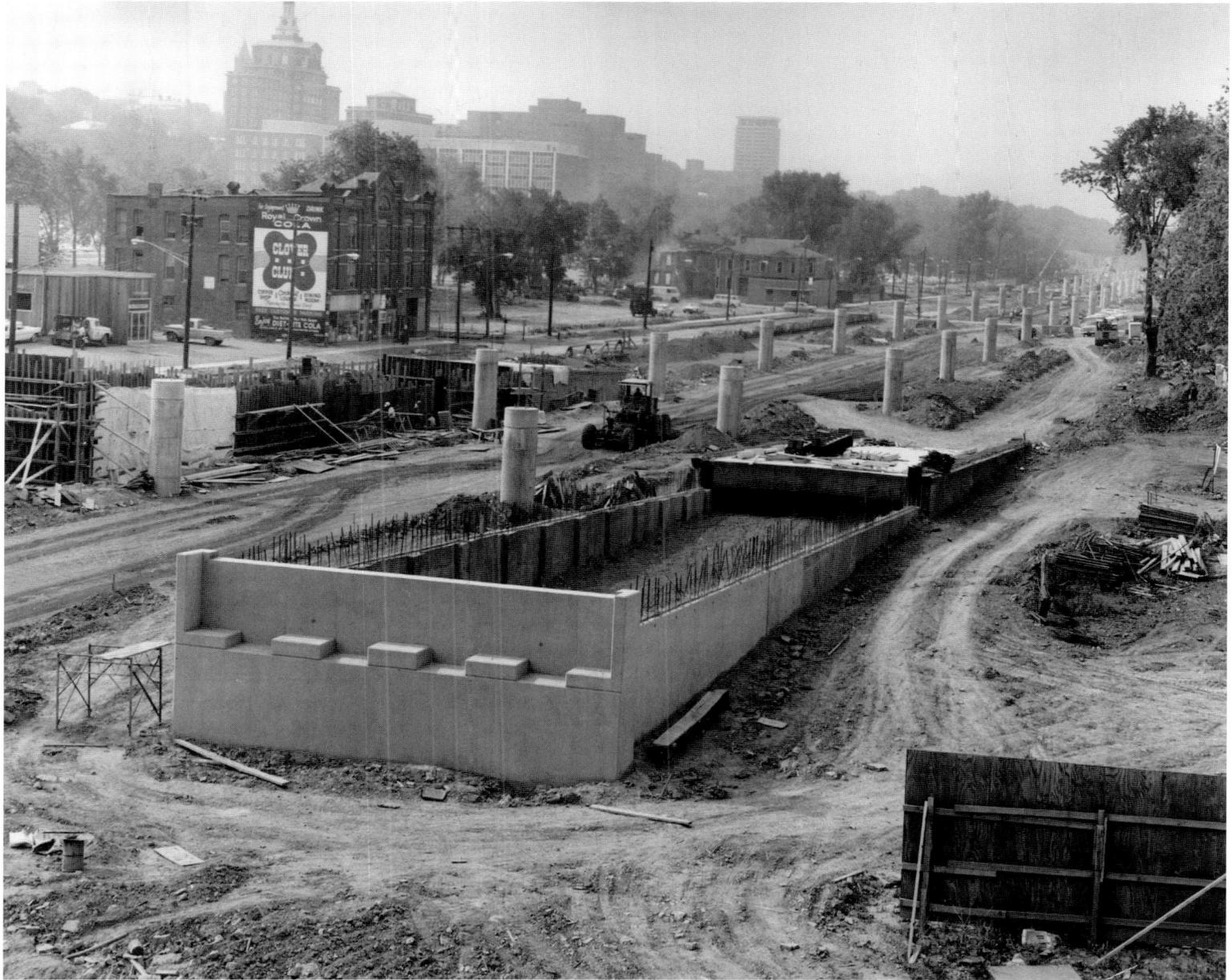

It was initially thought that the routing of elevated Interstate 81 between University Hill and downtown, under construction here in 1965, would benefit traffic flowing in and out of the city. Although that may have been true, the psychological wall that it created between downtown and Syracuse University is now considered a disadvantage. Its potential redesign is under review.

Elizabeth "Libba" Cotten was a guitar-playing folksinger most noted for her composition *Freight Train,* considered an American folk classic. Raised in the South, she moved to Syracuse in 1978 to be with family. In 1983 the city officially named her a "Living Treasure." She died in 1987 at the age of 95.

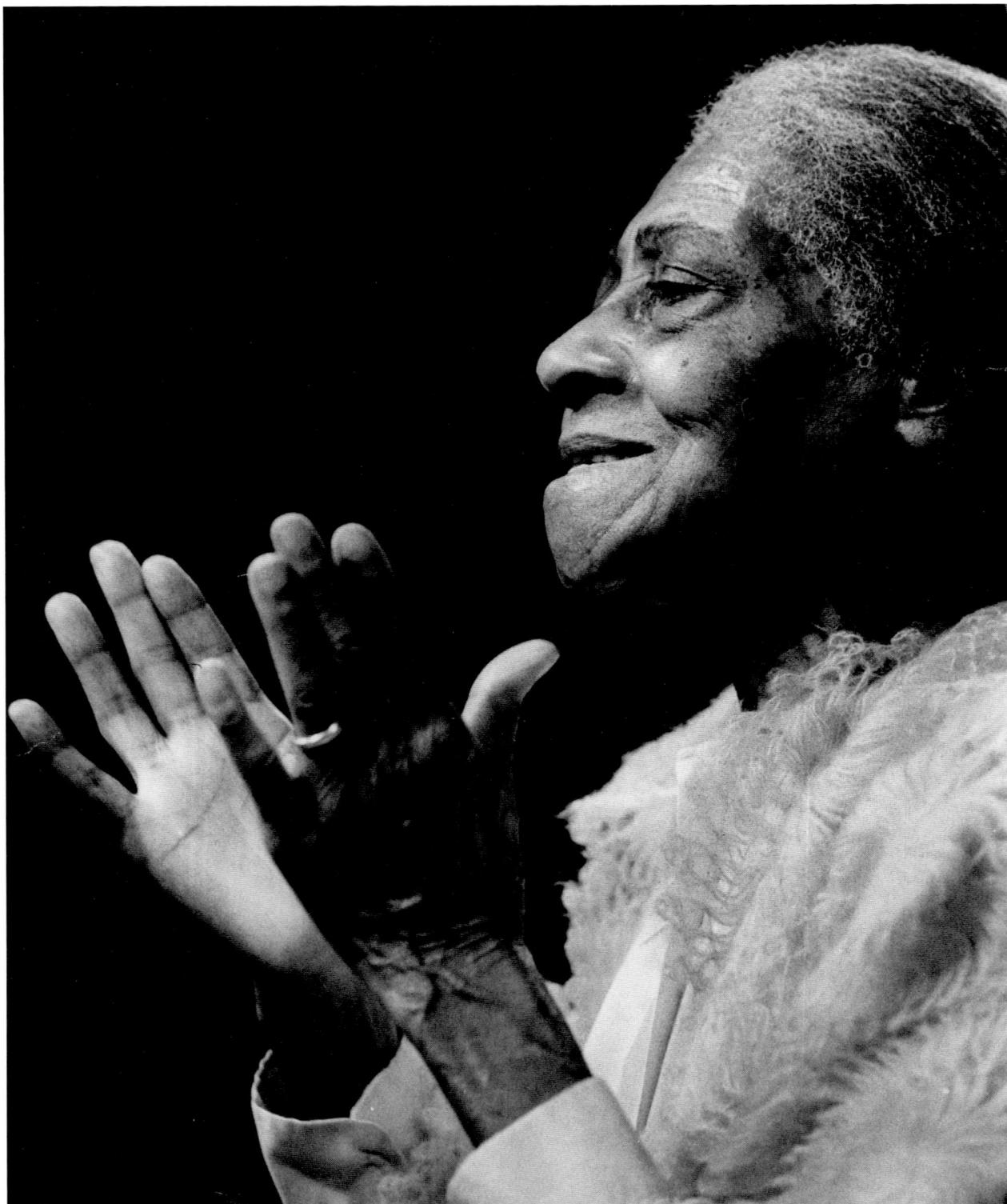

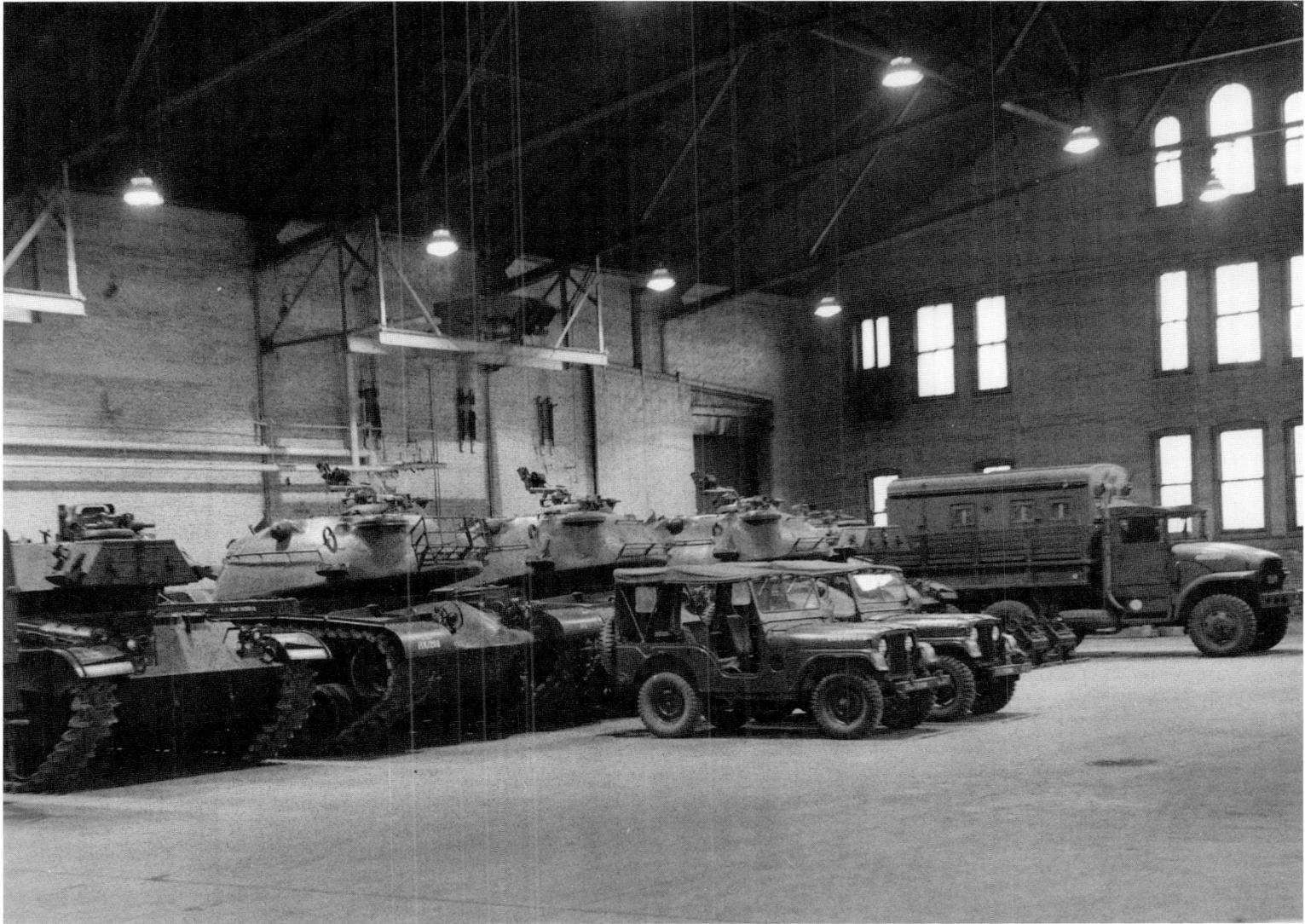

A group of Cold War–era army jeeps and tanks are parked inside the Jefferson Street National Guard Armory around 1960.

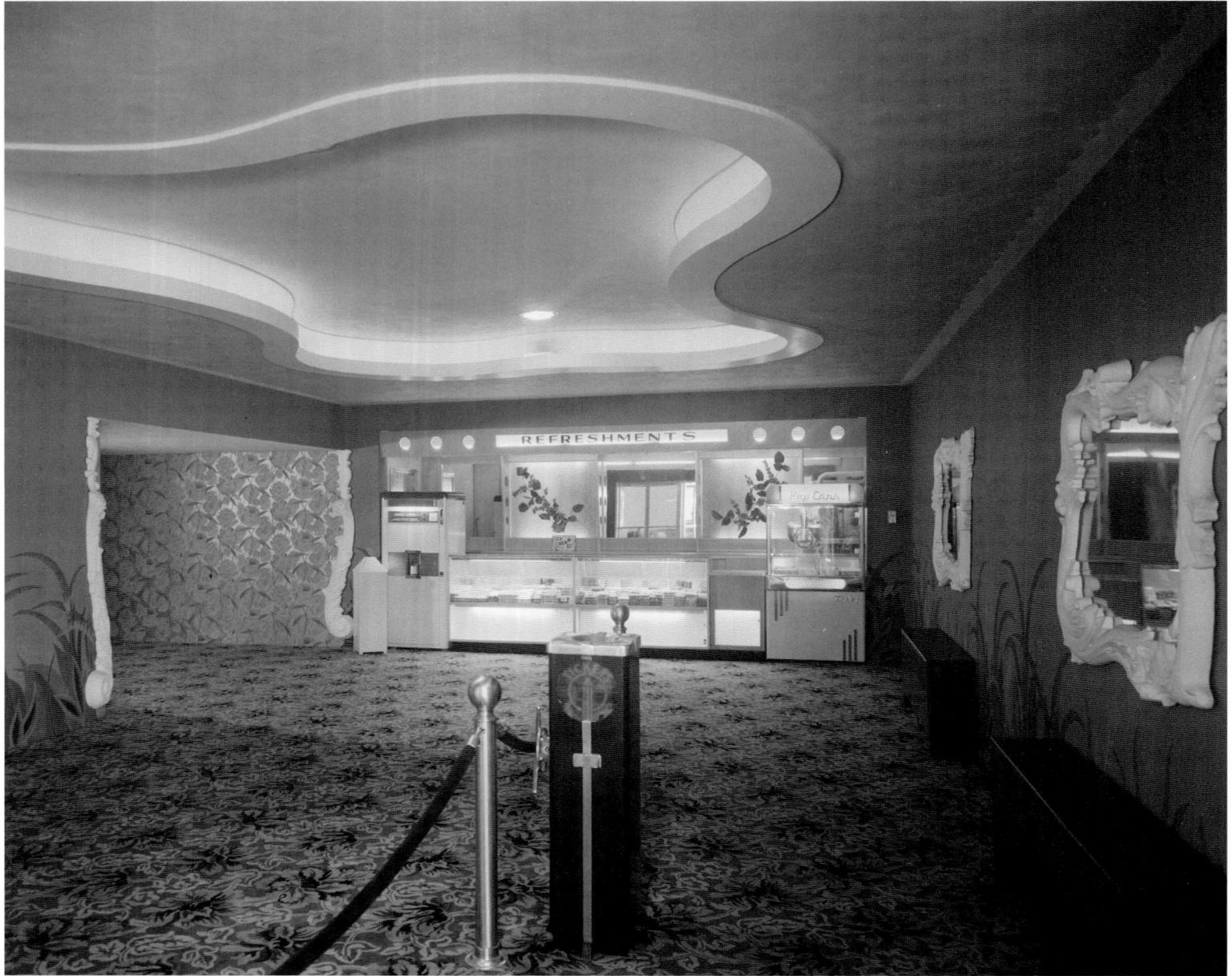

The Genesee Theater opened in 1950 on the western edge of the city in Westvale Plaza, one of the area's first Post–World War II shopping centers. Its style was much simpler than the downtown movie palaces but had a period allure all its own. It operated until 2001 when it was sold and then demolished for an auto parts store that lasted little more than a year.

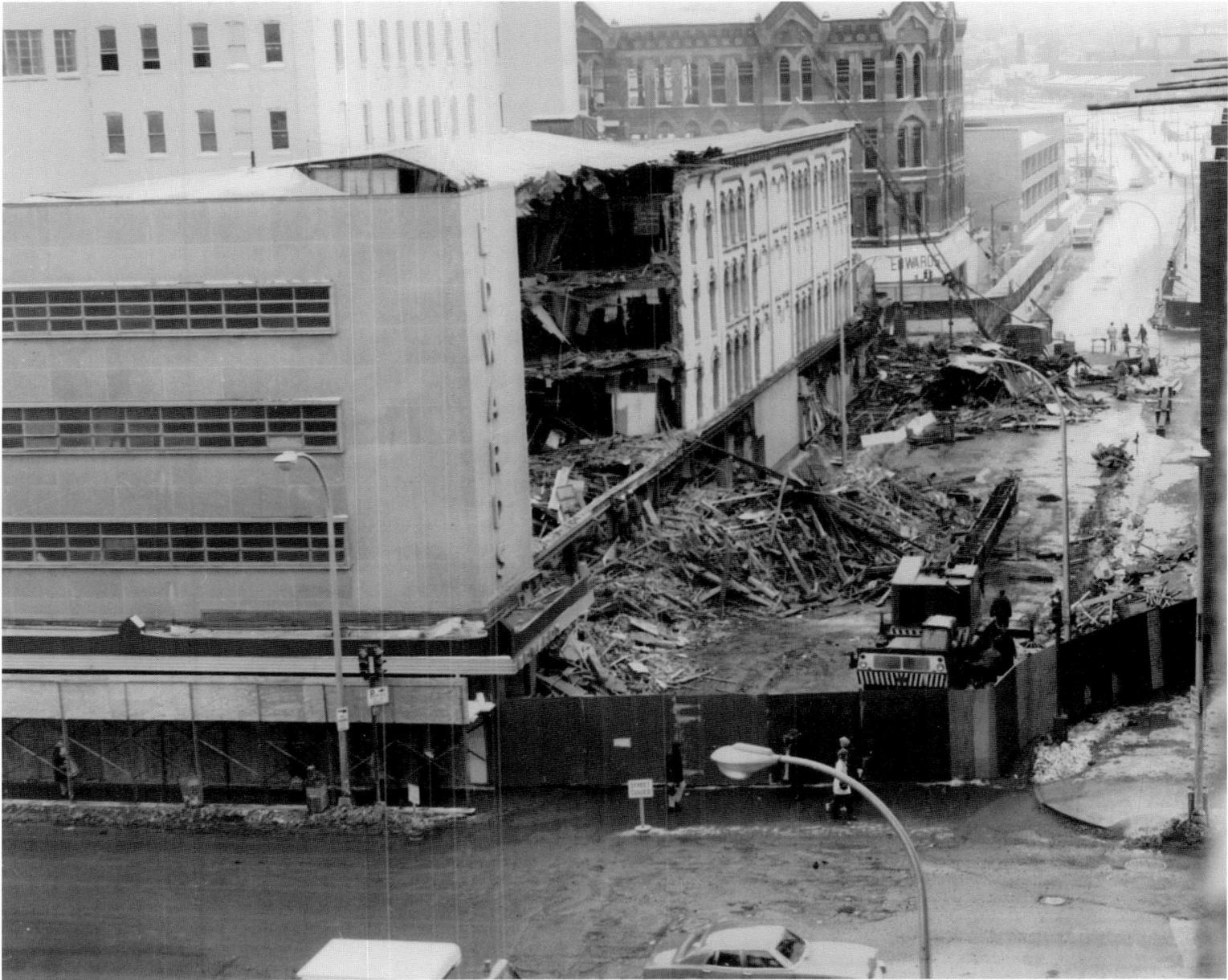

The old Edwards Department Store at Washington and Salina streets was demolished in 1970 to make way for One Lincoln Center. Most did not know that the building had actually begun life in 1847 as the Globe Hotel, the city's prime lodging establishment when nearby Vanderbilt Square held the city's first train station and James K. Polk was President.

The 1970s saw the first inklings of the historic preservation movement in Syracuse, one that is playing an increasingly vital role in the future of the city. The preservation and rehabilitation of the Gridley Building in 1974 and the 1978 rescue of the ornate Loew's State Theater, seen here, were key turning points.

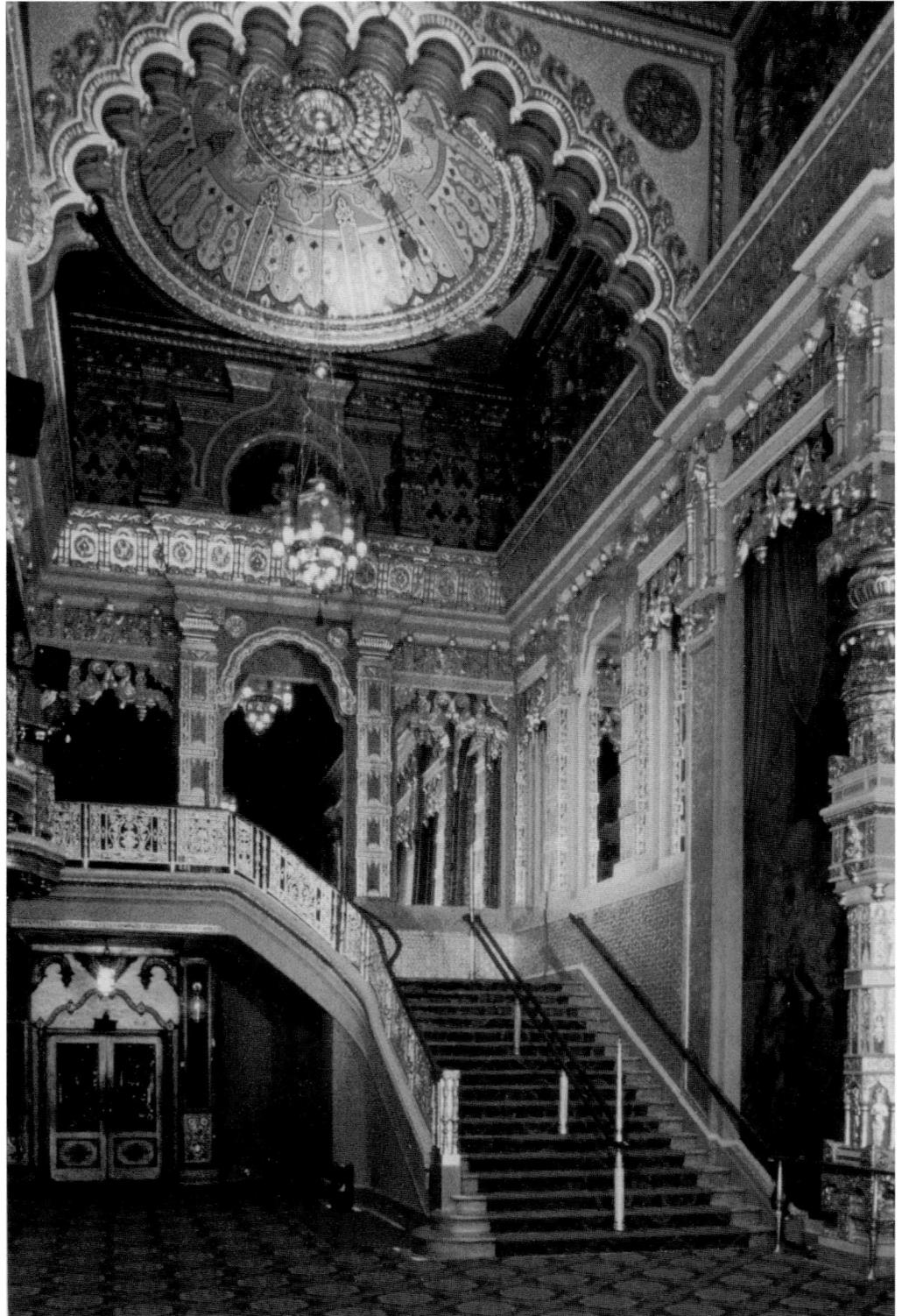

NOTES ON THE PHOTOGRAPHS

These notes attempt to include all aspects known of the photographs. All images are from the collection of the Onondaga Historical Association in Syracuse. Each of the photographs is identified by the page number, photograph's title or description, photographer and collection, archive, and call or box number when applicable. Although every attempt was made to include all data, in some cases complete data may have been unavailable.

II **ERIE CANAL 1880s**
Onondaga Historical Association
Views-Downtown-West

VI **PERRY & ROBINSON**
Onondaga Historical Association
Syracuse Block 109

x **SALT WORKS**
Onondaga Historical Association
Industry-Salt-Fine-Interiors

2 **SYRACUSE 1854**
Onondaga Historical Association
Clinton Square Northwest

3 **COLONEL BARNUM**
Onondaga Historical Association
Biographical Images-Barnum

4 **GENESEE STREET 1865**
Onondaga Historical Association
Hanover Square

5 **SYRACUSE JOURNAL**
Onondaga Historical Association
Syracuse Block 109

6 **VANDERBILT SQUARE**
Onondaga Historical Association
Streets-Washington

7 **THIRD COURTHOUSE**
Onondaga Historical Association
Syracuse Block 81

8 **EARLY BANK BUILDING**
Onondaga Historical Association
Syracuse Block 108

9 **EAST ONONDAGA STREET**
Onondaga Historical Association
Syracuse Block 113

10 **ERIE LAUNDRY DAY**
Onondaga Historical Association
OHA 7587

11 **ERIE STEAM LAUNCH**
Onondaga Historical Association
Clinton Square East

12 **BRADLEY HOME**
Onondaga Historical Association
Syracuse Block 99

13 **SALINA STREET**
Onondaga Historical Association
Syracuse Block 110

14 **BETTS BUILDING**
Onondaga Historical Association
Syracuse Block 110

15 **OSWEGO LIFT BRIDGE**
Onondaga Historical Association
OHA 2002.497

16 **OSWEGO CANAL LOCK**
Onondaga Historical Association
Transportation-Canal-Oswego

17 **NAPOLEON WRIGHT'S GROCERY**
Onondaga Historical Association
Syracuse Block 153

18 **BRINE PUMP HOUSE**
Onondaga Historical Association
Industry-Salt-Brine

20 **SANDERSON STEEL**
Onondaga Historical Association
Sanderson Steel

21 **O'KEEFE AND DeGAN**
Onondaga Historical Association
J. R. Clancy Collection

22 **SNOWY MONTGOMERY**
Onondaga Historical Association
Syracuse Block 113

23 **PRETTIE SPORTS SHOP**
Onondaga Historical Association
Syracuse Block 100

24 **HANOVER SQUARE**
Onondaga Historical Association
OHA 2002.497

25 **SAUL RESIDENCE**
Onondaga Historical Association
Syracuse Block 270

26 **BARNES MARRIAGE**
Onondaga Historical Association
Biographical Images - Barnes

27 **BARNES HOUSE**
Onondaga Historical Association
Syracuse Block 400

28 **GEORGE BARNES**
Onondaga Historical Association
Syracuse Block 400

29 **BARNES-HISCOCK HOUSE**
Onondaga Historical Association
Syracuse Block 400

30 **SNOW DRUG STORE**
Onondaga Historical Association
Syracuse Block 101

31 **YATES CASTLE**
Onondaga Historical Association
15th Ward-Yates Castle

32 **CITY HALL OF 1845**
Onondaga Historical Association
Syracuse Block-City Hall Pre-1889

33 **FIRE DEPARTMENT**
Onondaga Historical Association
Fire Fighting-Groups

34 **WIETING BLOCK FIRE**
Onondaga Historical Association
Syracuse Block 100-Weiting

35 **PETER BRUMMELKAMP**
Onondaga Historical Association
Groups-Family

36 **ESTELLA PADGHAM**
Onondaga Historical Association
OHA 6861

37 **SENECA TURNPIKE 1889**
Onondaga Historical Association
Ward 14-Valley

38 **CORTLAND BRIDGE**
Onondaga Historical Association
Rivers & Streams-Onondaga
Creek-Water Works

39 VALLEY THEATER
Onondaga Historical Association
Barstow Transit Collection-H. J.
Clark Album

40 BUTTERNUT STREET
Onondaga Historical Association
Barstow Transit Collection-H. J.
Clark Album

41 HORSE-DRAWN STREETCAR
Onondaga Historical Association
Barstow Transit Collection-H. J.
Clark Album

42 NEW STREETCAR TRACKS
Onondaga Historical Association
Barstow Transit Collection-H. J.
Clark Album

43 SOUTH CROUSE SCENE
Onondaga Historical Association
Barstow Transit Collection-H. J.
Clark Album

44 SENIOR CLASS 1894
Onondaga Historical Association
Education-High School-Group

45 WEST GENESEE SCHOOL
Onondaga Historical Association
Syracuse Block 198

46 TRANSIT POWER PLANT
Onondaga Historical Association
Barstow Transit Collection-H. J.
Clark Album

47 SALINA STREET 1898
Onondaga Historical Association
Barstow Transit Collection-H. J.
Clark Album

48 NEW YORK CENTRAL
Onondaga Historical Association
OHA 7587

49 ONONDAGA BOATHOUSE
Onondaga Historical Association
Lakes-Onondaga

50 THE IRON PIER 1899
Onondaga Historical Association
Lakes-Onondaga-Iron Pier

52 KA-NOO-NO KARNIVAL
Onondaga Historical Association
Clinton Square Southeast

53 SALINA STREETCAR
Onondaga Historical Association
Transportation-Electric-
Miscellaneous

54 JERVIS HOUSE 1903
Onondaga Historical Association
Syracuse Block 1113

55 NYC TRAIN SHED
Onondaga Historical Association
OHA 7587

56 NYC STATION OF 1895
Onondaga Historical Association
Syracuse Block 104A

58 MOTORCYCLISTS
Onondaga Historical Association
Syracuse Block 18

59 AUTO RACE 1904
Onondaga Historical Association
Transportation–Auto-
Miscellaneous

60 FRANKLIN'S "TORPEDO"
Onondaga Historical Association
OHA 8767

61 FRANKLIN MOTOR WORKS
Onondaga Historical Association
OHA 8767

62 LEAVENWORTH PARK
Onondaga Historical Association
Parks-Leavenworth

63 UPPER ONONDAGA PARK
Onondaga Historical Association
Parks Onondaga

**64 CLINTON SQUARE
LANDING**
Onondaga Historical Association
Clinton Square-Southeast

65 HAMMERLE TAVERN
Onondaga Historical Association
Syracuse Block 9

**66 BRADLEY
MANUFACTURING**
Onondaga Historical Association
Industry-Machinery-Bradley

67 CANAL BOAT
Onondaga Historical Association
Transportation-Boats-Steam
Packet

68 WORLD SERIES SCORES
Onondaga Historical Association
Syracuse Block 111

69 NEW COURTHOUSE
Onondaga Historical Association
Views-Downtown-Northeast

70 SYRACUSE UNIVERSITY
Onondaga Historical Association
OHA 8605

72 SALINA LIFT BRIDGE
Onondaga Historical Association
Clinton Square East-Lift Bridge

73 DANA HOME RAILING
Onondaga Historical Association
Syracuse Block 80

74 FIRE CHIEF RYAN
Onondaga Historical Association
Biographical Images - Ryan

75 EUCLID FIREHOUSE 10
Onondaga Historical Association
Ward 17-Westcott

76 MERRELL-SOULE CO.
Onondaga Historical Association
Parades, Ceremonies &
Celebrations-1900-1910

77 FRANKLIN PICNICKERS
Onondaga Historical Association
Transportation-Auto-Franklin

78 TEDDY ROOSEVELT VISIT
Onondaga Historical Association
Visitors-Famous-T. Roosevelt

79 ROOSEVELT VS. BARNES
Onondaga Historical Association
Visitors-Famous-T. Roosevelt

80 KIRKWOOD PARK
Onondaga Historical Association
Fairs-Onondaga County

81 SEDGWICK TENNIS CLUB
Onondaga Historical Association
Ward 4-Sedgwick Farms

82 JOHN ARCHBOLD
Onondaga Historical Association
Education-Syracuse University-
Buildings

83 XAVIER ZETT HOUSE
Onondaga Historical Association
Salina Block 69

84 FOUR GENTLEMEN
Onondaga Historical Association
OHA 8767

85 SYRACUSE AUTO SHOW
Onondaga Historical Association
OHA 8767

86 COLUMBUS CIRCLE
Onondaga Historical Association
Circles-Columbus

87 JAMES STREET
Onondaga Historical Association
Streets-James-Salina to Pearl

88 HIAWATHA LAKE
Onondaga Historical Association
Parks-Onondaga

89 LIEDERKRANZ CLUB
Onondaga Historical Association
Salina Block 122

90 STAR PARK COLLAPSE
Onondaga Historical Association
Syracuse Block 901

91 GOOD SHEPHERD INTERNS
Onondaga Historical Association
Syracuse Block 370

**92 GOOD SHEPHERD
HOSPITAL**
Onondaga Historical Association
Syracuse Block 370

**93 GOOD SHEPHERD
AMPHITHEATER**
Onondaga Historical Association
Syracuse Block 370

94 HENRY DIDAMA HOME
Onondaga Historical Association
Syracuse Block 115

95 LIVERY STABLE
Onondaga Historical Association
Syracuse Block 110

**96 WOMEN'S AND
CHILDREN'S HOSPITAL**
Onondaga Historical Association
Geddes Block 116

97 HOSPITAL VOLUNTEERS
Onondaga Historical Association
Military-WWI-Civilian
Activities

98 DOUGHBOYS IN TRAINING
Onondaga Historical Association
Military-WWI-NY State Fair
Camp

99 LEAVING FOR THE FRONT
Onondaga Historical Association
Military-WWI-Selectives

**100 TROOPS WELCOMED
HOME**
Onondaga Historical Association
Military-WWI

**102 SOLDIERS AND SAILORS
MONUMENT**
Onondaga Historical Association
Parades, Ceremonies &
Celebrations-Americanization

104 B. F. KEITH'S THEATER
Onondaga Historical Association
OHA 8310

**105 TRAFFIC CONTROL
TOWER**
Onondaga Historical Association
Clinton Square West

106 WARREN STREET
Onondaga Historical Association
Syracuse Block 101

107 AMERICAN LEGION CONVENTION
Onondaga Historical Association
Visitors-Famous-Pershing

108 FRANKLIN MOTORS 1922
Onondaga Historical Association
Geddes Block 88-91

109 FRANKLIN ASSEMBLY LINE
Onondaga Historical Association
OHA 7543

110 FRANKLIN SEDAN
Onondaga Historical Association
Transportation-Auto-Franklin-
Late Models

111 EAST GENESEE SINCLAIR
Onondaga Historical Association
Syracuse Block 237

112 SOUTH SALINA STREET
Onondaga Historical Association
Syracuse Block 100

113 SMITH & BROTHERS TYPEWRITERS
Onondaga Historical Association
Industries-Typewriter

114 AMBOY AIRPORT
Onondaga Historical Association
Marvin Collection OHA
2003.493

115 LINDBERGH VISIT
Onondaga Historical Association
OHA 6265

116 TELEPHONE SWITCHBOARD
Onondaga Historical Association
Communication-Telephone

117 MONTGOMERY STREET
Onondaga Historical Association
Views-Downtown-East

118 WEILER BUILDING
Onondaga Historical Association
Syracuse Block 117

119 CENTRAL HIGH FOOTBALL SQUAD
Onondaga Historical Association
Sports-Football-Group

120 PERCY HUGHES BUS
Onondaga Historical Association
Ward 19-Hughes School

121 JACK DEMPSEY
Onondaga Historical Association
Visitors-Famous-Dempsey

122 RKO KEITH'S
Onondaga Historical Association
OHA 8310

123 KEITH'S BALCONY LOBBY
Onondaga Historical Association
OHA 8310

124 ACME MATINEE
Onondaga Historical Association
Salina Block 124

125 BRIGHTON THEATER
Onondaga Historical Association
Ward 19

126 HOTEL SYRACUSE
Onondaga Historical Association
Block 133

127 ORCHESTRA AT HOTEL
Onondaga Historical Association
Syracuse Block 133

128 HOTEL SYRACUSE CAFETERIA
Onondaga Historical Association
Syracuse Block 133

129 HOTEL SYRACUSE LOBBY
Onondaga Historical Association
Syracuse Block 133

130 WAGE RADIO
Onondaga Historical Association
Communication-Radio

131 CROUSE HOSPITAL CEREMONY
Onondaga Historical Association
Geddes Block 116

132 NEW MEMORIAL HOSPITAL
Onondaga Historical Association
Syracuse Block 355

133 SOUTH SALINA 1932
Onondaga Historical Association
Ward 18

134 LOBLAWS GROCERY
Onondaga Historical Association
Ward 12

135 STARS HOCKEY
Onondaga Historical Association
Sports-Hockey

136 MOST HOLY ROSARY SOCCER
Onondaga Historical Association
Sports-Soccer

137 ELIZUR CLARK HOME
Onondaga Historical Association
Ward 1

138 JEFFERSON AND WARREN
Onondaga Historical Association
Syracuse Block 116

139 EASTWOOD
Onondaga Historical Association
Ward 5-Eastwood

140 EVENING DOWNTOWN
Onondaga Historical Association
Syracuse Block 116

141 CLINTON PARKING LOT
Onondaga Historical Association
Clinton Square Northeast

142 AMOS BUILDING
Onondaga Historical Association
Clinton Square Southwest

143 CLINTON SQUARE 1930s
Onondaga Historical Association
Syracuse Views-Downtown-
1930s

144 GRIDLEY BUILDING INTERIOR
Onondaga Historical Association
Syracuse Block 94

145 NORMA SHEARER AND FRIENDS
Onondaga Historical Association
OHA 7872

146 NEWSPAPER SLED
Onondaga Historical Association
Syracuse Block 122

147 ONONDAGA HOTEL
Onondaga Historical Association
Block 111

148 DL&W RAIL YARD
Onondaga Historical Association
Grade Crossing Commission
Collection

149 GRADE-LEVEL CROSSING
Onondaga Historical Association
Syracuse Block 249

150 ADAMS STREET BRIDGE
Onondaga Historical Association
Transportation-Railroad-DL&W

151 ERIE BOULEVARD TERMINAL
Onondaga Historical Association
Syracuse Block 265

152 SOUTH WARREN STREET
Onondaga Historical Association
Block 111-East Half

153 ONONDAGA TRAVEL ROOM
Onondaga Historical Association
Syracuse Block 111

154 ADDIS BEAUTY SALON
Onondaga Historical Association
Syracuse Block 116

155 McCARTHY'S STORE
Onondaga Historical Association
Syracuse Block 108

156 HUNTERS DEPARTMENT STORE
Onondaga Historical Association
Syracuse Block 108

157 DOWNTOWN 1942
Onondaga Historical Association
Syracuse Block 115

158 HABERLE BREWERY
Onondaga Historical Association
Industry-Brewing-Haberle

159 HABERLE BEER BARRELS
Onondaga Historical Association
Industry-Brewing-Haberle

160 NIAGARA HUDSON ART DECO
Onondaga Historical Association
Syracuse Block 86

161 NIAGARA HUDSON 2
Onondaga Historical Association
Syracuse Block 86

162 CHILDS AND CLARKS
Onondaga Historical Association
Syracuse Block 115

163 WESTCOTT STREETCAR
Onondaga Historical Association
Transportation-Electric-
Miscellaneous

164 DEWITT AND MANLIUS BUS
Onondaga Historical Association
Barstow Transit Collection-Bus
Album #1

165 DOWNTOWN 1940
Onondaga Historical Association
Streets-South Salina at
Washington

166 POLICE DEPARTMENT
Onondaga Historical Association
Police-Miscellaneous

167 B-17 FLYING FORTRESS
Onondaga Historical Association
OHA 2002.293

168 JEFFERSON ARMORY
FAREWELL
Onondaga Historical Association
Military-World War II-
Soldiers

169 RETOOLING FOR WAR
Onondaga Historical Association
Industry-Appliances-Easy
Washer

170 SCRAP DRIVE
Onondaga Historical Association
Military-World War II-Civilian
Activities

171 V-J DAY
Onondaga Historical Association
Military-World War II-VJ Day

172 EASY WASHER
"SPINDRIERS"
Onondaga Historical Association
Industry-Appliances-Easy
Washer

174 SALINA THEATERS
Onondaga Historical Association
Syracuse Block 115

175 TOWNSEND AND
HARRISON
Onondaga Historical Association
Syracuse Block 137

176 SYRACUSE CENTENNIAL
Onondaga Historical Association
Parades, Ceremonies &
Celebrations-1948

177 CARL ROTERS MURAL
Onondaga Historical Association
Syracuse Block 133

178 WAR MEMORIAL
CONSTRUCTION
Onondaga Historical Association
OHA 8930

179 WAR MEMORIAL 2
Onondaga Historical Association
Views East

180 EASTWOOD 1949
Onondaga Historical Association
Ward 5-James Street

181 WHEN FASHION SHOW
Onondaga Historical Association
Syracuse Block 133-Hotel
Syracuse

182 WHITE TOWER AND
SYROCO
Onondaga Historical Association
Syracuse Block 119

183 NYC AUTO STATION
Onondaga Historical Association
Syracuse Block 265

184 ONONDAGA APARTMENTS
Onondaga Historical Association
Syracuse Block 246

185 PADDY WAGON 1955
Onondaga Historical Association
Police-Miscellaneous

186 LABOR TEMPLE FIRE
Onondaga Historical Association
Syracuse Block 105

187 MOWRY APARTMENTS
FIRE
Onondaga Historical Association
OHA 2002.255

188 SU MARCHING BAND
Onondaga Historical Association
Education-Syracuse University-
Student Activity

189 SU STUDENT ARRIVAL
Onondaga Historical Association
Education-Syracuse University-
Bldgs.-Residences

190 WALDORF CAFETERIA
Onondaga Historical Association
Syracuse Block 119

191 EDWARDS STORE
"ROCKET"
Onondaga Historical Association
Syracuse Block 106

192 MAGIC TOY SHOP
Onondaga Historical Association
Communication-Television

193 JEAN'S JUNIOR AUCTION
Onondaga Historical Association
Communication-Television

194 YATES CASTLE
DEMOLITION
Onondaga Historical Association
15th Ward-Yates Castle

195 CARMEN BASILIO AND
FAN
Onondaga Historical Association
Sports-Boxing

196 ROUTE 690
CONSTRUCTION
Onondaga Historical Association
Views-Northeast

197 INTERSTATE 81
CONSTRUCTION
Onondaga Historical Association
Roads-Route 81

198 ELIZABETH COTTEN
Onondaga Historical Association
Biographical Images-Cotten

199 JEFFERSON STREET
ARMORY
Onondaga Historical Association
OHA 7807

200 GENESEE THEATER
Onondaga Historical Association
Town of Geddes-Westvale

201 EDWARDS STORE—
GLOBE HOTEL
DEMOLITION
Onondaga Historical Association
Syracuse Block 107

202 LOEW'S THEATER
RESCUE
Onondaga Historical Association
Syracuse Block 110